MW00824122

NIKI DE SAINT PHALLE

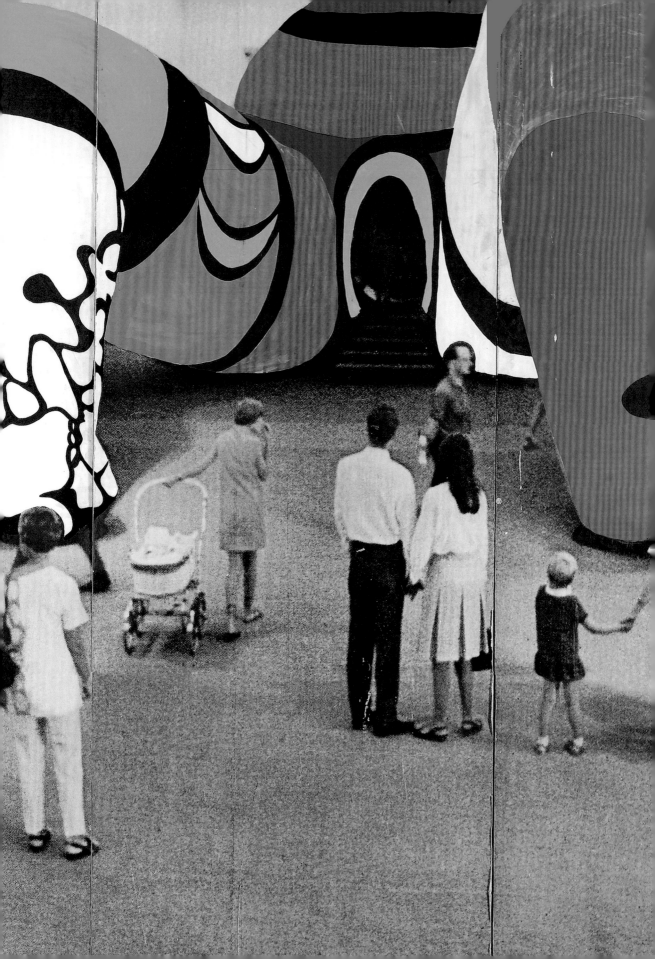

NIKI DE SAINT PHALLE IN THE 1960s

Jill Dawsey
Michelle White

with essays by
Amelia Jones, Ariana Reines, and Alena J. Williams
and contributions by
Molly Everett and Kyla McDonald

The Menil Collection, Houston
Museum of Contemporary Art San Diego
Distributed by Yale University Press, New Haven and London

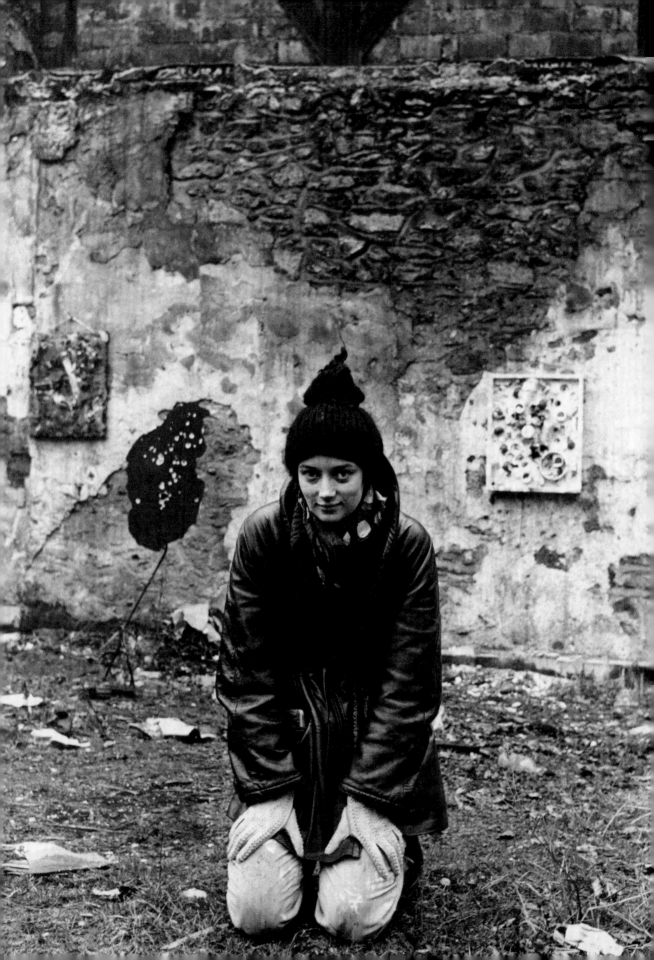

CONTENTS

The Menil Collection, Houston, and the Museum of Contemporary Art San Diego (MCASD) are proud to present *Niki de Saint Phalle in the 1960s*, the first North American exhibition and catalogue to survey the artist's prescient work of the 1960s. Born in France and reared in the United States, Niki de Saint Phalle (1930–2002) worked in Paris as an adult and ultimately settled in Southern California. Saint Phalle's *Tirs*, or "shooting paintings," created using a .22-caliber rifle, were startling in their critique of modern, masculine painting traditions, as well as in their conjuring of the pervasive violence of the mid-twentieth century. An active participant in international dialogues focused on assemblage, painting, and sculpture, Saint Phalle was the sole female member of the Paris-based Nouveaux Réalistes, and she also collaborated with American artists such as Jasper Johns and Robert Rauschenberg. Working at the center of male-dominated avant-garde circles in both France and the United States, the artist made a bold turn in the mid-1960s when she began exploring ideas of feminine identity, developing her signature *Nana* sculptures, which grew in scale and exuberance over the years. These vibrantly colored representations of joyous, powerful women anticipated the rise of international feminist movements and would inform subsequent conversations about gender and sexuality in art. They continue to resonate in our own era. This book and the exhibition that it accompanies advance new scholarship on Saint Phalle's role in the pivotal decade of the 1960s, asserting her place in postwar art history on both sides of the Atlantic Ocean.

Both of our museums have distinctive ties to Saint Phalle. John and Dominique de Menil, the founders of the Menil Collection, were early supporters and purchased three of her shooting paintings in the 1960s. The couple helped underwrite many of her projects, including the New York exhibition of the 1967 sculptural group *Le paradis fantastique* that Saint Phalle created with her partner, Jean Tinguely, as well as the realization of another collaborative work, *Le cyclop*, beginning in 1969. The Menil Archives hold extensive personal correspondence between the artist and the de Menils in addition to unpublished interview transcripts, drawings, photographs, exhibition ephemera, documentary films of Saint Phalle by Dominique and John's son Francois de Menil, and photographs by their daughter Adelaide de Menil Carpenter. The de Menil patronage of the artist was very much a family affair.

Saint Phalle's connection to Southern California dates back to 1962, when the artist staged the first of several shooting sessions in Los Angeles, in what are among the earliest instances of performance art in the area. In 1983, for her first outdoor commission in the U.S., the artist created *Sun God*, a colossal bird-like deity that sits atop an arch at the University of California, San Diego. Saint Phalle relocated to San Diego in 1994 and lived there until her death in 2002, leaving behind a legacy of vibrant public artworks across the region, including *Queen Califia's Magical Circle*, her only major sculpture garden in North America. In MCASD's collection, the monumental *Big Ganesh*, 1998, is particularly beloved by visitors. Today, the Niki Charitable Art Foundation (NCAF), which includes the artist's archives, is also based in San Diego.

We are deeply indebted to the foundation and, above all, to Bloum Cardenas, Saint Phalle's granddaughter and NCAF Trustee, who shared our vision for an exhibition that would bring renewed attention to this radical period of the artist's career. Likewise, we extend our sincere gratitude to the many institutions and collectors who have agreed to lend their extraordinary and fragile artworks to our exhibition. Saint Phalle's work from this period is particularly powerful, and we recognize the sacrifice in being separated from it for the length of the tour.

This project would not have been possible without the financial contributions of our donors and sponsors. Major support for this volume is provided by Cecily E. Horton; additional support is provided by the Niki Charitable Art Foundation and the Menil Collection Publishing Fund. Support for this exhibition at both the Menil Collection and the Museum of Contemporary Art San Diego is provided by Christie's. Research for the exhibition was supported by the Terra Foundation for American Art.

At the Menil we want to express our gratitude for major funding provided by Louisa Stude Sarofim; Cecily E. Horton; a gift in memory of Virginia P. Rorschach; Bettie Cartwright; and the National Endowment for the Arts. Additional support comes from Dragonfly Collection, Garance Primat; MaryRoss Taylor; Carol and David Neuberger; Julie and John Cogan, Jr.; Robin and Andrew Schirrmeister; MCT Fund; Niki Charitable Art Foundation; UBS Financial Services; and the City of Houston through the Houston Arts Alliance. We would also like to thank the Menil Board of Trustees for their leadership.

At MCASD, we celebrate the opening of *Niki de Saint Phalle in the 1960s* with the debut of our new La Jolla campus expansion, designed by the architect Annabelle Selldorf. We extend our thanks to MCASD's Board of Directors for their endorsement of this first special exhibition in the renovated building. We also acknowledge the City of San Diego Commission for Arts and Culture for their institutional support.

This institutional collaboration was spurred by the scholarly interest of Michelle White, Senior Curator at the Menil, and Jill Dawsey, Curator at MCASD. Together, they contribute new scholarship to under-researched areas of Saint Phalle's production from the 1960s, highlighting the significance of her work for art historical developments of this period. We thank this talented curatorial duo for their rigor, insight, and determination. We recognize the role of our capable museum staff members who helped bring the project to fruition, and gratefully acknowledge the Menil's Director of Publishing, Joseph N. Newland, who produced such a beautiful book during a global pandemic.

Niki de Saint Phalle's visionary artwork has long captivated us. It has been twenty years since the artist's death, yet her prolific production remains relevant and inspiring, as it continues to ignite the work of new generations of artists.

Rebecca Rabinow
Director
The Menil Collection, Houston

Kathryn Kanjo
The David C. Copley Director and CEO
Museum of Contemporary Art San Diego

In *Niki de Saint Phalle in the 1960s*, we set out to explore a highly experimental and generative decade in the artist's practice, and to offer a reassessment of her significant contributions to postwar art. From Saint Phalle's *Tirs*, which exposed the macho heroics of expressionist painting, to her *Nanas*, the jubilant figures whose complexities remain little discussed, this exhibition is the first to survey the dynamic early career of a French-American artist who remains seriously under-examined—especially in the context of the United States. Saint Phalle was at the center of transatlantic avant-garde circles in the 1960s, yet she is still routinely omitted from art historical discussions of her peers. Working in an almost exclusively masculine milieu, the artist developed an exuberant practice that challenged the patriarchal conditions of the art world and those of everyday life.

In 1961, brandishing firearms, Saint Phalle expanded the scene of painting to a public situation, inviting her audience to take part in demonstrations of violence as a form of participatory social critique. By 1963, years before artists of the 1970s feminist art movement began to interrogate women's roles and revalue women's handi-work, Saint Phalle introduced a succession of female archetypes in the form of figural assemblages: brides, mothers, goddesses, and monsters, all of them insistently handmade, imposing in scale, and constructed with an astonishing array of found materials and objects. These increasingly liberated freestanding figures developed in 1965 into the *Nanas*, harbingers of a rising feminist consciousness. As the figures grew to monumental proportions, their rambunctious and cartoonishly feminine forms seemed to stage a mockery of the monumental format as an instrument of power and authority. Meanwhile, their curves and corporeal excess were startlingly at odds with the aesthetic tenets of the pared-down visual language of so-called Minimalism then taking hold. Saint Phalle was producing work so ahead of its time that it could not be named and was little understood. Although her work received a great deal of media attention in its day, it revolved around the journalists' astonishment that a woman could create such audacious art. The oozing, dripping colors and expan-sive sculpted bodies of Saint Phalle's early corpus were bewildering in their embrace of a joyful, sensuous relationship to the world—an entirely novel gesture of defiance.

Our exhibition was conceived at the height of the #MeToo movement and came together in the long period of reckoning that followed, a context that, for us, has made the artist's early artistic investigations of gender and agency newly legible. It also gave us a renewed determination to bring Saint Phalle's work into contemporary conversations, reigniting the reverence and awe we both have had toward her work since we came of age as feminist art historians and curators. Saint Phalle's feminism, or feminisms, run as a current throughout the exhibition as well as this volume, where the subject is manifested in relation to a range of subjects: her emphasis on collective production; her explorations of scale and public space; her existentialism; and her dance between rage and elation, along with the many contributions she would make to a feminist art movement yet to come. Saint Phalle's achievements in the early and mid-1960s appear ever more remarkable from our temporal vantage point—a miracle, as Ariana Reines writes in her text. We are grateful that the exhibition's timing allowed us to travel to Europe for research just prior to the Covid-19 pandemic and to spend the following year working on this publication. It is an honor to publish the work of Amelia Jones, Alena J. Williams, Ariana Reines, and Kyla McDonald, and we thank all of them, with admiration and gratitude, for their illuminating writings

on the artist and her work. We also thank and applaud Menil Curatorial Assistant Molly Everett for her invaluable research and thoughtful contributions to the formation of the exhibition and catalogue, including her thorough research for the chronology of Saint Phalle's shooting sessions.

Featuring works by Saint Phalle from public and private European collections, including many rarely or never before seen in the U.S., *Niki de Saint Phalle in the 1960s* has involved the collaboration of many individuals to whom we must extend our thanks. First, we wish to first express our deepest gratitude to Bloum Cardenas for her passion, time, and commitment to this project from the start, along with the team at the Niki Charitable Art Foundation: Trustees David Stevenson and Marcelo Zitelli, Director of Archives Jana Shenefield, and Assistant Agata Juretko. Thank you to Georges-Philippe Vallois and Marianne Le Métayer at Galerie Georges-Phillippe and Nathalie Vallois, Paris, who have provided invaluable research support and graciously facilitated many loans.

We owe a debt of gratitude to the institutions and collectors who agreed to lend their extraordinary, often fragile artworks. Thank you to the Albright-Knox Art Gallery, Buffalo, New York; Carré d'Art, Musée d'art contemporain de Nîmes; Centre Pompidou, Paris, Musée national d'art moderne/Centre de création industrielle; Guggenheim Abu Dhabi; Hirshhorn Museum and Sculpture Garden, Smithsonian Institution, Washington, D.C.; Moderna Museet, Stockholm; Mamac, Nice; Museum of Contemporary Art Chicago; the Museum of Fine Arts, Houston; Niki Charitable Art Foundation, Santee, California; Princeton University Art Museum, New Jersey; and Sprengel Museum Hannover. Gratitude is due to Galerie Mitterrand, Paris, and Galerie Georges-Philippe & Nathalie Vallois, Paris. And our sincere thanks go to Isabelle and David Lévy, Bruxelles; Dragonfly Collection, Garance Primat; The Rand Collection; Marcel Lefranc, Paris; Suzanne and Michael Tennenbaum; Quenza Collection, USA; and private collectors who wish to remain anonymous.

We would like to extend our gratitude to Rebecca Rabinow, Director of the Menil Collection, and Kathryn Kanjo, the David C. Copley Director and CEO of the Museum of Contemporary Art San Diego (MCASD), for their guidance and enthusiastic support of our work. We are deeply thankful to the Menil's Associate Registrar Stephanie Harris Akin and the MCASD Associate Registrar Karin Zonis-Sawrey, who have been critical to managing all aspects of the loans and myriad tasks involved with transportation and venue coordination. Thank you to Jenna S. Jacobs, Senior Director, Curatorial Affairs at MCASD, for her unfailing guidance, and to Nadia Al-Khalifah, curatorial administrative assistant at the Menil, for her unflappable support on all aspects of this show. Tom Callas, former registrar at MCASD, and the Menil's former Exhibition Manager Alexis Pennington-Foster played a central role in the early administration of the project.

Our further thanks go to the staff at the Menil for their support in making this exhibition possible: Susan Slepka-Anderson in our Collections Department, and Tony Rubio and his team in Art Services. Archivists Lilly Carrel and Lisa Barkley assisted in tracing the de Menils' involvement with the artist and her work and prepared archival material for exhibition and publication. Thank you to the exhibition design team of Brooke Stroud and Kent Dorn, and a special debt of gratitude is owed to our Conservation Department team, led by Bradford A. Epley: Jan Burandt, Desirae (Peters) Dijkema, Joy Bloser, James Craven, and Kari Dodson, who worked extensively

on the conservation of the fragile loans. Additional appreciation to Sarah Hobson and her staff in the External Affairs Department for their extensive assistance. And, of course, tremendous thanks go to our Advancement Department, led by Judy Waters, for making our ambitions possible. Lauren Pollock and Tony Martinez in Public Programs have created an engaging series of programs that activate the ideas behind the work. Thank you to our membership, visitor services, and security staff for their unwavering dedication to helping create a safe and welcoming museum experience for the Menil's community.

At MCASD, we are grateful to the staff members whose collective efforts have brought this project to fruition at the same time as preparing to reopen our expanded La Jolla campus. Many thanks to Chief Advancement Officer Elizabeth Yang-Hellewell and her team—including former Advancement Operations Manager Allison Caruso and Senior Membership and Annual Giving Manager April Farrell—whose efforts were crucial to the success of this project. We also wish to acknowledge the support of Administrative Assistant Annie Hruska and the collegiality of Associate Curator Anthony Graham and former Assistant Curator Alana Hernandez. Director of Communications & Marketing Chris Cloud was instrumental in amplifying the reach of the exhibition, as was Senior Director, Education and Engagement Cris Scorza through her interpretation and public programming. Lead Preparator of Collections & Exhibitions Jeremy Woodall skillfully oversaw the installation of the artwork, assisted by Preparators Shawn Bigbee and Alexander Mazegue and their team of assistant preparators. Heartfelt appreciation goes to Chief of Security David Mesa, Security Supervisor Lori Watson, Security Services Lead Manny Garcia, and all our frontline visitor services and security services staff.

This catalogue was adeptly produced by the Publishing Department of the Menil, and we extend our special thanks to Joseph N. Newland, Director of Publishing, and Nancy L. O'Connor, Associate Editor, for their expertise and diligent efforts. Many thanks to Margaret McKee and Donna McClendon in Imaging Services for their assistance with photograph permissions. Librarian Lauren Gottlieb-Miller's research assistance was manifold. We are grateful for the brilliance of the catalogue editor Jennifer Bernstein, and the inspired catalogue design by the team of Lorraine Wild and Ching Wang at Green Dragon Office, Los Angeles.

Gratitude is due to the many individuals who assisted with our research through the course of the show's research and planning, and with the facilitation and care of the loans for the exhibition: Julia Blaut, Gina Guy, Kathy Halbreich, Helen Hsu, Shirin Khaki, Francine Snyder, and David White at the Robert Rauschenberg Foundation, New York; Julie Martin at the Klüver/Martin Archive; Cathleen Chaffee, Holly Hughes, Catherine Scrivo, and Janne Sirén at the Albright-Knox Art Gallery, Buffalo; Alexis Miller and Emma Poggioli at Balboa Art Conservation Center, San Diego; Béatrice Paquereau, Jean-Marc Prévost, and Delphine Verrières-Gaultier at Carré d'art, Musée d'art contemporain, Nîmes; Bernard Blistene, Odile Rousseau, Camille Mathonat, Raphaële Bianchi, and Sophie Duplaix at Centre Pompidou, Paris, Musée national d'art moderne/Centre de création industrielle; Sébastien Carvalho, Marie Dubourdieu, and Jean-Gabriel Mitterrand at Galerie Mitterand, Paris; HE Mohamed Al-Khalifa, Maisa Al Qassimi, and Zoë Joo-Inn Kwa at Guggenheim Abu Dhabi; Evelyn Hankins, Melissa Chiu, and Jenna Shaw at the Hirshhorn Museum and Sculpture Garden, Smithsonian Institution, Washington, D.C.; Numa Hambursin at La Malmaison Art

Center, Cannes; Olivier Bergesti, Hélène Guenin, Julia Lamboley, and Audrey Terlin at Mamac, Nice; Lena Essling, Olle Eriksson, Johan Larie, Ann Mossberg, Gitte Ørskou, Camila Rennstam Vaara, Stefan Ståhle, Jo Widoff, and Christina Wiklund at Moderna Museet, Stockholm; Michael Darling and Leah Singsank at the Museum of Contemporary Art Chicago; Alison de Lima Greene and Jennifer Levy at the Museum of Fine Arts, Houston; Lily Goldberg and Ann Temkin at the Museum of Modern Art, New York; Masashi Kuroiwa at Niki Museum Gallery, Japan; Omer Tiroche at Omer Tiroche Gallery, London; Bart J.C. Devolder, Carol Rossi, and James Steward at Princeton University Art Museum, New Jersey; Fabienne Stephan at Salon 94, New York; Tracey Baskoff, Sasha Kalter-Wasserman, and Margarita Lizcano Hernandez at Solomon R. Guggenheim Museum and Foundation, New York; Pamela Bannehr, Bianca Floss, Eva Köhler, Runa König, Hiltrud Mariot, and Carina Plath at Sprengel Museum Hannover; and Mary Ceruti and Kayla Hagen at Walker Art Center, Minneapolis. Additional support for research and loans was made possible through the assistance of the following individuals: Susan Davidson, Amy Dempsey, Ann Hindry, Ruba Katrib, Camille Morineau, Natilee Harren, Denyse Durand-Rueland, Barbro Schultz-Lundestam, MaryRoss Taylor, and Audrey Zecchin. Thanks are also due to Cecile Beyer and Natalie Dupêcher for their translation assistance.

We owe a great debt of gratitude to those who assisted with the research of archival images and footage for this publication and exhibition: Irene G. Olsen and Naja Rasmussen at ARKEN Museum of Modern Art, Ishøj, Denmark; Leigh Grissom at Center for Creative Photography, Tucson; Eva von Hanno at the Estate of Lennart Olsen, Steninge; Joseph DiSanza and Brian Sargent at Fox Archives, New York; Silvia Sokalski at Galerie Bruno Bischofberger AG, Männedorf; Dina Elsayed and Martha McClintock at Getty Images, New York; Emily Park at the Getty Research Institute, Los Angeles; Richard Hammarskiöld, Suzy Hammarskiöld, and Vicky Hammarskiöld Spendrup at Hans Hammarskiöld Heritage, Stocksund; Zoé Laboue at Ina, Bry-sur-Marne; Patricia Pince van der Aa at Maria Austria Instituut, Amsterdam; Annja Müller-Alsbach at Museum Tinguely Basel; Hanna Baudet and Numa Hambursin at Pôle Art Moderne et Contemporain de Cannes; Annalise Flynn at Seymour Rosen's SPACES archives, Kohler, Wisconsin; Maria Bergenman and Joakim Edholm at Sveriges Television SVT, Stockholm; Tim De Canck and Linda De Leeuw at Vlaamse Radio- en Televisieomroeporganisatie Archieven, Brussels; Christopher Claxton and Thierry Demont at William Claxton Archives / Demont Photo Management, New York; Dorothée Dujardin and Alissa Friedman at Yves Klein Archives, Paris; and the following individuals: Joan Kron, Francois de Menil, Anthony Flores, André Morain, Maître Patricia Moyersoen, and Ad Petersen.

Finally, we would like to recognize the support and guidance of our friends and families, as well as each other, for a truly generous and fun collaboration that prevailed through many challenges. And to Oliver and Willa, for teaching us about joy and strength—the most potent dualities in Saint Phalle's work.

Michelle White
Senior Curator, The Menil Collection

Jill Dawsey, PhD
Curator, Museum of Contemporary Art San Diego

Chronology of

TIRS SÉANCES

NIKI DE SAINT PHALLE'S SHOOTING SESSIONS, 1961–1972

Molly Everett

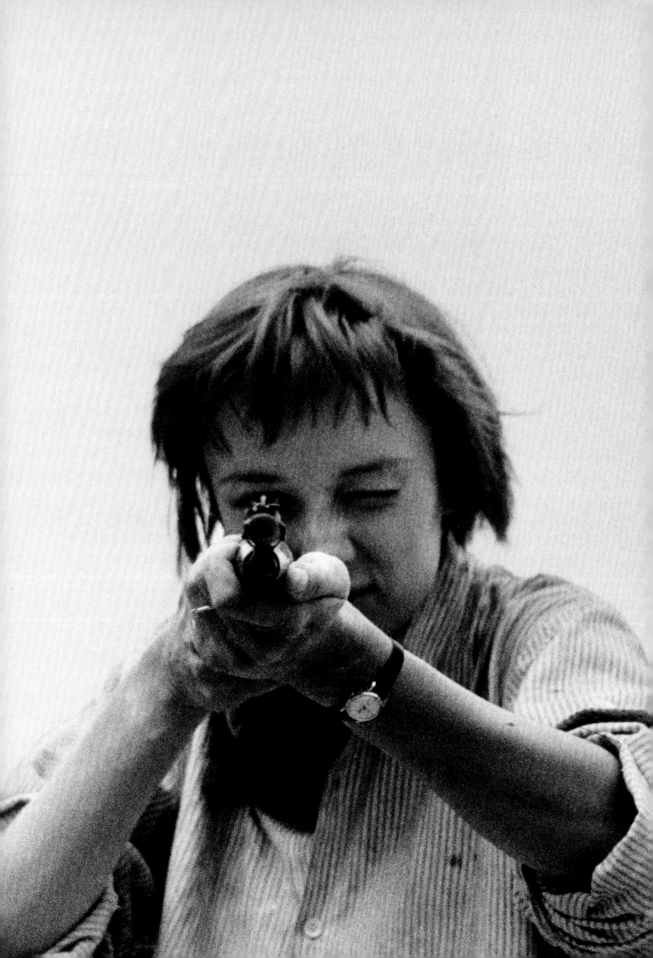

Note to the Reader

Throughout this volume, NCAF refers to the Niki Charitable Art Foundation, Santee, California. The first volume of the artist's catalogue raisonné was published in 2001: *Niki de Saint Phalle: Catalogue Raisonné, 1949–2000*, vol. 1 [in English, French, and some German] (Lausanne: Acatos; Wabern: Benteli, 2001). The catalogue was issued in a slipcase together with *Niki de Saint Phalle: Monographie/Monograph; Malerei/Paintings/Peintures, Tirs, Assemblages, Reliefs, 1949–2000* [in English, French, and German] (Lausanne: Acatos; Wabern: Benteli, 2001), which is sometimes mistakenly catalogued as "vol. 2" of the catalogue raisonné. However, that volume is a large monograph, not a catalogue raisonné. NCAF is continuing work on the artist's catalogue raisonné, currently focusing on the *Nanas*. See http://nikidesaintphalle.org/catalog-raisonne-project/. This chronology encompasses all of Saint Phalle's known shooting sessions based on archival research conducted at NCAF. Under "Related Works," *Tirs* and partial *Tirs* that are included in the catalogue raisonné are identified by their numbers in that publication, preceded by "CR." Titles of all finished works reproduced in this chronology and throughout the volume have been provided by the owners of the works or suppliers of the images. Variant titles have been provided by the institutions; translations in square brackets are provided by the editors. Descriptions of mediums in captions respect those that have been provided by the owners.

In 1961 Niki de Saint Phalle first created a painting with a rifle. She fired it at a relief made of wood, nails, and white plaster embedded with bags of paint and small household items and then invited friends and fellow artists to join her. The paintings erupted with color as the bullets pierced the surfaces. Saint Phalle recounted, "It was an amazing feeling shooting at a painting and watching it transform itself into a new being. It was not only EXCITING and SEXY, but TRAGIC—as though we were witnessing a birth and a death at the same moment."[1]

Saint Phalle called the works *Tirs* ("shots" or "shootings"). Through 1963 she orchestrated a variety of shooting sessions (known in French as *tirs séances*), which she conceived as performances, to create the *Tirs*. These began as casual gatherings among her close-knit artistic community in Paris, often held outside her studio in the Impasse Ronsin, and progressed into public events as she invited others to participate in the creation of *Tirs* in gallery and museum settings. Although Saint Phalle also carried out sessions as the sole shooter, staging performances for the camera or an audience, the involvement of other people was fundamental to many of them. As Saint Phalle described them, the captivating energy of the shooting events integrating spectacle and viewer engagement made them "event[s] of life and death, and everybody got totally involved."[2]

The visual appearance of the *Tirs* took various forms. Although the first reliefs, made in 1961, were relatively small (not more than a couple of feet wide or high), they grew into large assemblages, incorporating a wide array of found objects and materials, and eventually evolved into sprawling and monumental tableaux. By 1963, when she decided to end the series, they were taking the form of altars, cathedrals, and figurative reliefs. Saint Phalle would later, on a few occasions, return to shooting; however, at this time, she chose to initiate a new body of work. The artist reflected:

> Why did I give up the shooting . . . ? I felt like a drug addict. After a shoot-out I felt completely stoned. I became hooked on this macabre yet joyous ritual. It got to the point where I lost control, my heart was pounding during the shoot-outs. . . . I don't like losing control. It scares me and I hate the idea of being addicted to something—so I gave it up.[3]

1 Niki de Saint Phalle, "Letter to Pontus," n.d., in Pontus Hultén, *Niki de Saint Phalle* (Bonn: Kunst- und Ausstellungshalle der Bundesrepublik Deutschland; Stuttgart: Gerd Hatje, 1992), 161.

2 Niki de Saint Phalle, interview by Billy Klüver, April 21, 1990, transcript, Klüver/Martin Archive, New York.

3 Saint Phalle, "Letter to Pontus," 164–65.

Niki de Saint Phalle aiming during a shooting session on June 15, 1961. Photo by Shunk-Kender

Sunday, February 12

Location
Impasse Ronsin, Paris

Known Participants and Attendees*
Artists Daniel Spoerri, Vera Spoerri,
Jean Tinguely, Hugh Weiss
Critic Pierre Restany
Gallerist Jeanine de
Goldschmidt-Rothschild
Unidentified gun owner

Documentation
Photographed by Harry Shunk
and János Kender

Related Works
CR 159–62 (CR 161, p. 17)

Pierre Restany (shooting), Jeanine de Goldschmidt-Rothschild (standing at far left), and Daniel Spoerri (behind Goldschmidt-Rothschild), Impasse Ronsin, Paris, February 12, 1961. Photo by Shunk-Kender

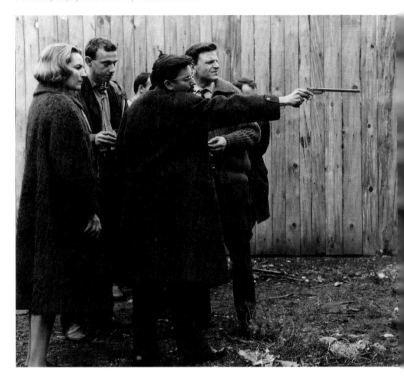

In the alley outside her Paris studio, Saint Phalle initiated her first shooting performance. For the event, she had prepared four small reliefs by placing whole eggs, soft spaghetti, and bags of paint, among other objects, on a wood support and covering them in a dense layer of plaster. Using a borrowed .22-caliber rifle, the artist, along with invited participants, shot at the reliefs (three were wall-mounted and one was freestanding). The photographers Harry Shunk and János Kender documented her process of preparing the works as well as the ensuing spectacle; they would ultimately photograph nine of Saint Phalle's sessions. Pierre Restany, the founder of the Paris-based movement Nouveau Réalisme, was also present. Impressed by the "spectacular ritual and metamorphic effect" of the shootings, he immediately invited Saint Phalle to join the avant-garde group.[4] One of the few critics at the time to focus on the formal aspects of the *Tirs,* Restany wrote in 1968 that "the linear streams of paint immediately evoke the characteristic splashes of Action Painting."[5] With a nod to Jackson Pollock's drip paintings, he called Saint Phalle's method "dripping au revolver."

*For this shooting event and all others in this chronology, Niki de Saint Phalle was present.

4 Pierre Restany, "An Immense Oeuvre All Set to Brave the Coming Century," in *Niki de Saint Phalle: La donation* [in English and French] (Geneva: G. Naef; Nice: Musée National d'Art Moderne et d'Art Contemporain, 2002), 32.
5 Translation by Natalie Dupêcher. The original reads: "Les coulées linéaires évoquent immédiatement les éclaboussures caractéristiques de l'Action Painting." Pierre Restany, *Le Nouveau Réalisme* (Paris: Planète, 1968; repr., Paris: Transédition, Luna-Park, 2007), 102.

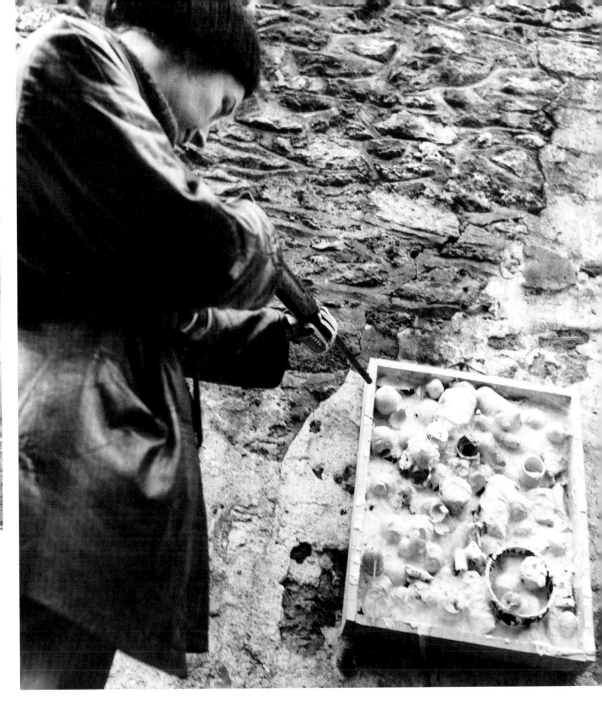

Saint Phalle taking aim at a *Tir* during her first shooting
session, Impasse Ronsin, Paris, February 12, 1961.
Photo by Shunk-Kender

Sunday, February 26

Location
Impasse Ronsin, Paris

Known Participants and Attendees
Artists Eva Aeppli, Gérard Deschamps,
Shirley Goldfarb, Raymond Hains,
James Metcalf, Jean Tinguely, Hugh
Weiss, Sabine Weiss
Lawyer and artist Sam Mercer
Poet and critic John Ashbery
Saint Phalle's sister Elisabeth de
Saint Phalle
Unidentified gun owner

Documentation
Photographed by Harry Shunk
and János Kender, Vera Spoerri

Related Works
CR 163–69 (CR 167, p. 18)

Unidentified man shooting during the second *Tir séance* in
the Impasse Ronsin, Paris, February 26, 1961. A freestanding
sculptural *Tir* (CR 167) is visible in the foreground, before
it was completely destroyed during the shooting. Photo by
Shunk-Kender

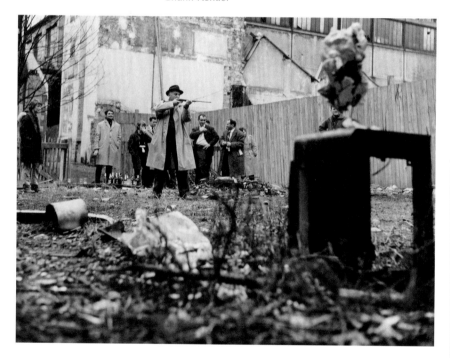

At her second shooting session, Saint Phalle realized seven
Tirs with the participation of invited guests, primarily friends and
artists. Among those present was the American poet and critic
John Ashbery, who later that year described Saint Phalle as
an "American Dadaist" and became one of her most dedicated
champions.[6] The day before the shooting, Shunk and Kender
had documented the preparation of the *Tirs* in the studio.
The photographs show the artist interspersing fake eyeballs, ripe
tomatoes, whole eggs, yogurt containers, and plastic bags of
paint among dozens of nails hammered into wood panels and
shallow wood boxes, before covering the entirety in plaster.

6 John Ashbery, "Paris Art Season
Ending with Bangs, Not Whimpers,"
New York Herald Tribune, Paris,
July 2, 1961.

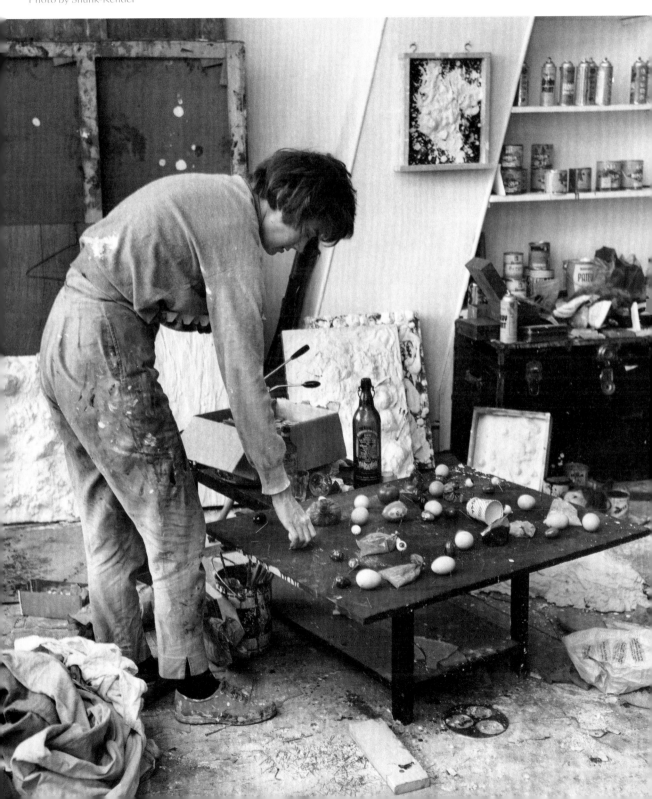

Saint Phalle preparing a *Tir* in her studio on rue
Alfred Durand-Claye, Paris, February 25, 1961.
Photo by Shunk-Kender

Sunday, March 12

Location
Amsterdam region

Known Participants and Attendees
Artists Jean Tinguely, Per Olof Ultvedt
Curators Pontus Hultén, William Seitz
Film producer Anna-Lena Wibom
and her brother Magnus Wibom
Saint Phalle's sister Elisabeth
de Saint Phalle

Documentation
Photographed by Harry Shunk
and János Kender

Related Works
CR 170 (5 *Tirs* in total; p. 21)

7 This exhibition, *Movement in Art*,
has had multiple titles with multiple
English translations. It originated
at the Stedelijk Museum, Amsterdam,
as *Bewogen Beweging* (Moving
Movement), March 10–April 17, 1961,
and traveled to the Moderna Museet,
Stockholm, under the title *Rörelse
i konsten* (Movement and Art), May
17–September 3, 1961. It closed at the
Louisiana Museum of Modern Art,
Humlebaek, outside Copenhagen,
as *Bevaegelser i kunsten* (Movements
in Art), September 22–October 29,
1961. In the present publication, the
show, in all of its iterations, is
referred to as *Movement in Art*. See
Anna Lunderström, "Movements
in Art: The Layers of an Exhibition,"
in Daniel Birnbaum, ed., *Pontus
Hultén and Moderna Museet: The
Formative Years* (Stockholm: Moderna
Museet; Koenig Books, 2017), 67–93.

Held in a garden near Amsterdam, this session was organized
in conjunction with *Movement in Art*, an international exhibition
surveying Kineticism in contemporary art production that
opened at the Stedelijk Museum on March 10 and traveled to
Stockholm and Humlebaek, Denmark, later that year.[7]
Participants fired at reliefs suspended from the branches of
a tree. Among those who took a shot was one of the exhibition's
curators, Pontus Hultén.

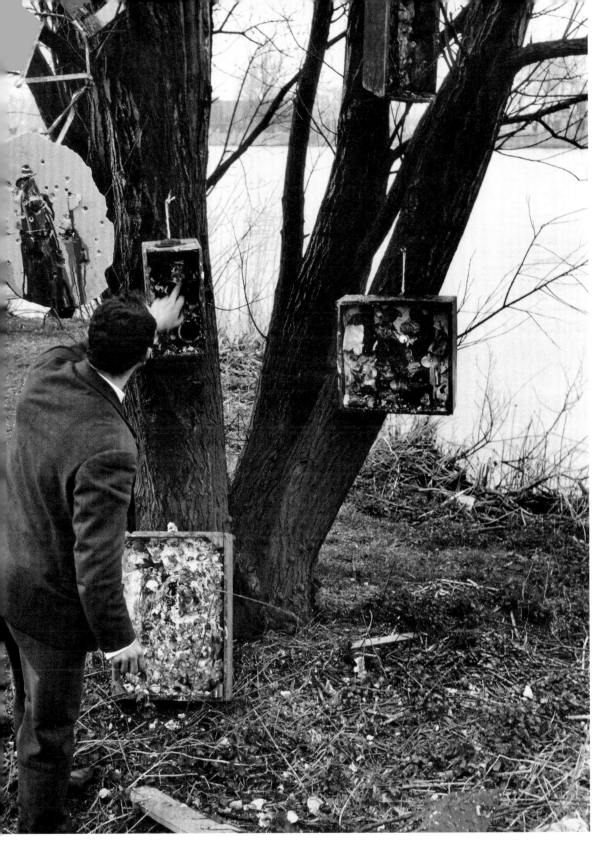

Jean Tinguely inspecting *Tirs* during shooting session near
Amsterdam, March 12, 1961. Photo by Shunk–Kender

Tuesday, April 25

Location
Impasse Ronsin, Paris

Known Participants and Attendees
Unidentified gun owner
Unidentified woman

Documentation
Filmed for an episode of *En français dans le texte*, directed by Yvan Jouannet and produced by Louis Pauwels, Jacques Mousseau, and Jean Feller; broadcast by Office National de Radiodiffusion Télévision Française

Related Works
Unrecorded

Tirs in courtyard of the Impasse Ronsin prior to the shooting

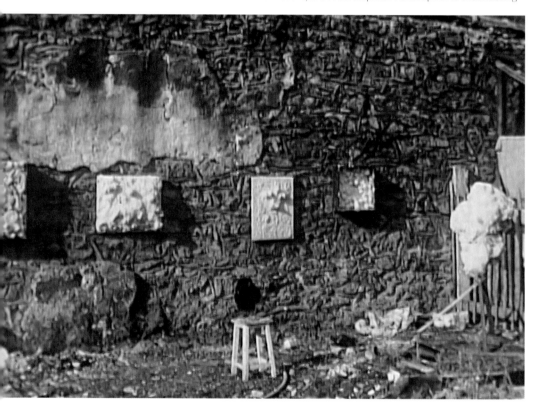

On this day, a previously recorded shooting session with seven *Tirs*, likely executed earlier in the month, appeared on the French television program *En français dans le texte*, introducing Nouveau Réalisme to a wider public. Pierre Restany discussed Saint Phalle's practice alongside work by her contemporaries Arman, François Dufrêne, Raymond Hains, Yves Klein, and Jean Tinguely.

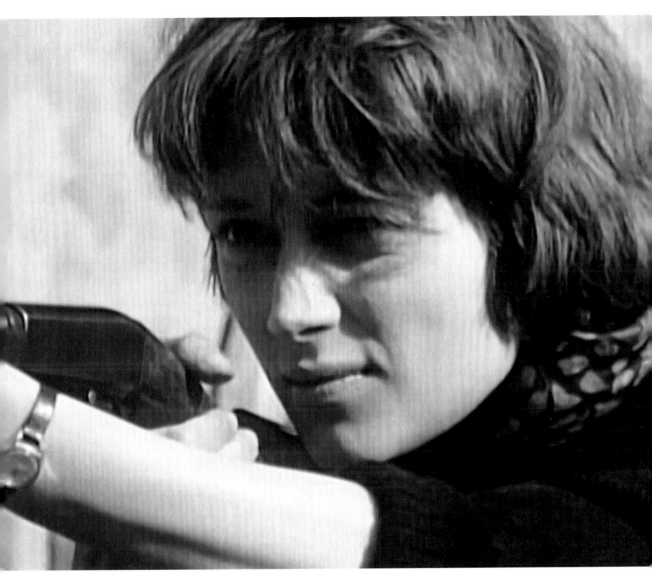

Saint Phalle aiming a rifle on the television program
En français dans le texte, directed by Yvan Jouannet
and broadcast in France on April 25, 1961

Friday, April 28

Location
Impasse Ronsin, Paris

Known Participants and Attendees
Unidentified spectators

Documentation
Filmed for Fox Movietone newsreel,
narrated by Mel Allen

Related Works
CR 246 (p. 25, bottom right frame)

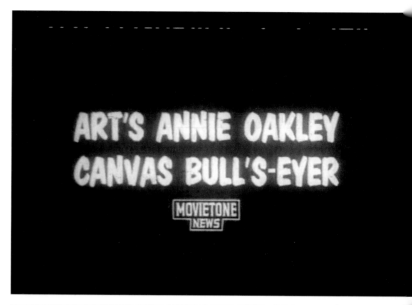

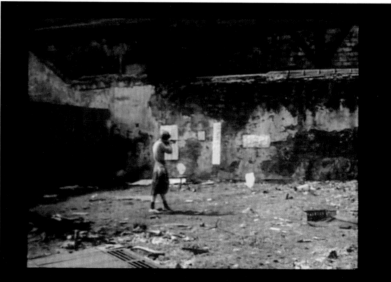

Three days later, on April 28, another previously recorded film
of Saint Phalle shooting in the Impasse Ronsin was released
by Fox Movietone News as part of a newsreel presented in
American cinemas. Under the title *Art's Annie Oakley: Canvas
Bull's-Eyer*, the narrator, the sports announcer Mel Allen,
enthusiastically describes the artist's process as she prepares
the *Tirs* in her studio. Then, as Saint Phalle shoots, Allen
announces "plastic bags of many colors are punctured by this
Annie Oakley of the palette and she explodes a riot of color-
ful paintings over the powdered boards."

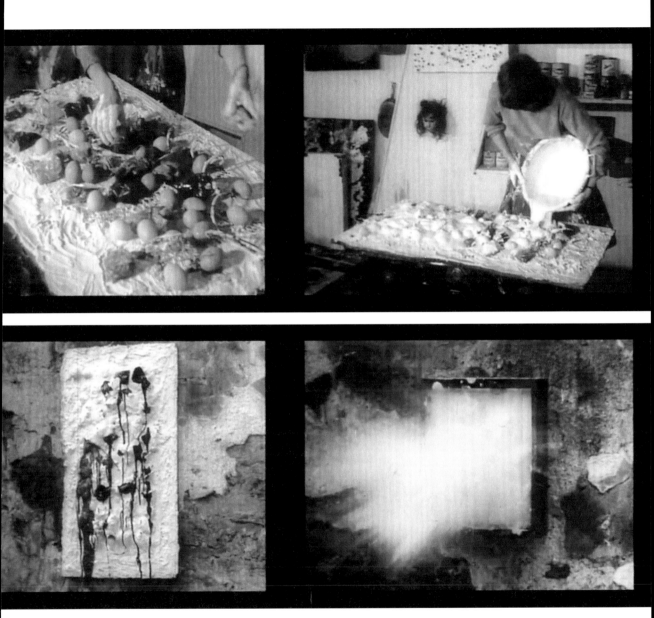

Saint Phalle as featured in Fox Movietone newsreel

25

Sunday, May 14

Location
Stockholm

Known Participants and Attendees
Artists Jean Tinguely, Per Olof Ultvedt
Curator Pontus Hultén
Film producer Anna-Lena Wibom, and
Hultén and Wibom's infant daughter,
Klara Hultén

Documentation
Photographed by Lennart Olson
Filmed by Torbjörn Axelman for
Sveriges Television (SVT)

Related Works
CR 226 (pp. 26–27), 227 (3 *Tirs* in total)

Saint Phalle organized this shooting session, held in Stockholm
and filmed by a local television station, with Pontus Hultén
to coincide with the opening of the exhibition *Movement in Art*
at the Moderna Museet.

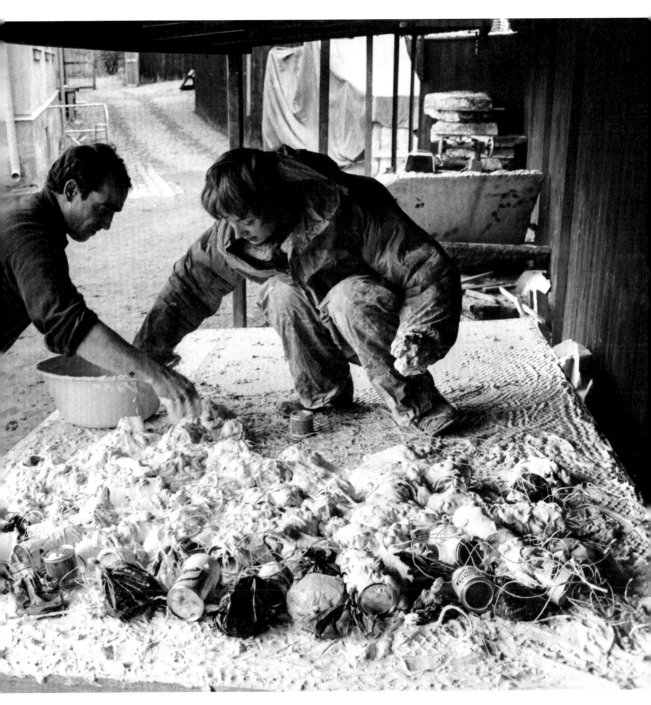

Saint Phalle preparing a *Tir* with Jean Tinguely in Stockholm, May 1961. Photo by Lennart Olson

Tuesday, May 23

Location
Staket sandpit,[8] Värmdö, Sweden

Known Participants and Attendees
Artists Robert Rauschenberg,
Jean Tinguely, Per Olof Ultvedt
Artist and filmmaker Robert Breer
Critic Ulf Linde
Curator Pontus Hultén
Film producer Anna-Lena Wibom, and
Hultén & Wibom's infant, Klara Hultén
Wibom's relatives Gösta Wibom and
Katrin Wibom

Documentation
Photographed by Gunnel von Essen,
Lennart Olson, Harry Shunk
and János Kender
Filmed by Billy Klüver

Related Works
CR 228 (p. 29, twice), 229 (p. 28)

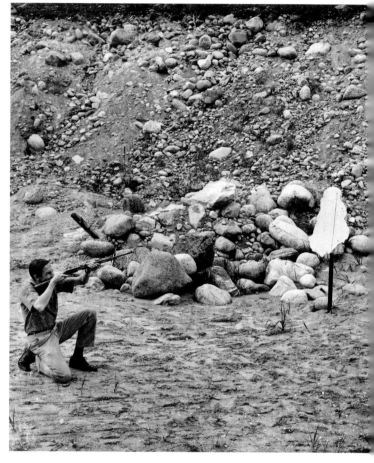

Robert Rauschenberg taking a shot at *Grand Tir—
séance Stockholm*, Värmdo, Sweden, May 23, 1961.
Photo by Shunk-Kender

Almost a week after *Movement in Art* opened at the Moderna
Museet, Saint Phalle led a shooting session in a sandpit outside
Stockholm. Billy Klüver, a Swedish engineer who had worked
with Pontus Hultén to organize the U.S. contribution to
Movement in Art, filmed the session with a Super 8 camera.
Klüver later remembered the impassioned nature of the event:
"Everyone was very intense and terribly serious. . . . When
a bag exploded everybody was thrilled and applauded."[9] Saint
Phalle recalled that when there were no more bullets, "every-
body started taking rocks and throwing [them] at the painting."[10]
The group of spirited shooters included the artist Robert
Rauschenberg, a participant in the *Movement in Art* exhibition.

8 Sources differ on the name of the
 sandpit in Värmdö. It has been
 referred to variously as the "Staket,"
 "Wik," and "Vik" quarry.
9 *Tir Shoot, Niki de Saint Phalle*,
 directed by Barbro Schultz Lundestam,
 2013, sound, color, 12:06 min.,
 Klüver/Martin Archive, New York.
10 Saint Phalle, interview by Klüver,
 April 21, 1990.

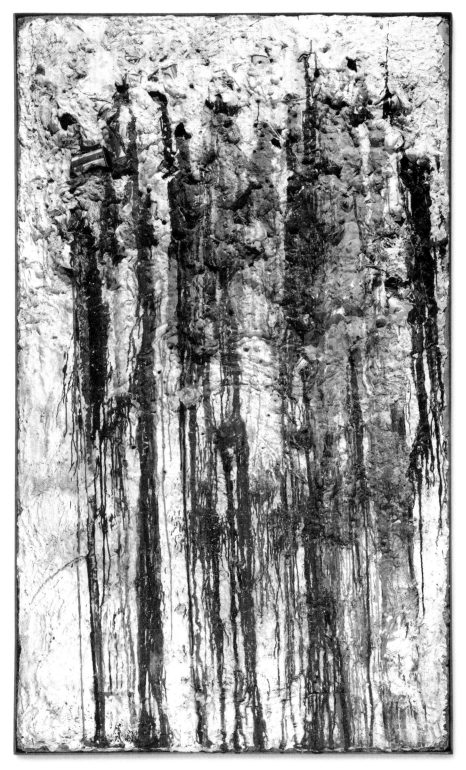

Niki de Saint Phalle
Grand Tir—séance Stockholm, 1961
Paint, plaster, plastic, rope, and metal
101⅝ in. × 61 in. (258 × 155 cm)
Moderna Museet, Stockholm, Donation 1972 from the artist

Thursday, June 15

Location
Impasse Ronsin, Paris

Documentation
Photographed by Harry Shunk
and János Kender

Related Works
CR 231 (pp. 30–31), 232

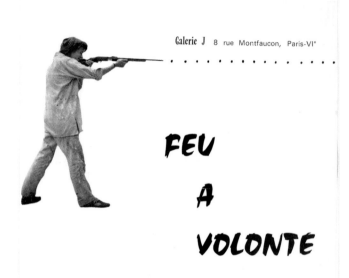

Galerie J 8 rue Montfaucon, Paris-VI°

FEU A VOLONTÉ

Vernissage le Vendredi 30 Juin, à 17 heures
Jusqu'au 12 Juillet

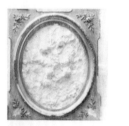
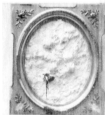

int-phalle • niki de saint-phalle • niki de saint-

Brochure for Saint Phalle's exhibition *Feu à volonté*, Galerie J,
Paris, June 30–July 12, 1961 (text by Pierre Restany).
The interior shows a *Tir* from the *Old Master* series created
on June 15, 1961. Photos by Shunk-Kender. Menil Archives,
The Menil Collection, Houston

In preparation for her first solo exhibition under the name
Niki de Saint Phalle, *Feu à volonté (Fire at Will)*, to be mounted
at Galerie J in Paris from June 30 to July 12, Saint Phalle held
a shooting session at her studio. The results included one of the
first works in her *Old Master* series. As captured in a sequence
of photographs by Shunk and Kender, she took aim at a white
monochrome painting in an ornate gilded frame. As her bullets
punctured the pristine oval surface, rupturing the bags of
buried paint, the plaster was transformed into a spattering
of orifices that spurted and dripped paint over both the
relief and the frame. The photographs were reproduced in the
exhibition brochure.

 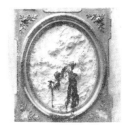

saint-phalle ● niki de saint-phalle ● niki de saint-phalle ● niki de saint-phalle ● niki de saint-phalle ● niki de saint-phalle

31

Tuesday, June 20

Location
Théâtre de l'Ambassade des États-Unis,
Paris

Known Participants and Attendees
Artists Jasper Johns, Robert
Rauschenberg, Jean Tinguely
Pianist David Tudor
Unidentified professional marksman
In the audience cultural attaché
to the U.S. Embassy Darthea Speyer
Gallerist Leo Castelli

Documentation
Photographed by Harry Shunk
and János Kender

Related Works
CR 233 (p. 33, twice)

At the theater of the United States Embassy in Paris, Jasper Johns, Robert Rauschenberg, Jean Tinguely, David Tudor, and Saint Phalle took part in *Homage to David Tudor*, a multimedia performance organized by Darthea Speyer. During the show, a professional marksman shot at Saint Phalle's *Shooting Painting American Embassy*, a long, vertical *Tir* positioned in the center of the stage. Tudor played John Cage's *Variations II* on the piano while, on the other side of the stage, Rauschenberg made a Combine (his term for the assemblages he had been making since the mid-1950s); Tinguely turned on a machine he had built that performed a "striptease," shedding metal parts as it moved around the stage; and Johns, who also contributed a target made of flowers ordered from a local florist, arranged for his painting *Entr'acte*, an homage to René Clair and Francis Picabia, to be carried across the stage to announce an intermission that never occurred.[11] "The audience, except for Leo Castelli and a few fans," recalled Saint Phalle, "was not nearly as enthusiastic about the concert as we were. . . . They hissed and booed and a lot of people left before the end. We found the hostility and anger stimulating."[12] Early the next day, Tudor sent a telegram to Cage at Wesleyan University: "You had a wonderful concert tonight with me Jasper Johns Niki de Saint Phalle Robert Rauschenberg Jean Tinguely at the American Embassy, David."[13]

11 Picabia's ballet *Relâche* was performed at the Théâtre des Champs-Élysées, Paris, in December 1924. The film *Entr'acte* (directed by Clair) played during the intermission. For a discussion of the ballet and film, see "Ciné-Theater-Dance, 1924," chap. 5 in Anne Umland and Cathérine Hug, eds., *Francis Picabia: Our Heads Are Round So Our Thoughts Can Change Direction* (New York: Museum of Modern Art, 2016).

12 Saint Phalle, "Letter to Pontus," 162. Darthea Speyer, who arranged the event, was "highly criticized for it by US Information Service officials and forbidden to organize anything similar again under any circumstances." Lilian Tone, "Chronology," in Kirk Varnedoe, *Jasper Johns: A Retrospective* (New York: Museum of Modern Art, 1996), 193.

13 David Tudor to John Cage, telegram, June 21, 1961, John Cage Collection, Charles Deering McCormick Library of Special Collections and University Archives, Northwestern University, Evanston, IL; reprinted in Tone, "Chronology," 388n19.

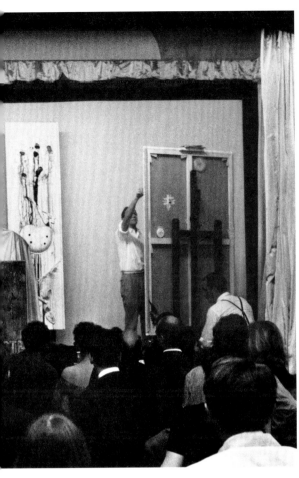

View from the audience of the collaborative performance *Homage to David Tudor*, Théâtre de l'Ambassade des États-Unis, Paris, June 20, 1961. Saint Phalle's *Shooting Painting American Embassy* is at center stage; to the right, Rauschenberg creates a Combine; and Johns's painting *Entr'acte* is in front of the piano. Tinguely and the marksman are partially visible in the bottom right corner. Photo by Shunk-Kender

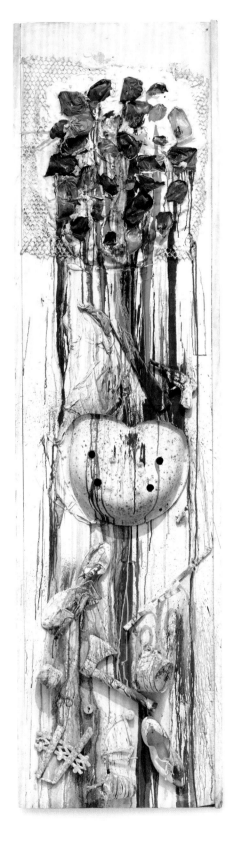

Niki de Saint Phalle
Shooting Painting American Embassy, 1961
Paint, plaster, wood, plastic bags, wire mesh, and objects on wood
96⅜ × 25⅞ × 8⅝ in. (244.8 × 65.7 × 21.9 cm)
The Museum of Modern Art, New York,
Gift of the Niki Charitable Art Foundation

Monday, June 26

Location
Impasse Ronsin, Paris

Known Participants and Attendees
Artists James Metcalf, Jean Tinguely

Documentation
Photographed by Harry Shunk
and János Kender
Filmed by Jean Dypréau;
later broadcast on French television
by Pathé

Related Works
CR 236 (pp. 34, 35, 137)

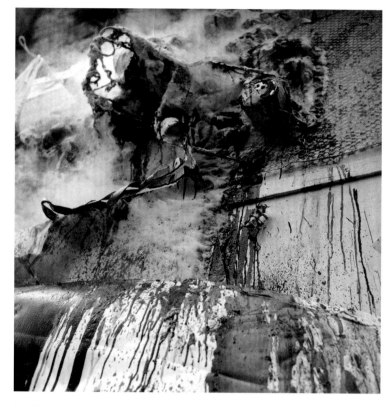

Detail of the *Tir* in progress. Photo by Shunk-Kender

Continuing to prepare for her upcoming exhibition at Galerie J, which would open to the public in just a few days, Saint Phalle held a shooting session to create one of the largest *Tirs* she ever made. Almost eleven feet by seven feet, *Tir, séance 26 juin 1961* (p. 137) features a roller skate, a zither, a defunct vacuum cleaner, and a metal body panel from an automobile, among other detritus. Throughout the session, Saint Phalle adjusted and added elements to the assemblage. After the shooting, she attached the final element: a birdcage containing live birds. The event was covered by a French newspaper, which ran the headline "Un scandale nommé Niki" (a scandal named Niki).[14] The article publicized the upcoming show, enticing readers with the promise that the artist had reserved a few "blank canvases" for visitors.

14 Jean-François Devay, "Un scandale nommé Niki," *Paris-Presse-L'Intransigeant*, June 29, 1961, NCAF Archives.

Saint Phalle attaching a mesh bag to *Tir, séance 26 juin 1961*
prior to shooting, Impasse Ronsin, Paris, June 26, 1961.
Photo by Shunk-Kender

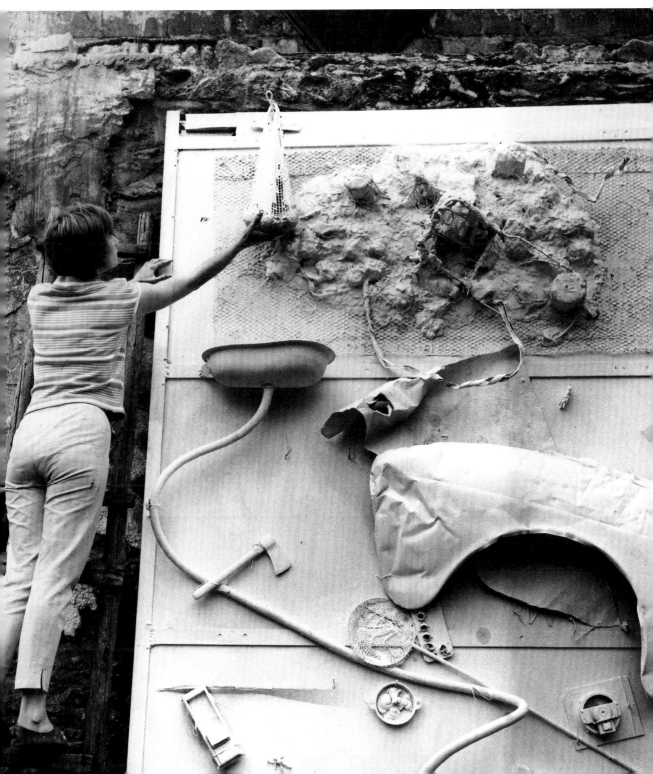

Wednesday, June 28;
Friday, June 30–Wednesday, July 12[15]

Location
Galerie J, Paris

Known Participants and Attendees
Artists Eva Aeppli, Christo, Gérard
Deschamps, Jean Fautrier, Raymond
Hains, Jasper Johns, Yves Klein, Robert
Rauschenberg, Daniel Spoerri, Frank
Stella, Jean Tinguely, Sabine Weiss
Art historian Barbara Rose
Poet and critic John Ashbery
Writer Harry Mathews (Saint Phalle's
first husband)
Lawyer and artist Sam Mercer
Collector Marcel Lefranc
Gallerists Leo Castelli, Iris Clert,
Jeanine de Goldschmidt-Rothschild,
Lawrence Rubin
Saint Phalle's sister Elisabeth
de Saint Phalle

Documentation
Photographed by Robert Cohen, Heidi
Meister, Harry Shunk and János Kender

Related Works
CR 234 (p. 84), 235 (p. 139), 236–52
(3 of which were never shot at ;
CR 236, pp. 34, 35, 137; CR 239, p. 134;
CR 243, pp. 130, 132; CR 246, p. 25,
bottom right frame)

On the occasion of Saint Phalle's first solo exhibition, *Feu à volonté*,
at Galerie J in Paris, the artist extended the participatory nature
of the *Tirs* by inviting viewers to shoot at works in the gallery
throughout the run of the show. It was the first time Saint Phalle
did not select the participants for a session; any visitor to the
gallery could take part in the activity. She outfitted the space
with a shooting stand, customized by Jean Tinguely, and the
public went on to create three works with a .22-long rifle. In his
review of the exhibition in the international edition of the
New York Herald Tribune, John Ashbery emphasized the commu-
nal aspect of Saint Phalle's practice: "She feels that she is
close to the spirit of the French surrealist poet Lautréamont,
who said that 'poetry should be made by all, not by one.'"[16]
Among the works exhibited were *Tir de Jasper Johns* (p. 139) and
Homage to Bob Rauschenberg (Shot by Rauschenberg) (p. 84),
both made a few days prior. At Saint Phalle's invitation, Johns
and Rauschenberg had each fired at a *Tir* featuring recognizable
motifs from his own work, such as a target and a wire coat-
hanger. Saint Phalle noted that each artist approached shooting
his homage in a manner that reflected his personality. Johns,
she said, "took hours deciding where to shoot the few shots he
finally fired at the target."[17]

15 On June 28 there was a "pre-opening"
 for *Feu à volonté*, featuring cock-
 tails and shooting, followed by the
 public opening on June 30. The
 exhibition was on view from June 30
 to July 12.
16 Ashbery, "Paris Art Season Ending
 with Bangs."
17 Saint Phalle, "Letter to Pontus," 162.

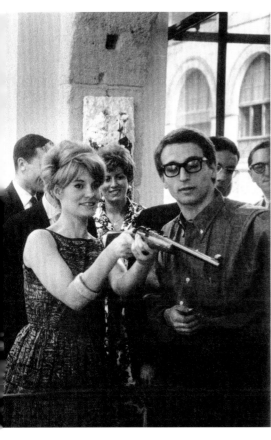

Barbara Rose taking aim at a *Tir* during the pre-opening of Saint Phalle's exhibition *Feu à volonté*, Galerie J, Paris, June 28, 1961. Frank Stella, at the right, and Jean Fautrier, holding the railing at the left, look on. Photo by Shunk-Kender

Jasper Johns sighting a rifle during the opening of the *Feu à volonté* exhibition with Frank Stella at the right. Photo by Shunk-Kender

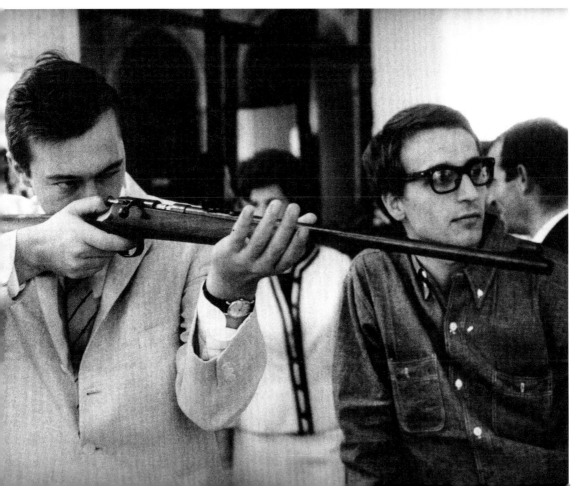

Thursday, July 13–Friday, July 14

Location
Abbaye de Roseland, Nice

Known Participants and Attendees
Artists of the Nouveau Réalisme group,
including Arman, César, François
Dufrêne, Raymond Hains, Yves Klein,
Martial Raysse, Mimmo Rotella, Daniel
Spoerri, Jean Tinguely, Jacques Villeglé
Critic Pierre Restany
Gallerists Jeanine de Goldschmidt-
Rothschild, Jean Larcade

Documentation
Photographed by Gilles Raysse

Related Works
CR 253

Saint Phalle executed *Tir à volonté* [*Fire at Will*] with a .22 rifle
just after midnight on the evening of the opening of the first
Festival du Nouveau Réalisme in Nice. According to the magazine
Sud communications, nearly five hundred people attended the
opening. Pierre Restany organized the festival at Galerie
Muratore and the Abbaye de Roseland, the estate of Jean Larcade
(owner of Galerie Rive Droite in Paris). The highly orchestrated
event, involving several "action spectacles," began on the eve of
Bastille Day and continued through the night at the estate.
In the invitation, Restany announced, "We want to make this
a true *festival*, not only by exhibiting the works themselves
but also by organizing a series of practical demonstrations to give
this manifestation its true human value: executing of blue
anthropomorphic prints, reconstituting of accumulation of
objects, shooting at surprise-reliefs."[18]

18 Pierre Restany, "Festival of New
 Realism," leaflet enclosed with
 Galerie Muratore's invitation to the
 Festival du Nouveau Réalisme,
 Abbaye de Roseland, Nice, NCAF
 Archives.

FESTIVAL DU NOUVEAU REALISME

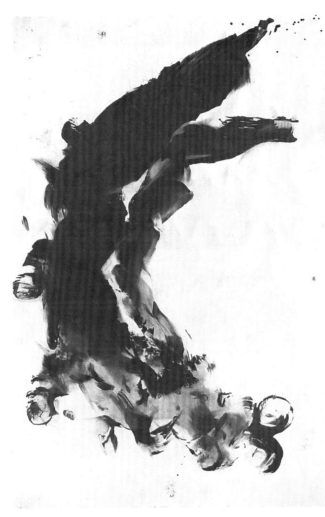

A R M A N M A M

C E S A R

D U F R Ê N E

H A I N S

K L E I N

M A R T I A L

R A Y S S E

R O T E L L A
Rotella

N I K I DE
SAINT-PHALLE
niki de Saint Phalle

S P O E R R I

T I N G U E L Y

V I L L E G L E

du
13 Juillet
au
13 Septembre
1961

RESTANY
Jeannine

13 et 14 JUILLET 1961 : COCKTAIL ET FESTIVAL de 21 à 24 HEURES
A L'ABBAYE ROSELAND - NICE - Avenue de Fabron - Tél. 86-51-52

M. Muratore

GALERIE MURATORE - NICE

19 bis, Boulevard Victor-Hugo - Téléphone 80-25-74

VERNISSAGE : JEUDI 13 JUILLET 1961, à 18 HEURES

IMPRIMERIE DU SUD-EST - NICE

Poster for the first Festival du Nouveau Réalisme,
held at the Abbaye de Roseland, Nice, July 13–14, 1961,
and at Galerie Muratore, Nice, July 13–September 13, 1961
Yves Klein Archives, Paris

Friday, September 15

Location
Galerie Køpcke, Copenhagen

Known Participants and Attendees
Artists Gunnar Aagaard Andersen,
Bamse Kragh Jacobsen,
Bernhard Luginbühl, Albert Mertz,
Jean Tinguely; Mertz's teenaged
daughter, Susanne Mertz
Artist and gallerist Arthur "Addi"
Køpcke

Documentation
Photographed by Willy Henriksen,
Jacob Maarbjerg

Related Works
CR 254–62 (1 *Tir* in total; 10 known
fragments exist, 2 of which are not
in CR)

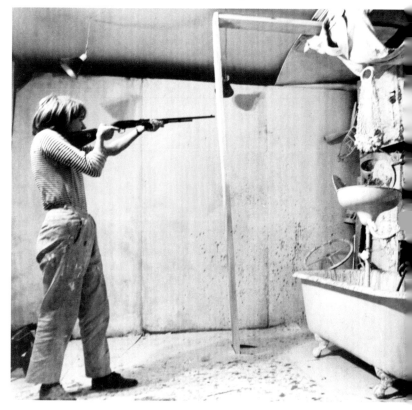

Saint Phalle shooting the room-sized *Tir tableau Galerie
Køpcke*, Galerie Køpcke, Copenhagen, September 15, 1961

Saint Phalle staged a shooting event at Galerie Køpcke in
Copenhagen while her work was on view in the exhibition
Movement in Art at the Louisiana Museum of Modern Art,
Humlebaek. For the large-scale *Tir*, Saint Phalle painted house-
hold items—such as a kettle, a bicycle frame and wheels, and
even a clawfoot bathtub—completely white. The white
objects were integrated among white plaster reliefs and bags
of paint into a room-sized assemblage that sprawled over
the walls of the gallery. The artist used a gun and a small cannon
designed by the Swiss sculptor Bernhard Luginbühl to shoot
at the tableau and then distributed fragments of the work to the
public. Gunnar Aagaard Andersen, a Danish artist who was
present that evening, remembered, "Niki shot live ammunition
at the big still life, and from each hole red, yellow, or blue
paint seeped down the relief. For three hours she kept us mes-
merized with her concentration. Finally, a Luginbühl cannon was
put in position, and paint was shot directly at the relief."[19]
The Danish newspaper *Politiken* covered the event, featuring
Saint Phalle on the front page the following day under the
headline "Fireworks with Colors."

19 Gunnar Aagaard Andersen,
"Om og omkring Galerie Køpcke,"
Billedkunst, no. 3 (1968): 147–49.
Translation by Cecilie Beyer and
Irene G. Olsen.

Saint Phalle lighting a cannon to fire at *Tir tableau Galerie Køpcke*, Galerie Køpcke, Copenhagen, September 15, 1961.
Photo by Willy Henriksen

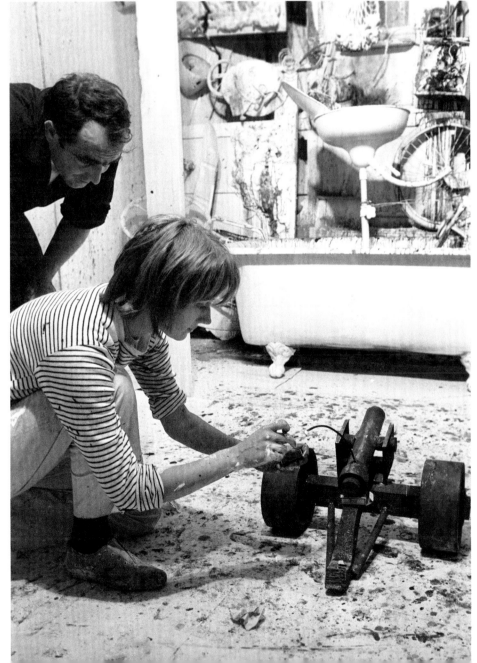

Wednesday, December 13

Location
Impasse Ronsin, Paris

Documentation
Filmed for an episode of *David Brinkley's Journal*, broadcast by NBC News

Related Works
Unrecorded

On this day, one of Saint Phalle's earlier shooting sessions was broadcast by NBC News on the television program *David Brinkley's Journal*, introducing her to a broader American audience in a two-part series on avant-garde artists. Saint Phalle is shown preparing and subsequently shooting, with two different firearms, a large *Tir* propped against the wall outside her studio. "The shooting," she says, "is that one moment in which the miracle happens."[20] Lighting a small cannon, she continues, "My problem is creating, it's creating now, it's creating beauty, it's creating something, it's creating something which has to do with you, which has to do with now, which has to do with bombs and everything exploding and the end of the world and BANG."[21] Brinkley, with skepticism, concludes the segment by saying, "Those who work in these violent, physical, even athletic art styles say the act of creation itself is what really counts—the making of the picture, not the picture itself."[22]

20 *David Brinkley's Journal*, NBC News, New York, December 13, 1961, NCAF Archives.
21 Ibid.
22 Ibid.

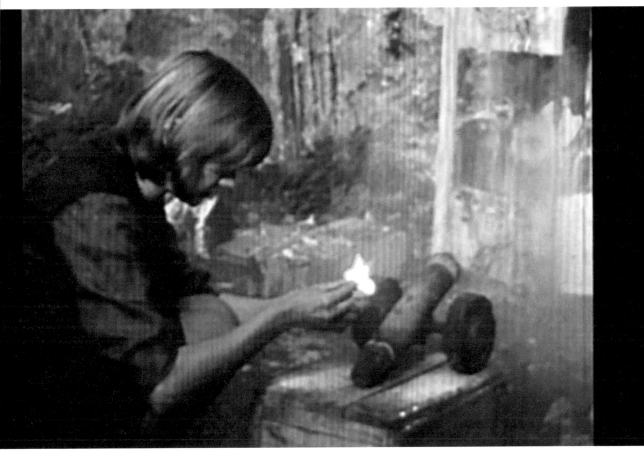

Saint Phalle as featured on *David Brinkley's Journal*,
NBC News

Location
Impasse Ronsin, Paris

Documentation
Photographed by Giancarlo Botti,
François Gragnon, Jesper Høm

Related Works
CR 263, 264, 265 (p. 140), 266 (p. 141),
267, 268 (pp. 44, 45), 269 (p. 142), 270,
271 (pp. 144–45), 272–75, 293, 294

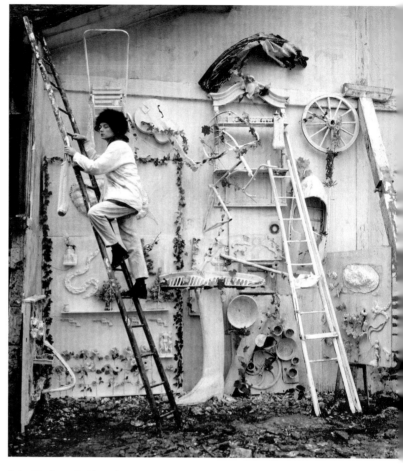

Saint Phalle on ladder prior to a winter 1961–62
shooting session, Impasse Ronsin, Paris. *Tir tableau Dracula
II* is visible in the background. Photo by Giancarlo Botti

During this winter, Saint Phalle held numerous shooting sessions
in the Impasse Ronsin. Frequently documented, they reveal the
recurring themes and iconography of her evolving work. As
the artist expanded the scale of her assemblages, she also began
to incorporate more explicit references to war and disaster.
Tir avion [*Airplane Tir*], for example, includes a figure with arms
outstretched toward plastic flowers while, in the upper
register of the composition, a fleet of toy airplanes appears to
bombard the scene below. Among the other works Saint Phalle
created during this time were *Tir tableau Dracula I* and *Tir
tableau Dracula II* (see pp. 140–45). After shooting these towering
accumulations of found objects and reliefs outside her studio,
the artist disassembled them into many individual fragments.

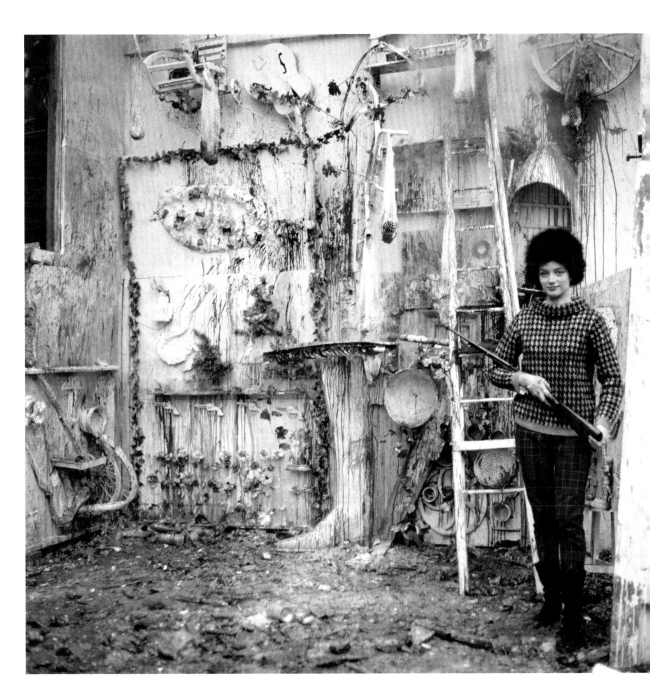

Saint Phalle posing with a rifle during the shooting of *Tir tableau Dracula II*, winter 1961–62. Photo by Giancarlo Botti

Sunday, March 4

Location
Renaissance Club parking lot,
Sunset Strip, Los Angeles

Known Participants and Attendees
Artists Edward Kienholz, Robert
Rauschenberg, Arthur Secunda,
Jean Tinguely
Composer John Cage
Curator Walter Hopps
Gallerists Leo Castelli, Frank Perls
Writer Lawrence Lipton

Documentation
Photographed by William Claxton,
Seymour Rosen

Related Works
CR 296 (p. 47), 297 (1 *Tir* in total)

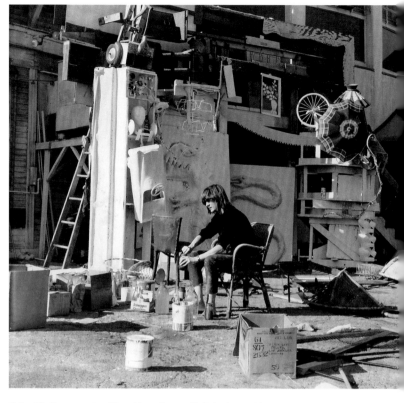

Saint Phalle preparing *Tir tableau Sunset Strip* in the parking
lot of Club Renaissance, Los Angeles, March 1962. Photo by
Seymour Rosen

In the parking lot of a jazz club on Sunset Strip in Los Angeles,
Saint Phalle orchestrated her first public shooting event
in the United States, coordinated by Everett Ellin Gallery along
with the gallerist Virginia Dwan. The artist began preparing
the *Tir* on March 1. With a wide array of found objects, she repre-
sented a dragon and a snake within an assemblage spanning
more than twenty feet and painted entirely white. For the
shooting, Saint Phalle donned a fitted white bodysuit and black
boots (a costume she would wear at subsequent shooting
sessions) and climbed a ladder to take aim. The artist Edward
Kienholz assisted her by reloading the gun, round after round.
Although the *Tir* did not survive in its entirety, fragments
of the tableau still exist. It was an eventful day for many in atten-
dance. Down the street, immediately following the shooting,
Everett Ellin Gallery held an opening for Jean Tinguely's
viewer-activated machines, and later that same evening, Dwan
Gallery hosted a reception for Robert Rauschenberg's first
solo exhibition in California.

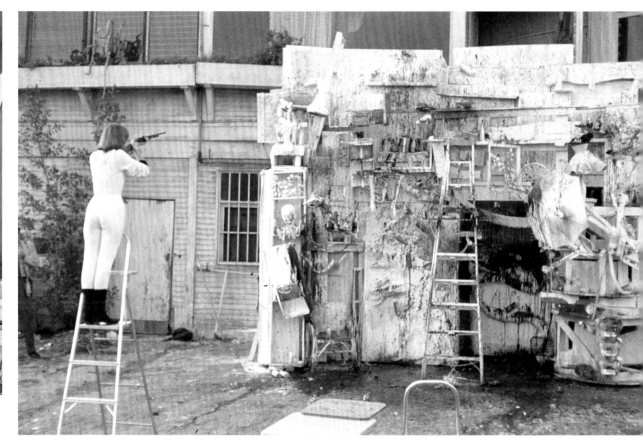

Saint Phalle atop a ladder aiming at *Tir tableau Sunset Strip*
during the March 4, 1962, shooting session in Los Angeles.
Photo by William Claxton

Late March

Location
Malibu, California

Known Participants and Attendees
Actor Jane Fonda
Actor and film/theater producer
John Houseman
Artists Philip Guston, Edward Kienholz,
Louise Nevelson, Jean Tinguely
Critic Jules Langsner
Curator Henry Geldzahler
Dancer and choreographer
Merce Cunningham
Journalist Lois Dickert
Model Peggy Moffitt
Theater producer and director
Bertrand Castelli
Writer Lawrence Lipton

Documentation
Photographed by William Claxton,
Len Sirman
Filmed by unknown[23]

Related Works
CR 298 (pp. 48, 49), 299 (1 *Tir* in total)

Saint Phalle shooting the large-scale *Tir tableau Malibu*
in the Malibu Hills, California, late March 1962.
Photo by William Claxton

At the invitation of Virginia Dwan, Saint Phalle performed
a shooting session in the Malibu Hills on a Sunday afternoon
in late March 1962. The tableau, an enormous, four-paneled
assemblage, was propped up like a billboard or movie screen.
Glass bottles were arranged on ledges at varying levels;
a large sculptural dinosaur emerged roughly in the center; and to
the right, a small, framed plaster relief (reminiscent of some
of Saint Phalle's earliest *Tirs*) was surrounded by toys, silverware,
and a birdcage, among other objects, all coated in the artist's
customary layer of white. Saint Phalle, clad in her white
shooting costume, fired at the assemblage methodically, striking
buried ink containers and aerosol paint cans. The audience,
which included Hollywood celebrities, was seated on rows of
benches. Filmed footage of the event shows the crowd gasping,
screaming, and cheering while Saint Phalle shoots. Edward
Kienholz was again present to assist with loading the rifles.[24]
Concluding the event, Jean Tinguely fired a small cannon, releas-
ing a plume of yellow smoke. Dwan purchased the completed
Tir and installed it by her pool (with the cannon chained to it and
a live bird in the cage). In a letter to Saint Phalle and Tinguely,
the gallerist described how "sandy bathers up and down
the beach bring their friends, relatives, children, friends' children
etc. . . . to view the marvel. They seem to believe that it is on
public exhibition."[25]

23 Original footage included in Monique
 Alexandre and Francois de Menil's
 film *Niki de Saint Phalle*, 1982,
 and Peter Schamoni's film *Niki de
 Saint Phalle: Who Is the Monster—
 You or Me?* 1995, both in the Menil
 Archives, The Menil Collection,
 Houston.
24 Lois Dickert, "Shooting at Malibu"
 (unpublished manuscript, n.d.),
 NCAF Archives.
25 Virginia Dwan to Niki de Saint
 Phalle and Jean Tinguely, August 27,
 1962, NCAF Archives.

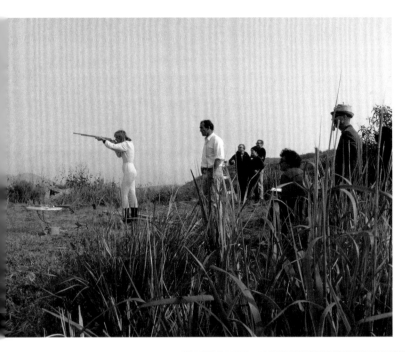

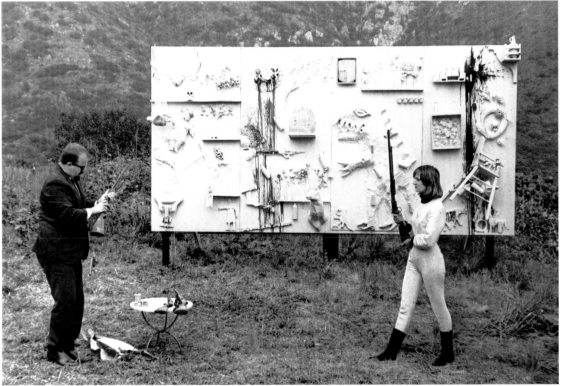

Edward Kienholz assisting Saint Phalle during the shooting.
Photo by Len Sirman

Friday, May 4

Location
Maidman Playhouse, New York

Known Participants and Attendees
Artists Oyvind Fahlström,
Allan Kaprow, Robert Rauschenberg,
Frank Stella, Jean Tinguely
Curator Henry Geldzahler
Dancers Viola Farber, Steve Paxton
Dancer and choreographer
Merce Cunningham
Editor Clay Felker
Engineer and filmmaker Billy Klüver
Literary agent Maxine Groffsky
New York Senator Jacob Javits,
and Marion (Borris) Javits
Philanthropist Joan Kron
Poet Kenneth Koch
The Stewed Prunes comedians
MacIntyre Dixon and Richard Libertini
Theater producer John Wulp

Documentation
Photographed by Sam Kron,
Hans Namuth

Related Works
CR 300 (p. 50)

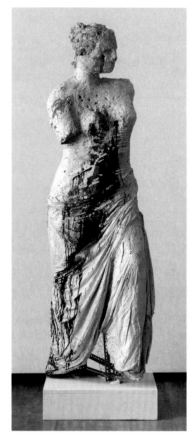

Niki de Saint Phalle
Vénus de Milo, 1962
Paint and plaster on metal structure
76 × 25¼ × 25¼ in. (193 × 64 × 64 cm)
Private collection; courtesy
of Galerie Georges-Philippe & Nathalie
Vallois, Paris

For one night, in front of a sold-out audience at the Maidman Playhouse in New York City, Saint Phalle collaborated with Robert Rauschenberg and Jean Tinguely, among others, to present the play *The Construction of Boston*, written by Kenneth Koch.[26] The plot revolved around the founding of the United States. For the performance, Rauschenberg made a machine that produced "rain," and Tinguely and Henry Geldzahler, wearing ball gowns, built a towering wall out of cinderblocks. Saint Phalle, dressed as Napoleon Bonaparte, with a tailcoat over her white jumpsuit, shot at a cast of the Venus de Milo as Oyvind Fahlström and Billy Klüver, outfitted as Napoleonic soldiers, assisted. Recalling the shooting, Saint Phalle said, "Paint was running down her face. People were fainting. It was a fantastic assassination."[27] While Saint Phalle shot, the Stewed Prunes delivered the onstage chorus:

Men say she has a magic pistol
Which can turn plain glass to crystal. . . .
Niki, bring us beauty's virtue!
Fire at that ancient statue—
Perhaps it has retained some value.[28]

26 Although Merce Cunningham
directed this play, he ultimately
"refused to have his name
associated" with the production.
See Catherine Dossin, "Niki de
Saint-Phalle and the Masquerade
of Hyperfemininity," *Woman's Art
Journal* 31, no. 2 (Fall/Winter 2010): 33.

27 *Tinguely: A Kinetic Cosmos*,
directed by Francois de Menil and
Monique Alexandre, ca. 1970s,
Menil Archives, The Menil Collection,
Houston.

28 Script reproduced in Kenneth Koch,
*The Banquet: The Complete Plays,
Films, and Librettos* (Minneapolis:
Coffee House Press, 2013), 580.

Maxine Groffsky, Saint Phalle, Jean Tinguely, Henry Geldzahler,
and other members of the cast of *The Construction
of Boston*, performed at Maidman Playhouse, New York,
May 4, 1962. Photo by Hans Namuth

Thursday, August 30[29]

Location
Stedelijk Museum, Amsterdam

Known Participants and Attendees
Artists Robert Rauschenberg, Martial Raysse, Daniel Spoerri, Jean Tinguely, Per Olof Ultvedt
Curator Pontus Hultén
Museum director and exhibition curator Willem Sandberg

Documentation
Photographed by Ed van der Elsken, Christer Strömholm
Filmed by unknown

Related Works
CR 304–6 (1 *Tir* in total)

Saint Phalle taking aim at *Tir tableau pour DYLABY* during the run of the exhibition *Dylaby*, Stedelijk Museum, Amsterdam, August 30–September 30, 1962. Willem Sandberg, the museum's director, looks on, wearing a bowtie. Photo by Ed van der Elsken

For *Dylaby* (short for *Dynamisch Labyrint*, or *Dynamic Labyrinth*), a collaborative exhibition with Robert Rauschenberg, Martial Raysse, Daniel Spoerri, Jean Tinguely, and Per Olof Ultvedt, installed like a maze in seven rooms at the Stedelijk Museum, Saint Phalle created a shooting range for the public. The *Tir* covered an entire wall of a gallery and featured two giant sculptures of dinosaurs, enlivened by mechanical jaws that moved up and down. In front of the tableau, bags of paint hung down from the ceiling for viewers to shoot. A security guard, dressed in a colonial safari uniform, assisted participants by loading the gun. The "labyrinth" in which the work was installed was intended to cultivate an immersive and interactive experience for the visitor.

29 It is not clear whether the shooting took place throughout the run of the exhibition, August 30– September 30, 1962, or only for the opening. After the close of the exhibition, however, only two elements of the *Tir* remained. One of these, a roller skate signed by Saint Phalle, entered Rauschenberg's personal collection.

Jean Tinguely, Saint Phalle, and an unidentified museum
guard standing before *Tir tableau pour DYLABY*,
Stedelijk Museum, Amsterdam, August 30, 1962.
Photo by Ed van der Elsken

Monday, October 15[30]

Location
Alexander Iolas Gallery, New York

Known Participants and Attendees
Artist Robert Rauschenberg
Gallerist Leo Castelli

Documentation
Photographed by Adelaide de Menil,
Hans Namuth

Related Works
CR 307 (pp. 55, 149; also on view was
CR 345 [pp. 154–55] and a set of
Cathédrales, including CR 328 [p. 152])

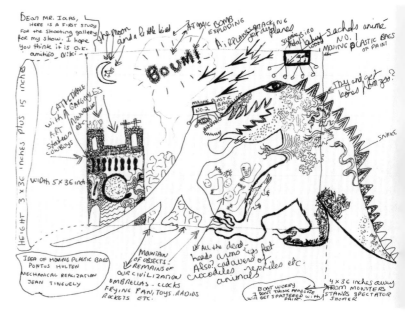

Saint Phalle's preparatory drawing for the "shooting gallery"
installed at her Alexander Iolas Gallery solo exhibition, included
in a letter to the gallery and reproduced on the exhibition
invitation. Menil Archives, The Menil Collection, Houston

For her first solo exhibition in New York, held at the Alexander
Iolas Gallery and organized with the Parisian gallerist Jean Larcade,
Saint Phalle invited the public to participate in the making
of *Hommage au Facteur Cheval* [*Homage to Cheval the Mailman*]
(see p. 149). Within a specially built shooting range, visitors
aimed at a *Tir* encrusted with found objects and inspired by
Joseph Ferdinand Cheval (1836–1924), a French self-taught artist
who constructed a "palace," the Palais Idéal, primarily of
stones he had collected during his route as a mailman. In the
foreground of Saint Phalle's tableau, a sinuous snake curved
upward alongside a hulking dragon, and the entire assemblage
teemed with toys. Rotating mechanisms, designed by Jean
Tinguely, animated the *Tir* so that bags of paint became moving
targets. Prior to the exhibition, Saint Phalle sent a preparatory
drawing to Iolas. The sketch shows various elements of
the elaborate scene, such as a "mountain of objects—remains
of our civilization . . . umbrellas, clocks, frying pans, toys,
radios, rockets, etc.," and a diagram explaining how the kinetic
bags of paint would work. The drawing was reproduced on the
invitation to the exhibition. Saint Phalle also exhibited *Gorgo
in New York*, 1962 (pp. 154–55), a black-and-white, four-panel
Tir made while she and Tinguely were staying at the Chelsea
Hotel in Manhattan.

30 It is not clear whether the shooting
occurred throughout the run of the
exhibition, October 15–November 3,
1962, or only during the opening.

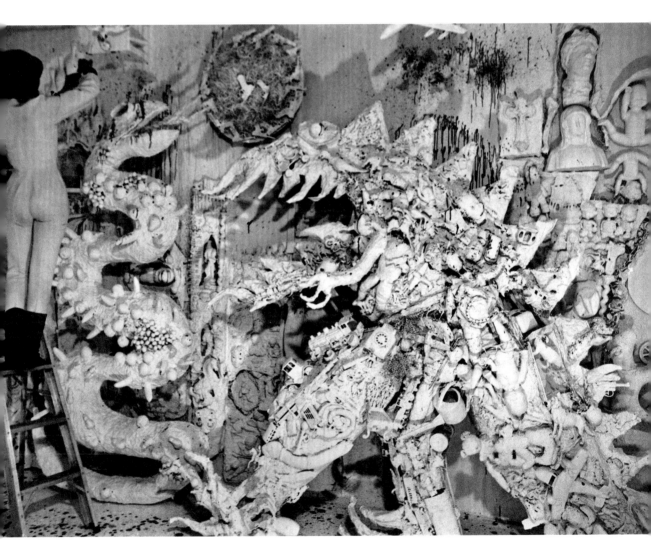

Saint Phalle making adjustments to *Hommage au Facteur
Cheval* [*Homage to Cheval the Mailman*], 1962, on view at the
Alexander Iolas Gallery, New York, October 15–November 3,
1962. Photo by Hans Namuth

Saturday, February 9

Location
Neue Galerie im Künstlerhaus, Munich

Documentation
Photographed by Friedrich Rauch
Filmed for an episode of *Medium: Plastische Kunsten*, directed by Filip Tas and produced by Ludo Bekkers; broadcast by Belgische Radio en Televisie (BRT)

Related Works
CR 358

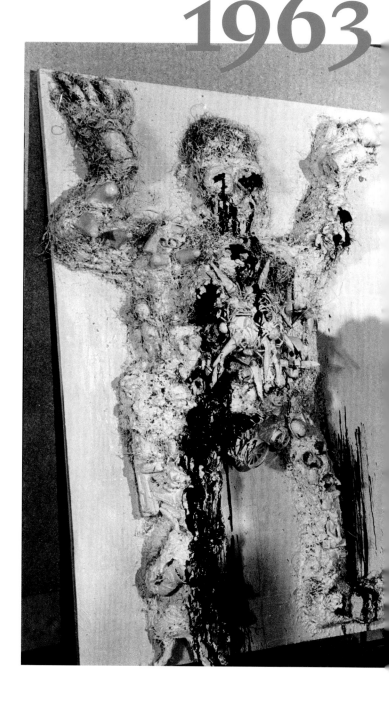

For the second Festival du Nouveau Réalisme, held at the Neue Galerie im Künstlerhaus in Munich, Saint Phalle created *Drôle de mort (Gambrinus)* [*Strange Death (Gambrinus)*] in a shooting session covered by the Belgian television program *Medium: Plastische Kunsten*. During the interview for the program, which followed the shooting, Saint Phalle identified "spectacle" as an important part of her work, calling it "a way to make people enter my world."[31]

31 Translation by Natalie Dupêcher. Saint Phalle's original words were "un moyen de faire entrer les gens dans mon monde." "Het Nieuwe Realisme in München," episode of the series *Medium: Plastiche Kunsten*, filmed February 9, 1963, 16mm, b/w, 30 min. Courtesy NCAF Archives.

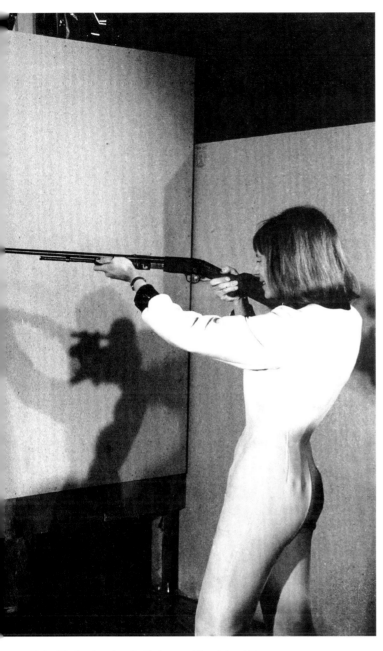

Saint Phalle shooting *Drôle de mort (Gambrinus)* |*Strange Death (Gambrinus)*|, 1963, during the second Festival du Nouveau Réalisme, Neue Galerie im Künstlerhaus, Munich, February 9, 1963. Photo by Friedrich Rauch

May

Location
Los Angeles

Known Participants and Attendees
Artists Edward Kienholz, Jean Tinguely

Documentation
Photographed by Virginia Dwan,
Dennis Hopper

Related Works
CR 367 (pp. 58–59)

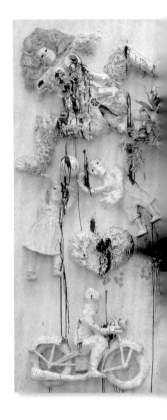

Saint Phalle traveled to Los Angeles in March 1963 to prepare
work for her upcoming exhibition at Dwan Gallery. She
was joined there by Jean Tinguely, also invited by Virginia Dwan
for a residency in preparation for his own exhibition. The gallerist
rented an old sheet-metal factory for the artists, which she
later remembered as a hive of activity: "Jean was welding away,
and Niki was pasting and gluing and painting and filling bags
with paint and pigment to shoot later."[32] During the artists' stay,
Edward Kienholz acted as an informal guide to the city,
introducing them to local junk shops and supply stores. Dwan
recalled accompanying Saint Phalle to wholesale warehouses
in downtown Los Angeles "looking for lots of nasties, like
rubber spiders and alligators and snakes and skeletons and so
forth. . . . We went with a shopping basket and filled it up with
creepy-crawlies."[33] With these materials, Saint Phalle created
a five-panel tableau spanning twenty feet called *King Kong*.
The depicted scene, rich with multiple references to film and
pop culture, invokes the social and political backdrop of the
Cold War more explicitly than her other works to date.[34] Despite
the title, it is Godzilla who looms over the city of Manhattan
(the name "King Kong," by the early 1960s, had direct associations
with the atomic bomb).[35] In addition to the subject matter, the
scale and staged imagery of the *Tir* are deliberately cinematic.
King Kong was featured prominently in an exhibition of Saint
Phalle's work (much of which she had produced in Los Angeles)
held at Dwan Gallery in January 1964.

32 Virginia Dwan, interview by Charles
F. Stuckey, March 27, 1984,
transcript, 24, Archives of American
Art, Smithsonian Institution,
Washington, D.C.

33 Ibid.

34 Saint Phalle addressed Cold War
tensions even more explicitly in
Kennedy-Khrushchev (p. 231),
a *Tir* consisting of a double "portrait"
of John F. Kennedy and Nikita
Khrushchev. Although there is con-
flicting information regarding the
date of this work, it was created for
the Biennale de Paris (the third
edition, held in the fall of 1963). The
work, however, was rejected by the
fair's organizers.

35 Cécile Whiting discusses the
associations of the name "King Kong,"
specifically with the atomic bomb,
in her essay on the work Saint Phalle
made in Los Angeles. See Whiting,
"Apocalypse in Paradise: Niki
de Saint Phalle in Los Angeles,"
Woman's Art Journal 35, no. 1 (Spring/
Summer 2014): 16–17.

Niki de Saint Phalle
King Kong, 1963
Paint, plaster, and objects on board
9 ft. ⅝ in. × 20 ft. ½ in. × 18 ½ in. (276 × 611 × 47 cm)
Moderna Museet, Stockholm, Donation 1972 from the artist

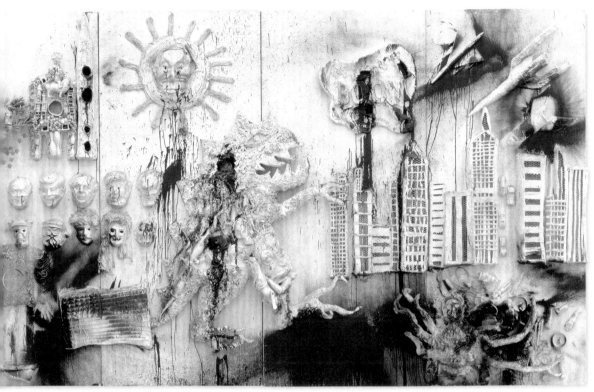

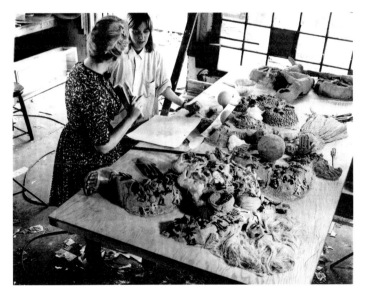

Saint Phalle working on the left panel of *King Kong*
in Los Angeles, 1963. Photo by Dennis Hopper

Saturday, October 12

Location
Berlin

Documentation
Filmed for an episode of *Das Leben ist
die größte Schau* with Wolfgang
Rademann and Henno Lohmeyer,
produced by CCC Television Berlin and
broadcast by Zweites Deutsches
Fernsehen (ZDF)

Related Works
CR 370 (p. 61)

At the invitation of the German television program *Das Leben
ist die größte Schau*, Saint Phalle traveled to Berlin to execute
a *Tir* in front of the camera. *Dragon de Berlin*, one of the last *Tirs*
realized by Saint Phalle, consists of found objects amassed
into a dragon-like figure on a five-foot-high wood panel. The
artist's ninety-minute performance occurred shortly before
the Auschwitz trial began in Frankfurt in December 1963, and the
Tir contains several references to both postwar Germany and
the then divided city of Berlin. The head of Saint Phalle's monster,
positioned in profile, resembles that of the black bear in the coat
of arms of Berlin.[36] A toy bunker, positioned vertically in one
of the creature's legs, references Nazi concentration camps and
the horrific photos that were being more widely circulated
by the press during this decade. The metal box in the monster's
belly is said to have contained live white mice that escaped
during the shooting.[37]

36 In her reading of the work, Jennifer
 Sudul Edwards observes that the
 "profile of the dragon also resembles
 the profile of a rearing bear,
 the symbol of Berlin, both East and
 West." See Edwards, "The Early
 Works of Niki de Saint Phalle"
 (PhD diss., Institute of Fine Arts,
 New York University, 2014), 253.
37 Ibid., 253. See also Catherine
 Francblin, *Niki de Saint Phalle: La
 révolte à l'oeuvre* (Paris: Hazan, 2013),
 128.

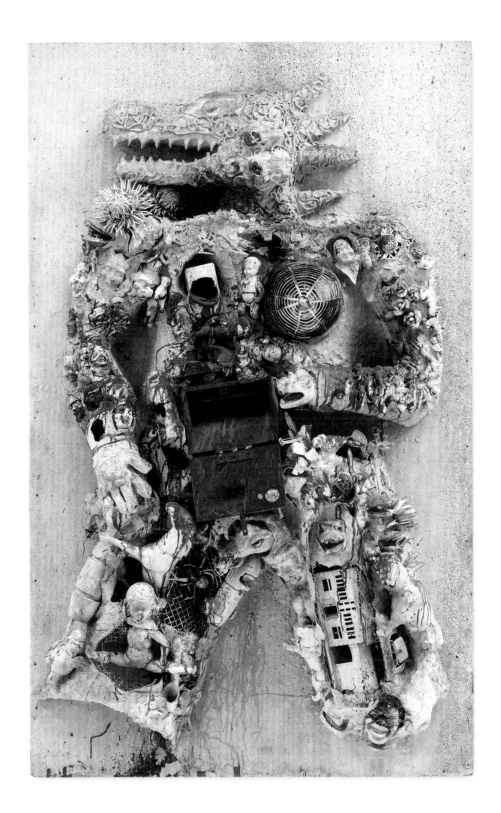

Niki de Saint Phalle
Dragon de Berlin, 1963
Paint, plaster, wire mesh, and objects on wood
70¾ in. × 43½ in. × 13¼ in. (180 × 110 × 34 cm)
Sprengel Museum Hannover, Donation of the artist (2000)

Spring

Location
Auberge du Cheval Blanc, Essonne

Documentation
Photographed by Monique Jacot
Filmed for an episode of *Métamorphoses:
L'Aventure de l'objet*, directed by
Jean Antoine, produced by Henri Billen,
and hosted by Pierre Restany;
broadcast by Radio-Télévision Belge
de la Communauté Française (RTBF)

Related Works
CR 350, 355

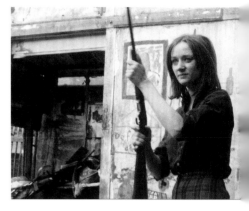

Saint Phalle shooting *Tir–assemblage femme*,
1964, filmed for the Belgian television program
Métamorphoses

In 1963, facing eviction from the Impasse Ronsin, which was slated for destruction, Saint Phalle and Jean Tinguely purchased a former inn, Auberge du Cheval Blanc, in Essonne, south of Paris. The artists relocated to their new home and studio during the winter of 1963–64. As the weather improved, Saint Phalle moved much of her work outdoors and staged two shootings. For an interview with Maurice Rheims and photo shoot with Monique Jacot commissioned by *Vogue Paris*, Saint Phalle donned her white shooting jumpsuit and took aim at *La sorcière rouge* [*The Red Witch*], propped up outside the inn's former bar.[38] Multiple photographs of Saint Phalle and her work in Essonne appear in the article, which was published in February 1965.[39] During this period, the artist also shot *Tir—assemblage femme* for the Belgian television program *Métamorphoses*, which covered contemporary art.[40] In the black-and-white footage, which first aired on June 1, 1964, Saint Phalle is interviewed prior to shooting the freestanding figural assemblage. Pierre Restany inquires, "Your relief and your characters, Niki, before being shot, are already works of art, why not remain there? Why shoot them with a hunting rifle?" Saint Phalle responds:

> Well, I must shoot them for multiple reasons. This relief that I am about to shoot, I worked on it for two weeks. It's arduous work, it's almost the work of an artisan, it is also an artistic work. But the shoot that is going to take place now, it is pure poetry for me, it is the moment of truth. It is creation, it gives a new life to the object, which otherwise would have remained an art piece but that doesn't have this new dimension that the shoot can give it. And now I will shoot it.[41]

38 Regarding *La sorcière rouge*, although the relief itself is frequently dated to 1962, it may have been shot later. In Jacot's photograph, Saint Phalle is shown aiming at the relief; however, it is not clear whether the artist shot the *Tir* at the time Jacot made the photographs or only posed that way for the camera. Francblin claims that Saint Phalle was completing *La sorcière rouge* at the time Jacot came to Soisy on assignment for *Vogue*. See Francblin, *Saint Phalle*, 143.

39 Maurice Rheims, "Niki de Saint Phalle: L'art et les mecs," with photographs by Monique Jacot, *Vogue Paris*, February 1965, 58–61, 94.

40 The relief known as *Tir—assemblage femme* is commonly dated to ca. 1962. As with *La sorcière rouge*, however, it seems likely that it was shot later, in the spring of 1964.

41 *Métamorphoses: L'Aventure de l'objet*, Radio-Télévision Belge de la Communauté Française (RTBF), June 1, 1964, Sonuma Archives, Liège, Belgium. The translation is taken from the English subtitles of *Seductive Subversion: Women Pop Artists, 1958–1968*, directed by Glenn Holsten and produced by Pew Center for Arts and Heritage, 2010, sound, color, 57 min., which includes a clip from the original program.

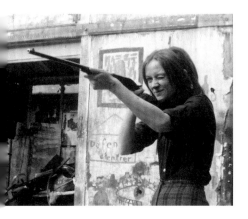

Page of Monique Jacot photographs accompanying Maurice
Rheims, "Niki de Saint Phalle: L'art et les mecs," *Vogue Paris*,
February 1965, 60–61. Courtesy of Menil Library

Location
Auberge du Cheval Blanc, Essonne

Documentation
Photographed by Giancarlo Botti
(see p. 233) and Harry Shunk
and János Kender
Filmed for *Éloge de la folie*, directed by
Roland Petit, produced by Comacico,
and featuring Roland Petit,
Niki de Saint Phalle, Martial Raysse,
and Jean Tinguely

Related Works
CR 440 (p. 65), 441 (p. 64)

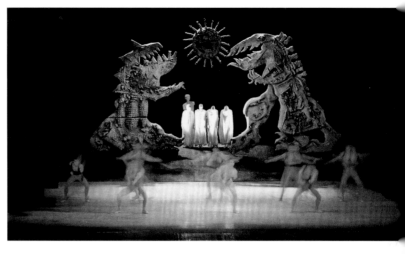

Saint Phalle's set for the sixth act, "La guerre" ("The War"),
of Roland Petit's ballet *Éloge de la folie*, performed
at the Théâtre des Champs-Élysées, Paris, March 1966.
Photo by Shunk-Kender

Roland Petit developed his film *Éloge de la folie* (*In Praise of Madness*) along with his contemporary ballet of the same title, a collaboration with Saint Phalle, Jean Tinguely, and Martial Raysse. In addition to contributing their ideas for the concept of the ballet, the visual artists designed stage sets and costumes. For one act, "La guerre" ("The War"), Saint Phalle created a monumental set for a purely imaginary shooting. The set consisted of two towering monsters and a sun hanging above the stage. Saint Phalle's large, white sculptures contrasted with the deep blood orange of the floor and the backdrop. A group of male dancers, resembling a firing squad, performed a gestural "shooting" of a line of blindfolded female dancers, clad in white. The women fell, one by one. At the end of the line, a white sculpture of a woman appeared, which was also "shot" by the dancers' gestures. As the men fired their make-believe guns, paint spilled from the statue's abdomen, released by an unseen mechanism. The ballet was performed at the Théâtre des Champs-Élysées, Paris, in March 1966. Although Saint Phalle did not appear on stage during the live performance, she orchestrated a shooting in Essonne for the filmed version. In the film, the artist wears her white shooting costume as she fires a rifle at a *Tir* titled *Le monstre de Soisy* [*The Monster of Soisy*]. From spine to tail, the crest of the stand-alone sculpture is covered with various objects, including weapons and toys. Its belly appears to be gouged with knives, with only the handles visible, while, from the same surface, several gun barrels emerge, pointing wildly outward. As Saint Phalle shoots the burly monster in the film, explosions of bright blue and vibrant yellow color the sculpture.

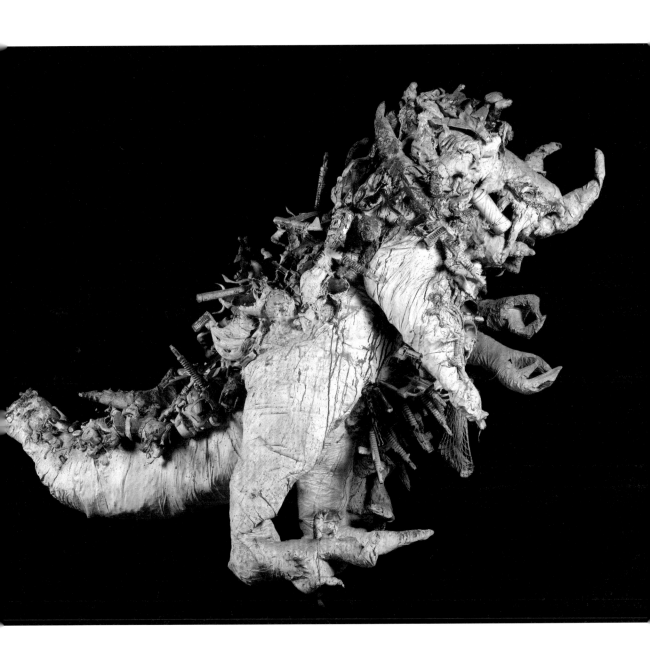

Niki de Saint Phalle
Le monstre de Soisy | The Monster of Soisy, 1966
Newsprint, paint, textiles, stuffed animal, and objects
on metal and wood structure
70⅞ × 64⅛ × 99⅝ in. (180 × 163 × 253 cm)
Centre Pompidou, Paris, Musée national d'art moderne/
Centre de création industrielle, Donation of Pontus
Hultén 2005

Saturday, November 28/
Sunday, November 29[42]

Location
Galleria Vittorio Emanuele II, Milan

Known Participants and Attendees
Artists of the Nouveau Réalisme group
including Arman, César, Christo,
François Dufrêne, Raymond Hains,
Martial Raysse, Mimmo Rotella, Daniel
Spoerri, Jean Tinguely, Jacques Villeglé
Artists Claude Lalanne, François-Xavier
Lalanne, Jacqueline Matisse
Collector Marcel Lefranc
Critic Pierre Restany
Curator Pontus Hultén
Former schoolteacher Clarice Rivers
Gallerists Alexandre Iolas, Guido
Le Noci
Scientist Étienne-Émile Baulieu
Theater director Rainer von Hessen

Documentation
Photographed by Enrico Cattaneo,
Ad Petersen, Harry Shunk, Rico Weber,
Lothar Wolleh
Filmed by unknown

Related Works
CR 236 (p. 137), 281 (p. 147),
538 (p. 67, bottom)

Spectators gathered at Galleria Vittorio Emanuele II, Milan,
to witness Saint Phalle's shooting session, late November
1970. Photo by Ad Petersen

For the tenth anniversary of the founding of Nouveau Réalisme,
Pierre Restany and Guido Le Noci, director of Galleria
Apollinaire, organized an exhibition in Milan's newly restored
Rotonda della Besana that was accompanied by a series of
"actions-spectacles" in the city over three days. The exhibition
included Saint Phalle's *Tir, séance 26 juin 1961* (p. 137), which
had not been shown since its 1961 debut at the Galerie J exhibi-
tion *Feu à volonté*, and *Composition à la trottinette "Tir à la
carabine"* [*Composition with Scooter, "Rifle Tir"*] (p. 147), also
from 1961. During the weekend, Saint Phalle executed the shoot-
ing of *Autel* [*Altar*] in Galleria Vittorio Emanuele II, a famous
shopping arcade that was crowded with onlookers as night fell.
The altarpiece, constructed of five wood panels forming a
triptych, stood over ten feet tall. The central apex was topped by
a crucifix, and several religious figurines were strung along the
base. Dressed all in black except for a white ruff and frilly cuffs,
with a cross hanging from her neck, Saint Phalle fired a rifle at
the sacred imagery, splattering predominantly red paint across
the structure.

42 Sources differ concerning the date
of Saint Phalle's shooting perfor-
mance. Although certain accounts
(including Hultén, *Saint Phalle*,
293, and the catalogue raisonné, no.
538, 248–49), specify November 29,
the third and last night of the
festivities, Francblin mentions the
second day, November 28, in *Saint
Phalle*, 198–99.

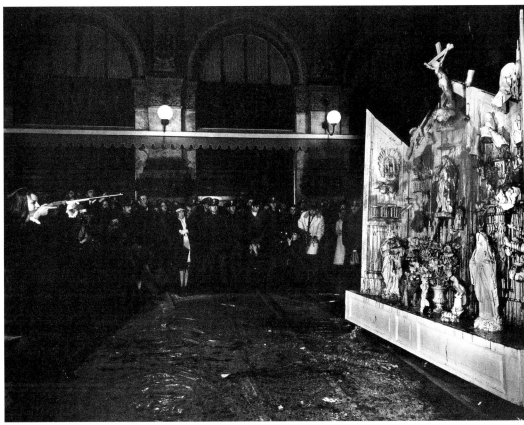

Saint Phalle shooting *Autel [Altar]* at Galleria Vittorio
Emanuele II, Milan, during the tenth-anniversary celebration
of Nouveau Réalisme, late November 1970. Photo by
Shunk-Kender

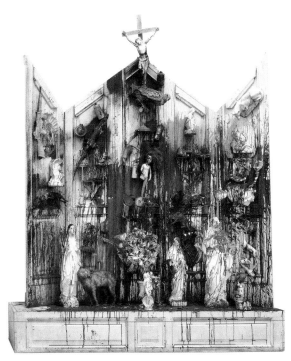

Niki de Saint Phalle
Autel [Altar], 1970
Paint and objects on wood
123¼ × 103 × 22⅛ in. (313 × 261.5 × 56 cm)
Collection of Stedelijk Museum, Amsterdam

Location
Château de Beauregard, Mons, and
Château La Commanderie, Dannemois

Documentation
Filmed for *Daddy*, directed and edited
by Peter Whitehead, written by and
starring Niki de Saint Phalle, featuring
Rainer von Hessen (credited as
Rainer von Diez), Mia Martin (second
version only), Clarice Rivers (credited
as Clarice Mary), Gwynne Rivers
(uncredited), Marcel Lefranc,
and Jean-Pierre Raynaud; produced by
Peter Schamoni and Tome G. Neuman

Related Works
CR 541, 547 (p. 69)

Saint Phalle shooting *La mort du
patriarche* [*Death of the Patriarch*],
1962/72. Still from *Daddy*, 1972/73

In her first feature-length film, *Daddy*, Saint Phalle performed
two shootings. Filmed in the South of France at the Château de
Beauregard in Mons and La Commanderie in Dannemois,
Daddy follows the relationship of a young girl, Agnes (played by
Gwynne Rivers), and her father, "Daddy" (played by Rainer
von Hessen, under the stage name Rainer von Diez). In the open-
ing scene, Saint Phalle shoots *Autel du chat mort* [*Altar of the
Dead Cat*], ca. 1972. The camera closely pans over the work's
details: taxidermied animals, a bust, a crucifix, an animal's horned
skull with a doll locked in its jaws, all painted white. Red paint
then explodes over the objects, followed by blue, then black, as
gunshots ring out. As the camera zooms out, Saint Phalle
can be seen aiming a rifle at an altarpiece positioned in front of
a majestic sixteenth-century building. After she fires, white
billows of smoke emerge from the *Tir*, dramatically obscuring it.
The film concludes with the symbolic death of Daddy, when
the artist shoots *La mort du patriarche* [*Death of the Patriarch*],
1962/72. Among the materials that shape the hefty *Tir* figure
is an erect airplane prominently issuing from its groin. As
Saint Phalle shoots, aerosol paint cans burst, releasing streams
of red from the figure's chest, and she says, "Goodbye, Daddy."
The first version of the film was presented in November 1972 at
Hammer Cinema in London. The second, final version was
screened in 1973 at the Museum of Modern Art, New York, as part
of the New York Film Festival. In the years following the shooting
events, Saint Phalle would dedicate her work to the represen-
tation of the female figure. In the artist's own words: "I started
making brides, hearts, women giving birth, the whore—various
roles women have in society."[43]

43 Saint Phalle, "Letter to Pontus,"
164–65.

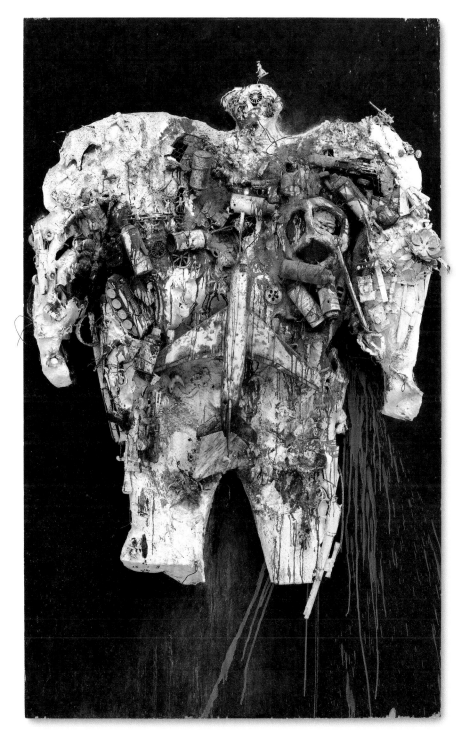

Niki de Saint Phalle
La mort du patriarche [*Death of the Patriarch*], 1962/72
Paint and objects on panel
98¹³⁄₁₆ × 63 × 15¾ in. (251 × 160 × 40 cm)
Sprengel Museum Hannover, Donation of the artist (2000)

Following Page: Saint Phalle shooting atop a ladder
at *Tir tableau Sunset Strip*, 1962, on March 4, 1962. Photo
by Seymour Rosen

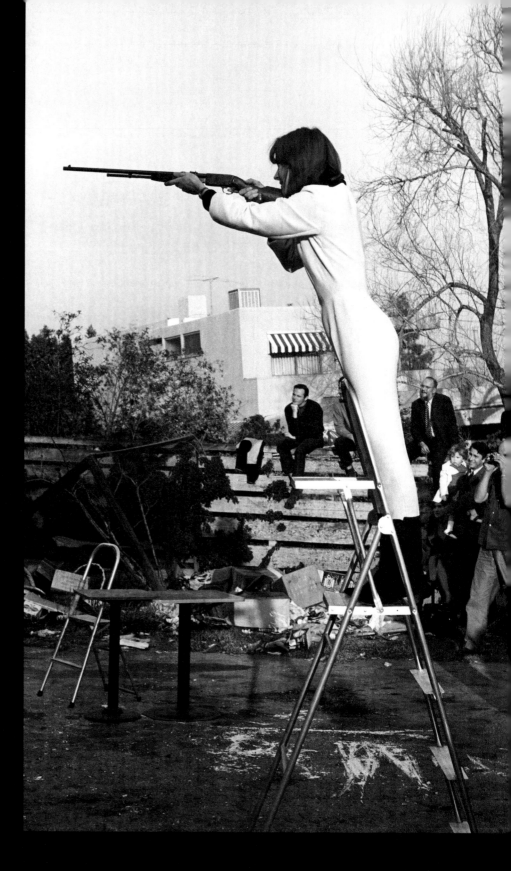

THE OUTSIDE WORLD
Niki de Saint Phalle's *Tirs* and American Art, 1961–1963

Michelle White

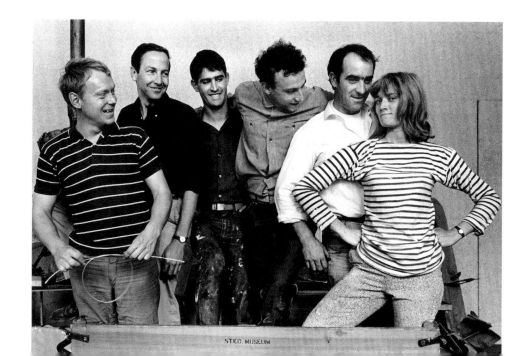

I needed a confrontation with the outside world and I wanted to be taken seriously in my communications with it.

No one thinks of me as an American artist, which is really what I am.

Niki de Saint Phalle

On Sunday, February 12, 1961, Niki de Saint Phalle (1930–2002) made an explosive entry into the international art world when she set up an outdoor shooting gallery at her Paris studio. With a borrowed .22-caliber-long rifle, she choreographed an event with a handful of participants, who, along with the artist, completed a group of paintings by opening fire. The bullets, each about one inch long, flew into compositions she had constructed in advance with found objects and plastic bags of paint, held together by metal chicken wire attached to a wood support and then covered in plaster. When the ammunition tore into the lumpy white surfaces, the concealed pockets of paint popped and splattered spectacularly and colorfully across the tabulae rasae. The artist stated that through this disarming, chance-based process of creation, her paradoxical intention had been to make painting bleed. It was only through such acts of ecstatic destruction, she would later insist, that there was life.[1]

Saint Phalle's violent practice quickly gained attention both within artistic circles and in the popular press, aided by widely circulated photographs and films of the gun-toting thirty-year-old artist and her increasingly theatrical spectacles. In Europe, Saint Phalle was soon one of the most recognizable artists of the time, and just three years later, her method was parodied in a Hollywood film.[2] While most of the sessions involved audience participation, she also staged events with herself as the sole shooter. In the hills of Malibu, California, in the spring of 1962, with celebrities and art-world luminaries in attendance, she donned a white jumpsuit and lodged bullets in a massive tableau spanning sixteen feet, dominated by a sculpted relief of a prehistoric beast (p. 49). The assemblage also contained a live bird in a cage, around which the sharpshooting artist expertly maneuvered; at the conclusion of the session, she fired off a cannon that engulfed the whole composition in yellow smoke.[3]

Saint Phalle used this novel technique of making a painting for just under three years.[4] From February to July 1961, she executed eleven shootings; approximately a dozen known sessions followed through 1963. The sessions resulted in what she called *Tirs* (in English, "shots" or "shootings"). Also known as the

Per Olof Ultvedt, Robert Rauschenberg, Martial Raysse, Daniel Spoerri, Jean Tinguely, and Saint Phalle on the occasion of the *Dylaby* exhibition at the Stedelijk Museum, Amsterdam, August 1962. Photo by Christer Strömholm

"shooting paintings," the *Tirs* evolved over this brief period as the artist explored different approaches to handling paint and found materials and to activating the audience. Cumulatively, the works are a searing comment on patriarchal violence and, in the wake of the dominance of Abstract Expressionism in the United States, a critique of the medium and tradition of painting itself.

At the time she made the *Tirs*, Saint Phalle was not alone in her impulses: art was teetering away from modernism and into the experimental terrains of performance and conceptualism, among many other developments at the onset of this game-changing decade. When considered formally and contextually, the *Tirs* become fundamental to this narrative and integral to conversations about avant-garde practices on both sides of the Atlantic. This approach to the artist's work intentionally steps away from the dominant role often played by her biography. Previous interpretations have tended to pit Saint Phalle's generative artistic activity not against the weight of history or the *outside* world but against past traumas and *inner* yearnings for creative freedom. Such a framework situates her struggle as an entirely personal one, rather than one stemming from systematic sexism. If the artist's private life and particularly her past, which involved sexual violence, are seen as the primary rationale for the *Tirs*, they turn into a cathartic exercise, differentiated from the artistic intentions of her male peers. The curator and museum director Pontus Hultén—Saint Phalle's great champion, who, beginning in the 1960s, put her in cutting-edge shows alongside Jasper Johns and Robert Rauschenberg—reflected on her work as if it were worlds apart from that of the men next to which it was frequently hung in museums. Saint Phalle recognized the power of the "poisoned fruit of outcasts," he said, asserting that her works needed to be "considered as a result of an existential struggle" because of the way she "threw herself into painting, not to become 'an artist' but in order to find an identity."[5]

Saint Phalle's personal story is important and, today, has an even greater moral imperative within the #MeToo movement, but it is limiting if used as the sole means of reading her work. Elsewhere in this volume, the art historian Amelia Jones articulates the problem of what it means to link the artist's oeuvre to her biography, offering an understanding of Saint Phalle's work as strategically ambiguous. Both of the mind and of the body, her work stands, Jones argues, in a liberating place in between. The scholar Sarah G. Wilson has also discussed the power of this position. She points out that the pronunciation of *Tirs* sounds like the English word "tear," and for the bilingual artist, this would have likely been an intentional slippage. "Shooting" becomes a consequence of violence and sadness. A tear, after all, is a physical manifestation of grief.[6] If we take Wilson's semantic analyses a step further, still more meanings can be applied. A tear is a salty secretion, according to the dictionary, but also, pronounced differently, "a brief spell of erratic or unrestrained behavior; a binge or spree," as well as "a hole or split in something caused by it[s] having been pulled apart forcefully."[7] Biologically and biographically, these definitions relate to the mythos that swirls around Saint Phalle, that conflates her work with her body, while bringing to mind everything from a perineal laceration after childbirth to a short and wild rumpus with a gun.

How might we *also* evaluate her work, in all its complexity, as controlled, rhetorical, and divorced from bodily manifestations of anger and hysteria, among other gender-loaded connotations? The French artist Arman, Saint Phalle's contemporary, carried out performances he called *Colères* [Rages]. He smashed fancy eighteenth-century furniture and musical instruments, among other items related to bourgeois life, in works that have typically been described as virile, intellectual commentaries on art, not slips of sanity or irrational flairs of testosterone-filled fury. One writer interprets his "tantrums" in

this cerebral fashion: "Arman's explosive physical action directed toward breaking historically bound artifacts was a way of demonstrating a rupture with the historical standard of cultural validity."[8] What would happen if we were to apply this type of language to Saint Phalle's work? How might the formal attributes of her *Tirs* be more easily understood as intellectual rips in the fabric of tradition?

An American Dadaist

Saint Phalle was both American and French. Born in France into an aristocratic banking family with roots in both places, she grew up in New York City in the 1940s. The Metropolitan Museum of Art, which she called her "first teacher," was a few blocks from her home on Park Avenue.[9] After she moved back to France as an adult in 1952, and after her first exhibition in Europe, called *New York*,[10] she became part of an influential colony of artists in the Impasse Ronsin, a center of Parisian intellectual and artistic circles since the late nineteenth century.[11] Despite the rough edges and lack of plumbing in the inexpensive studios at the end of a cul-de-sac, the Impasse was a fertile hive of activity for the international artists who worked there and optimized the romantic spirit of *la bohème*. According to the historian Adrian Dannatt, Saint Phalle's "Yanko-Franco-hybrid" identification embodied the colony's atmosphere.[12] Reflecting back on this time, the artist stated that she relished such indeterminacy: "I didn't feel I had a nationality. As a matter of fact, that's what I liked, I had no nationality."[13]

Despite her fluid understanding of her identity, the artist has most often been considered French, primarily because of her affiliation with the Paris-based movement Nouveau Réalisme. She was formally asked to join the group following her first shooting session. Yves Klein, Arman, and Jean Tinguely (whom Saint Phalle met in the Impasse in 1956 and with whom she began living in 1960) were among its notable members. Prizing acts of destruction and the use of *real* objects in their work, they were organized under the critic Pierre Restany's 1960 manifesto. A "poetic recycling of urban, industrial and advertising reality," he declared, stripped art of romantic idealism and was the true reflection of the age.[14] Saint Phalle's use of detritus, along with her method of making a work through the paradoxical process of "killing" it, was well aligned with the movement's ethos.

While writers have flirted with her possible "Americanness," Saint Phalle's reception at the time also tended to situate her as European, as demonstrated by the first article solely about the artist to appear in the United States, in July 1961. In his dispatch from Paris in the international edition of the *New York Herald Tribune*, the critic and poet John Ashbery described her as an "American Dadaist."[15] In doing so, he complicated her identity from the start by linking her possibly "American" work to the European avant-garde; he also qualified her association with the United States by referring to her affluent French family. Moreover, in the handful of times Saint Phalle is identified as American in the more than fifty articles written about her between 1961 and 1963, it is not through any formal comparison to the work of her peers but in the context of the the nation's storied popular culture. For example, the *Tirs* are often described as cowboy shootouts and the artist compared to Calamity Jane or Annie Oakley.[16]

Such distinctly American readings certainly provide ways to understand Saint Phalle's critique of masculine violence through the nation's ingrained gun culture, which continues to define it today and which the artist discussed as a manifestation of "extremism."[17] Whether she was or was not a gun-slinging "American," however, her work was affiliated with certain strains of artistic production in the United States, and dismissing that relationship hinders an understanding of her important position within the much broader story of the visual arts after

World War II. These connections can be drawn through an analysis of the *Tirs* as a formal critique of modern painting, via the legacy of Jackson Pollock, and by considering them in relation to emerging questions around artistic agency and participatory art, interests she shared with Robert Rauschenberg. Saint Phalle was certainly taking aim at the patriarchy and her traumatic bourgeois past, but she was also looking down her barrel at art history.

Tirs: A Formal Introduction

While the basic structural formula Saint Phalle established at her first shooting—white plaster embedded with concealed bags of paint and an assemblage of found objects—remained consistent at the beginning of the 1960s, the artist's methods and materials were nonetheless highly experimental. She stuck glass ink jars, yogurt containers, and aerosol paint cans in the plaster or suspended them in front of the work so that, after they were shot at and burst, fine droplets sprayed over the surface. She also experimented with further diluting her liquid paint.[18] There are passages of viscous globs that sit on the surface as well as faint halos of watery drips, absorbed into the porous plaster. In most of the *Tirs*, Saint Phalle's wild paint fell against reliefs incorporating an assortment of found objects: cheap plastic toys and tchotchkes, scraps of metal, umbrellas, balls of string, bent bicycle wheels, a pair of scissors, a high-heeled shoe, and other bric-a-brac that seemed to have come from a junk pile or been found on the street. In other works, she left out these quotidian items. After impact, the unhindered colors fell down the bumpy white surfaces as abstract vertical streams. She also experimented with paint-launching cannons and smoke bombs. She was known to stuff tomatoes and whole eggs into some surfaces, and in the so-called *Old Master Tirs*, she shot at plaster reliefs in neoclassical-style frames: drips gushed over the decorative carving and gilding (pp. 130–33).

Saint Phalle also often arranged found objects to tell a story, especially as the compositions for the *Tirs* increased dramatically in size and assumed an almost cinematic structure. For example, in *Gorgo in New York* (pp. 154–55) and *Pirodactyl over New York* (pp. 156–57),[19] both 1962, the prehistoric beasts humorously defy their bulk by teetering on roller skates on a collision course with phallic skyscrapers. Invoking Hollywood's infatuation with monsters and sexual innuendo, these are among a group of *Tirs* the artist dedicated to the motif of large creatures terrorizing the Big Apple.[20] Further perils, and even more overt plays with the demolition of masculine symbols, are suggested in works such as *Heads of State* (*Study for King Kong*), 1963 (pp. 160–61), in which she lodged bullets in the plastic foreheads, grinning teeth, and eye sockets of store-bought masks representing Stalin, Kennedy, and Castro, along with other male leaders who were battling out the future of humanity in Cold War–era headlines. This narrative impulse is extended by a thematic group of *Tirs* that imply the ills of organized religion. In these works, the paint is strewn, often dripping like blood, on supports covered with Roman Catholic kitsch or configured like altars.

Needless to say, as a result of their variable materials and processes, the *Tirs* were inherently fragile from their inception. More than six decades after their creation, we can see plastic bags and full-sized aerosol cans haphazardly wired to compositions that never met a bullet, still filled with paint. Rusty tools and toothy exploded cans drip brown stains; torn plastic bags push through metal mesh; leftover twine pokes out. Dirt, perhaps kicked up in the various outdoor spaces in which the works were made, casts a dusty patina. In his review of the first solo show of the *Tirs*, John Ashbery delighted in the fact that chips of flying plaster kept splashing into Champagne flutes at the vernissage.[21] Conservators call such precarious qualities as these "inherent vice," and they are the primary reason many *Tirs* no longer exist or

cannot be shown in public. Curators have remarked that bullets still rattle in the works when they are hung on the wall, and during preparations for one exhibition, old ammunition shell cases tumbled out of a *Tir* onto the museum floor. One Paris-based collector discovered this volatility when an intact aerosol paint can, embedded in a work of 1961, spontaneously exploded, releasing a spray of fresh paint across her living room thirty-six years later.[22]

Thanks to their fragility, which is conversely tied to their violent inception, the *Tirs* are not just *about* painting but about the medium's anxious relationship with the past, in a premonition of the postmodern sensibility to come. Consider, for example, how Saint Phalle dramatized certain aspects of her works' creation. Surface cracks, exposed chicken wire, smooth cavities where bulbs of paint once hid, remain intact, and these remnants of process reveal Saint Phalle's past actions to the point that they become a hyperbolic enactment of "painting." When a ruptured paint can or searing constellation of smoke-rimmed bullet holes collides with abstract drips of paint over crumbling plaster, the nonrepresentational subject matter of traditional modern painting transforms into its converse: a parodic representation of itself that makes it difficult to project *anything* onto Saint Phalle's works of art, be it an emotion or a basic human yearning for a representation of a landscape, for instance. She inhibited this inclination to such a degree that we might ask if she was using the indicators of inherent vice to question the preciousness of the work of art itself, and whether the *Tirs* were even meant to last. Are they only relics of a performance?

The art historian Leo Steinberg's concept of the "flatbed picture plane" provides one way of understanding how Saint Phalle's work operates within a larger critique of the painting tradition. Steinberg's famous 1968 lecture at the Museum of Modern Art did not address Saint Phalle, but it did demonstrate how integrated her formal explorations were at the beginning of the 1960s. In that moment, Steinberg said, there had been a marked shift away from the idea that painting is an illusion toward a reconsideration of how a work hanging on the wall addresses a standing viewer. Rather than orienting the work of art vertically—as a proverbial window onto the world or a space into which to optically sink—artists turned it horizontal, and thereby opaque, by filling it with actual stuff. This gesture, he argued, pushes the viewer out and onto the surface, the "flatbed picture plane," which is "no longer the analogue of a visual experience of nature."[23] This plane limits optical projection by asking the viewer to engage with the work as one might read a newspaper or look at information on the floor of a studio, a bulletin board, or a tabletop.

Steinberg illustrated his thesis by analyzing Robert Rauschenberg's *Bed*, 1955. In that work, colorful drips of paint splash over a real pillow and quilt and slide down the (in this case, vertical) support. Not unlike Saint Phalle's *Tirs*—including *Composition*

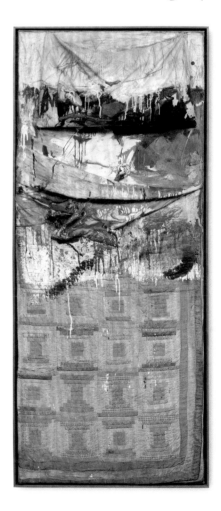

Robert Rauschenberg
Bed, 1955
Oil and pencil on pillow, quilt, and bedsheet on wood supports
75¼ × 31½ × 8 in. (191.1 × 80 × 20.3 cm)
The Museum of Modern Art, New York,
Gift of Leo Castelli in honor of Alfred H. Barr, Jr.

à la trottinette "Tir à la carabine," 1961 (p. 147), which contains a real headboard and bedsprings—*Bed* is an assemblage of everyday materials encrusted on a surface, mixed with paint handled in an expressionistic manner that seizes on gravity: the drips build tension between the medium's representational history and blaring reality. The detritus that made it into Saint Phalle's *Tirs*, often swept off the floor of her studio, along with all the salient visual clues that tell us a gun was used, nods to Steinberg's argument: this is the kind of disruption that prevents a work from being illusionistic. It is what it is. The picture plane is the artist's surface to act on (in Saint Phalle's case, to shoot at), and as a result, we can see that, like Rauschenberg's *Bed*, the *Tirs* address the medium of painting, specifically its fading history in the postwar moment, while pushing it into a new realm of interactivity and engagement with the spectator.

Guns, Godzilla, and the Atomic Age

Saint Phalle's critical approaches to paint, assemblage, and the picture plane also became the means of expanding the very definition of art. Her interrogation of tradition extended to her *Tirs*' relationship to the audience. From the inception of the series, she was always the mastermind, but after the often labor-intensive preparation of the reliefs, she was typically not the only person physically completing the works with a gun. She called the shots but did not always pull the trigger. This role is clarified in Ashbery's review of the first solo show of the *Tirs*. Just the second sentence points out that these paintings "must be finished by the spectator," and the poet goes on to describe, from his position as a witness at the opening, the satisfaction felt by those carrying out the act.[24]

The misconception that Saint Phalle was the primary shooter is aided by the widely circulated images of her holding a gun. Many of these posed photographs were made for the promotion of an upcoming exhibition or staged for the media at a time when the press was clearly enamored with the sexual innuendo of a beautiful woman holding a gun but shocked that she was actually quite a skilled marksman (p. 81). In *Artforum*, a critic commented that "she is not really such a bad shot—for a woman. In fact she is a very attractive shot."[25] The artist, aware of this paradox, was known to accentuate it through her increasingly theatrical flair and costuming in the handful of times when she was the lead marksman in front of an audience. After she descended the ladder following her 1962 shooting on Sunset Boulevard, Lawrence Lipton, the revered critic and poet, took the liberty of explaining the fallacy of her work to the artist. "It's marvelous," he commented to her. "But, you realize, you are just an exhibitionist." She replied: "But of course."[26]

Lipton's imputation of Saint Phalle's triviality, attempting to reduce her *Tirs* to *just* spectacle, reveals how distracted critical (usually male) eyes were by the artist's body. Why wouldn't this art critic, renowned for his discerning observations, notice the incredible precision and preparatory labor required of Saint Phalle in her studio, including the exacting ability to know, when she fired a bullet, where she had happened to conceal a bag of paint? This critical misperception could be tied to the fact that the images of Saint Phalle with a gun effortlessly coincided with images in the popular culture of the time. Toward the end of the 1950s, the "girl with a gun" trope was taking hold.[27] The motif of a femme fatale brandishing a firearm, or a female body wrapped around the enlarged shaft of a gun, was widely found on movie posters and pulp-fiction covers in Europe and the United States, affirming that a combination of sex and violence sells. The early 1960s also coincided with the height of the popularity of westerns in television and film. For titillating effect, some productions replaced the typically male gunslinger with a woman, such as the 1957 film *The Dalton Sisters* and *Cat Ballou* of 1965, starring Jane Fonda. Jean-Luc Godard, the premier French

film director of the 1960s, filled screens with women brandishing firearms during this decade and was famously said to proclaim that all you need for a successful movie is "a gun and a girl."[28]

While deliberately and coyly performing this trope for the camera, perhaps acknowledging the cinematic recipe of eroticism and violence, Saint Phalle was nevertheless emphatic that her intention, from the onset of the *Tirs*, was participatory. In a 1962 interview, she said, "I began by not shooting myself. I began by having other people shoot at them."[29] The artist's rules of engagement changed with each piece, but in general, they were open-ended, unscripted, and welcoming of the chance-based results that arose from the shooters' inexperience. For example, for her show at Galerie J in 1961, the first solo presentation of the *Tirs*— aptly called *Feu à volonté* [*Fire at Will*]—she invited gallery visitors to take a shot and contribute to the completion of the works of art (pp. 36–37). The title's military directive, implying discretionary action, is fitting. While Leo Castelli, Jasper Johns, Frank Stella, Barbara Rose, and other notable art-world figures participated, so did members of the public. For the duration of the exhibition, a gun, tucked behind the front desk, was available and ready to be loaded for gallery goers from 5:00 to 7:00 p.m. daily.[30] For her first solo show in New York a year later, the artist attached bags of paint to a rotating wheel so viewers could "shoot at the whirling color spectacles," according to one witness, who compared the playful setup to a carnival game.[31] The artist also developed a *Tir* as an edition—a clean plaster surface embedded with her now signature concealed bags of paint—that included instructions to the buyer about how to consummate the purchase.[32]

Anticipating this democratic approach are Saint Phalle's five "dart portraits" of 1960–61 (pp. 80, 128, 203). This group of works consists of effigies of male figures, depicted from the waist up and with real dartboards as heads, surrounded by objects that complete the likeness: a man's collared shirt from Saks Fifth Avenue splattered with paint, a tie, or a pack of cigarettes drooping from a pocket. The artist first installed one next to a tray of darts and a small sign inviting the audience to throw them at the visages (but to please avoid damaging the other works in the show).[33] The targets are a clear reference to Jasper Johns's well-known use of the concentric sign, and Saint Phalle later expanded on this nod in a *Tir* prominently featuring a target, *Tir de Jasper Johns* (p. 139), 1961. Johns himself completed it with a gun, a format Saint Phalle set up and replicated for Robert Rauschenberg, who also finished a *Tir* titled in his honor.

For the artist, watching the audience delight in one of the dart portraits, *Hors-d'oeuvre ou Portrait of My Lover* (p. 128), when it was installed in a group exhibition in Paris less than two weeks before she completed her first *Tir*, truly paved the way.[34] The participatory action that continued to accompany the works' presentation in the following years—one witness described eager guests "queuing up to get at the darts"—demonstrated the power of her experiment and ignited the idea that it might be more dramatically achieved if a gun were up for grabs instead of a dart.[35] As the *Tirs* evolved into more elaborate theatrics, questions about the role of the artist were pushed to the fore. One critic, observing that male participants were more likely to take a turn with the gun, set forth the idea that this was not a benign tendency but a seductive trap of castration, which

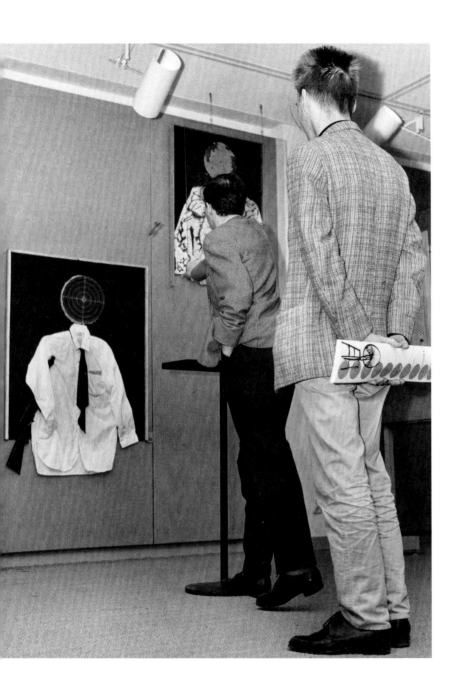

Visitors throwing darts at *Saint Sébastien (Portrait of My Lover / Portrait of My Beloved / Martyr nécessaire)*, during the exhibition *Movement in Art*, Moderna Museet, Stockholm, May 17–September 3, 1961. Photo by Shunk-Kender

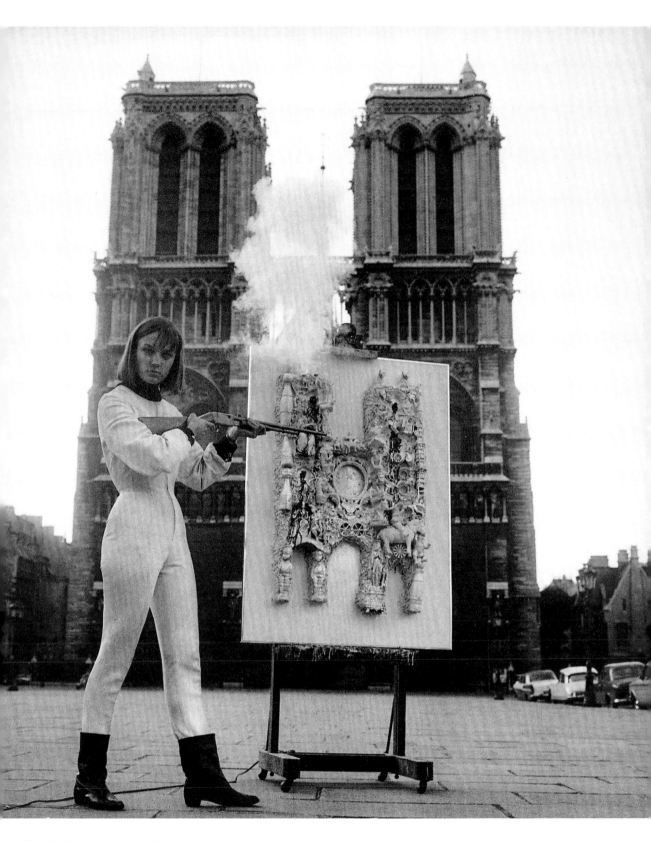

Saint Phalle posing before a *Tir* on the occasion
of the eight hundredth anniversary of Notre-Dame Cathedral,
Paris, 1962

tricked men into carrying out a "symbolic act" of self-destruction.[36] Indeed, Saint Phalle's orchestrated interactions addressing artistic agency and power dynamics were extraordinary in their foresight, anticipating strategies found in some of the most groundbreaking works of feminist performance art to come. It would still be a year or two before Yoko Ono, by placing a pair of scissors in front of her kneeling body, invited the audience to cut away her clothing on stage.[37]

Toward the end of the 1950s, other artists were similarly invested in raising questions about artistic tradition and artistic agency through overt demonstrations of violence as paradoxical acts of creation. Lucio Fontana slashed fields of paint with a razor, and Yves Klein made "paintings" with a blowtorch: after naked models pressed their wet bodies onto large sheets of paper, he blasted fire at the surface to create haunting, vacant figures. The year 1961 was especially loaded with such gestures of defilement: Piero Manzoni canned his feces, Jasper Johns took a bite out of the built-up encaustic surface of a painting, and Claes Oldenburg looked to the street for inspiration, making messy new forms of art with scraps of cardboard, soiled newsprint, burlap, and other debased materials. He declared, "I am for an art that takes its form from the lines of life, that twists and extends impossibly & accumulates and spits and drips, and is sweet and stupid as life itself."[38]

These critical, sometimes aggressive or crude, gestures—each an attack on the traditional work of art, often symbolized by the rarefied canvas of Western painting—have been understood in connection with the beginning of the atomic age and the related collective trauma that was unfolding worldwide. After the Holocaust, Hiroshima, Nagasaki, and so on, with civil unrest engulfing France in response to the Algerian War and novel threats such as the Cuban missile crisis, artists were questioning the past with a sense that they were teetering at the end of history itself. The close dance of demolition and creation was a reflection of this frightening new reality.[39] As the art historian Jennifer Sudul Edwards has pointed out, the *Tirs*, by capturing the tension between the past and the future, reflected this postwar atmosphere: "With her shots, Saint Phalle brutalized the work, leaving behind a ruined landscape. The incorporated objects, sometimes fragmentary at the start, other times fractured by a bullet, populated the field with their stained, amputated forms. Her work was a vivid analogy for the effects of war on the European landscape and populace—and the destruction of the old guard and the old traditions."[40]

A fascinating anecdote about Saint Phalle's life in Paris at this time, which illustrates an anxious preoccupation with the old guard, involves her relationship with Constantin Brancusi. The modern sculptor, with his long, white beard and fondness for wearing white garments, had a famously white-washed atelier filled with smooth, white plaster reproductions of his sold sculptures. When she began working in the Impasse Ronsin in 1956 (see p. 200), Saint Phalle briefly befriended the artist, who presented a formidable gravitas.[41] After he died in 1957, his studio became a strange ruin, and a mythos took hold.[42] Former neighbors described climbing over a wall and wandering into the studio to remind themselves of their proximity to history. Given this remarkable backdrop, Saint Phalle's work is ever more clearly a reaction against tradition. She always began her colorful and defiant *Tirs* by giving them "a white bath."[43] Covering the relief in white plaster was a ritual act of purification before the demolition of the sacrosanct surface. The fact that she often carried out her symbolic act in the alley against a wall that was *actually* supporting the "pure" relics of high modernism, which were literally collecting dust, made the symbolism all the more pronounced.[44]

Color from Action

In post–World War II art history, the early 1960s were marked by the waning dominance of Abstract Expressionism. Reaching its pinnacle at midcentury, the New York School, in the most common understanding, espoused a nonrepresentational approach to painting that was epitomized by the work of Jackson Pollock. He dripped, poured, and threw paint onto canvases that were radical for their "all-over" composition, an approach intended to yield a centerless, metaphysical dreamscape informed by the inner psyche of the artist and to transport the viewer into realms untethered to the everyday. While Pollock died in 1956, awareness of his work took hold in Europe only toward the end of the decade.[45] In January or February 1959, Saint Phalle, along with so many others in Paris, saw the wildly popular touring show *The New American Painting*. Pollock was featured prominently not only there but in a simultaneous presentation, *Jackson Pollock: 1912–1956*, also organized by the Museum of Modern Art. The shows' adjacency situated Pollock as the premier practitioner in this group of artists, which was only then becoming known overseas, and the suddenness with which his work became well known was greeted with a mix of incredulity and wonder in the press. According to the biographer Mary Gabriel, in the late 1950s, "American art was *the* topic of cultural conversation on the Continent."[46]

Yet despite the communal shock Pollock's process suddenly caused in Europe, the fact of his late and posthumous arrival on the scene, according to the scholar Catherine Dossin, presupposed the work as already historical.[47] Artists, however awed, would have seen it as a point of *departure* from the very start, as would critics. For example, in 1961, Restany immediately tied Saint Phalle's *Tirs* to Pollock's legacy, later recalling that he had praised them as "dripping *au revolver*."[48] Pollock, to reiterate, would have still been a fresh association in Europe. At the moment bullets first barreled into the surface of a *Tir*, Saint Phalle also recognized her profound relationship to Pollock. "I immediately realized," she reflected, that "I could put a bullet in a spray can and it would make the most beautiful Jackson Pollocks in the world."[49]

While little is known of the extent of Saint Phalle's awareness of Pollock's work while she was living in New York City in the 1940s, it is fascinating to note that both artists graced the pages of *Life* magazine in 1949, just seven weeks apart. Saint Phalle, wearing a silk taffeta evening gown, was on the cover of the September 26 issue in her then occupation as a fashion model,[50] while the magazine's August 8 article on Pollock reproduced one of the now most iconic images of him flinging paint onto a canvas laid on the floor and asked, "Is he the greatest living painter in the United States?"[51] The piece catapulted him into popular awareness in the United States, far beyond the confines of the art world, in the most widely circulated publication in the country. It would have been hard not to notice.

What *is* known is that, for Saint Phalle, Pollock was highly influential. After she saw his work a decade later in Paris, she described the encounter as a "boom!"[52] Her direct response can be seen in works predating the *Tirs*, such as *Pink Nude in Landscape*, 1959 (p. 86), in which skeins of paint constitute the sky. "In discovering [Pollock's] gesticulated energy of paint on the canvas, I decided to incorporate it into my own paintings," she later reflected. "The skies in my paintings would no longer be flat black, they would have drips of white."[53] Putting his spatters in the decorative service of landscape painting, she transformed them into the very type of representational content Pollock had wanted to overturn. This playful approach, which arguably verges on appropriation, is also found in *All Over*, ca. 1959–60 (p. 126). In this assemblage, named after the modernist critic Clement Greenberg's well-known description of Abstract Expressionist compositions, she pushed small fragments of debris into the plaster surface to

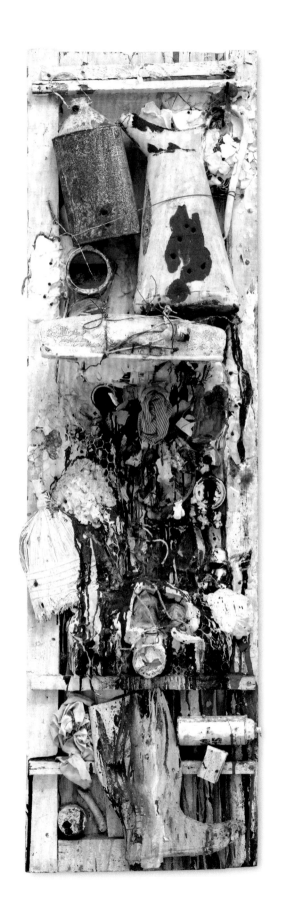

create her own centerless work. Saint Phalle's bits of grit pull real life into the emotional gravitas of a Pollock, perhaps exposing the ego-driven ambitions of the elder and, possibly as well, the hegemony of critics such as Greenberg.

At the same time, these works by Saint Phalle are not critical one-liners. Rather, they reveal how expansive (if not infinite) she saw art could be after Pollock. In the early 1960s Greenberg's dicta were beginning to be a contentious point for many artists who were anxious to debase a definition of art as something necessarily apart from the everyday world. These artists, including Saint Phalle, were interested in upending the insularity of the modern artist and stretching art not only through the use of everyday objects—through what has become known as assemblage or a "junk" aesthetic, with which Saint Phalle was certainly aligned—but also into the physical space of life itself. That meant not just injecting bits of commonplace stuff from the street into works of art but also contemplating the great potential of the previously passive viewer in the new terrain of social space. In 1963 Dorothy Gees Seckler published an article in *Art in America* titled "The Audience Is His Medium!" Highlighting artists such as Jim Dine, Walter De Maria, and Saint Phalle, the author discussed what she called "audience-participation art."[54] The title of the piece was based on a comment by Saint Phalle during an interview with Seckler the previous year, when she was in the middle of making the *Tirs*. Trying to emphasize the importance of experience over object, the artist explained: "*You* are the medium!"[55]

This understanding of the audience as the artistic medium is indebted, in part, to the American artist and writer Allan Kaprow and his invention of "happenings" around 1959. For these events, he invited the audience to interact optically and haptically with constructed environments—a giant room containing dirty, loose tires, most famously. In *Stockroom*, installed for the Stockholm presentation of the

exhibition *Movement in Art* in 1961, of which Saint Phalle was a part, museumgoers entered a gallery filled with cardboard boxes that were to be "continuously altered by the visiting public."[56] They could stack, paint, sculpt, hang, or do anything they wished with the boxes. For Kaprow, incorporating the messy motions of the world in this type of performative, ephemeral, and chance-based work was *the* legacy of Pollock: an expression of "ritual, magic and life" derived from "the rites of American Action Painting."[57]

Kaprow's contributions thus provide a way to connect Saint Phalle's insistence on participation to a much larger critique of painting. He also provided a direct model for the artist, who would have experienced *Stockroom* in 1961. Indeed, she explicitly expressed her admiration of his liberating understanding of viewer participation: Kaprow set up a fluid and plotless situation for the audience to navigate, with materials that allowed for unplanned outcomes and did not force a certain set of behaviors or outcomes.[58] This was an invitational approach she wished to emulate, one grounded in personal freedom and choice; she distinguished it, too, from Oldenburg's approach in his more scripted versions of happenings, which she also experienced that year, in New York (presumably one of his Ray Gun Theater performances on East Second Street, which ran through late May). She described the Oldenburg events as "shut" and uncomfortable for a captive audience precisely because they precluded agency and elicited a type of involuntary reaction.[59]

One way Saint Phalle demonstrated her participatory intention with the *Tirs* was through her consistent use of a white support. This neutral surface provided a contrast to the rainbow streams of color and, for the participants, who were required to keep a safe distance, would have simply made it easier to see the results of their actions, perhaps increasing the likelihood of a surprising and satisfying experience as they found out what their bullets might reveal and create. In the *Tirs*, it is fundamental

Niki de Saint Phalle
Pink Nude in Landscape, 1959
Oil and objects on wood
55½ × 79⅛ 2¾ in. (141 × 201 x 7 cm)
Sprengel Museum Hannover, Donation of the artist (2000)

that the application of paint, the formal basis of an abstract painting, is a consequence of participatory action. It is the people who "color this world," the artist stated in the 1962 interview with Seckler:

> NIKI DE SAINT PHALLE: And as I was saying before about a ritual being involved, when I make people color this world that I have built, this complicated world out of different objects, but which I have then later transformed and made my own, I paint it all white before they start.
>
> DOROTHY SECKLER: Yes.
>
> NIKI DE SAINT PHALLE: In other words, it's sort of purified before they start shooting at it. And I don't really know whether—it is very important to me that it not be colored before the shooting starts.
>
> DOROTHY SECKLER: Mm-hmm. So, the color should come from action?
>
> NIKI DE SAINT PHALLE: Yes.[60]

Dancing with Rauschenberg

A critical and rarely discussed relationship Saint Phalle had at this time that further reflects her connection to American art and the rise of participatory art in the post-Pollock moment was with Robert Rauschenberg (p. 90).[61] The two artists were acquainted through Tinguely, whom Rauschenberg had first met at the Museum of Modern Art, New York, in the winter of 1960 during preparations for Tinguely's *Homage to New York*, the epic performance/self-destructing kinetic sculpture that churned and smoked and burst into flames in the museum's courtyard in March of that year.[62] While the specifics of Rauschenberg's initial encounter with Saint Phalle are unknown, the two began to spend time together, and their friendship blossomed in the spring of 1961 as he was preparing for the first European solo show of his Combines.[63]

By 1959 Rauschenberg had already established himself as a descendent of Marcel Duchamp through a series of solo exhibitions that brought the term "Neo-Dada" to the fore and happened to coincide with Pollock's late introduction to Europe.[64] Saint Phalle shared her friend's interest in the core tenets reshaping art: in addition to the previously discussed reorientation of the picture plane, both were exploring notions of ephemerality; the intersection of performance, painting, and found objects; and the breaking down of distinctions between art and life through collaboration.[65]

In the early 1960s Rauschenberg was beginning to dramatically expand his ideas with respect to the audience. He had initially explored the question in the 1950s with his *Elemental Sculptures*, which provided viewers with simple yet specific instructions for interacting with a work: put a tethered stone in a wood box, for example, or shake the box. Other boxes were left empty for the audience to add things of their choice.[66] In 1961, as Saint Phalle was handing a gun to members of her audience to paint a picture, Rauschenberg was making *Black Market*, one of the most aggressively interactive of his Combines (p. 88).[67] He invited the audience to take an object (such as a flashlight or a handkerchief) from a valise sitting on the floor and replace it with one of their own possessions. They were then asked to make a tracing of the pilfered object, using a sheet from a pad of paper hanging on a nearby clipboard. Aligned with Kaprow's open-ended ethos, *Black Market* had an entirely unpredictable result.[68] The fact that the written instructions were translated into multiple languages testifies to the seriousness of Rauschenberg's participatory aspirations.[69]

This sincere solicitation of a voluntary encounter, relinquishing artistic control, adhered to the same chance-based model as Saint Phalle's *Tirs* as well as her earlier dart portraits, which were shown alongside *Black Market* (and Kaprow's *Storeroom*) in the aforementioned 1961 exhibition *Movement in Art*.[70] The high-profile international exhibition opened in

Amsterdam and traveled to Sweden and Denmark through the fall of that year. Pontus Hultén, the lead curator, set forth the idea that kinetic action was a driving force in the development of modern art and an ideal metaphor for contemporary art's spirit of anarchy and desire to be freed from the past. The activation of the art object through mechanized movement, therefore, established the exhibition's historical framework, connecting Alexander Calder's gently swaying mobiles and Duchamp's spinning rotoreliefs to Tinguely's quivering machines, a "ballet" of discarded objects suspended from the ceiling. In the show, Rauschenberg's and Saint Phalle's inherently *non-kinetic* contributions would have stood out. Through the darts and drawing pads, they established that physical movement could also come from the audience and, more specifically, from their freedom to participate at will. Archival photographs of the Amsterdam presentation show the two artists' adjacency, with *Black Market* in the background of a scene of enthusiastic dart throwers. Astonishingly, the connection of *Black Market* to Saint Phalle's work continued in Los Angeles, when the former was installed in Rauschenberg's show at the Dwan Gallery. The exhibition opened on Sunday, March 4, 1962, the same day Saint Phalle's shooting performance took place at 4:30 in the afternoon, not too far away on Sunset Boulevard—of course, attended by Rauschenberg.

Between 1961 and 1963, Rauschenberg attended and/or participated in seven of Saint Phalle's shootings.[71] He reflected that he liked the feeling of surprise when colored paint emerged on the "neutral" surface and admired that it was "through the course of action that the art takes form."[72] Further, in those years, the two artists showed together in four exhibitions, including *The Art of Assemblage* at the Museum of Modern Art, New York, and *Le Nouveau Réalisme à Paris et à New York* at Galerie Rive Droite, Paris, opening in June 1961.[73] There,

Saint Phalle's *Tir avion* [*Airplane Tir*], 1961, was hung next to Rauschenberg's *First Time Painting*, made in the same year. Further still, when the aforementioned *Movement in Art* exhibition traveled to Stockholm, the two artists created a work together: *Painting Made by Dancing*, 1961 (p. 91). The exuberant, "all-over" painting on an unstretched canvas was made through an exceptional participatory process during the after party of the show's opening. According to Rauschenberg, he and Saint Phalle laid a canvas "under the rug" of the dance floor and, underneath that, placed balloons filled with paint that popped and bled through the fabric as the unsuspecting art-making audience danced to live jazz played by Thelonious Monk. By all accounts, it was a raucous and spirited event, a true manifestation of Kaprow's theory of Pollock's legacy.[74] Despite Saint Phalle's now signature technique of using concealed pouches of pigment, many texts about this work leave her out, and she was formally given shared attribution of the painting only in 2016.[75]

In these three action-packed years, Rauschenberg and Saint Phalle also collaborated on three major

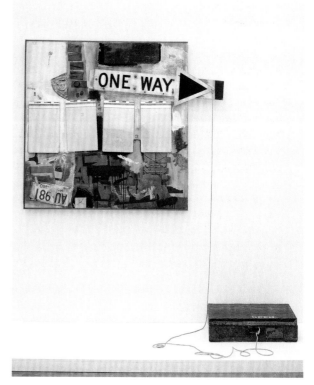

Robert Rauschenberg
Black Market, 1961
Oil, wood, and metal on canvas
with suitcase
49½ × 59 × 4 in. (125.7 × 149.9 × 10.2 cm)
Museum Ludwig, Köln / Cologne,
Donation Ludwig Collection 1976

projects and live performances.[76] *Homage to David Tudor* occurred in June 1961 in the theater of the United States Embassy in Paris. Works by several artists, including Tinguely and Johns, were presented simultaneously on stage as Tudor, a musician and avant-garde composer, played John Cage's highly experimental *Variations II* on the piano. Rauschenberg and Saint Phalle's contributions shared a humorous take on the idea of painting and an emphasis on the performance of process. A barefooted Rauschenberg painted a canvas with his back turned to the audience and his brush connected to a microphone, so that the sounds of his movements were amplified. Meanwhile, a marksman shot at Saint Phalle's assemblage for a startled, and unamused, audience.[77]

The two artists' collaborations continued through the innovative exhibition *Dylaby* (short for *Dynamic Labyrinth*), on view in the summer of 1962 at the Stedelijk Museum, Amsterdam. Within a seven-room Gesamtkunstwerk, Saint Phalle set up two freestanding, human-sized, mechanized white behemoths embedded with paint for the audience to shoot. Rauschenberg built what he described as a "sculpture jungle" for viewers to walk through; by confining them to a designated path, he playfully positioned them as exhibits in a zoo, while the sculptures were "wandering free."[78] These projects were joined by Martial Raysse's "beach" filled with kiddie pools and tossable inflatables and Daniel Spoerri's disorienting picture galleries, with framed paintings lying on the floor. As illustrated by archival images of the artists and audience dancing, touching the art, and enjoying the festive atmosphere, the show was about making visitors feel as if they were *in* the work. "In surroundings full of variety, gay and weird, loud and silent," the exhibition brochure states, "you are not outside the objects but constantly within them as part of the whole."[79] This apt summation of the show's spirit of collaboration, granting the audience a sense of freedom and driven by a desire for art to seep into the complex space of life itself, is one that powerfully ties together the work of Rauschenberg and Saint Phalle at the beginning of this decade.

When *You* Are the Medium

Serious recognition of Saint Phalle's intellectual contributions in the 1960s has been a long time coming.[80] Beginning in the 1990s, the artist began to write extensively about her life and first announced publicly that one of the reasons she had begun to paint, at age twenty-two, was as a revenge fantasy for sexual abuse. Her sharing of this narrative, along with its emotional consequences, was courageous and helps us to interpret her work. The problem is that this origin story, locating her ambitions primarily in her body and her biography, has clouded critical eyes. Art historians have continued to reinforce the claim, which first took hold in the 1960s, that Saint Phalle was an untrained outsider, using such language as "unencumbered by the prevailing paradigms"[81] and "uninhibited by the narrow criteria of modernist art or academic shibboleths"[82] to, essentially, pull her out of history. These examples demonstrate the powerful obstacles to interpreting Saint Phalle's work as an astute formal and conceptual rebuttal of modernism. The great paradox of this circumstance is that the artist, along with her contemporaries, actually wished to engage deeply with her audience. By prophetically asking others to participate in coloring the outside world, she was bringing viewers *inside* her works through an intimate, playful, and violent dance

Visitor throwing darts at Saint Phalle's dart portraits during the exhibition *Movement in Art*, Stedelijk Museum, Amsterdam, March 10–April 17, 1961. Robert Rauschenberg's *Black Market* is visible in the background.

Saint Phalle with Robert Rauschenberg in Sweden, May 23, 1961. Photo by Shunk-Kender

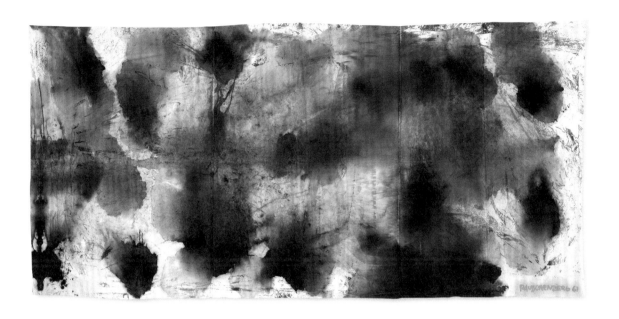

Niki de Saint Phalle and Robert Rauschenberg
Painting Made by Dancing, 1961
Acrylic on canvas
81½ in. × 13 ft. 6¾ in. (207 × 413.5 cm)
Moderna Museet, Stockholm.
Donation 2005 from Pontus Hultén

that was, at its core, a brilliant and literal assault on the modernist picture plane and on the esoteric, aesthetic remove from reality that the painted surface, by 1961, had come to represent so powerfully. As Saint Phalle declared: "*You* are the medium!"[83]

As the 1960s moved forward and the artist put down her firearms, she turned to the representation of the female body in the *Nanas*, a group of works that would dominate her career in the decades to come. During the early development of the series, her desire for an encompassing relationship that might rip apart a rarefied tradition, represented by the *Tirs*, reached a crescendo. In the collaborative work *Hon—en katedral* [*Hon—A Cathedral*], viewers punctuated a giant sculpture of a reclining goddess by walking right into her body through a passage between her massive and colorful thighs (p. 187). The invitation for the audience to enter was not unlike the intention behind Saint Phalle's decisions to hand them a gun. Again, she was asking *others* to symbolically liberate an abstruse object, ensconced in a complex, masculine history that she was actively overturning, and to do this through an exceedingly heavy and violent gesture of violation. This contradictory behavior was made all the more profound by what we might imagine to be the conflicting emotions of people climbing though a vagina or shooting a gun in an art gallery. Was it delight, horror, laughter, trepidation, or startling awe? It is this visionary preoccupation with the potential of the audience to participate in the creation of works of art for political ends, and as a transgressive act, that plants Niki de Saint Phalle at the very forefront of avant-garde artistic production in the 1960s.

Epigraphs

Niki de Saint Phalle, *Harry and Me: 1950–1960, the Family Years* (Zürich: Benteli, 2006), 117.

Niki de Saint Phalle, quoted in Barbara Rose, "A Garden of Earthly Delights," *Vogue*, December 1987, 366.

Special thanks to the staff at the Robert Rauschenberg Foundation and Archives for their review of this text.

1 "I told Jean Tinguely about my vision and my desire to make a painting bleed by shooting at it." Niki de Saint Phalle, "Letter to Pontus," n.d., in Pontus Hultén, *Niki de Saint Phalle* (Bonn: Kunst- und Ausstellungshalle der Bundesrepublik Deutschland; Stuttgart: Gerd Hatje, 1992), 160.

2 On April 25, 1961, France's only television station broadcast one of Saint Phalle's shooting sessions, and in August of that year, prior to feature films, some French cinemas played clips of her shooting at Galerie J, Paris. See Émilie Bouvard, "Niki de Saint Phalle, An American Artist," in Camille Morineau, ed., *Niki de Saint Phalle, 1930–2002* (Madrid: La Fábrica; Bilbao: Guggenheim Museum Bilbao, 2015), 48–55. The Hollywood film, starring Paul Newman and Shirley MacLaine and directed by J. Lee Thompson, was *What a Way to Go!* (20th Century Fox, 1964).

3 See Lois Dickert, "Shooting at Malibu" (unpublished manuscript, n.d.), sheet ref. no. AS200P1SE, NCAF Archives, Santee, CA.

4 Despite declaring an official end to the shootings in 1963, Saint Phalle conducted a few additional sessions in the years that followed, including those done for her 1972/73 film, *Daddy*, and for the 1970 event in Milan celebrating the tenth anniversary of Nouveau Réalisme. In general, the later shootings were symbolic, commemorative, or completed solelyfor the camera.

5 Pontus Hultén, "Niki de Saint Phalle," in Pontus Hultén and Iris Müller-Westermann, eds., *The Pontus Hultén Collection . . .* (Stockholm: Moderna Museet, 2004), 293–94.

6 Sarah G. Wilson, "Tu es moi: The Sacred, the Profane and the Secret in the Work of Niki de Saint Phalle," in Simon Groom et al., *Niki de Saint Phalle* (London: Tate Publishing, 2008), 18.

7 Lexico, s.v. "tear," accessed August 26, 2020, https://www.lexico.com/en/definition/tear.

8 Rosemary O'Neill, "Nouveaux Réalistes Niçois and the Formation of an Ecole de Nice," in *Art and Visual Culture on the French Riviera, 1956–1971: The Ecole de Nice* (London: Routledge, 2017), 110.

9 Niki de Saint Phalle, interview by Billy Klüver, April 21, 1990, transcript, n.p., Klüver/Martin Archive, New Berkeley, New Jersey.

10 *Niki Mathews New York: Gemälde, Gouachen*, Galerie Restaurant Gotthard, Saint Gallen, Switzerland, April 28–May 19, 1956.

11 Saint Phalle started going to the Impasse Ronsin in 1955 and, in the following year, started using James Metcalf's studio. The Impasse had been an enclave for artists and craftsmen since the late nineteenth century. Odilon Redon and Marcel Duchamp spent time there, and Constantin Brancusi kept an atelier there for four decades, until his death in 1957.

12 Adrian Dannatt, "Introduction: On Reaching an Impasse," in Adrian Dannatt, ed., *Impasse Ronsin* (New York: Paul Kasmin Gallery, 2016), 21.

13 Saint Phalle, interview by Klüver, April 21, 1990.

14 Pierre Restany, *60/90: Trente ans de Nouveau Réalisme* (Paris: La Différence, 1990), 76.

15 John Ashbery, "Paris Art Season Ending with Bangs, Not Whimpers," *New York Herald Tribune* (international edition), July 2, 1961, as included (as "Niki de Saint Phalle") in John Ashbery, *Reported Sightings: Art Chronicles, 1957–1987* (New York: Alfred A. Knopf, 1989), 145. The *International Herald Tribune* did not come into being until May 1967, when the *New York Times* joined the *Washington Post* as a co-owner of the surviving international edition of the by-then-otherwise-defunct *New York Herald Tribune*.

16 For example, see *Art's Annie Oakley: Canvas Bull's-Eyer* (April 24/25, 1961, Fox Movietone News), DVD, NCAF Archives.

17 "Extremism is part of America's vitality and part of its problem. Also mine. Violence. My own violence is linked to my personal history, energy and temperament, and the city I grew up in." Niki de Saint Phalle, *Traces: An Autobiography; Remembering 1930–1949* (Lausanne: Acatos, 1999), 75.

18 For more on the artist's process and materials, see Patricia Smithen, "Shot and Dropped: The Conservation of a Niki de Saint Phalle Shooting Picture," in *ICOM-CC Lisbon 2011: Preprints; 16th Triennial Conference, Lisbon, 19–23 September 2011* (Paris: International Council of Museums Committee for Conservation, 2011).

19 According to the artist's foundation (NCAF), it is unknown whether the artist was aware of the misspelling of "pterodactyl" in the title of this work.

20 For more on this series of beasts, see Cécile Whiting, "Apocalypse in Paradise: Niki de Saint Phalle in Los Angeles," *Woman's Art Journal* 35, no. 1 (Spring/Summer 2014): 14–22.

21 Ashbery, "Paris Art Season Ending with Bangs," 146.

22 Unidentified collector, in conversation with the author, Paris, September 24, 2019.

23 Leo Steinberg, "Reflections on the State of Criticism," *Artforum* 10, no. 7 (March 1972): 46.

24 Ashbery, "Paris Art Season Ending with Bangs," 145.

25 C[lair] W[olfe], "Niki de Saint-Phalle, Dwan Gallery," *Artforum* 2, no. 9 (March 1964): 11.

26 Unidentified author, "Assemblage Artists at Work," March 4, 1962, sheet ref. no. 17898, NCAF Archives.

27 See France Winddance Twine, *Girls with Guns: Firearms, Feminism, and Militarism* (New York: Routledge, 2013).

28 This well-known and frequently quoted statement has a complicated history of attribution in the scholarship of Godard's work. While it has most often been attributed to the filmmaker, following the release of his 1964 film *Bande à part* (*Band of Outsiders*), it has also been attributed to a 1966 review of that film by Pauline Kael and, much earlier, to the American filmmaker D. W. Griffith. Regardless, the popular association with Godard reflects his propensity—in the 1960s, especially—to make films replete with "guns and girls."

29 Quoted in Dorothy Gees Seckler, "Interview with Jean Tinguely and Niki de Saint Phalle," November 1962, transcript, n.p., Dorothy Gees Seckler Collection of Sound Recordings Relating to Art and Artists, Archives of American Art, Smithsonian Institution, Washington, D.C.

30 "The painting was actually made for the public to shoot at. At the time no one used the term art performance, but today [that] is what one would call it. A .22 rifle was kept at the gallery, somebody was there to load it and the public could shoot at the painting." Niki de Saint Phalle to Frances Morris (then curator at Tate Modern, London), February 23, 1988, quoted in Smithen, "Shot and Dropped," 1.

31 Dorothy Gees Seckler, "The Audience Is His Medium!" *Art in America* 51, no. 2 (April 1963): 67.

32 See Nicole L. Woods, "Pop Gun Art: Niki de Saint Phalle and the Operatic Multiple," in Eric Crosby with Liz Glass, ed., *Art Expanded, 1958–1978*, Living Collections Catalogue 2 (Minneapolis: Walker Art Center, 2015), http://walkerart .org/collections/publications /art-expanded/pop-gun.

33 John Ashbery, "'Comparaisons,' at Musée d'Art Moderne: Schools Meet—From Middle-of-Road to Neo-Dada," *New York Herald Tribune* (international edition), February 8, 1961.

34 The work was first shown in *Comparaisons: Peinture Sculpture* (Comparisons: Painting Sculpture), Musée d'Art Moderne de la Ville de Paris, February 6–March 6, 1961. For the artist's statement on the dart portraits' sparking the *Tirs*, see Seckler, "Interview with Tinguely and Saint Phalle."

35 Ibid.

36 Amy J. Dempsey, "Niki de Saint Phalle Enters the Art Scene with a Bang," in Groom et al., *Niki de Saint Phalle*, 57.

37 Yoko Ono first performed *Cut Piece* in Kyoto, Japan, on July 20, 1964.

38 Claes Oldenburg, "I Am for an Art . . . ," in *Environments, Situations, Spaces* (New York: Martha Jackson Gallery, 1961), reprinted and expanded in Claes Oldenburg and Emmett Williams, eds., *Store Days: Documents from the Store (1961) and Ray Gun Theatre (1962)* (New York: Something Else Press, 1967), 39–42.

39 See Paul Schimmel, ed., *Destroy the Picture: Painting the Void, 1949–1962* (New York: Skira Rizzoli; Los Angeles: Museum of Contemporary Art, 2012), 188–203.

40 Jennifer Sudul Edwards, "The Early Works of Niki de Saint Phalle," PhD diss., Institute of Fine Arts, New York University, 2014, 235.

41 "[Brancusi's] presence is something more than a reassurance to the artists here; it's a solid inspiration. It makes us think that it may be worthwhile painting pictures or sculpting stones after all." William N. Copley, "Brancusi Buddy of Writer—Almost," *Glendale News-Press*, June 1952, reprinted in Dannatt, *Impasse Ronsin*, 98. See also Jon Wood, "Brancusi's White Studio," in Mary Jane Jacob and Michelle Grabner, eds., *The Studio Reader: On the Space of Artists* (Chicago: University of Chicago Press, 2010), 270.

42 The artist bequeathed his white studio to the French state, but it remained shuttered at 11, Impasse Ronsin, through the mid-1960s, when its contents were relocated and reassembled at the Centre Georges Pompidou, Paris.

43 Niki de Saint Phalle, quoted in Seckler, in "Interview with Tinguely and Saint Phalle." In 1960 Tinguely painted his monumental, self-destructing *Homage to New York* white because he wanted viewers to feel sad that something beautiful was being destroyed. The curator Peter Selz remarked, "You had a real feeling of tragedy that the great white machine couldn't be preserved somehow." See Calvin Tomkins, "Beyond the Machine," *The New Yorker*, February 10, 1962, 76.

44 In his autobiography, Larry Rivers describes how Saint Phalle shot against this shared wall. She "hung balloons full of paint on that wall above her sculptures of doll figures and objects, colored the sculptures by shooting holes in the balloons with a hunting rifle." Larry Rivers and Arnold Weinstein, "Paris 1961–62," in *What Did I Do? The Unauthorized Autobiography* (New York: HarperCollins, 1992), 377.

45 See Catherine Dossin, "To Drip or to Pop? The European Triumph of American Art," *The Art!@s Bulletin* 3, no. 1 (Spring 2014): 79–103.

46 Mary Gabriel, *Ninth Street Women: Lee Krasner, Elaine de Kooning, Grace Hartigan, Joan Mitchell, and Helen Frankenthaler: Five Painters and the Movement That Changed Modern Art* (Boston: Little, Brown and Company, 2017), 678.

47 Dossin, "To Drip or to Pop?" 87.

48 Pierre Restany, *Le Nouveau Réalisme* (Paris: Planète, 1968; repr., Paris: Transédition, Luna-Park, 2007), 102.

49 Saint Phalle, interview by Klüver, April 21, 1990.

50 *Life*, September 26, 1949, inside front cover. On the inside of the front cover, Saint Phalle was identified as a "popular New York postdeb" who "combines American endurance with French chic." Harry Mathews indicated that Saint Phalle was aware of the images of Pollock working in Robert Goodnough's article "Pollock Paints a Picture," *ARTnews* 50, no. 3 (May 1951): 38–41, 60–61; the photographs were taken by Hans Naumuth, who had been Saint Phalle and Mathews's wedding photographer the year before. See Edwards, "Early Works of Saint Phalle," 112.

51 "Jackson Pollock," *Life*, August 8, 1949, 42–45.

52 Saint Phalle, interview by Klüver, April 21, 1990.

53 Niki de Saint Phalle, *Harry and Me: 1950–1960, the Family Years* (Zürich: Benteli, 2006), 104.

54 Seckler, "The Artist in America," 63.

55 Ibid., 66.

56 Anna Dezeuze, "Junk Aesthetics in a Throwaway Age," in *Almost Nothing: Observations on Precarious Practices in Contemporary Art* (Manchester, UK: Manchester University Press, 2017), 62.

57 Allan Kaprow, "The Legacy of Jackson Pollock," *ARTnews* (October 1958): 56–57.

58 Seckler, "Interview with Tinguely and Saint Phalle."

59 "In the Oldenburg happenings that we saw, it was something very shut, and the audience is outside and you watch this going on." Ibid.

60 Ibid.

61 The curator Leah Dickerman, in her comprehensive discussion of Rauschenberg's "cooperative art," does not mention Saint Phalle. See Leah Dickerman, "Robert Rauschenberg: Five Propositions," in Leah Dickerman, Achim Borchardt-Hume, et al., *Robert Rauschenberg* (New York: Museum of Modern Art, 2016), 403–4. More often, the collaborative relationship between Tinguely and Rauschenberg is discussed. See Roland Wetzel, ed., *Robert Rauschenberg—Jean Tinguely: Collaborations* (Bielefeld, Germany: Kerber; Basel: Museum Tinguely, 2009). Here (p. 216), Saint Phalle's *Tirs* are described as work "with Tinguely," implying that they were a collaboration between the two artists. In the same catalogue, Saint Phalle is present in more than half of the archival photographs of Rauschenberg and Tinguely together (all three artists are in thirteen, and just Rauschenberg and Tinguely are in seven). Also, Saint Phalle was included in all but one of the eight shows and collaborations listed in the catalogue that Rauschenberg and Tinguely were both in or worked on together between 1961 and 1963. This is not acknowledged in the catalogue.

62 Tinguely had invited Rauschenberg to contribute to the project, and Rauschenberg made a small sculpture that, when ignited by gunpowder, spat out coins. See Tomkins, "Beyond the Machine," 78.

63 Rauschenberg's show was held at Galerie Daniel Cordier, Paris, in April 1961, and the artist's then partner, Jasper Johns, had a Paris show that opened a month later, so Rauschenberg remained in Paris through the late spring.

64 In 1959 Rauschenberg was included in several important European group shows: Documenta 2 in Kassel, Germany; the first Biennale de Paris; and *Exposition internationale du Surréalisme, 1959–60* at Galerie Daniel Cordier, Paris.

65 In the early 1960s, following his theatrical work with John Cage in the 1950s, Rauschenberg was still designing sets and costumes for Merce Cunningham, among many other projects with artists, scientists, and choreographers. According to Leah Dickerman, art, for Rauschenberg, was not about "the expressive outpouring of a single creative genius." Rather, it was a "framework for encounter—between artist and material, between elements within the work, between work and viewer—with outcomes neither fully certain nor controlled." Dickerman, "Rauschenberg: Five Propositions," 401.

66 See "Documents," in Walter Hopps, *Robert Rauschenberg: The Early 1950s* (Houston: The Menil Collection; Houston Fine Art Press, 1991), 232.

67 David White, Curator at the Robert Rauschenberg Foundation, New York, email message to author, May 27, 2020.

68 See Billy Klüver and Robert Rauschenberg, "Art in Motion—A Combined Memory," in Olle Granath and Monica Nieckels, eds., *Moderna Museet, 1958–1983* (Stockholm: Moderna Museet, 1983), 143.

69 The instructional cards for *Black Market*, 1961, are held in the archives of the Museum Ludwig, Cologne (item no. 61.004008).

70 For the venues and original titles of the traveling exhibition *Movement in Art*, see present volume.

71 See "Chronology of *Tirs Séances*" in the present volume. Rauschenberg is known to have participated in the shooting sessions held on May 23 and June 28, 1961, and August 30, 1962 and to have attended those held on June 20, 1961, and March 4, May 4, and October 15, 1962.

72 *Tir Shoot, Niki de Saint Phalle*, directed by Barbro Schultz Lundestam, 2013, sound, color, 12:06 min., includes an interview with Rauschenberg conducted in New York on November 18, 1997.

73 Rauschenberg and Saint Phalle exhibited work together in the following four shows between 1961 and 1963: *Movement in Art*, Stedelijk Museum, Amsterdam, March 10–April 17, 1961 (traveled to Moderna Museet, Stockholm; and Louisiana Museum of Modern Art, Humlebaek, Denmark); *Le Nouveau Réalisme à Paris et à New York*, Galerie Rive Droite, Paris, July–September 1961; *The Art of Assemblage*, The Museum of Modern Art, New York, October 2–November 12, 1961 (traveled to the Dallas Museum for Contemporary Arts and the San Francisco Museum of Art); and *Le dessin*, Galerie Breteau, Paris, January 10–February 7, 1963.

74 Billy Klüver recalled, "After the vernissage, the guests were taken by ferry to the Arena Theater on Djurgården, to hear a special performance by Thelonious Monk, and a performance by Per Olof Ultvedt, Niki de Saint Phalle, Tinguely and Rauschenberg, followed by dancing on the stage of the theater in the round. Pontus and Niki planned to end the evening by unveiling the world's largest instant work of art. Niki had found a huge beige theater drop canvas. This was spread out on the floor of the theater. On top of the canvas, she had attached hundreds of small bags with paint in them. On top of that was placed a plastic sheet and a carpet. When people danced, the bags were to be crushed and the paint would smear on the canvas." Klüver and Rauschenberg, "Art in Motion," 143–50.

75 The 2016 Rauschenberg retrospective (Dickerman, Borchardt-Hume, et al.) does not mention Saint Phalle as an author of this work. Rauschenberg, who allowed cars to run over the work in the street in the early morning after the party, was the sole artist Hultén asked to sign the painting years later, which he did, reluctantly. See Catherine Wood, "'Force of Contact': Objects and Performance," in Dickerman, Borchardt-Hume, et al., *Rauschenberg*, 236–38. According to Rauschenberg in a 1997 interview, they came up with the idea together. See *Tir Shoot, Niki de Saint Phalle*, directed by Lundestam.

76 See Gerard J. Forbe, "Dramatis Personae: The Theatrical Collaborations of Kenneth Koch, Niki De Saint Phalle and Jean Tinguely," in Beate Kemfert, ed., *Niki de Saint Phalle und das Theater* (Heidelberg: Kehrer, 2016), 38–53.

77 Niki de Saint Phalle to Pontus Hultén, n.d., in Pontus Hultén, *Niki de Saint Phalle* (Ostfildern, Germany: Gerd Hatje, 1992), 162.

78 "It was a walk through with sculpture, but the people were fenced in. So it was like a sculpture jungle. So like the sculptures were wandering free and the people had to stay on the path. . . . I had special lighting that was blue and I had flowers growing inside. I had fun." Robert Rauschenberg (unpublished manuscript, 1985), Robert Rauschenberg Foundation Archives, for inclusion in Esther Sparks, "Robert Rauschenberg," in *Universal Limited Art Editions: A History and Catalogue; The First Twenty-Five Years* (Chicago: Art Institute of Chicago; New York: Harry N. Abrams, 1989), 215–37, 430–67.

79 *Dylaby* [in Dutch and English] (Amsterdam: Stedelijk Museum, 1962), 2.

80 For example, Saint Phalle's *Grand Tir—séance Stockholm* (one of the largest *Tirs*, made during the 1961 exhibition *Movement in Art* in Stockholm and held in the Moderna Museet's collection ever since) was given to the museum by the artist in 1972 but shown for the first time in 1981. Pontus Hultén, one of the show's curators and a former director of the museum, remarked in 2013 that "it was some time until we showed it but [it] is now an appreciated part of the collection." Hultén, interviewed in *Tir Shoot, Niki de Saint Phalle*," directed by Lundestam.

81 Stijn Huijts, "Niki de Saint Phalle: Outside-In," in Stijn Huijts et al., *Niki de Saint Phalle: Outside-In* [in Dutch and English] (Heerlen, Netherlands: Shunck, 2011), 11.

82 Barbara Rose, "Niki as Nana," in Groom et al., *Saint Phalle*, 83–84.

83 Seckler, "The Artist in America," 66.

Following Page: Detail of *Clarice*, 1964–65, see p. 173

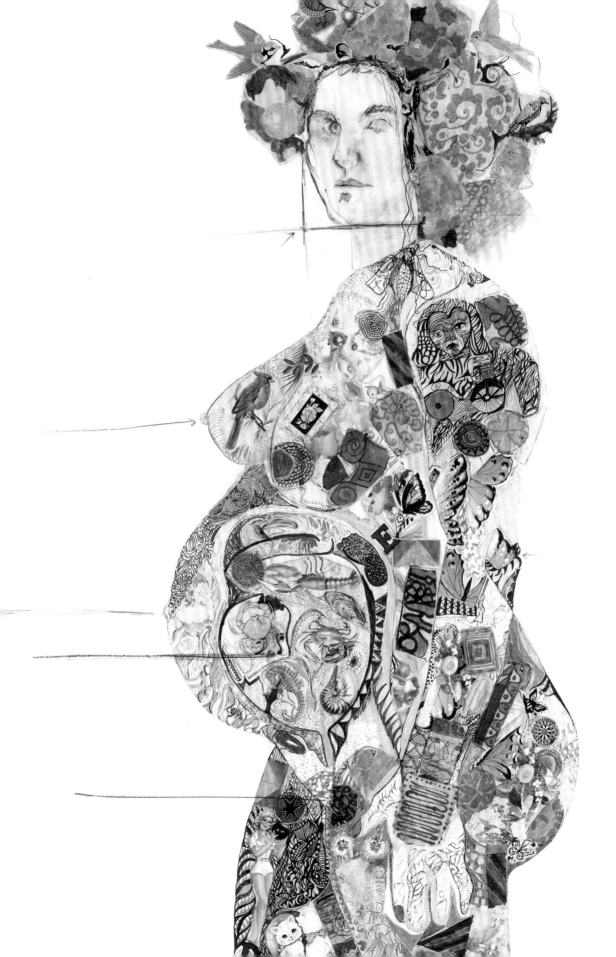

THE FIRST
FREE WOMEN
Niki de Saint Phalle's *Nanas*

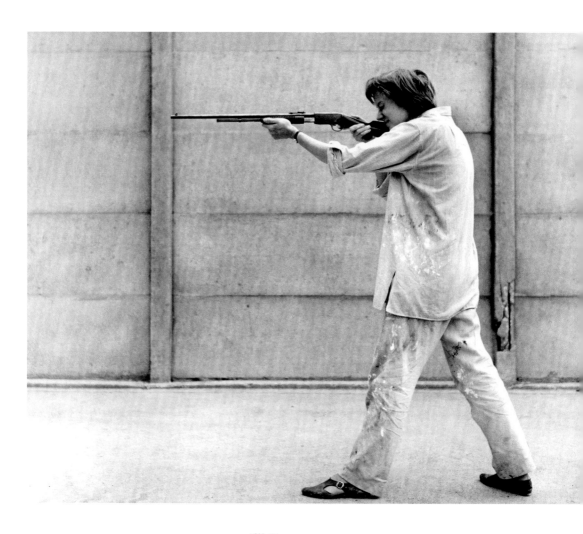

Jill Dawsey

I remember . . . being on 57th Street in New York a long time ago, and I saw a person I did not know at the time. It later turned out it was Niki de Saint Phalle, the French artist. She was walking on 57th Street and she had on one of those Australian raincoats, the black oil cloth, and it was flowing out behind her. She had a cowboy hat and cowboy boots and no purse—very important to me, I don't know why she had no purse. And I thought, "That is the first free woman I have ever seen in real life."

Gloria Steinem

Niki de Saint Phalle was not, by her own account, the "first free woman," but she devoted much of her career to imagining what such a thing might look like. Consider, as an early example, the photograph Harry Shunk captured of her holding a rifle while creating one of her *Tirs*, or "shooting paintings," in the Impasse Ronsin in Paris in 1961.[1] It is an image that approaches the iconicity of Hans Namuth's photographs of Jackson Pollock at work. Relaxed, steady, dressed in a paint-splattered man's shirt and pants, she squints and aims the rifle, which appears as an extension of her physical frame. The photograph, which circulated on the invitation to the first exhibition of the artist's *Tirs*, surfaced a striking image of female agency and volition.[2] Later, as Saint Phalle's shooting paintings expanded to the scale of architectural tableaux, she would ascend a ladder to shoot, further extending the reach of her body in space, as if to transform herself into a kind of monument (p. 70).[3]

By the mid-1960s, Saint Phalle had distanced herself from the destructive register of the *Tirs* and embraced an ethos of defiant joy, which she imparted to a new series of figural sculptures she called *Nanas*—the name was her playful appropriation of a rude French slang term for "girl." As her output expanded in these years from wall-bound paintings and assemblages to large-scale sculptures in the round, the *Nanas* were a vehicle for exploring women's freedom and mobility, as evoked in Gloria Steinem's description of the artist herself walking the streets of New York City. Athletic, acrobatic figures resembling fertility goddesses, the *Nanas* inhabit the world as freestanding sculptures, which Saint Phalle arranged and rearranged in a variety of configurations and contexts. She would soon expand them to monumental proportions and begin siting them in public spaces, as if to remodel the world in their image. They were, she said, "the symbol of a happy liberated woman."[4]

Saint Phalle during a shooting session, Impasse Ronsin, Paris, June 15, 1961. Photo by Shunk-Kender

Steinem's depiction, in the epigraph to this essay, of the purseless, cowboy-hat-wearing artist offers an evocative snapshot of Saint Phalle in the 1960s, capturing her subtly gender-bending style, the signifiers of her American identity, and, indeed, the way she seemed to perform female liberation well in advance of the feminist movement Steinem would later help to lead.[5] But perhaps we should not be so quick to agree with Steinem's assessment of Saint Phalle as a "free woman," unencumbered by feminine baggage.[6] For one thing, prior to the *Nanas*, the artist had produced far more tortured representations of womanhood, in the form of grotesque assemblages depicting female archetypes. Fashioned out of small plastic toys and other debased materials, these decrepit, legless witches, sex workers, goddesses, and birthing mothers project themselves out toward the viewer yet remain bound to the wall, signaling their ultimate imprisonment. Themes related to the constraints of gendered life are found throughout Saint Phalle's autobiographical writings, detailing her struggles to undo the imprint of her childhood, and are often relayed in terms of her mother's and father's asymmetrical access to the "outside world" and public life:

> I could not identify with my mother or
> my grandmother, my aunts or my mother's
> friends. . . . Our home was confining.
> A narrow space with little liberty or privacy.
> I didn't want to become like them, guardians
> of the hearth, I wanted the world and the
> world then belonged to MEN.[7]

The artist concluded that she would "trespass into the world of men,"[8] an apt description not only of her personal stance but of the tactical approach she would take in her work, particularly with the *Nanas*. The rigid patriarchal order of postwar France discouraged such acts of trespass; we can see that the steps toward independence taken by the artist in her work and her life were improvisational—a set of negotiations.[9] Arriving too early to benefit from the collectivity of the feminist movement, the *Nanas* forged an aspirational path to liberation in the absence of any models.[10] Saint Phalle's peer group was almost exclusively male, making it all the more remarkable when she turned from producing the *Tirs*, which explored a range of themes—politics, religion, war, everyday life—to exclusively representing women in her work. The *Nanas* presaged images, ideas, and modes of making that would be developed by feminist artists in the coming years, even as the sculptures embodied complicated and, at times, ambivalent attitudes toward this feminism *avant la lettre*. As Amelia Jones writes in her 2014 essay republished in this volume, Saint Phalle's work "made future feminist art and culture possible."[11]

The mid-1960s were a pivotal period for Saint Phalle's practice. The early years of the decade saw her experimenting continuously with new artistic mediums and formats as she moved from assemblage, painting, and participatory actions to sculpture and large-scale installations. Each time she arrived at a new series or body of work, her impulse was to broaden its spatial parameters, expanding the works' scale and public reach. The *Tirs*, for example, were staged both in galleries and in the open space of the street, amid large groups of people and, most often, in front of cameras.[12] Opening to a performance-based practice that invited the participation of the public, the *Tirs* themselves grew dramatically, becoming tableaux of architectural proportions. On one hand, this trajectory of Saint Phalle's work was in sync with a larger shift toward spatialization in postwar art, which was catalyzed, in part, by the expanded scale of Abstract Expressionist painting and which included performance and environmental sculpture.[13] In Saint Phalle's work, this expansion also animated a specifically feminist set of inquiries directed at women's circumscribed position in the private and public spheres of life. It is with the *Nanas*

that these concerns played out most emphatically, as the artist experimented with scale and monumentality, using her figures to envision how women might, quite literally, take up more space in the world.

It is the aim of this essay to trace the emergence and evolution of the *Nanas*, leading up to an example enlarged to colossal proportions: *Hon—en katedral* [*She—A Cathedral*] of 1966, Saint Phalle's immense walk-in environment in the form of a recumbent pregnant woman (pp. 109, 187, 226). The artist continued repositioning and expanding what constituted the *Nanas* in future series, transforming them into dwelling spaces and outdoor public art in the later 1960s. As the years progressed, the *Nanas*' bodies, of increasing scale, seemed to align with and amplify countercultural movements and the advent of women's liberation to propose new possibilities for social life and, in particular, for women's presence in public space.

Saint Phalle began constructing the *Nanas* in the summer of 1965 at her home studio in Essonne, outside Paris.[14] Photographs show her carting around the large papier-mâché figures in various stages of completion in the gardens surrounding the studio, configuring them in lively groupings. She constructed them first by shaping their forms with an armature of chicken wire, which she wrapped with strips of linen, adding bamboo for support in places of tension. She then covered these chicken-wire mummies with paper and rabbit-skin glue and, finally, with a patchwork of patterned fabrics, wool, lace, and small objects such as toys. She often sheathed the figures in dense skeins of yarn—she was said to unravel her old sweaters[15]—to produce colorful, swirling striations. The additive process lent itself to collective production, and Saint Phalle included her daughter, Laura, along with a

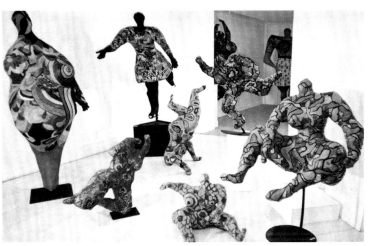

group of Laura's friends, in sorting the textile swatches and gluing them onto the sculptures.[16] After the figures dried, the artist painted some of them with graphic patterns—hearts, flowers, and calligraphic doodles—and eventually began sealing their intricate surfaces with a coat of resin. Insistently handmade, the *Nanas* embrace materials and modes of making traditionally associated with women's

handiwork and craft forms that had seldom been admitted to the spaces of high art. In this manner, Saint Phalle anticipated the reclamation of such practices by feminist artists and the Pattern and Decoration movement of the 1970s.[17]

The *Nanas* made their debut in late September 1965 at Galerie Alexandre Iolas in Paris, where eleven vibrantly patterned figures were arrayed in a dynamic installation. Some *Nanas* stood, some were seated, and many perched on metal rods that allowed them to leap and dance in improbable ways. Of various shapes and sizes, displayed at different heights, the *Nanas* produced unexpected shifts in scale. Several towered over the heads of the crowd on opening night. One of these, a Black ice skater titled *Janine*, held up a leg in arabesque. Nearby, one of the smaller, fully patterned *Nanas*, *Erica*, stood on her head, while

Installation view of Saint Phalle's *Nanas* at Galerie Alexandre Iolas, Paris, fall 1965. Photo by André Morain

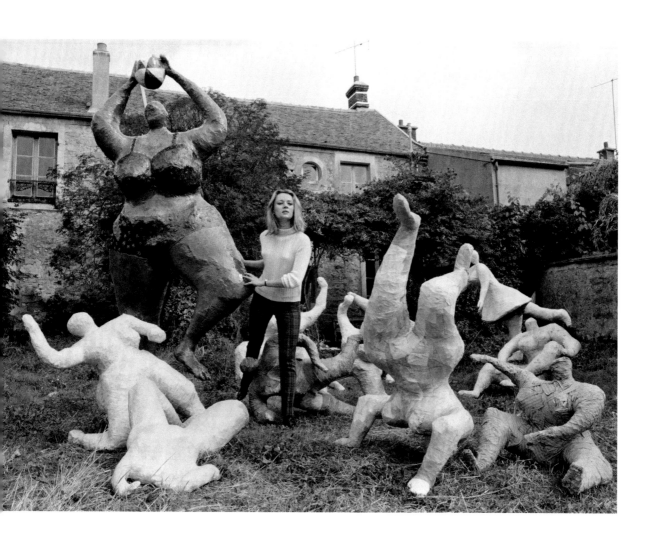

Saint Phalle with unfinished *Nanas* in the garden of her studio,
Essonne, France, 1965. Photo by Robert Delpire

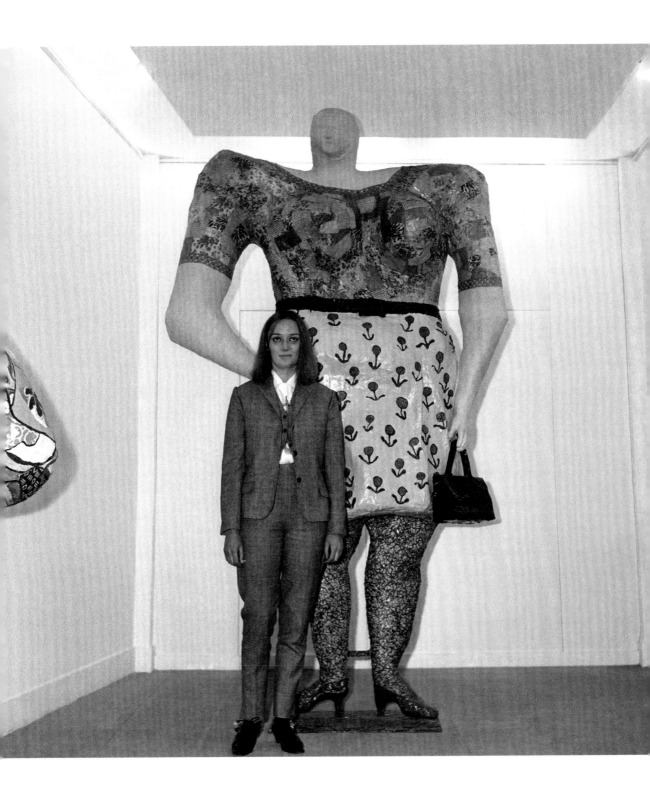

Saint Phalle standing before *La Waldaff* during her solo
exhibition at Galerie Alexandre Iolas, Paris, fall 1965

Eva cavorted with a wine bottle. *Elisabeth*, an impos-ing, polychromatic figure, was observably pregnant. Collectively, the *Nanas* were a voluptuous group. The round forms of most of them were entirely enveloped in mosaics of fabric, lace, and wool while painted details gave others greater individuality. Taken together, they conjured a strikingly original scene: that of an all-female society, fueled by joy and unhin-dered by laws of gravity or patriarchy. Confronted with such an unprecedented depiction of women's bodily autonomy, reviewers drew comparisons to prostitutes and circus performers. Saint Phalle, on the other hand, claimed that they represented "a new matriarchal society."[18]

Legendarily, the *Nanas* were inspired by Saint Phalle's friend Clarice Rivers, whose curvaceous pregnant body is memorialized in a large drawing on which Saint Phalle collaborated with the artist Larry Rivers, Clarice's husband, in September 1964 while staying with the couple in Southampton, Long Island (p. 173).[19] Rivers drew the face and contours of the fig-ure, and Saint Phalle fleshed it out with kaleidoscopic collage work and calligraphic drawings in felt-tip marker. Clarice's body appears as a fecund universe, teeming with flowers, butterflies, and decorative imagery culled from illustrations and magazines. Recalling the proto-Surrealist portraits of the Renaissance painter Giuseppe Arcimboldo, whose faces are bizarre amalgams of flowers, fruits, and vegetables, *Clarice* finds a more immediate prece-dent in Saint Phalle's aforementioned assemblage reliefs, such as *Lucrezia (The White Goddess / Weiße Hexe [White Witch])*, whose body-in-pieces is a com-posite of doll parts, toys, and artificial flowers, with flora and fauna nesting in a mass of brittle hair. Clarice is similarly crowned. Yet the spectral *Lucrezia (The White Goddess / Weiße Hexe)* was also marked by symbols of war and death—skulls and guns—that were consistent with the violent bent of the artist's earlier work.[20] *Portrait de Clarice* signaled a defining shift in Saint Phalle's practice toward representa-tions of the empowered, procreative female body.

As sculptures, the *Nanas* have their origins in the large-scale figural assemblages Saint Phalle made early in 1965 at the Chelsea Hotel in New York.[21] It was there, using two rented rooms as a studio, that she created some of her earliest freestanding works, including *The Bride (or Miss Haversham's Dream or When You Love Somebody)*, a larger-than-life figure that stands freely but is immobilized by a voluminous wedding dress and veil (p. 168). At this time, the artist also made *Leto*, or *Crucifixion* (p. 171), the closest iconographic and material precedent for the *Nanas*. A massive, armless figure hanging on a wall, this pro-to-*Nana* is a grotesque amalgam of female types, at once a sex worker in a garter belt and a doomed mother goddess in curlers.[22] (The "Leto" often pub-lished in the work's title evokes the Greek goddess of motherhood, who was impregnated by Zeus and subsequently exiled by Hera.) The pink skin of the figure's open thighs is a patchwork of the patterned fabrics that would soon envelop the *Nanas'* entire bodies. At her crotch sits a tangle of black yarn, another material the artist used to embellish the early *Nanas*, although to more abstract and decora-tive ends. If Saint Phalle's earlier archetypal figures were physically constrained, the *Nanas* are unen-cumbered, set free in three dimensions. They none-theless retain from *Crucifixion* a protean identity, combining aspects of the maternal and the erotic, the sacred and the profane.

La Waldaff, a monumental work that towered in a back room of Galerie Alexandre Iolas in the fall of 1965,[23] was distinguished from the larger group of whole-body-patterned *Nanas* by its painted street clothes and high-heeled shoes. This was likely the very first *Nana*: in the summer of 1965, Saint Phalle had written to Pontus Hultén, director of Stockholm's Moderna Museet, that she had "made a huge statue. A very strange woman. 15 times bigger than me and taller, too. She is standing on high heels."[24] Included in the Iolas exhibition catalogue is a preparatory drawing that diagrams the sculpture, indicating a yel-low floral-patterned skirt along with *bigoudis* (curlers)

atop the head—a detail that went unrealized in the finished sculpture but seems to confirm an association with the crucified prostitute-mother *Leto*. *La Waldaff* itself was the prototype for other woman-about-town types the artist would elaborate in the coming years, culminating in the formidable *Madame ou Nana verte au sac noir*, of 1968 (p. 181). For Saint Phalle, *La Waldaff*'s matching belt, shoes, and purse were signifiers of a proper *bourgeoise*, associated, in the artist's mind, with her own mother. (As we know from Steinem's anecdote, the artist did not weigh herself down with a handbag.) "The *Nanas* are really like the women I saw as a child walking down the street," she remarked.[25] The comment is evocative, for it suggests that Saint Phalle's interest in monumentality can be traced to her perspective as a child, when all women were giantesses of a kind, and when she first observed the gendered limitations of her world.

In spite of *La Waldaff*'s matronly associations, some writers, such as the critic Michel Conil-Lacoste, insinuated that she was a sex worker, conflating the image of a woman in public with that of a "public woman."[26] Perhaps this was because, historically, the role of the prostitute was one of the few that allowed women entry into public space—at least as evidenced in the canonical art and literature of modernity. Charles Baudelaire had viewed the prostitute as the nearest female equivalent to the quintessentially modern figure of the flaneur; indeed, such associations are embedded in the word *nana*, an impolite colloquialism the artist embraced with a tinge of irony. "It means chick or dame or broad," Saint Phalle told *Life* magazine, downplaying it a bit.[27] Whatever etymological relationship the word may have had to the maternal ("Nana" being one nickname for a grandmother or a nanny), viewers in the French context would have understood *Nana* to reference the eponymous heroine of Émile Zola's novel about a tragic, larger-than-life prostitute (who was also a mother) or, even more fittingly, Édouard Manet's 1887 painting of the same name.[28] On a related note, the title may also have recalled Anna Karina's turn as Nana—a wife and mother turned actress turned prostitute—in Jean-Luc Godard's 1962 film *Vivre sa vie* [*To Live Her Life*]. As Hultén wrote, "'Nana' had nothing respectful when it was used in French vernacular, but Niki de Saint Phalle has somehow ennobled it."[29] The artist rerouted the existing associations to suggest a streetwise spirit and sense of contemporaneity.[30] After all, there was a limited lexicon available for designating women as volitional figures taking up space in the world. Individually, the *Nanas* were named in honor of women the artist loved and admired, such as *Elisabeth* (de Saint Phalle, her sister), *Clarice* (Rivers), *Jackie* (Matisse), *Bénédicte* (Pesle), and *Janine* (perhaps Jeanine de Goldschmidt-Rothschild, who owned Galerie J). Increasingly, Saint Phalle spoke of the *Nanas* in exultant terms. "They are like goddesses to me, even superwomen," she said at the time of their second exhibition.[31]

This second show took place at the Alexander Iolas Gallery[32] in New York in late March 1966, on the heels of the Paris exhibition, and presented the *Nanas* in a range of more active poses, with the large-scale *Miss Miami Beach* rotating on a turntable.[33] She and several other *Nanas* wore bathing suits—Picasso's or Matisse's bathers reimagined for the era of sexual revolution. By the time of this show, Clarice Rivers was again pregnant, and Saint Phalle again paid homage to her friend with *Gwendolyn*, named for Rivers's first-born daughter. The artist would elaborate this *Nana boule*[34] type in future works such as *Clarice Again* of ca. 1966–67 (p. 179), in which the figure's breasts and buttocks are even more exaggerated, elevated on a base of legs as sturdy as tree trunks. The group of *Nanas* at Iolas incorporated some new materials—*Miss Miami Beach* was made of polyester resin, and the artist subsequently produced *Nanas* in fiberglass, an indication of her intention to site them outdoors. At this time, she also reproduced the various types of *Nanas*—*Waldaffs*, *Boules*, acrobats, bathers, dancers, ice skaters—as *Mini Nanas*,

which she cast in plaster or polyester and painted by hand (pp. 182–84). These smaller *Nanas* often served as models for the architecturally scaled examples Saint Phalle would make later in the decade.

In April 1966 the *Nanas* appeared in a photo spread in *Life* magazine, for which Saint Phalle transported several of her Amazonian figures to Paris's Bois de Boulogne.[35] Bypassing the rods and pedestals that typically anchored the sculptures in a gallery setting, she hung them upside down from trees so that they appeared to tumble through the mist. In some ways, the scene recalls an early shooting session Saint Phalle had staged in a park near Amsterdam,

Les guérrillères (1971). We might also recall the Amazonian/Paradise Island origins of one of Saint Phalle's favorite comic-book superheroes, Wonder Woman,[36] here echoed in the *Nanas'* almost superhuman physicality.

Saint Phalle's vision for her matriarchal society included both light- and dark-skinned *Nanas*, which were presented together beginning with the first Iolas show in 1965. That exhibition had featured *Janine*, the Black ice skater, who was as tall as *La Waldaff*; the two figures were frequently paired, appearing together again in the Bois de Boulogne. Saint Phalle often reworked and repainted individual *Nanas*, as with the early monumental *La baigneuse*, 1965, rechristened *Black Venus* two years later, when the artist changed her skin from green to black.[37] Saint Phalle was deeply influenced by the civil rights movement in the United States and declared that her *Nanas* stood for all women, *all* of whom she viewed as being "on the outside of our society."[38] She had a tendency to make this point by equating racial oppression with gender oppression, echoing similar statements made by Simone de Beauvoir in *The Second Sex*.[39] In 1967 the artist openly appropriated the slogan "Black Power" with the title of her exhibition at the Stedelijk Museum, Amsterdam: *Les Nanas au pouvoir* [*Nana Power*].[40] From today's vantage point, Saint Phalle may come across as a white artist attempting to speak to realities far beyond her own.[41] Indeed, she was, and the privileges of her class, too, enabled her to gloss over structural differences in power. But let it at least be acknowledged that when this artist envisioned a matriarchal society, her vision was arguably more inclusive than that of the feminist movement itself in

A Parisienne named Niki produces wire-and-cloth sculptures called Nanas

Calico Dames in a Frolic of Art

where she hung numerous small *Tirs* from tree branches for shooting (p. 21). That gesture had shifted her practice from the intimacy of the painterly object to the level of open, public space. Here, the exuberant, all-female scene presented a new challenge to the existing spatial order. In the absence of men, the *Nanas* enjoyed total physical abandon. The scene conjures fantasies of feminist separatism, as portrayed in Charlotte Perkins Gilman's utopian novel *Herland* (1915) and Monique Wittig's later, radical

Life magazine spread featuring Saint Phalle's *Nanas* in the Bois de Boulogne, Paris, published April 1, 1966. Menil Archives, The Menil Collection, Houston

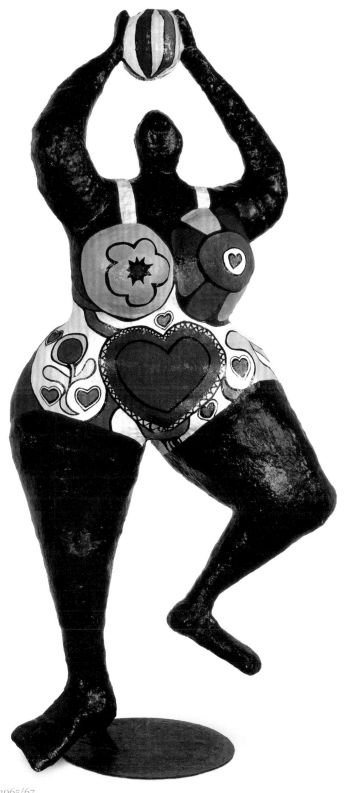

Niki de Saint Phalle
Black Venus (formerly *La baigneuse* [*The Bather*]), 1965/67
Painted polyester
110 × 51⅝ × 30¹³⁄₁₆ in. (279.4 × 131.1 × 78.3 cm)
Whitney Museum of American Art, New York,
Gift of the Howard and Jean Lipman Foundation, Inc., 68.73

its first and second waves. She seems to have gleaned that patriarchy intersects with whiteness—an insight that the whole of Western culture has been slow to grasp.

Saint Phalle was consistently questioned about the *Nanas'* odd proportions—the smallness of their heads in relation to their bodies, especially. Many viewers understood them as referring to Paleolithic Venus figures, a comparison the artist encouraged, although she would later claim not to have seen the Venus of Willendorf until afterward. ("The unconscious dreams of people who lived more than thirty thousand years ago were identical to my own," she said.)[42] Nonetheless, she increasingly spoke of the *Nanas* in deified terms and later described *Hon* as a "great pagan goddess."[43] Here, Saint Phalle's ideas once again predicted themes of the feminist art movement beginning in the 1970s, certain veins of which sought to recuperate matriarchal histories and channel ancient maternal energies.[44] In later phases of feminist art production, such works came to be viewed with skepticism for promoting essentialism, or an identification of woman with a natural or biological essence. Likewise, the *Nanas*, with their exaggerated anatomies—swollen breasts, bellies, hips, and buttocks—might be viewed as overvaluing the procreative body to the exclusion of other attributes. ("No work of art can approach childbirth," Saint Phalle said.)[45]

Yet, given the conservatism and paternalism of postwar French society, the *Nanas'* insistent corporeality was also legible as a reclamation of women's sexuality, which had been policed and suppressed for so long. It is worth noting in this regard that French women had no access to legal birth control until 1967 or to legal abortion until 1975. Perhaps the *Nanas'* cartoonish female forms, hollow as they are, do not correspond to real bodies at all but instead are signifiers—emblems of women, deployed in the service of an argument. The art historian Kalliopi Minioudaki describes the *Nanas'* "erotic colonization of the everyday," which positions libidinal subjectivity against "one-dimensional man's achievements: bureaucracy and technology, war and nuclear threat, poverty and famine."[46] These were the philosopher Herbert Marcuse's themes, and in many ways, they were also Saint Phalle's.[47] Conjoining the generally separate categories of the erotic and the maternal, the *Nanas* point to a liberated and sensuous relationship with the world, challenging the death drive of male culture, as Saint Phalle had come to see it. "Men with their rockets, their atomic bomb, and all that filth they've dumped on us. . . . They've sterilized themselves," she said, proposing a female-run society as a corrective.[48]

In many cases, the *Nanas'* strange proportions complicate their idealized curves, harking back to their more monstrous predecessors, such as the birthing figures with no legs and the crucified *Leto* with no arms. With regard to the *Nanas*, the poet and critic John Ashbery explained that this disproportionality resulted from foreshortening, which Saint Phalle used to produce the illusion of commanding height. Reviewing the first Iolas exhibition of the *Nanas*, he described them as "piano-legged giantesses, poetically distorted to emphasize their size and solidity; for example, some have pin heads peeking down over bulging breasts so that they seem to hover over you."[49] In Florence, around 1500, Michelangelo famously enlarged the head of *David*, anticipating that the sculpture would be viewed from below or from afar. Saint Phalle, by contrast, shrank her *Nanas'* heads so that they would be perceived in precisely that way—as if from far below. This was also a means of shrinking her (male) viewers, who were thereby required to look up to women. At the time, Saint Phalle said, "The reason the Nanas are so large is because men are big and [the *Nanas*] had to be bigger to fulfill their ideas."[50] The works' imposing stature signals an aspiration for monumentality, surpassing even the kind that traditionally commemorated male victories.

●

Saint Phalle's ambition to produce her *Nanas* on an increasingly monumental and architectural scale reached a new apex with her iconic *Hon—en katedral* [*She—A Cathedral*], created with Tinguely and Per Olof Ultvedt for the Moderna Museet in Stockholm at the invitation of Pontus Hultén, the museum's director and a champion of Saint Phalle's work (pp. 186, 187, 226).[51] Constructed of papier-mâché over a steel armature and painted like "an Easter egg,"[52] as Saint Phalle put it, the immense sculptural environment took the form of a recumbent pregnant woman, her legs spread to receive visitors through a vaginal portal. Above, the dome of *Hon*'s pregnant belly held a panoramic platform, where viewers could survey the topography of the vast *Nana*, described in a preparatory diagram as a "cathedral, factory-whale, Noah's ark, Mama." Approximately eighty feet long, twenty feet high, and thirty-two feet wide, *Hon* filled the museum's large front gallery, a onetime drill hall for the Swedish Navy, and could hold up to 150 people. Stepping inside the sculpture, visitors encountered the moving wheels of a Tinguely machine, followed by stairs leading to a constellation of scenes and situations: a pool of goldfish; a "cinema" projecting Greta Garbo's first film; a telephone booth, a vending machine, and a bar in one breast; a lover's seat that recorded and broadcast couples' conversations to the bar; a gallery of brazenly fake modern paintings; a slide for children; and more.[53] It was a cacophonous space in which organ music by Bach mixed with the noise of Tinguely's machine as it crushed glass bottles that had been drained of their Coca-Cola at the bar upstairs. Ultvedt contributed a kinetic wood sculpture whose components evoked a reclining man watching television, striking an androcentric note somewhat discordant with the mother goddess that surrounded it. But *Hon* contained multitudes, and in this way, it harked back to the Saint Phalle–Rivers drawing of the expectant Clarice, whose body swarmed with life. Conceived as a temporary work, *Hon* received 100,000 visitors in the course of its three-month life span, and Saint Phalle claimed that the sculpture was responsible for a spike in Sweden's birth rate that year.[54]

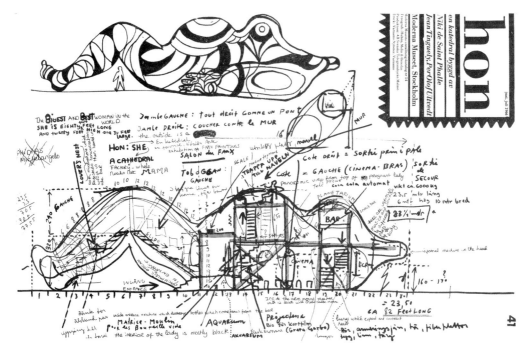

Niki de Saint Phalle, Jean Tinguely, and Per Olof Ultvedt
Engineering drawing for *Hon—en katedral* [*She—A Cathedral*] on the cover of the exhibition brochure, Moderna Museet, Stockholm, 1966
Lithograph on offset print
14½ × 22¹³⁄₁₆ in. (37 × 58 cm)
Menil Archives, The Menil Collection, Houston

Hon merged two forms to which Saint Phalle frequently returned in the early to mid-1960s: the pregnant female body and the cathedral. Many of the late *Tirs* of 1962 and 1963, sculptural reliefs made of chicken wire and plaster embedded with doll parts, religious figurines, and aerosol paint cans, had taken the form of crumbling cathedrals and altars (pp. 67, 152, 153, 207). The artist professed a love of cathedrals,[55] but her bullet-riddled structures suggest an iconoclastic attack on the religion of her family of origin, against which she had rebelled even as child.[56] A similar architectural assault is found in other *Tirs* she made that year, especially the tableaux featuring prehistoric monsters threatening city skylines.[57] Saint Phalle's works of the 1960s share the logic of polemics "against architecture" made by Surrealists such as Georges Bataille, who viewed buildings as the embodiment of societal authority. "Thus great monuments," he wrote, "are erected like dikes, opposing the logic and majesty of authority against all disturbing elements: it is in the form of cathedral or palace that Church or State speaks to the multitudes and imposes silence upon them."[58] Saint Phalle first shot at the cathedral, destroying it, and then rebuilt it according to her own vision. The phallic verticality of the cathedral and the skyscraper is replaced by *Hon*'s sprawling horizontality. If the cathedral imposes silence and order, Saint Phalle offered an unmelodious space of carnivalesque activity. With *Hon*, the woman's body is elevated and sanctified, while the Church is feminized and paganized—transformed into the very body it would seek to contain and control. In a final gesture worthy of Bataille, *Hon*'s destruction was built into the project from its conception, and its spectacular dismantling was captured on film.[59]

It is instructive to note that some Surrealists, in their opposition to the "castrating" effects of modernist architecture, also imagined buildings modeled on the maternal body—everyone's first architecture.[60] Tristan Tzara espoused the "intrauterine architecture" of caves, grottos, and tents, while the entrance to Salvador Dalí's *Dream of Venus* pavilion for the 1939 World's Fair in New York was framed by two pillars representing women's legs.[61] Such architectural propositions were driven by a desire to soothe the male psyche by way of a nostalgic return to the mother's body. *Hon*'s dissonant interior entertainments, however, withheld the prenatal "luxe, calme et volupté"[62] imagined by Tzara, and its gargantuan scale was as confrontational as it was inviting. Nonetheless, Saint Phalle later acknowledged her own desire for maternal reunion: "This joyous, huge creature," she wrote in a letter to Clarice Rivers, "represented for many visitors and for me the dream of the return to the Great Mother."[63] That Saint Phalle included herself ("for me") here is significant, for it reminds us that her project in these years was to reimagine the world as one that was hospitable, first and foremost, to herself and other women. Her invocation of the "Great Mother" rejects the individualist fantasies of the masculine avant-garde, suggesting a return not to one's own biological mother but to the goddess of ancient matriarchal cultures. With this in mind, *Hon* connects to a different lineage of architectural environments inspired by the female body, such as those made in the 1970s by feminist artists who were searching for spaces of their own. For example, the 1972 exhibition *Womanhouse*, staged in an abandoned Hollywood mansion, included Faith Wilding's *Crocheted Environment*, also known as *Womb Room*—a weblike enclosure the artist linked to the shelters "our female ancestors first buil[t] [for] themselves and their families."[64] Such works were motivated by a desire to produce spaces of nurturance for adult women through acts of collective re-mothering.[65] Prior to an organized political movement of women, Saint Phalle imagined her own matriarchal society and her own spaces of rebirth. *Hon* was not her conclusion to this project, but a beginning.

The artist would elaborate this vision in the creation of her first *Nana maison*—a "doll's house for adults" in the form of a woman's body—which debuted on the occasion of the *Nanas au pouvoir* exhibition at the Stedelijk Museum the following year.[66] The hips of the wildly patterned figure were widened to be "just big enough to sit and dream in." The artist went on to create three more *Nana maisons* for *Le rêve de l'oiseau* [*The Bird's Dream*]—her first permanent architectural complex—for her friend the director Rainer von Hessen in the South of France.[67] Each *Nana maison* is a distinct room: *Le rêve de l'oiseau* is a functional kitchen; *La sorcière* is the bathroom; and *Big Clarice* provides living space. Later, while building her Tarot Garden in Tuscany, Saint Phalle resided in the bosom of *The Empress*, a *Nana*-like sphinx (p. 117), for five years, inhabiting her own sculpture as she was in the process of building it and the environment around it. The curator Camille Morineau has described this category of Saint Phalle's production as the "body-house," which represents "at the same time a central feature of her sculptural oeuvre and a fundamental step towards taking possession of public space."[68] With their fantastically sculpted exteriors—now made of reinforced concrete rather than polyester resin or fiberglass—the *Nana maisons* in the South of France were visionary "outsider architecture" of the kind embraced by the Surrealists and later by members of the Situationist International in their search for an alternative to modern architecture's rationalizing systems.[69] Saint Phalle, in fact, had been interested in an idiosyncratic, imaginative kind of "sculpture in the expanded field"[70] at least since 1955, when she visited Park Güell, Antoni Gaudí's sprawling public garden in Barcelona. And in Los Angeles in

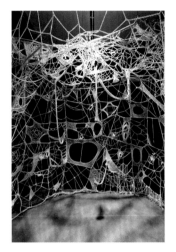

1962, she had seen Simon Rodia's Watts Towers, another visionary public monument that seems to have given her permission to invent her own utopian structures, modeled on the image of a woman.

Engaging in a bold act of city planning, Saint Phalle even drew up a *Plan for Nana Town*, which appeared in the 1967 Stedelijk Museum exhibition alongside models of works envisioned for outdoor public spaces. The drawing maps a vibrant city full of "*Nana* houses" and other buildings that evoke the artist's past sculptures. The vaginal door of a *Nana* apartment building opens onto a road that leads to the equally vaginal door of a *Hon*-like complex containing a concert hall, a game room, a library, a bar, and a heliport. One could enter the elevator of the "*Nana* empire state building" through the high heel of a dark-skinned *Waldaff*-style *Nana* with windows in her breasts—an architectural detail that would appear in real life in von Hessen's *Big Clarice* house and again in *The Empress*. The *Nana* church features both a cross and a star of David, while one of its arms holds aloft a flag emblazoned with the female, or Venus, symbol. Imagining a vibrant, mixed-use neighborhood modeled on and made for women's bodies, *Nana Town*'s rounded architectural forms and winding roads can be seen to counter modernist models of urban planning, which, by midcentury, had begun to transform city centers across the United States and Europe into increasingly privatized and isolated spaces, designed more for automobile traffic than for people.

Seen in this light, Saint Phalle's *Nanas* seem to insist on a "right to the city," as the philosopher Henri Lefebvre articulated in the wake of the Paris uprisings of May 1968. Asserting that a city's inhabitants have the right to contest the domination of

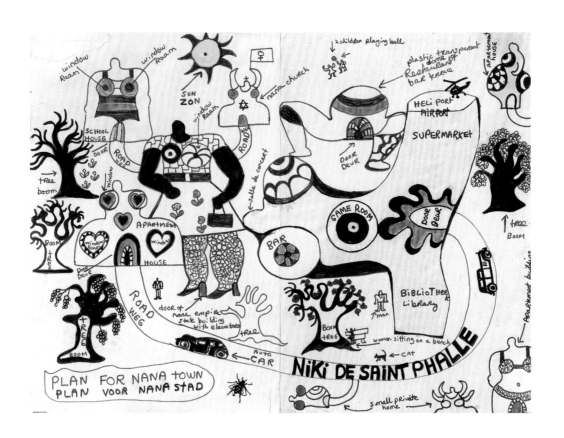

Niki de Saint Phalle
Plan for Nana Town, 1967
Ink, colored ink, and gouache on paper
10¹⁵⁄₁₆ × 14½ in. (27.8 × 36.8 cm)
Museum Jean Tinguely, Basel

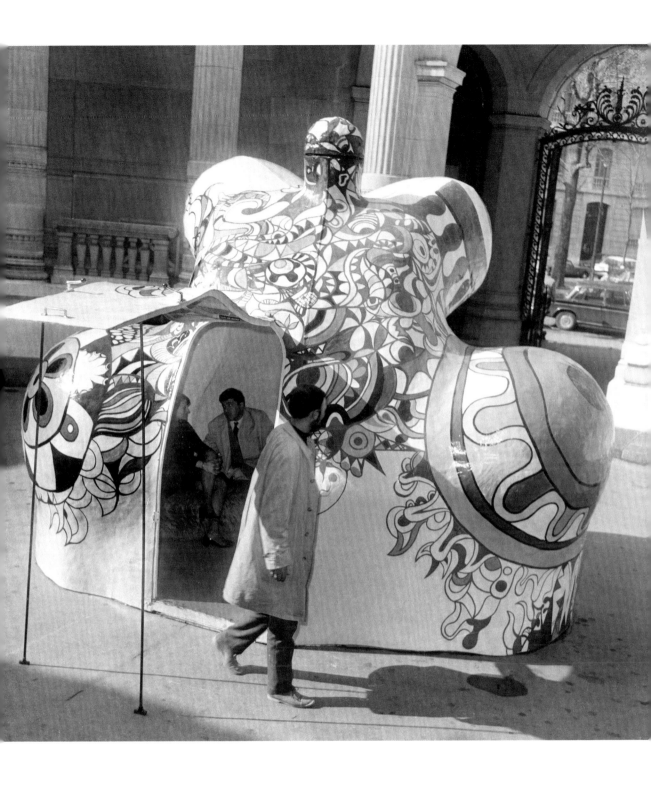

Saint Phalle's *Nana maison* [*Nana House*] in front
of the Musée Galliera, Paris, April 10, 1968

urban space by the forces of industrialization and technocracy—homogenizing tendencies that lead to what he described as the "abstraction of space"— he wrote, "Abstract space erases distinctions, as much those which derive from nature and (historical) time as those which originate in the body (age, sex, ethnicity)."[71] Lefebvre, an eccentric Marxist, was not a feminist per se, but his work has distinct feminist implications, in part because he viewed space not as an inert, empty container but rather as something humans *produce*—from which it follows that new spatial configurations may be imagined and brought into being.[72] Saint Phalle's *Nana Town* begins to imagine a different set of relations between the city and city dwellers, locating the equality and liberty implied by Lefebvre's "right to the city" in the singularities of the city's inhabitants. As Lefebvre himself concluded:

> Listening—even with half an ear—to the vengeful discourse of a Valerie Solanas in her *S.C.U.M. Manifesto*, powered as it may well be by deep resentments, it is hard to resist the conclusion that it is time for the sterile space of men, founded on violence and misery, to give way to *a women's space*.[73]

Although Saint Phalle's *Nana Town* went unrealized, in the later 1960s her work increasingly permeated urban spaces, and the public realm became her primary domain.[74] In 1967 she and Tinguely created *Le paradis fantastique* [*The Fantastic Paradise*], originally commissioned for the French pavilion at the Montreal World's Fair (Expo '67), which saw Saint Phalle's outsized, polychromatic *Nanas* facing off against Tinguely's menacing black machines. The collaboration produced what is less an example of "women's space," pace Lefebvre, than a conjuring of the war between the sexes that evokes Saint Phalle's pseudo-Marcusean characterization of male culture. The ambiguous spectacle of Tinguely's militaristic machines, with their tanks, drills, and blades, assaulting the ever-joyful *Nanas*—among them *La Nana embrochée* [*Skewered Nana*]—was a far cry from the scene in the Bois de Boulogne or in *Nana Town* (p. 112). In private, the artist expressed her misgivings about the project.[75] However, importantly for Saint Phalle, the outdoor sculptural installation saw the *Nanas* expanding into new public territory. In the initial presentation, nine monumental polyester-resin figures covered the rooftop of the Expo pavilion; the installation subsequently traveled to Buffalo, New York, where the colorful sculptures occupied the courtyard of the Albright-Knox Art Gallery. They next landed at the Conservatory Garden in Central Park, near Harlem; the installation opened on May 1, 1968, on the eve of the revolts that would fill the streets of Paris.[76] In the extensive press coverage of the work, Saint Phalle expressed her pleasure at the work's proximity to Harlem and the potential to reach people who rarely visited museums. "That is the show I am happiest about," she said, continuing, "Now this is what I would like to do: make things for the out-of-doors for everyone to see."[77]

Saint Phalle accomplished this aim, and came closer to her vision for *Nana Town*, with the creation of three immense concrete *Nanas* for the city of Hanover, Germany. Debuting in January 1974 beside the Leine River, the exuberant *Sophie, Caroline*, and *Charlotte* were named for great women in the city's history—respectively, an electress of Hanover, a female astronomer, and the unrequited love interest of both Goethe and his fictional character Werther (p. 116). Despite their namesakes' pedigrees—and the fact that the trio was meant to evoke the Three Graces, a revered art-historical trope—the boldly colored, boisterous *Nanas* became the object of protests and untoward media attention.[78] Two of the figures—they ranged from sixteen to twenty feet tall—wore bathing suits and assumed acrobatic poses, while the third was a pregnant *Nana boule* type, with breasts as large as her belly and buttocks. All were painted in "flower power" colors and motifs. With their rambunctious life force and cartoonish

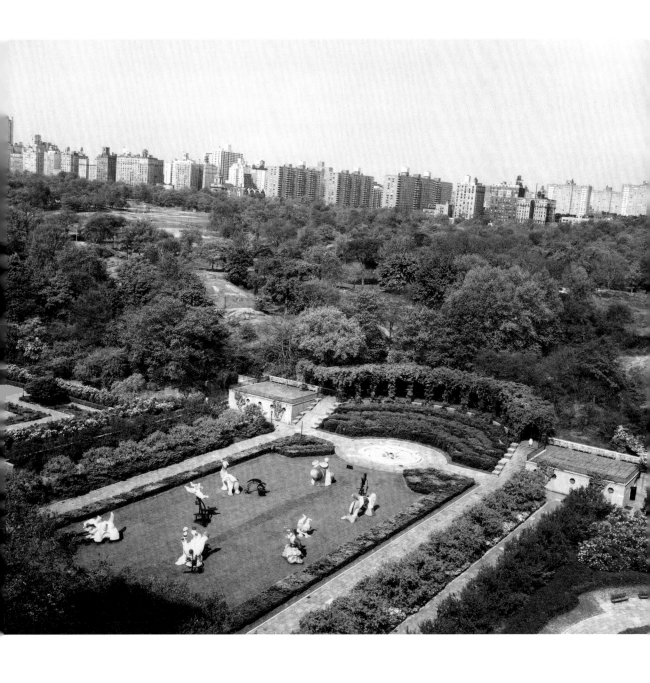

Saint Phalle and Jean Tinguely's *Le paradis fantastique* [*Fantastic Paradise*], 1967, as installed in the Conservatory Garden, Central Park, New York, 1968. Photo by Shunk-Kender. Menil Archives, The Menil Collection, Houston

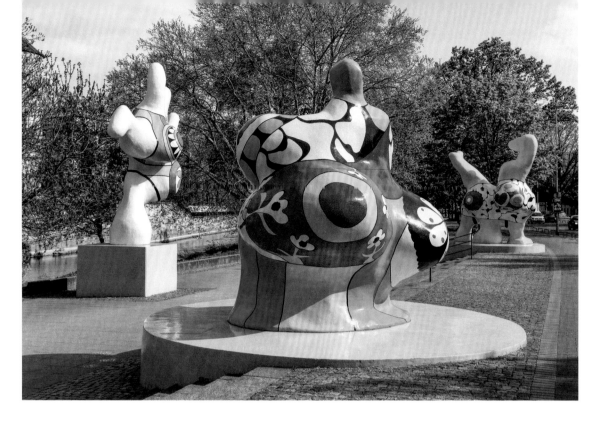

femininity, they seemed to mock the monument format itself as a traditional instrument of power and authority. Indeed, *Sophie*, *Caroline*, and *Charlotte* publicly "trespass[ed] into the world of men," as Saint Phalle had long imagined, proposing, in turn, a new and uninhibited mode of experiencing urban space. The artist later reflected that "the Nanas were born at the moment when the public was ready to accept women taking a step forward."[79] Yet this process was slightly delayed in Hanover. Citizens divided into pro- and anti-*Nana* camps in a conflict that culminated in a literal tug-of-war on the quay involving one thousand participants. The pro-*Nana* camp prevailed, and in a sign of the changing times, the Hanover *Nanas* were eventually embraced as a source of civic pride. They seemed to herald the arrival of an international women's movement. Their efficacy as public artworks, however, may be evidenced not in their ultimate popularity but in the moment of their initial provocation, instantiating, as it did, a space of public discourse and debate. Saint Phalle's *Nanas* advocated for a broad embrace of dissent and difference as a necessary condition of public space, emblematized through women's bodies.

In the following years, Saint Phalle's vision became more fantastical while her artworks and environments grew ever more ambitious in size and scope. Drawing on her interest in history and mythology, her later work constructs a heterogeneous universe in which animals, humans, monsters, and deities coexist. Embracing children as a key audience, she turned to the creation of play structures, including, in 1972 in Jerusalem, *The Golem*, a monster whose three red tongues function as slides, and, in 1973 in Knokke-le-Zoute, Belgium, the sprawling playground *Dragon of Knokke*. (The latter housed plumbing and sleeping accommodations; Keith Haring once stayed and left a mural behind.)

Saint Phalle's trio of *Nanas*, *Charlotte*, *Sophie*, and *Caroline*, 1974, installed in Hanover, Germany, 2019

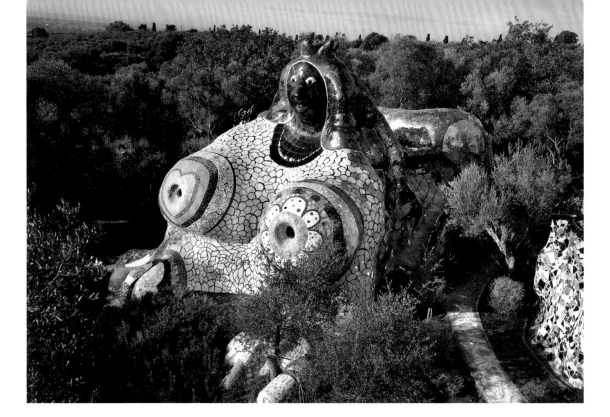

Monumental women continued to preside over most of Saint Phalle's visionary architectural projects, as in the Tarot Garden, the epic sculpture park she began in Tuscany in 1979, which featured the Medusa-like *High Priestess* and *The Empress*, the Black sphinx figure in which the artist made her home for a time.[80] "The Empress is the great goddess; she is the queen of heaven, the mother, the whore, emotion, sacred magic and civilization," Saint Phalle wrote, echoing her earlier evocation of *Hon*.[81] In this new era of her production, it was if *Nana Town* had been dispersed and transformed into sculpture gardens—themselves miniature towns—in various global locales. In 1983 Saint Phalle placed *Sun God* atop a triumphal arch at the University of California, San Diego, in the city to which she would move a decade later, motivated by health issues stemming from her use of polyester resin, with its toxic by-products, in her early *Nanas*. It was there, in San Diego, that she created her last major project and only sculpture park in the United States, *Queen Califia's Magical Circle*, an homage to a fictional pagan warrior-queen, Califia, who governed an island called California populated entirely by women.[82] If Saint Phalle's work of the 1960s consistently predicted themes of the feminist art movement to come, she later discovered, in history and mythology, societies that had prefigured her own.

Epigraph

Abigail Jones, "Gloria Steinem at 80: Taking Stock of Today's Women's Movement," *Newsweek*, February 14, 2014, https://www.newsweek.com /gloria-steinem-80-taking-stock-todays -womens-movement-229170.

I owe deep thanks to Gwen Allen and J. Myers-Szupinska for their generous feedback on this essay. I am also grateful to Kalliopi Minioudaki for her patience with my inquiries as well as for her scholarship on Saint Phalle's protofeminism, referenced in the notes below.

Niki de Saint Phalle, *The Empress*, Tarot Garden, 1979–2002, Garavicchio, Italy

1 The photographer duo Harry Shunk and János Kender captured many exhibition openings and performances in their documentation of art-world activities from the 1950s to the early '70s, including many of Saint Phalle's shooting sessions. The Impasse Ronsin was a cul-de-sac of ramshackle studios and long-standing hub of avant-garde activity in Paris; Saint Phalle made her studio there beginning in the late 1950s.

2 Saint Phalle's first exhibition of *Tirs, Feu à volonté [Fire at Will]* took place from June 30 to July 12 at Galerie J, a space owned and directed by Jeanine de Goldschmidt-Rothschild, the wife of Pierre Restany. Although "girl with a gun" images circulated in popular culture, as discussed in Michelle White's essay in the present volume, Saint Phalle's gesture was especially daring in the years before images of radical, gun-wielding women became more frequent in the art world and the culture at large, in the later 1960s and '70s. Saint Phalle anticipated not only Valie Export's 1969 performance *Action Pants: Genital Panic*, in which the artist posed holding a rifle, wearing crotchless pants and a teased, Medusa-style hairdo, but also any number of "terrorist" women of the period, including Patty Hearst, Valerie Solanas, and female members of the Baader-Meinhof group in Germany and Weather Underground in the U.S.

3 As, for example, on the occasion of her first shooting in the U.S., which took place in Los Angeles in a parking lot off the Sunset Strip on March 4, 1962. In what was among the earliest instances of performance art in Southern California, Saint Phalle donned a new white shooting uniform and climbed the ladder to take aim at an architecturally scaled *Tir* tableau, towering over the heads of audience members.

4 Quoted in *Niki de Saint Phalle: Retrospektive 1954–80* (Duisburg: Wilhelm Lehmbruck Museum, 1980), 36; quoted in turn, in English translation, in Carla Schulz-Hoffmann, ed., *Niki de Saint Phalle: My Art, My Dreams*, trans. Stephen Telfer (Munich: Prestel, 2003), 14n15.

5 Saint Phalle's penchant for wearing men's-style suits with high heels in the early to mid-1960s was the inspiration for Yves Saint-Laurent's *le smoking*, the first tuxedo designed for women, in 1966. Regarding her American identity, see White's essay in this volume. On gender play in Saint Phalle's wardrobe, see Jill Carrick, "Phallic Victories? Niki de Saint-Phalle's *Tirs*," *Art History* 26, no. 5 (November 2003): 712. Carrick (p. 709) also discusses Saint Phalle's self-conscious staging of herself as a femme-fatale-style "phallic woman," who "poses not only as Marlene Dietrich, but as a modern-day Medusa."

6 Pertinent to this discussion—but well-rehearsed—is Saint Phalle's rebellion in her late teens and early twenties against the societal position into which she was born—upper-class and destined for the "marriage market"—as well as the roles of wife and mother. Such a rebellion did not equate to freedom, however, per her comment to Pontus Hultén about leaving her husband and children: "The very worst thing a woman can do." No male artist could write an equivalent line. Niki de Saint Phalle, "Letter to Pontus," n.d., in Pontus Hultén, *Niki de Saint Phalle* (Bonn: Kunst- und Ausstellungshalle der Bundesrepublik Deutschland; Stuttgart: Gerd Hatje, 1992), 147.

7 Ibid., 147–48.

8 Ibid.

9 It was only in the summer of 1965 that France reformed its marriage laws, finally allowing women to work without their husbands' permission and to open bank accounts in their own names. Moreover, the French feminist movement materialized later than the U.S. movement, in the wake of May 1968, and was narrower in scope.

10 For a discussion of Saint Phalle's complicated relationship to the women's movement in the U.S. and France, see Catherine Dossin, "Niki de Saint-Phalle and the Masquerade of Hyperfemininity," *Woman's Art Journal* 31, no. 2 (Fall/Winter 2010): 29–38.

11 Amelia Jones's essay "Wild Maid, Wild Soul, a Wild, Wild Weed: Niki de Saint Phalle's Fierce Femininities in the 1960s" was first published in 2014 in Camille Morineau, ed., *Niki de Saint Phalle, 1930–2002* (Paris: Réunion des musées nationaux-Grand Palais, 2014); an English edition was published in in 2015 when the exhibition was in Bilbao. A modified version appears in the present volume.

12 Regarding the open space of the street, Saint Phalle observed in retrospect, "it seems quite incredible that one was able to shoot freely in the middle of Paris," noting that "this was the middle of the Algerian war!" (Saint Phalle, "Letter to Pontus," 161.) Here the artist acknowledges the larger historical backdrop against which her *Tirs* were created, a context that included protests surrounding the Algerian War of Independence (1954–62) that were playing out in the streets of Paris. In the coming years, her large-scale, figural *Tirs* would incorporate scenes of urban destruction, channeling Cold War anxieties in the form of movie monsters. On the subject of Saint Phalle's use of cameras, note that photography and film were another

means by which the artist expanded the spatial parameters of her work, enabling it to circulate well beyond the conventional conduits of art-world publicity. Her *Tirs* and, later, her *Nanas* garnered a remarkable amount of media attention—unusual for any artist and unprecedented for a female artist. See Catherine Gonnard, "Niki de Saint Phalle, Figurehead of the Avant-Garde on Television," in Camille Morineau, ed., *Niki de Saint Phalle, 1930–2002* (Madrid: La Fábrica; Bilbao: Guggenheim Museum Bilbao, 2015), 110.

13 Relevant here are the work and writings of Allan Kaprow, whose "happenings"—the collage-based form of performance he invented—were understood to extend Jackson Pollock's painterly processes into three-dimensional space and everyday life. See White's essay in the present volume.

14 Saint Phalle conceived of the *Nanas* during a period when Jean Tinguely was away from their home in Essonne—so, sans his masculine presence. Tinguely was traveling with Pontus Hultén to attend the 8th Bienal de São Paulo.

15 "Calico Dames in a Frolic of Art," *Life*, April 1, 1966, 60.

16 Laura Duke, email message to the author, August 28, 2020. In 1964 Saint Phalle produced a series of large-scale collages representing *Nana*-type figures in a similar collaborative fashion. To make *Pink Lady* (p. 172), for example, she invited artists, friends, and children to draw on and color in portions of the densely collaged figure, which she subsequently cut out and adhered to a field of black paint on canvas. The works were presented at Galerie Lawrence, Paris, in 1965.

17 Other notable uses of fabric in 1960s sculpture include the Swiss sculptor Eva Aeppli's fabric mannequins and the soft sculptures of the American Pop artist Jann Haworth; yet Saint Phalle's emphasis on craftwork and patterning is distinctive.

18 Quoted in Charlotte Phelan, "Leave It to the Nanas," *Houston Post*, March 25, 1969. Elsewhere, Saint Phalle described them as "heralds of a new matriarchal age which I believe is the only answer"; quoted in *Saint Phalle: Retrospektive*, 22, and in English translation in Schulz-Hoffmann, *Saint Phalle*, 14.

19 Clarice Rivers became a long-standing muse for Saint Phalle, inspiring future sculptures and starring in the artist's unfinished 1971 film *Nana Island*, in which Rivers and other women (including the artist Patty Mucha, wife and collaborator of Claes Oldenburg) appear as eroticized maternal figures clad in lingerie, lounging amid the *Nanas*, while children climb around them. For a discussion of Rivers's involvement in the underground art world of the 1960s, see Alissa Clarke, "'Am I Providing a Good Show for You?' Potent Female Performances in Niki de Saint Phalle and Peter Whitehead's *Daddy* (1973)," *Feminist Media Histories* 5, no. 2 (Spring 2019).

20 *Lucrezia (The White Goddess) / Weiße Hexe)* references Lucretia of Roman history and mythology. After she was raped by the Roman king's son, the young Lucretia committed suicide in order to prove her chastity, an action said to have inspired the overthrow of the monarchy. The piece is one of several white goddess and birthing figures that Saint Phalle created in 1963 and 1964.

21 The Chelsea was a legendary home to artists and writers of the downtown scene. Saint Phalle was preparing for her first show with the Alexander Iolas Gallery in New York in 1964. See also n. 32 below.

22 In her discussion of this work, Camille Morineau explains that Saint Phalle used the crucified "public woman" to critique Roman Catholicism as an institution and links *Leto or the Crucifixion* to future feminist works of art, literature, and film that explore themes of sex work, including Valie Export's *Action Pants: Genital Panic* (1969), Ti-Grace Atkinson's *Amazonian Odyssey* (1974), and Chantal Akerman's film *Jeanne Dielman, 23, quai du Commerce, 1080 Bruxelles* (1976). See Morineau, "From the Public Woman to the Public Work," in Kyla McDonald, ed., *Niki de Saint Phalle: Here Everything Is Possible* (Ghent: Snoeck, 2018), 37.

23 In her biography of Saint Phalle, Catherine Francblin notes that the sculpture was originally known as "Wanda." The term "Waldaff," pronounced in a Swiss dialect, indicates a "peasant girl" or "girl of loose morals." See Francblin, *Niki de Saint Phalle: La révolte à l'oeuvre* (Paris: Hazan, 2013), 156.

24 "Je viens de faire une enorme statue. Une femme très bizarre. 15 fois plus grosse que moi et plus grande aussi. Elle est debout su des talons hauts." Ibid., 144, 156. As director of the Centre Georges Pompidou, Pontus Hultén acquired *La Waldaff* for the museum's collection in 1975; today, it is missing or no longer extant. The sculpture also appeared on stage in March 1966 in Roland Petit's experimental ballet *Éloge de la folie*, along with several other large-scale *Nana* "dolls" carried by the dancers, and appeared as well as in Saint Phalle's unfinished 1971 film *Nana Island*.

25 *Niki de Saint Phalle*, film by Francois de Menil and Monique Alexandre, 1982; Menil Archives, The Menil Collection, Houston.

26 Michel Conil-Lacoste, "Niki Hottentote," *Le Monde*, November 2, 1965. See Francblin's discussion in *Saint Phalle*, 156.

27 Rosalind Constable, "Is It Painting or Is It Sculpture?" *Life International*, December 20, 1965, 134.

28 Hamburger Kunsthalle, Hamburg.

29 Pontus Hultén, "Working with Fury and with Pleasure," in Hultén, *Saint Phalle*, 15. See also the piece in the present volume by Ariana Reines, who writes that "there is something about a term that contains its opposite, an endearment that can also be a condemnation, that seems to speak to the enduringly peculiar position of the feminine on planet Earth."

30 Saint Phalle elaborated, "The public felt the Nanas insulting to women at first, but that was not my meaning, it was a way of 'blowing out' into the open my own femininity and liberation which were suppressed for so many years." Saint Phalle, quoted in Lael Scott, "Woman in the News: Niki de St. Phalle," *New York Post*, April 10, 1966.

31 Ibid.

32 Born in Alexandria, Egypt, to Greek parents, Iolas spelled his given name "Alexandre" at his Paris gallery and "Alexander" in New York.

33 *Miss Miami Beach* is no longer extant. For a description of the rotating figure, see Eugenia Sheppard, "Inside Fashion: The Night of the Nanas," *New York Herald Tribune*, March 30, 1966.

34 "Boule" can mean "ball," in the sense of sphere, or it can mean "ass," in the sense of buttocks.

35 "Calico Dames," 58–59.

36 Niki de Saint Phalle, *Traces: An Autobiography; Remembering 1930–1949* (Lausanne: Acatos, 1999), 71, 136.

37 For a discussion of the reception of *Black Venus*, see "Niki's Room: Carrie Mae Weems Talks with Jeanne Greenberg Rohatyn," in *Niki de Saint Phalle: The Joy Revolution Reader*, Salon 94, New York, 2021, 14. On the idea of the "Black Venus" in the French context, see T. Denean Sharpley-Whitin, *Black Venus: Sexualized Savages, Primal Fears, and Primitive Narratives in French* (Durham, NC: Duke University Press, 1999). With her title, Saint Phalle may have intended a reinterpretation of "Black Venus," but we should not overlook the specific associations the phrase carried in nineteenth-century French culture and beyond. Charles Baudelaire referred to his muse and lover Jeanne Duval as "Black Venus," and the term was also used to refer to Sarah Baartman, the South African Khoikhoi woman who was exploited and put on exhibit in England and France, 1810–15.

38 Saint Phalle's relationship to the civil rights movement is discussed in several texts in *Niki de Saint Phalle: The Joy Revolution Reader*; see especially Fabienne Stephan, "Black Dancer, 1966–67."

39 For example, Saint Phalle said, "Being a woman today is rather like being a Negro; you are a member of a second-class group. The world today is dominated by the white male, and I for one am getting pretty sick of that." Alexander Frater, "The Lady in the Orang-outang Skin Is Sitting on a Nana," *Daily Telegraph* (London), November 24, 1967. This echoes Simone de Beauvoir, who, in *The Second Sex* (1949), frequently analogized patriarchy to other systems of oppression, invoking anticolonialist struggles and the civil rights movement in the U.S. The artist's comment also paraphrases (presumably unwittingly) the words of the eighteenth-century French playwright, abolitionist,

and advocate for women's rights Olympe de Gouges: "Une femme dans la civilisation des hommes, c'est comme un nègre dans la civilisation des blancs" (a woman in the civilization of men is like a Negro in the civilization of whites). Aya Cissoko takes this as the title of her essay in Catherine Francblin, ed., *Belles! Belles! Belles! Les femmes de Niki de Saint Phalle* [in French and English] (Paris: Galerie Vallois, 2017), 66–67, 157–58.

40 "We have black power, so why not Nana power? Nana power is the only possibility. Communism and Capitalism are not that successful." Saint Phalle, quoted in Phelan, "Leave It to the Nanas."

41 For a discussion of Saint Phalle's family history and questions of race, see Cissoko, "'A Woman in the Civilisation of Men Is like a Negro in the Civilisation of Whites' (Olympe de Gouges)," in Francblin, *Belles!* 157–58. For the artist's own remarks on her family history, see Saint Phalle, "Letter to Pontus," 149–50.

42 Quoted in *Saint Phalle: Retrospektive*, 22, and in English translation in Schulz-Hoffmann, *Saint Phalle*, 14.

43 "We were about to build a goddess. A great PAGAN goddess." Saint Phalle, "Letter to Clarice," n.d., in Hultén, *Saint Phalle*, 166–69.

44 Imagery of primordial womanhood in Mary Beth Edelson's works of the 1970s comes to mind, as well as Ana Mendieta's *Silueta* series, begun in 1973.

45 "Aucune oeuvre d'art ne peut approcher un accouchement." Quoted in Anne-Marie de Vilaine, "Confession: Mieux que les hommes," *Le Nouvel Observateur*, no. 48 (October 13, 1965).

46 Kalliopi Minioudaki, "Unmasking and Reimag(in)ing the Feminine: The M/others of Niki de Saint Phalle," in Morineau, *Saint Phalle, 1930–2002*, 170. Minioudaki makes this point by comparing Saint Phalle's "erotic colonization" to Yayoi Kusama's "polka-dotting of the world." Indeed, Kusama's protofeminist work followed a similar spatial trajectory, coming to encompass everything from painting and sculpture to mirror-filled environments and happenings staged on the streets of Manhattan—as well as later monumental sculptures.

47 See Herbert Marcuse, *One-dimensional Man: Studies in the Ideology of Advanced Industrial Society* (Boston: Beacon Press, 1964).

48 Maurice Rheims, "Niki de Saint Phalle: L'art et les mecs," *Vogue Paris*, February 1965, 58–61, 94. The English translation appears in Morineau, *Saint Phalle, 1930–2002*, 88.

49 John Ashbery, *ARTnews* 64, no. 8 (December 1965): 54.

50 Quoted in Phelan, "Leave It to the Nanas."

51 The idea for a *Nana* cathedral was on Saint Phalle's mind as early as April 1966, when the *New York Post* reported, "Now she is looking forward to designing a church (perhaps even a Nana cathedral, but she does not know where)." Scott, "Woman in the News." On the centrality of Saint Phalle's authorship to the project, see Annika Öhrner, "Niki de Saint Phalle Playing with the Feminine in the Male Factory: *HON—en katedral*," *Stedelijk Studies*, no. 7 (Fall 2018), https://stedelijkstudies.com/journal/niki-de-saint-phalle-playing-with-the-feminine-in-the-male-factory-hon-en-katedral/.

52 Saint Phalle, "Letter to Clarice," 168.

53 The silent short film was *Luffar-Petter* [*Peter the Tramp*], 1922. Garbo plays one of a group of "Swedish bathing beauties" (Öhrner, "Saint Phalle Playing with the Feminine," 3), in an echo of Saint Phalle's own *Nana* bathers. Descriptions of *Hon* often note that one breast contained a planetarium evoking the Milky Way. Although "planetarium" is indicated on the preparatory sketch, Öhrner suggests that this element was unrealized. Accounts vary regarding what visitors actually encountered.

54 Saint Phalle, "Letter to Clarice," 169.

55 Francblin, *Saint Phalle*, 117.

56 "I was raised in a Catholic convent, and from the age of twelve I believed none of it anymore, but I've always felt greatly attracted to religious symbols." Quoted in Rheims, Saint Phalle, 88; English translation in Morineau, *Saint Phalle, 1930–2002*. Catherine Francblin elaborates on Saint Phalle's religious upbringing: "Raised by a devout Catholic mother and expelled from the Convent School of the Sacred Heart in New York at the age of 10, Saint Phalle felt nothing but aversion toward the family religion, even if she willingly acknowledged 'that inner longing within man which is an aspiration to God.'" Francblin, "Niki de Saint Phalle, an Exception among the Nouveaux Réalistes," in *En joue! Assemblages et Tirs, 1958–1964* (Paris: Galerie Georges-Philippe et Nathalie Vallois, 2012), 65. See also Saint Phalle, *Traces*, 78–80.

57 The title of her 1962 *Gorgo in New York*, for example, referenced a 1961 French sci-fi film in which a gigantic reptile—named for the Gorgon Medusa—wreaks destruction in London. In her *Gorgo*, Saint Phalle transposed the monster to the Manhattan of her youth, suggested through plaster-and-chicken-wire skyscrapers.

58 Quoted in Denis Hollier, *Against Architecture: The Writings of Georges Bataille* (Cambridge, MA: MIT Press, 1989), 34.

59 Annika Öhrner points out that, by Saint Phalle's account, *Hon* had to be destroyed to make room for an exhibition by Claes Oldenburg, who, along with Martial Raysse, had originally been invited to participate in the collaborative project that became *Hon*. Oldenburg was instead given a solo show in the exhibition slot following *Hon*. Öhrner discusses a "competitive spatial relation" between Saint Phalle's and Oldenburg's work; the latter was even made in a room above *Hon*'s feet, from which the artist could surveil the scene below. Öhrner, "Saint Phalle Playing with the Feminine," 9. See also Saint Phalle, "Letter to Clarice," 168.

60 My emphasis here is on womb-like environments, but Patrik Andersson ("Niki de Saint Phalle's Killing Game: Participation, Happenings, and Theater," in Morineau, *Saint Phalle, 1930–2002*, 58–60) and Camille Morineau, in their respective writing, have compared *Hon* to the nude figure in Marcel Duchamp's *Étant donnés*, 1966 (Philadelphia Museum of Art). Morineau suggests that if Duchamp positioned the museum visitor as a masculine "voyeur-hostage," *Hon* welcomed the public as "actor-inhabitants" of the work. "Instead of being absorbed by the

gaze, the feminine body absorbs other bodies, and moreover does so in the eyes of everyone, and on an architectural scale." Morineau, "Down with Salon Art! The Pioneering, Political, Feminist, and Magical Public Work of Niki de Saint Phalle," in Morineau, *Saint Phalle, 1930–2002*, 255.

61 Tristan Tzara, "D'un certain automatisme du Goût," *Minotaur*, nos. 3–4 (December 1937): 84, quoted in English translation in Anthony Vidler, "Homes for Cyborgs," in *The Architectural Uncanny: Essays in the Modern Unhomely* (Cambridge, MA: MIT Press, 1992), 151.

62 Ibid. *Luxe, calme et volupté* (luxury, peace, and pleasure) is a quotation from Charles Baudelaire's poem *Les fleurs du mal* (1857), adopted for the title of a 1904 painting by Henri Matisse (Musée d'Orsay, Paris).

63 Saint Phalle, "Letter to Clarice," in Hultén, *Saint Phalle*, 168.

64 Quoted in "*Crocheted Environment*, Faith Wilding, 1972/1995," Institute of Contemporary Art Boston website, https://www.icaboston .org/art/faith-wilding/crocheted -environment. Accessed September 7, 2020.

65 Writing of Wilding's work in a passage that evokes Saint Phalle's own biography, Arlene Raven elaborates: "The traditional housewife may have wanted to create this nest of her physical home most of all for herself. Often deprived of having been herself mothered, marrying young and having children before she could complete her education, housewives of all ages needed to be nourished again—this time in the metaphorical womb of the home."

Raven, "Womanhouse," in Norma Broude and Mary D. Garrard, eds., *The Power of Feminist Art: The American Movement of the 1970s, History and Impact* (New York: Harry N. Abrams, 1994), 55.

66 Saint Phalle created two *Nana maisons* in 1966–67. According to Camille Morineau, the second of these was repainted in the 1980s. Following the debut of the first *Nana maison* in the 1967 Amsterdam exhibition, the work was presented in 1968 at the Musée Galliera in Paris, in *Le décor quotidien de la vie en 1968*, and at the Fondation Maeght in Saint-Paul-de-Vence, in *L'art vivant: 1965–1968*. See Morineau, "Down with Salon Art!" 257n10, 362.

67 In 1966 Saint Phalle had collaborated with von Hessen (under his stage name, Rainer von Diez) on a production of Aristophanes's *Lysistrata*. Saint Phalle designed the costumes and set, with an armless and legless *Hon*-like figure serving as an Athenian fortress; the actors entered and exited through her open legs. For von Hessen's account of the creation of the *Nana maisons*, see Rainer von Hessen, "At Last I Found the Treasure: Working with Niki," in Beate Kemfert, ed., *Niki de Saint Phalle and the Theater: At Last I Found the Treasure* [in German and English] (Heidelberg: Kehrer, 2016), 181–97.

68 Morineau, "Down with Salon Art!" 254–59. See also Morineau, "From the Public Woman to the Public Work," 32–41.

69 In his essay "Situationists and Architecture," Peter Wollen discusses Saint Phalle's "series of strange houses" as examples of "outsider architecture" in the vein of follies created by "Mad King Ludwig" of Bavaria in the second half of the nineteenth century. Wollen, *Paris Manhattan: Writings on Art* (London: Verso Books, 2004), 205. On the subject of Saint Phalle's relationship to the SI, it is interesting to note that Guy Debord, who was critical of what he viewed as Nouveau Réalisme's complicity with consumer culture, reserved praise for Saint Phalle alone for her "target-paintings painted with a carbine." See Debord, "Editorial Notes: Once Again, on Decomposition," in Tom McDonough, ed., *Guy Debord and the Situationist International: Texts and Documents* (Cambridge, MA: MIT Press, 2002), 116.

70 See Rosalind Krauss, "Sculpture in the Expanded Field," in *The Originality of the Avant-Garde and Other Modernist Myths* (Cambridge, MA: MIT Press, 1985), 276–90.

71 Henri Lefebvre, *The Production of Space*, trans. Donald Nicholson-Smith (Oxford: Blackwell, 1991), 49.

72 Acknowledging the inherent phallocentricism of most architecture, Lefebvre suggested that physical space might be restored through the rehabilitation of "underground, lateral, labyrinthine—even uterine or feminine—realities." Ibid., 201. For a different theorization of pro-female spaces, see Dolores Hayden, "What Would a Non-sexist City Be Like? Speculations on Housing, Urban Design, and Human Work," in Richard T. LeGates and Frederic Stout, eds., *The City Reader*, 3rd ed. (London: Routledge, 2003), 448–63.

73 Emphasis mine. Lefebvre, *Production of Space*, 380. Solanas self-published her *SCUM Manifesto* in 1967.

74 On the subject of Saint Phalle's public art, see Kalliopi Minioudaki, *Bejeweled Reveries: Niki de Saint Phalle's Outdoor Wonders* (Chicago: City of Chicago Department of Cultural Affairs, 2007); Morineau, "Down with Salon Art!"; and McDonald, *Saint Phalle: Here Everything Is Possible*. The last is the catalogue for a 2018 exhibition organized by McDonald for the Musée des Beaux-Arts, Mons, Belgium, which surveyed Saint Phalle's career with an emphasis on her performance, public sculpture, and architectural projects.

75 Francblin, *Saint Phalle*, 181.

76 The installation's final destination was Stockholm, where it remains on public display outdoors under the stewardship of the Moderna Museet. As director, Pontus Hultén facilitated the acquisition in 1971.

77 Quoted in Phelan, "Leave It to the Nanas."

78 Saint Phalle took the opportunity to proselytize to journalists about the need for a public art that would "restore . . . humanity to modern cities, give them a sense of being lived," akin to cathedrals, which she upheld as the "street art" of the Middle Ages. Siegfried Barth, "Zustimmung-Begeisterung—Ablehnung-Empörung," *Neue Hannoversche Presse*, January 17, 1974, quoted in Francblin, *Saint Phalle*, 233.

79 "Les 'Nanas' sont nées au moment où le public était prêt à accepter que les femmes fassent un pas en avant." Quoted by Elisabeth Couturier on p. 4 of a 1989 issue of *Paris Match*; NCAF Archives.

80 The Tarot Garden comprises twenty-two sculptural-architectural structures made of reinforced concrete and covered in mosaics of tile and mirrors. Saint Phalle financed the work independently, selling editioned works and developing products such as a signature perfume—to the disapproval of some art-world voices. We might compare Saint Phalle's career trajectory with that of Christo, her Nouveau Réaliste peer (as of 1963) whose immense environmental sculptures and large-scale public works, coauthored with his wife, Jeanne-Claude, were financed through the sale of editions.

81 Niki de Saint Phalle, *Le Jardin des Tarots* (Bern: Benteli, 1997), 50.

82 Califia, also spelled Calafia, is a character in Garci Rodríguez de Montavo's 1510 chilvalric novel *Las sergas de Esplandián* [*The Adventures of Esplandián*]. The colonialist narrative has been reimagined numerous times, including in a mural by Diego Rivera (*Allegory of California*, 1931).

Autoportrait (Self-Portrait), 1958–59
Paint and objects on wood
55½ × 55½ × 3¹⁵⁄₁₆ in. (141 × 141 × 10 cm)
Collection of Niki Charitable Art Foundation, Santee

Couvercle Ripolin, ou All over [Ripolin Lid, or All Over],
ca. 1959–60
Plaster and objects on plywood
18⅛ × 24 in. (46 × 61 cm)
Collection of Niki Charitable Art Foundation, Santee

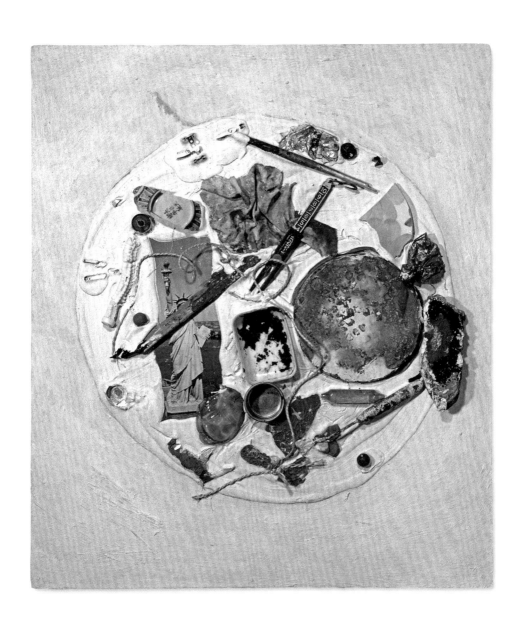

Statue of Liberty, 1960–61
Paint, plaster, and objects on plywood
25½ × 22 in. (64.8 × 55.9 cm)
Collection of Niki Charitable Art Foundation, Santee

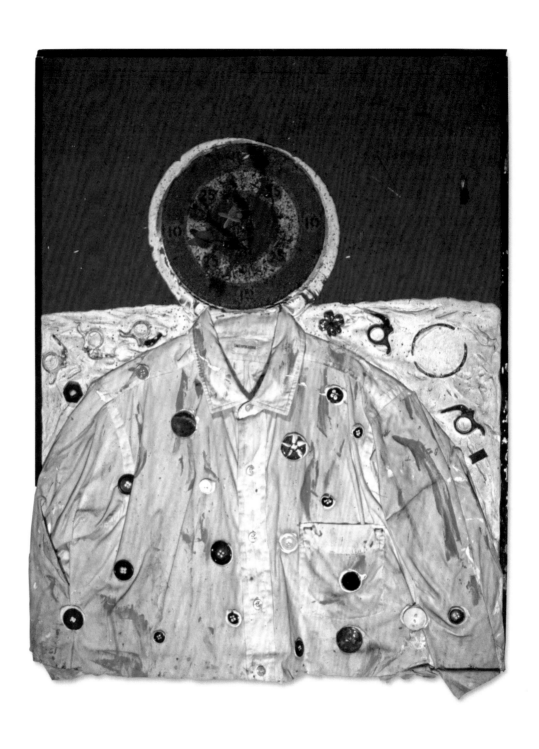

Hors-d'oeuvre ou Portrait of My Lover, 1960
Paint, plaster, and objects on wood
32¹⁄₁₆ × 24½ × 5⅞ in. (81.5 × 62.2 × 15 cm)
Private collection; courtesy of Galerie Georges-Philippe
& Nathalie Vallois, Paris

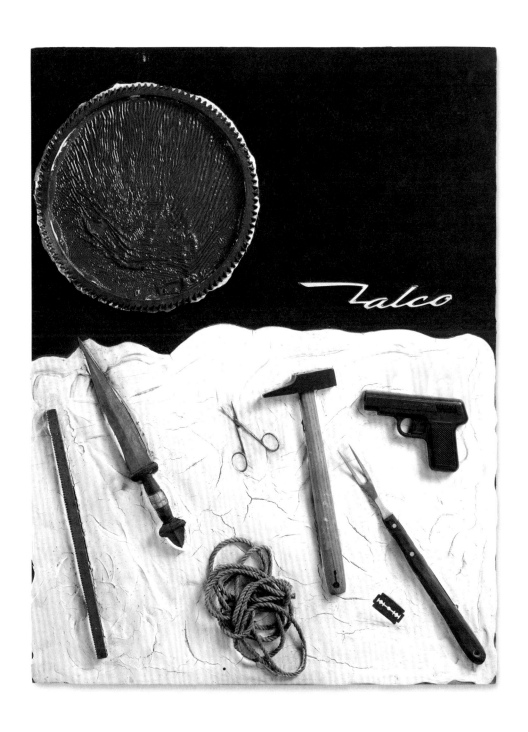

Tu est moi (You are me), 1960
Objects, wood, plaster, and paint
31⁵⁄₁₆ × 23⁵⁄₈ × 1³⁄₁₆ in. (79.5 × 60 × 3 cm)
Princeton University Art Museum. Gift of Irma S. Seitz
for the William C. Seitz, Graduate School Class of 1955,
Memorial Collection

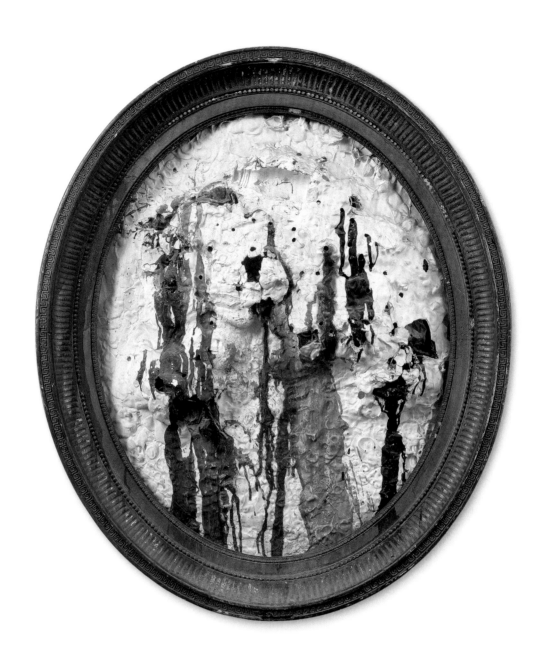

Tir (Old Master) – séance Galerie J, 1961
Paint, plaster, and wire mesh on wood in antique frame
35⁷⁄₁₆ × 29½ × 4¾ in. (90 × 75 × 12 cm)
Marcel Lefranc, Paris
Detail p. 132

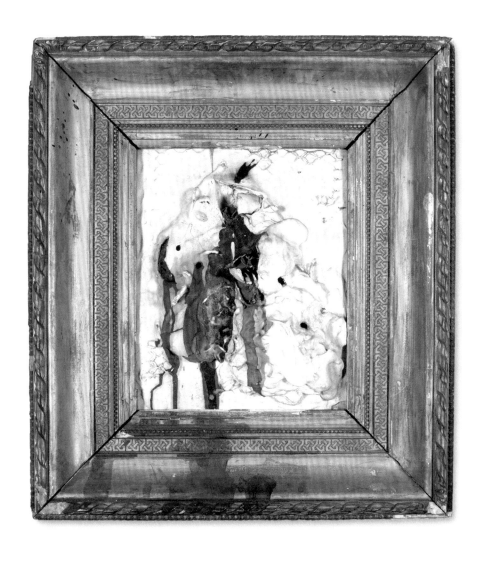

Old Master, 1961
Paint, plaster, and wire mesh on panel in antique frame
25½ × 22¾ in. (64.8 × 57.8 cm)
Private collection; courtesy of Niki Charitable Art
Foundation, Santee
Detail p. 133

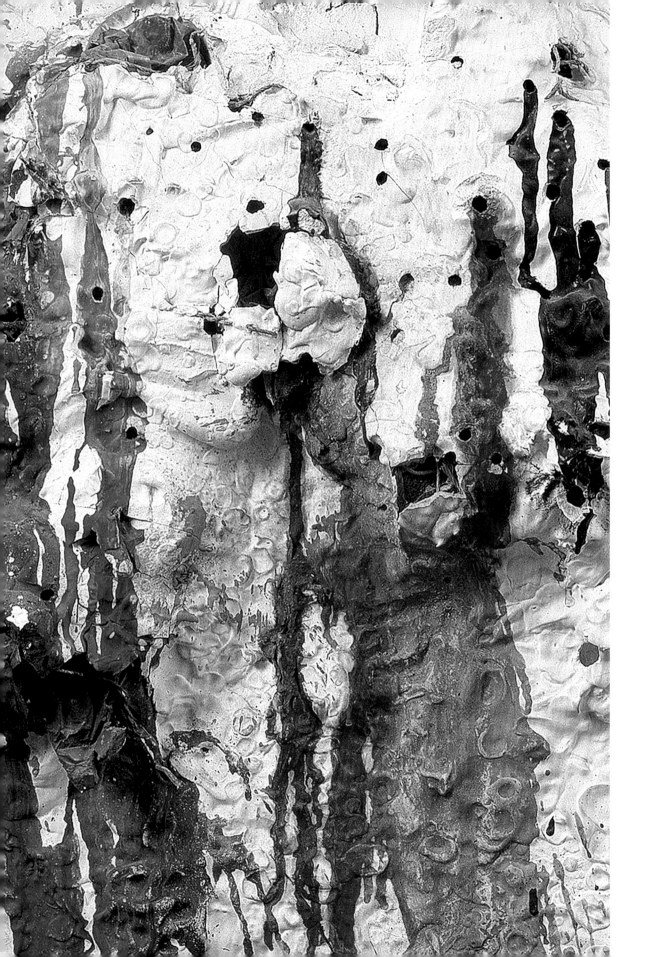

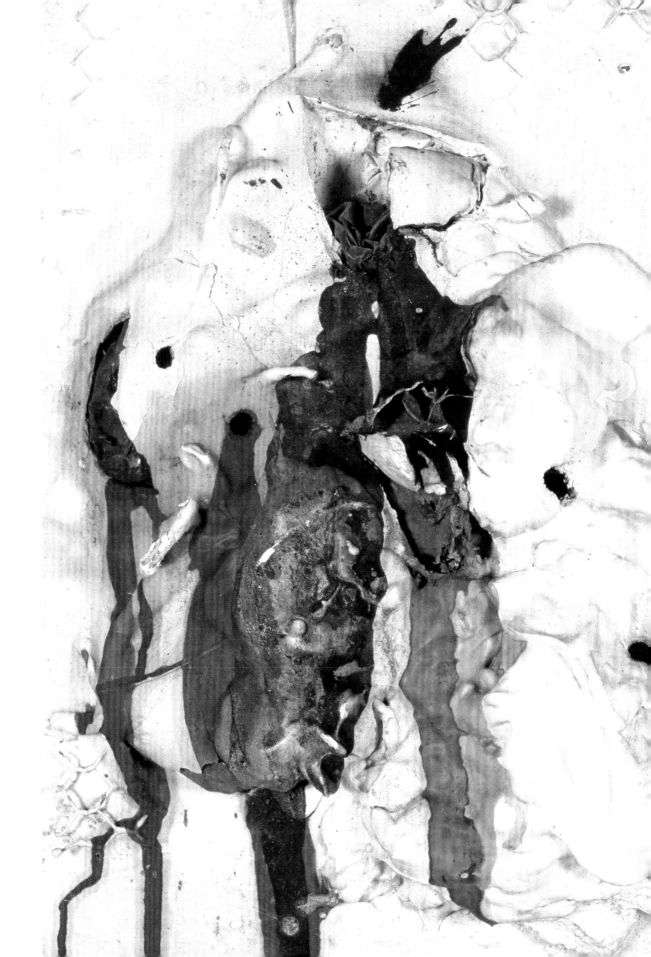

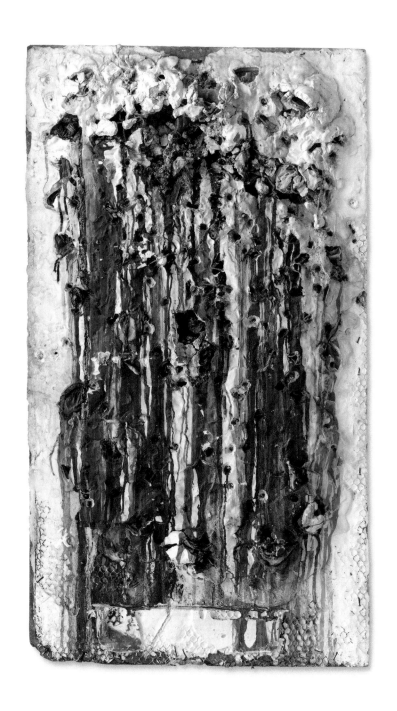

Grand Tir – Séance de la Galerie J, 1961
Paint, plaster, wire mesh, string, and plastic on chipboard
56¼ × 30¼ × 2¾ in. (143 × 77 × 7 cm)
Private collection; courtesy of Galerie Georges-Philippe
& Nathalie Vallois, Paris

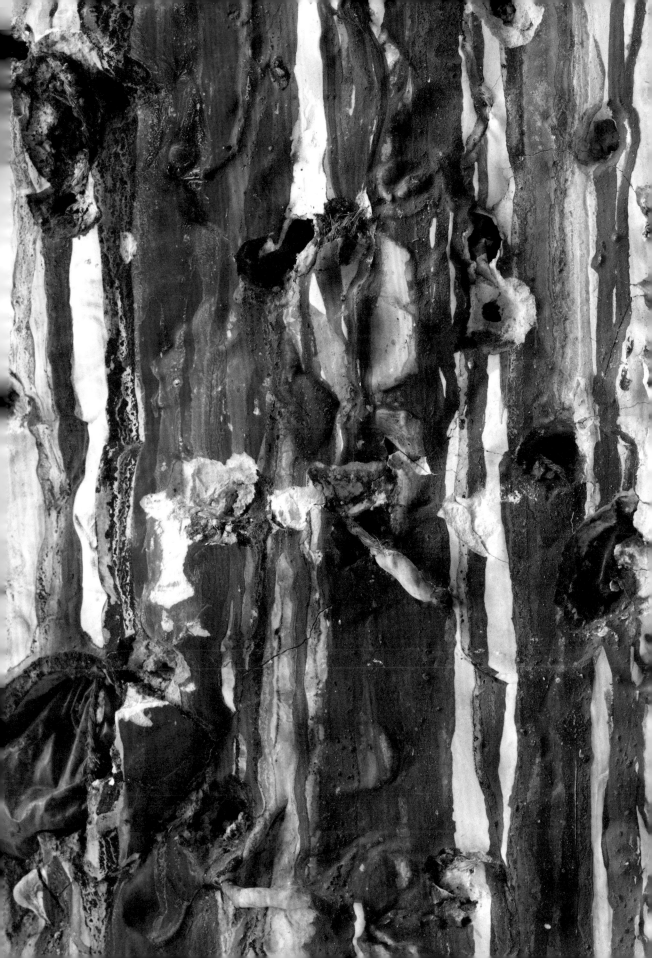

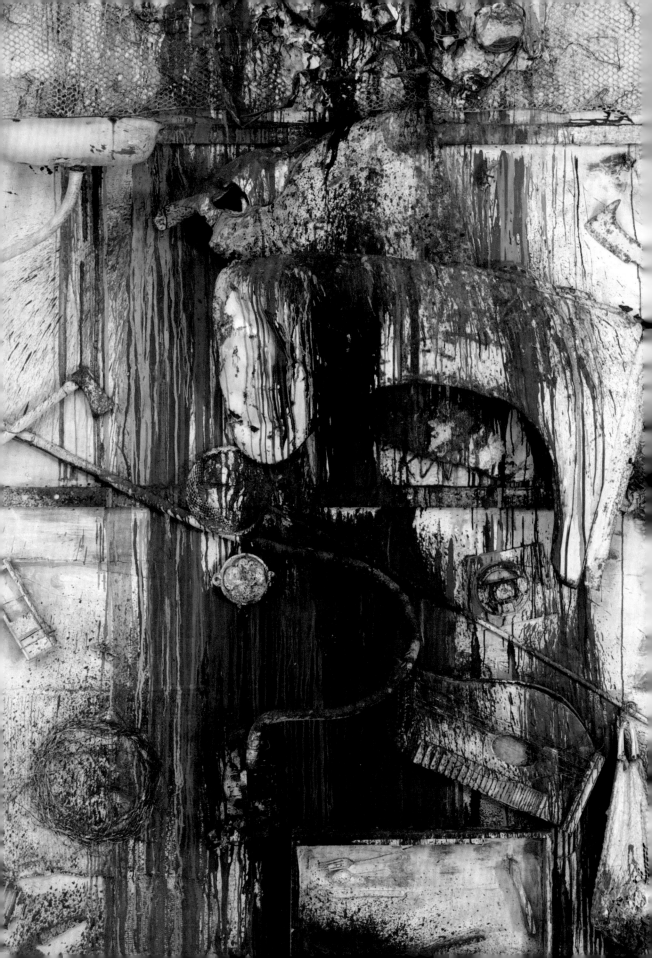

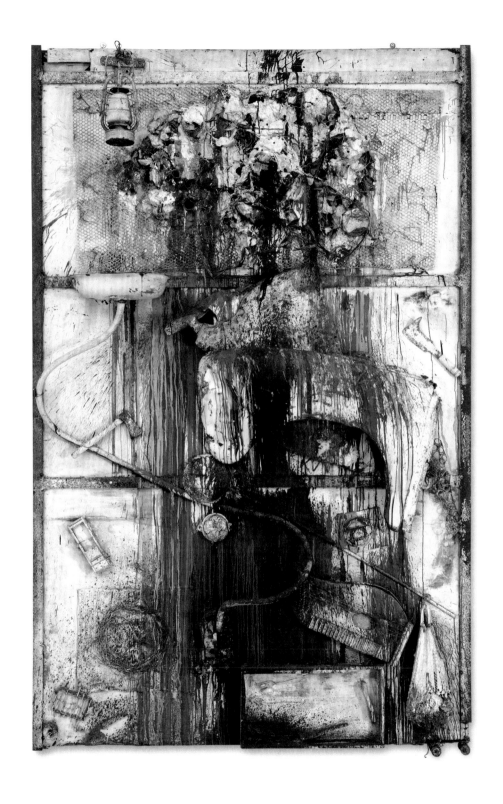

Tir, seance 26 juin 1961, 1961
Plaster, metal, acrylic, and objects on wood
129¹⁵⁄₁₆ × 82¾ × 13¾ in. (330 × 210 × 35 cm)
Collection of Mamac, Nice

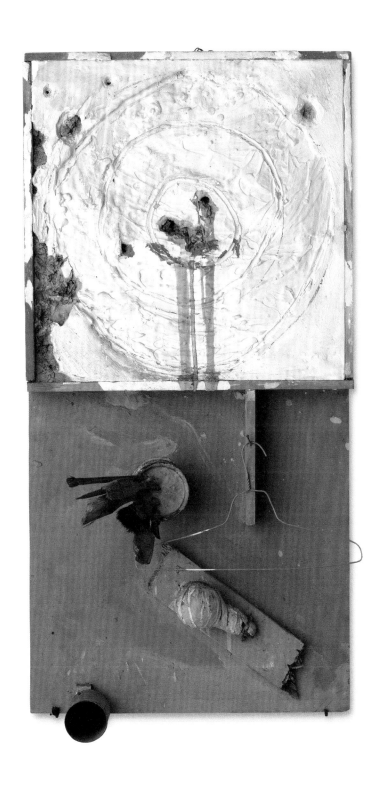

Tir de Jasper Johns, 1961
Plaster, wood, metal, concrete, newspaper, glass, and paint
47 × 23¼ × 10½ in. (119.5 × 59 × 26 cm)
Moderna Museet, Stockholm. Donation 2005
from Pontus Hultén

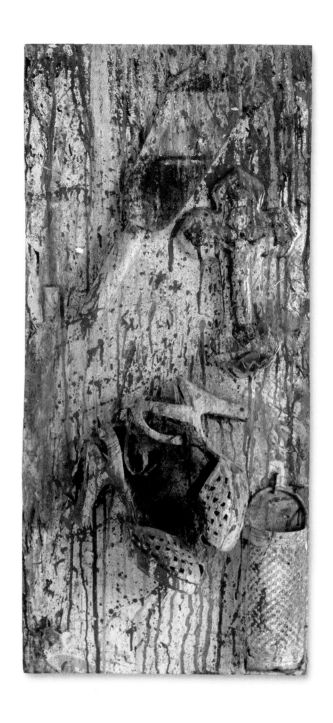

My Shoes (fragment de Dracula I), Winter 1961
Paint and objects on wood
33⁷⁄₁₆ × 14¹⁵⁄₁₆ × 4⁵⁄₁₆ in. (85 × 38 × 11 cm)
Private collection; courtesy of Niki Charitable Art
Foundation, Santee

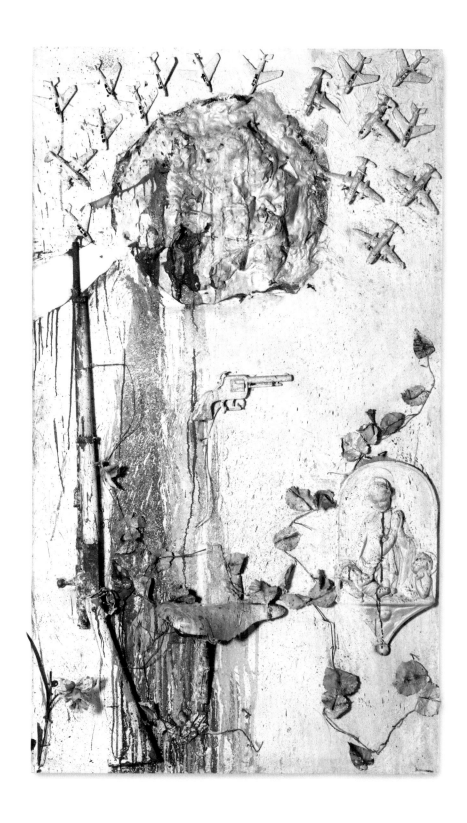

Tempête [*Tempest*], *(Fragment de Dracula I)*, Winter 1961
Paint, plaster, and objects on wood
59¹⁄₁₆ × 32⁵⁄₁₆ × 7⁷⁄₈ in. (150 × 82 × 20 cm)
Collection of Mamac, Nice. Donation de l'artiste

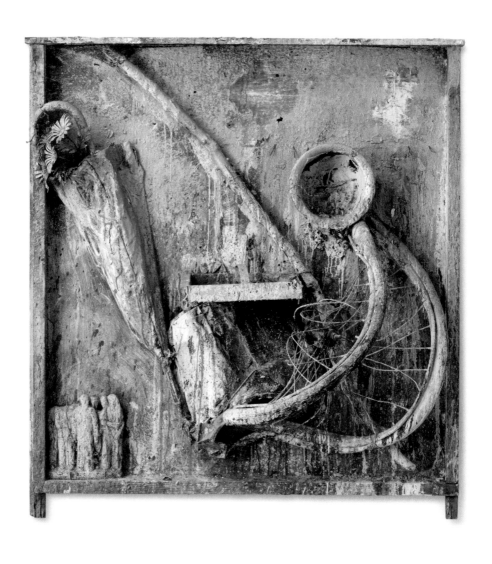

Dracula (Fragment de Dracula II), 1961
Paint and objects on plywood
44⅛ × 41⁵⁄₁₆ × 17¾ in. (112 × 105 × 45 cm)
Private collection; courtesy of Galerie Georges-Philippe
& Nathalie Vallois, Paris

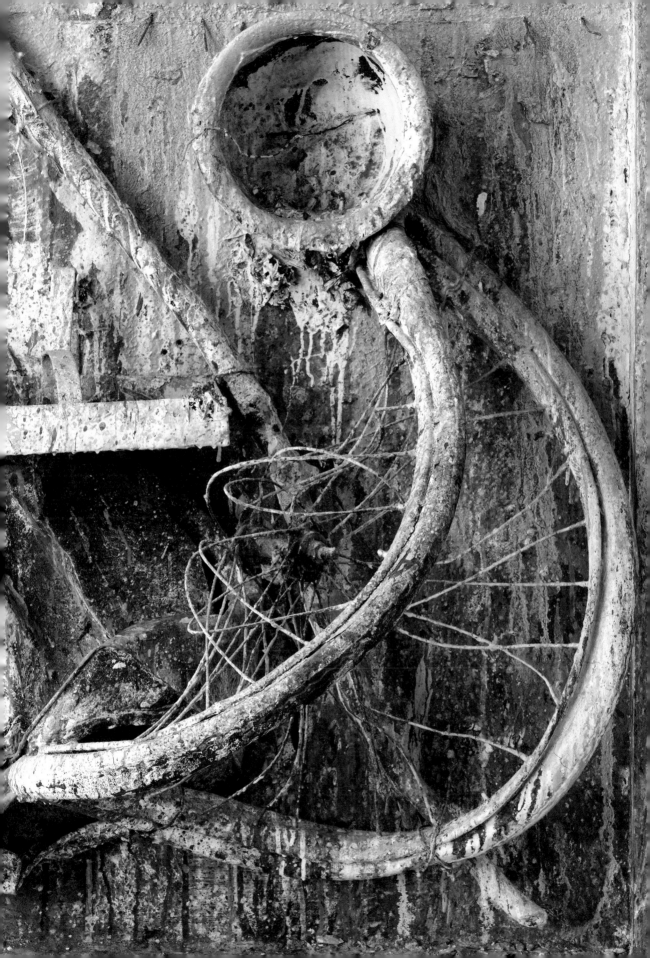

Tir (Fragment de Dracula II), 1961
Plaster, paint, and objects on plywood
34¼ × 59¹⁄₁₆ × 2¾ in. (87 × 150 × 7 cm)
Quenza Collection, USA;
courtesy of Galerie Georges-Philippe & Nathalie Vallois, Paris

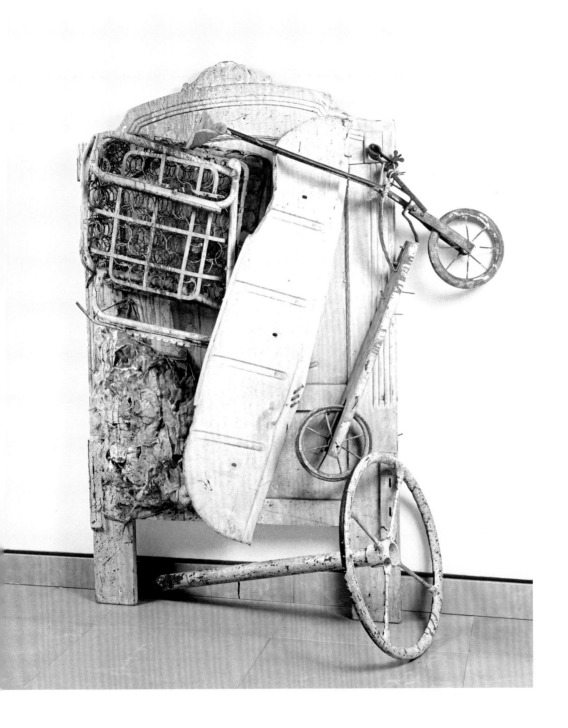

Composition à la trottinette "Tir à la carabine"
[*Composition with Scooter, "Rifle Tir"*], 1961
Paint, plaster, and objects on wood
59¼ × 39¼ × 19⅝ in. (151.8 × 99.7 × 49.8 cm)
Carré d'Art, Musée d'art contemporain de Nîmes

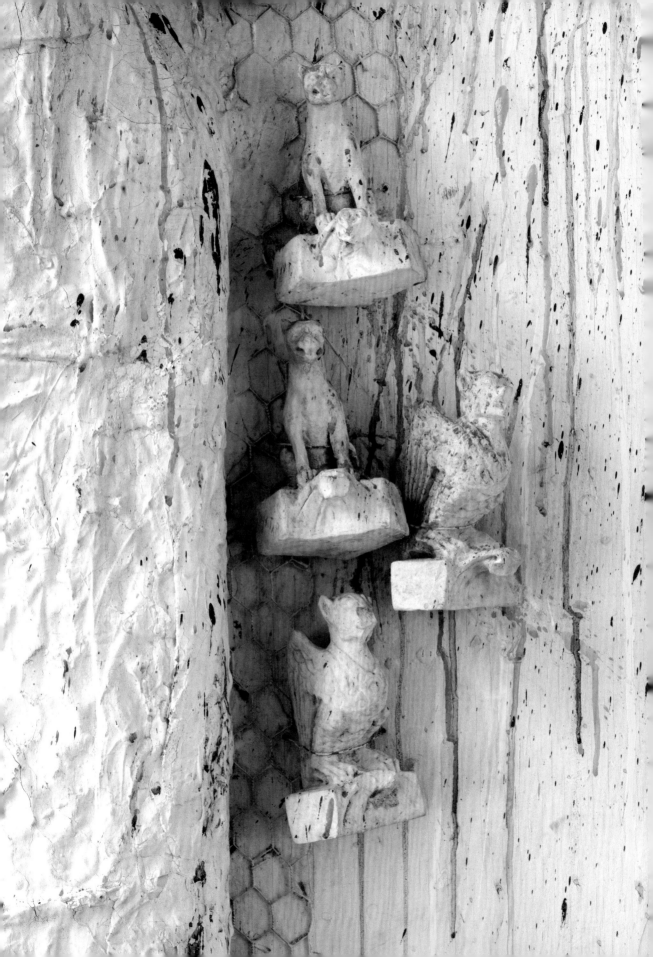

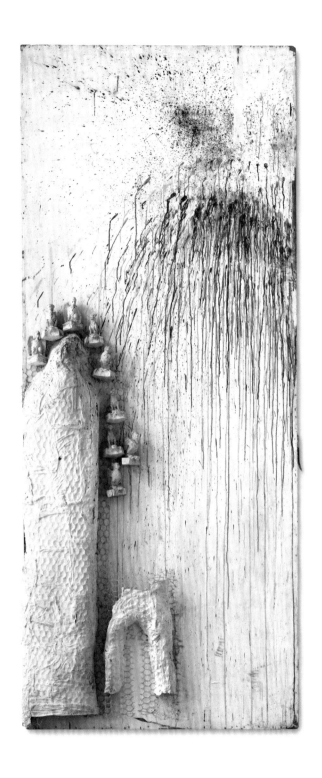

Fragment de l'Hommage au Facteur Cheval [Fragment of Homage to Cheval the Mailman], 1962
Plaster, paint, and objects on wood
118⅛ × 47¼ × 7⅟₁₆ in. (300 × 120 × 18 cm)
Collection of Georges-Philippe Vallois;
courtesy of Galerie Georges-Philippe & Nathalie Vallois, Paris

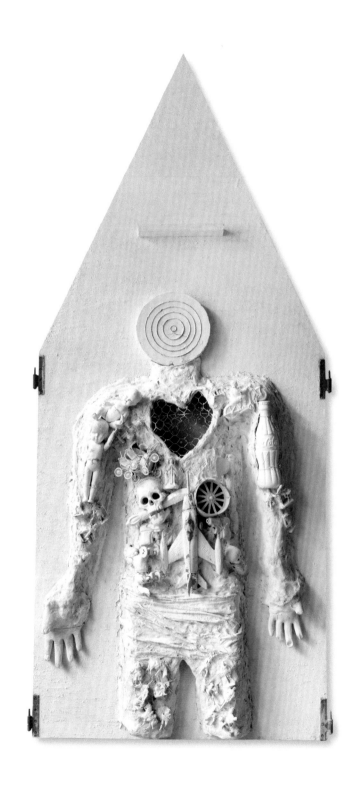

Assemblage (Figure with Dartboard Head), ca. 1962
Plaster, paint, and objects on wood
74¹³⁄₁₆ × 31½ × 5⅞ in. (190 × 80 × 15 cm)
Courtesy of Galerie Georges-Philippe & Nathalie Vallois, Paris

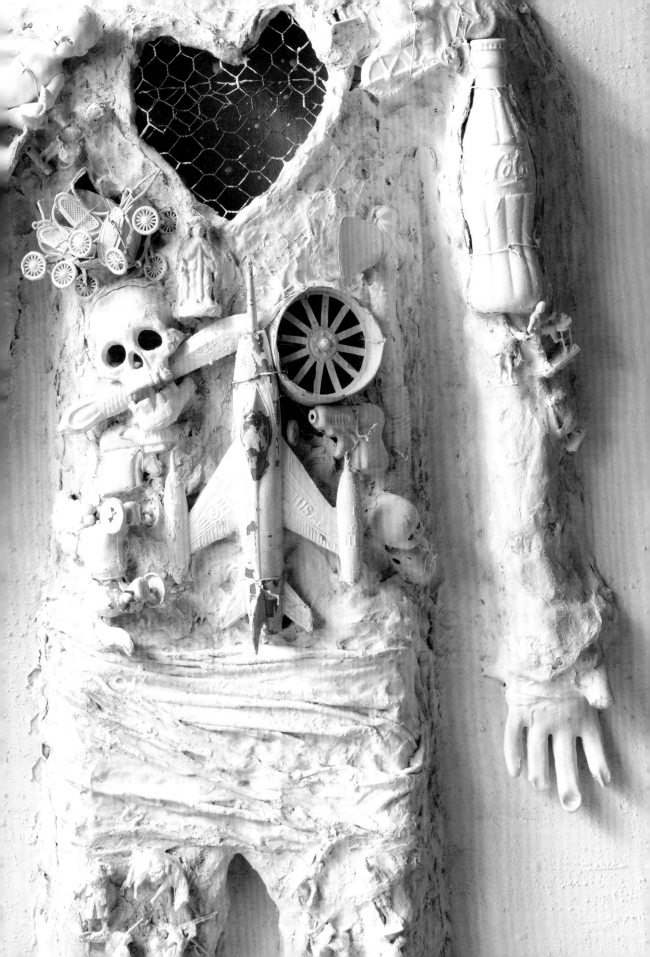

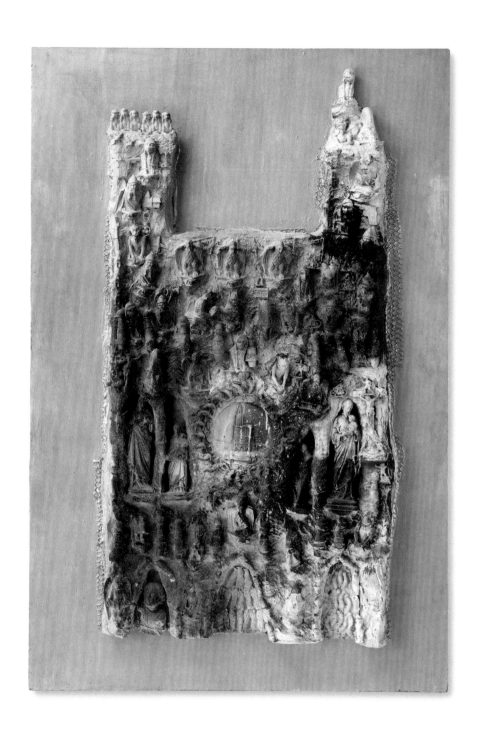

Cathédrale, 1962
Paint, plaster, and objects on wood
77 ³⁄₁₆ × 50 ¹³⁄₁₆ × 5 ⅞ in. (196 × 129 × 15 cm)
Collection of Niki Charitable Art Foundation, Santee

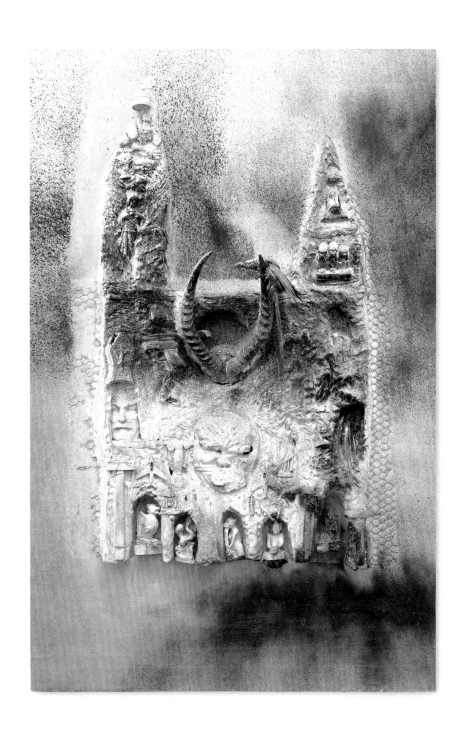

Reims, 1962
Paint, plaster, wire, wire mesh, cloth, and objects on plywood
74½ × 48 × 11⅞ in. (189.2 × 121.9 × 30.2 cm)
The Menil Collection, Houston

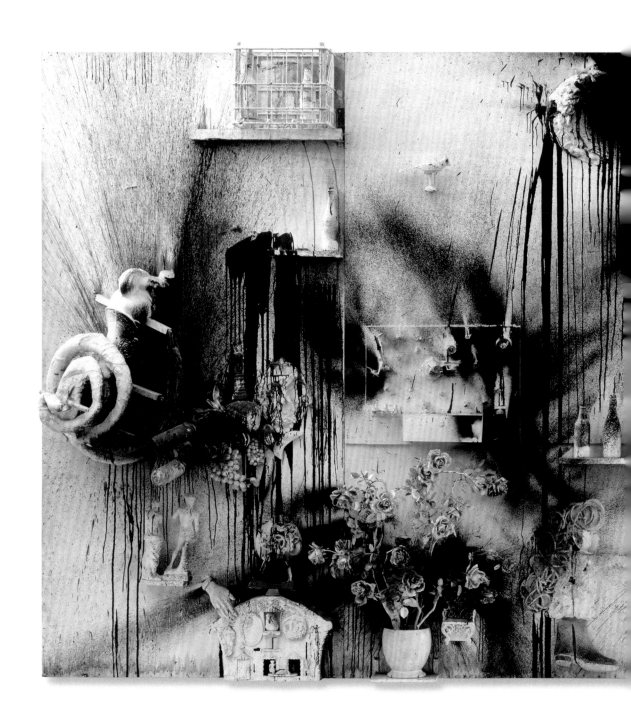

Gorgo in New York, 1962
Paint, plaster, wire, and objects on wood
95¾ in. × 16 ft. 1 in. × 19½ in. (243.2 × 490.2 × 49.5 cm)
Four panels, each 95¾ × 48¼ in. (243.2 × 122.6 cm)
The Museum of Fine Arts, Houston, Gift of D. and J. de Menil

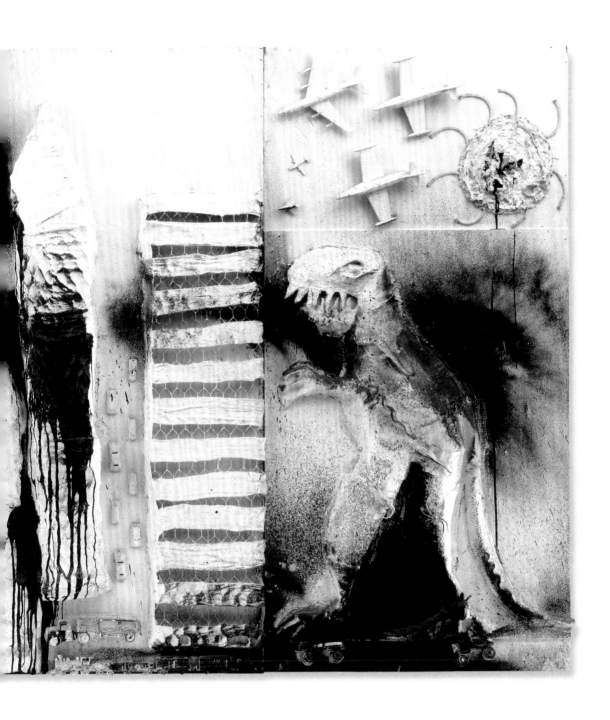

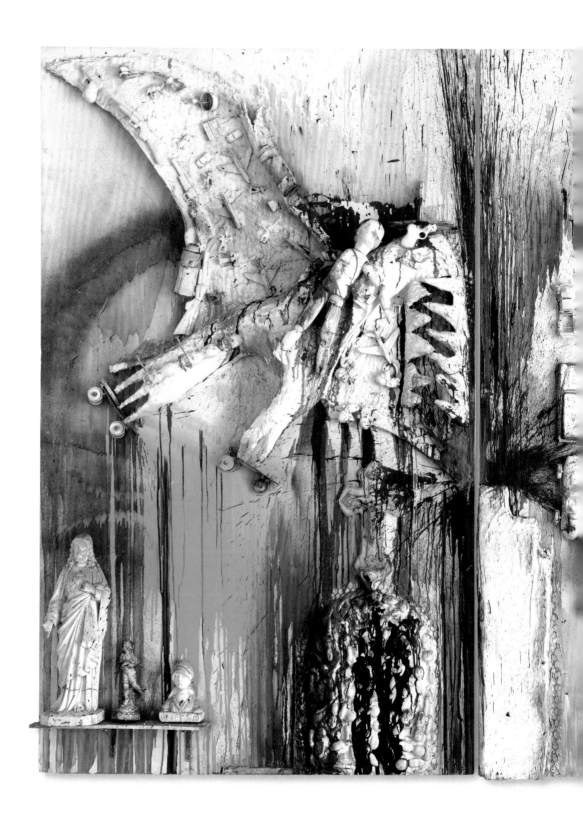

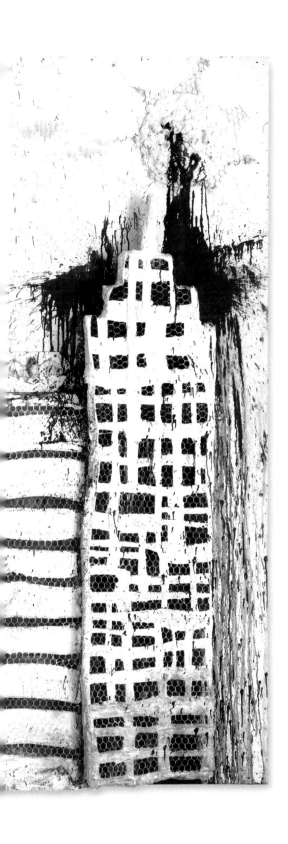

Pirodactyl over New York, 1962
Paint, plaster, and objects on two wood panels
98⅜ × 122 × 11¾ in. (249.9 × 309.9 × 29.8 cm)
Guggenheim Abu Dhabi

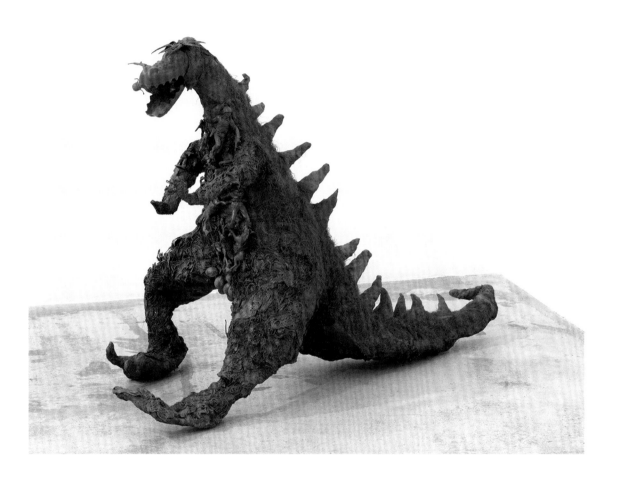

Le Dragon Rouge, 1964
Assemblage of plaster, mesh, fabric, spray paint, string, hair,
and plastic figures
34¼ × 51¹⁵⁄₁₆ × 22¹³⁄₁₆ in. (87 × 132 × 58 cm)
Private collection; courtesy of Galerie Georges-Philippe
& Nathalie Vallois, Paris

Heads of State (Study for King Kong), 1963
Masks, wood, plaster, and color on wood
48¼ × 77¹⁵⁄₁₆ × 8¼ in. (122.5 × 198 × 21 cm)
Sprengel Museum Hannover, Donation Niki de Saint Phalle

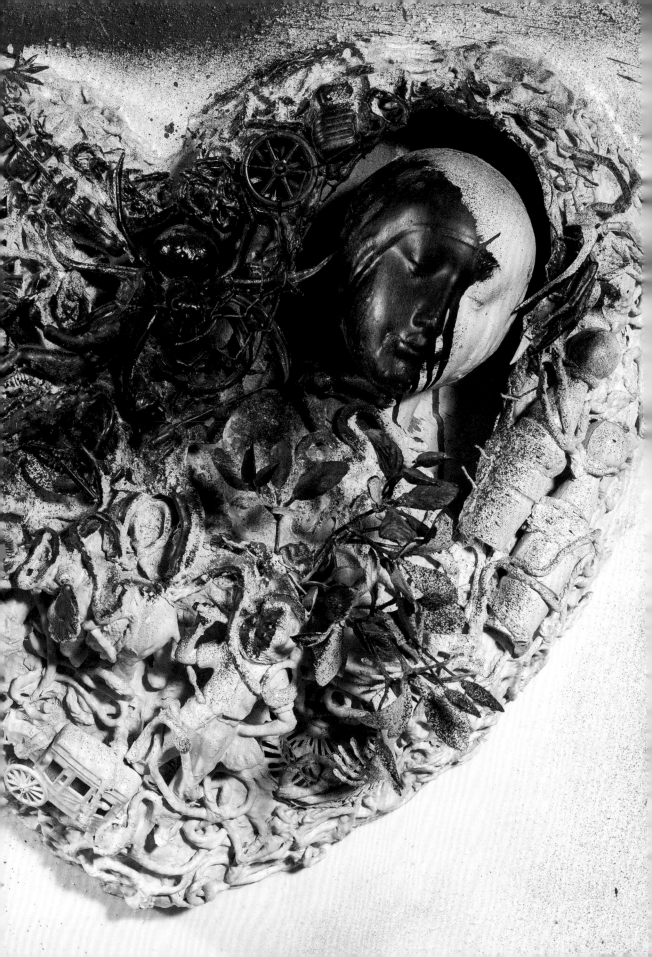

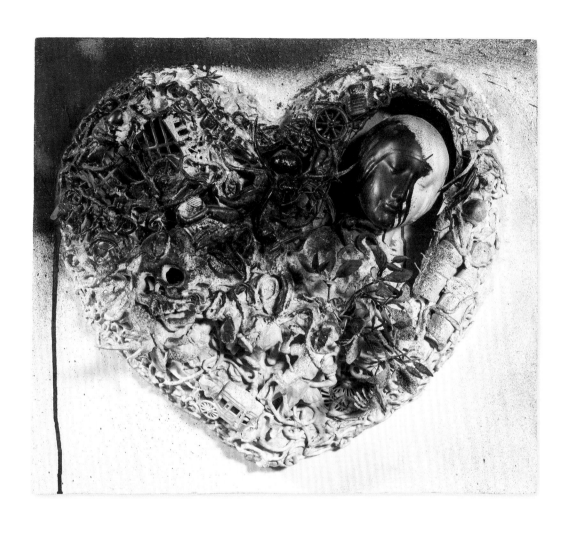

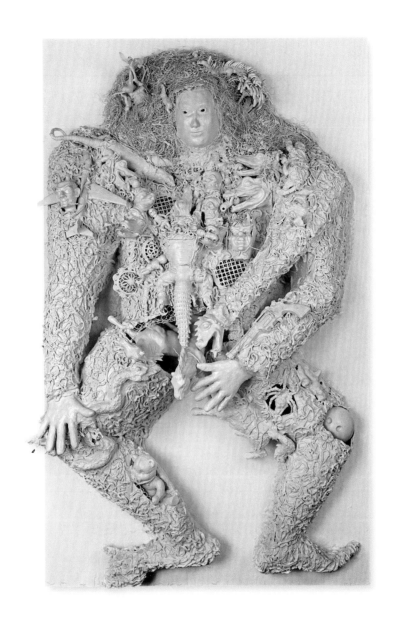

Lucrezia (The White Goddess / Weiße Hexe [White Witch]), 1964
Paint, wire mesh, and objects on board
70¾ × 43¼ × 15¼ in. (179.7 × 109.9 × 38.7 cm)
Private collection

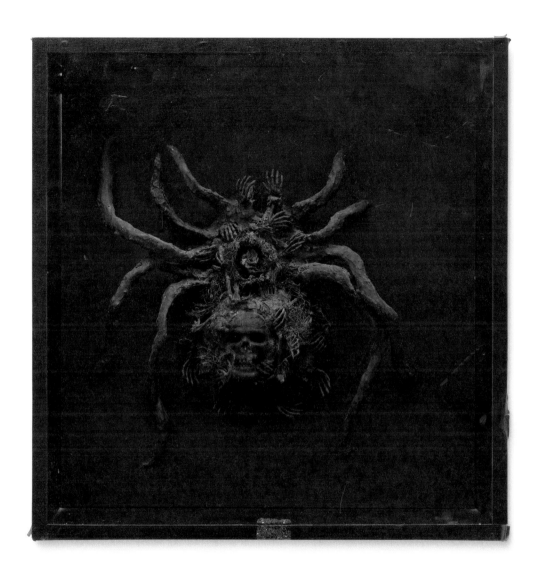

Black Widow Spider, 1963
Paint and assemblage of objects on wood
17¹¹⁄₁₆ × 17⅛ × 3⁹⁄₁₆ in. (45 × 43.5 × 9 cm)
Private collection; courtesy of Galerie Georges-Philippe
& Nathalie Vallois, Paris

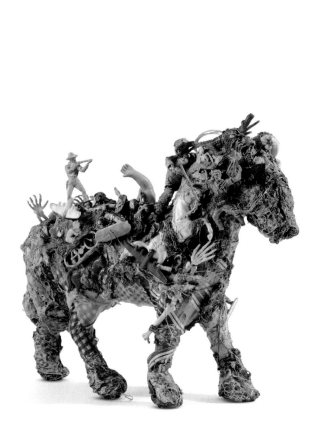

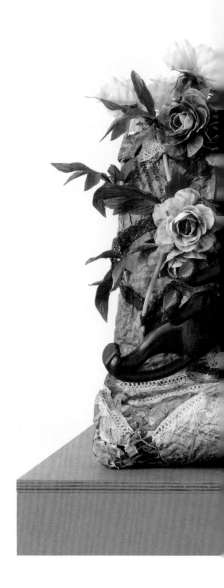

Le Petit Cheval, 1963
Assemblage of plastic, thread, fabric, and straw toys
12³⁄₁₆ × 12⁵⁄₈ × 4¾ in. (31 × 32 × 12 cm)
Collection of Niki Charitable Art Foundation, Santee

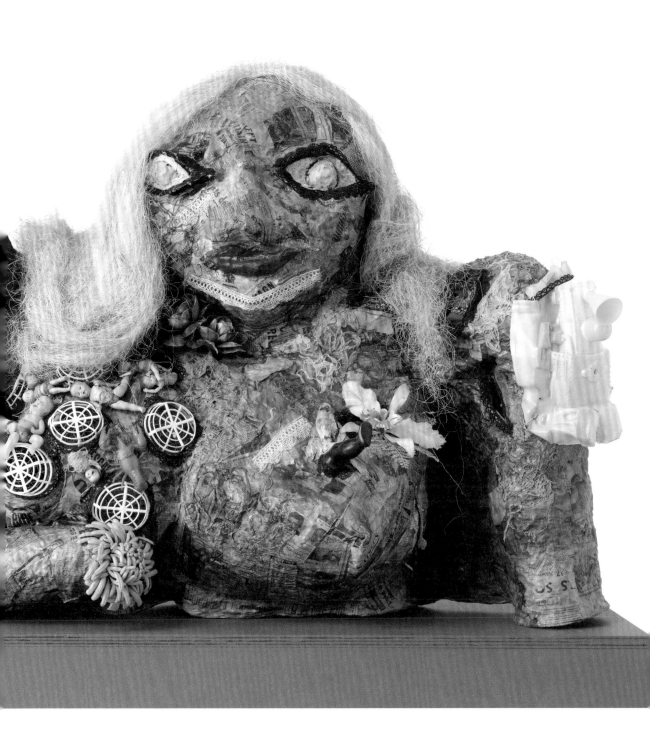

Marilyn, 1964
Mixed media
32½ × 50⅜ × 19⁵⁄₁₆ in. (82.5 × 128 × 49 cm)
Quenza Collection, USA;
courtesy of Galerie Georges-Philippe & Nathalie Vallois, Paris

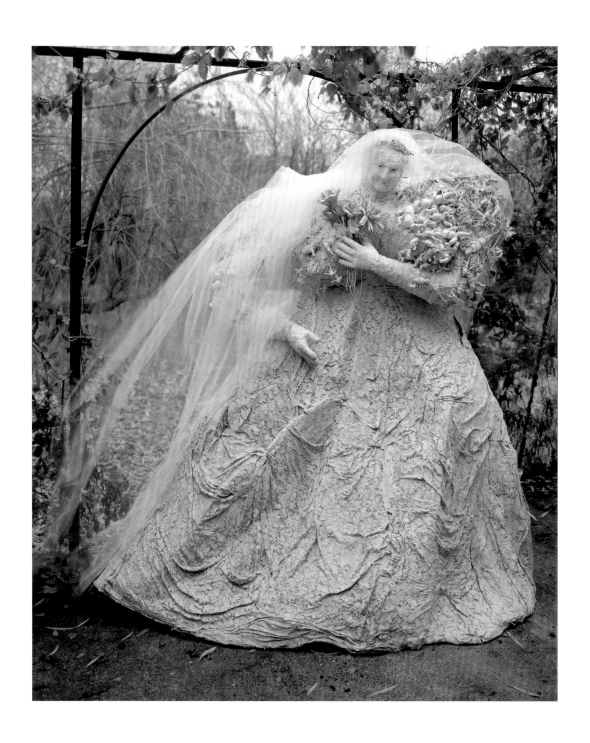

*The Bride (or Miss Haversham's Dream
or When you Love Somebody)*, 1965
Fabric, lace, objects, and wire mesh
74¹³⁄₁₆ × 76⅜ × 29½ in. (190 × 194 × 75 cm)
Collection of Niki Charitable Art Foundation, Santee

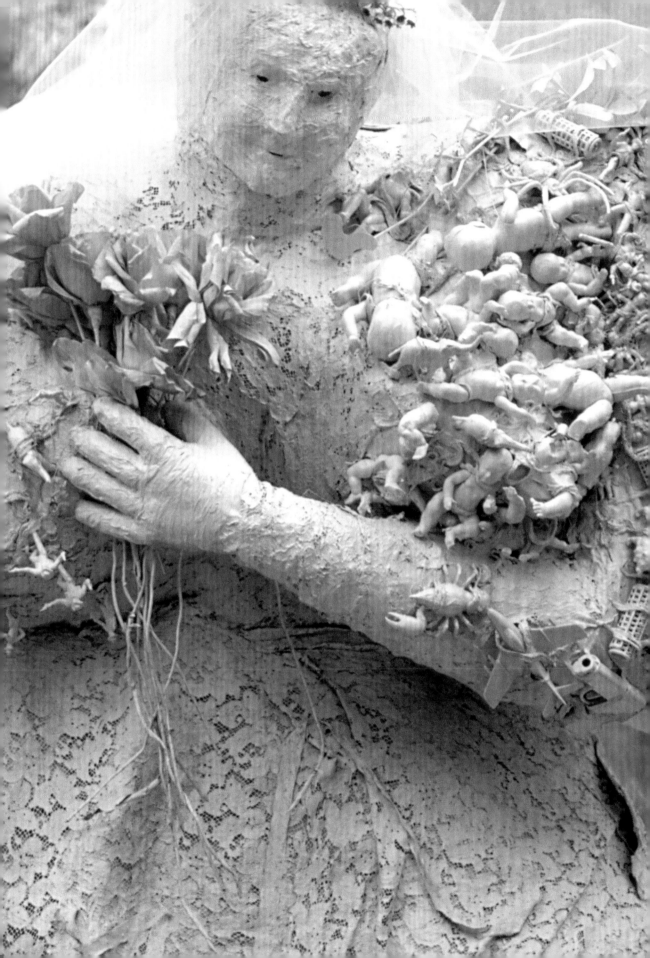

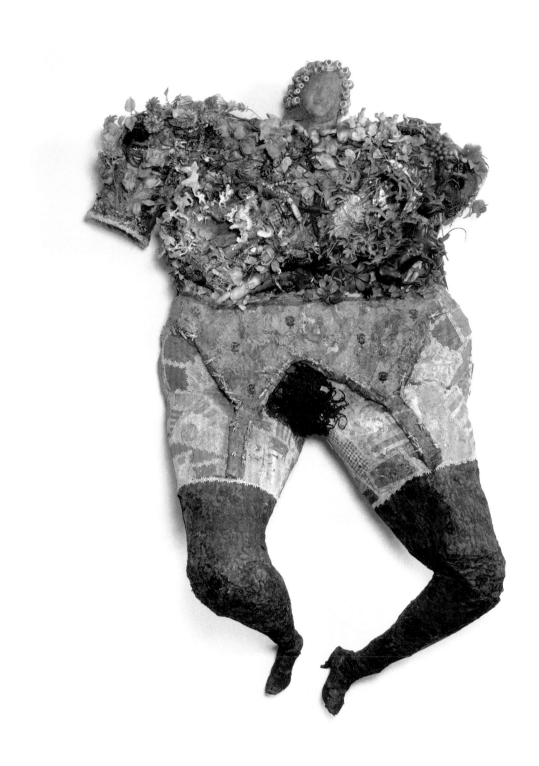

Crucifixion, ca. 1965
Objects on fabric, lace, and painted polyester resin
92¹⁵⁄₁₆ × 57⅞ × 24³⁄₁₆ in. (236 × 147 × 61.5 cm)
Centre Pompidou, Paris, Musée national d'art moderne/
Centre de création industrielle

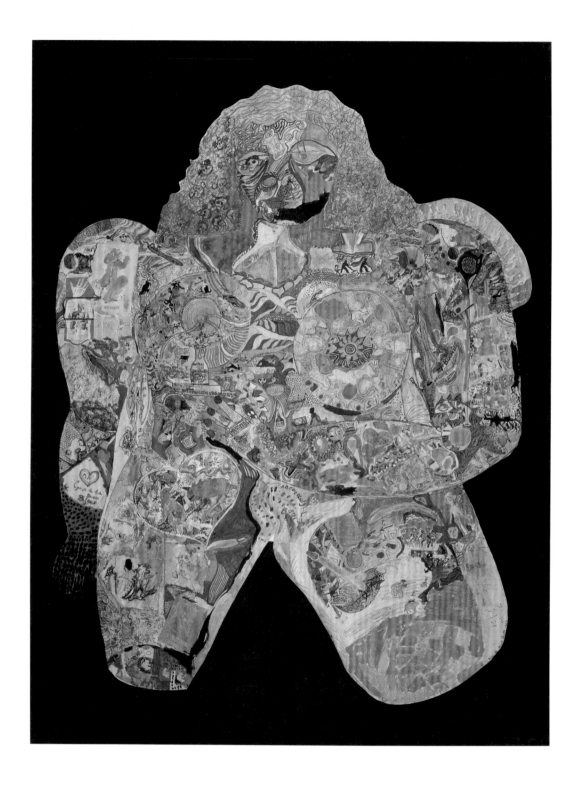

Pink Lady, 1964
Oil and collage of pastel, ink, pencil, enamel,
photograph, photomechanical reproduction,
and ink stamp on paper on canvas
78¾ × 59⅛ in. (200 × 150.2 cm)
Hirshhorn Museum and Sculpture Garden, Smithsonian Institution,
Washington, D.C., Gift of Joseph H. Hirshhorn, 1966

172

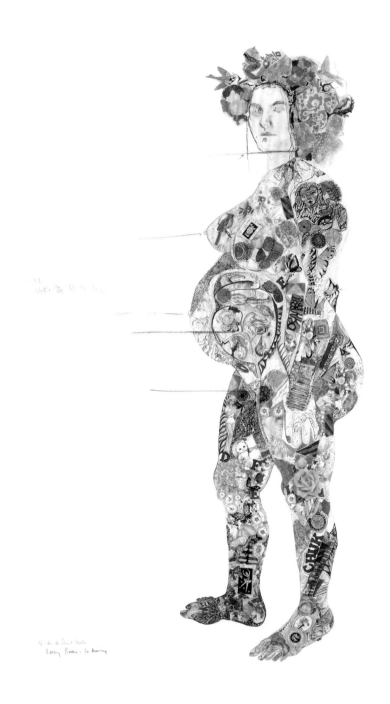

Niki de Saint Phalle in collaboration with Larry Rivers
Clarice, 1964–65
Collage, colored pencils, pastel, graphite, and ink on paper
61⅝ × 44⅟₁₆ in. (156.5 × 112 cm)
Collection of Isabelle and David Lévy, Bruxelles

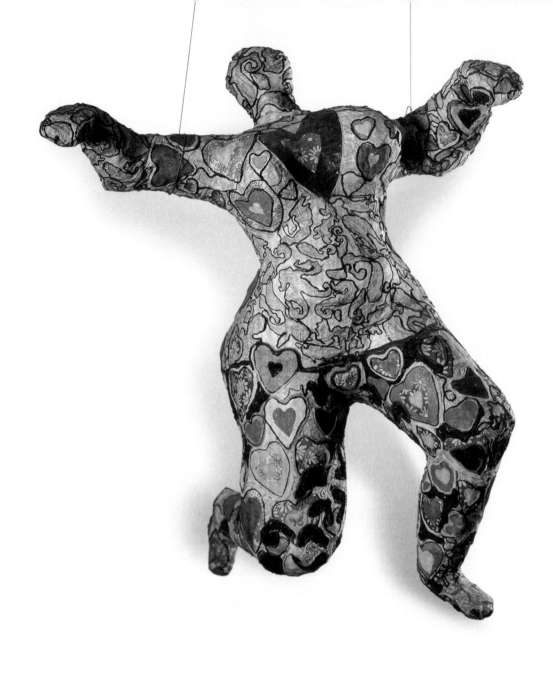

Samuela II/Nana, ca. 1965
Mixed media
52 × 38 × 30 in. (132.1 × 96.5 × 76.2 cm)
Collection of Albright-Knox Art Gallery, Buffalo, New York,
Gift of Seymour H. Knox, Jr., 1978

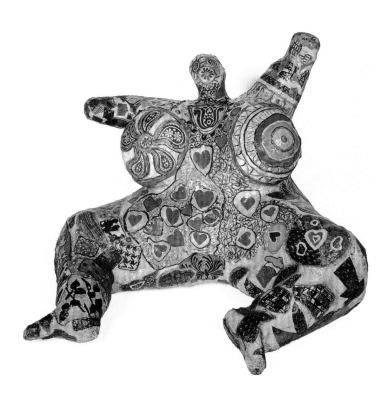

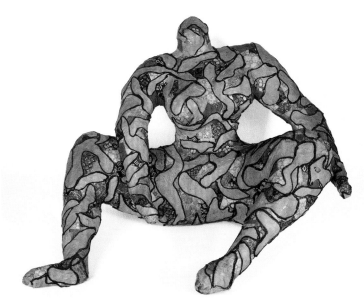

Nana Assise [*Seated Nana*], 1965
Painted polyester resin, fabric, wire mesh, and collage
39⅜ × 55⅛ × 55⅛ in. (100 × 140 × 140 cm)
Private collection; courtesy of Niki Charitable Art
Foundation, Santee

Bénédicte, 1965
Wool, fabric, and wire mesh
31½ × 42⅛ × 34¼ in. (80 × 107 × 87 cm)
Private collection; courtesy of Niki Charitable Art
Foundation, Santee

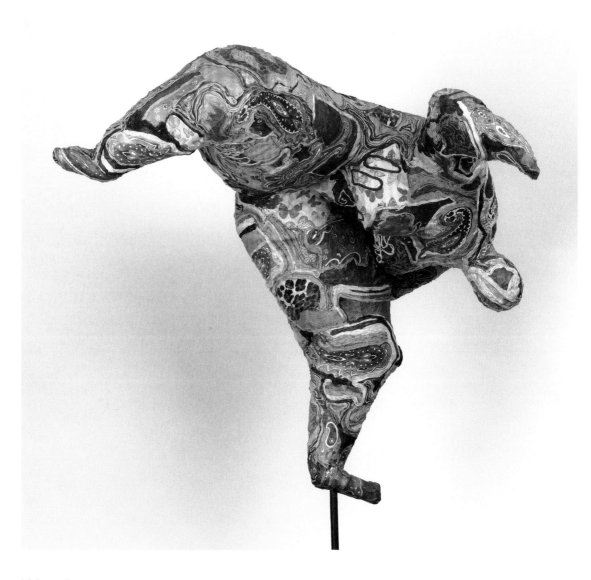

Vivian, 1965
Yarn, fabric, paper, and epoxy
42 × 47 × 40 in. (106.7 × 119.4 × 101.6 cm)
Collection of Museum of Contemporary Art Chicago,
gift of Joseph and Jory Shapiro

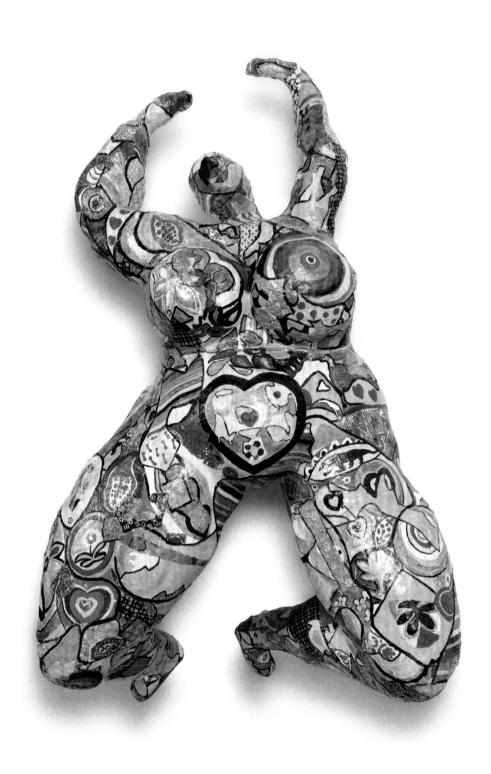

Lili ou Tony, 1965
Painted polyester resin, fabric, wire mesh, and collage
81⅛ × 51³⁄₁₆ × 51³⁄₁₆ in. (206 × 130 × 130 cm)
Dragonfly Collection / Garance Primat

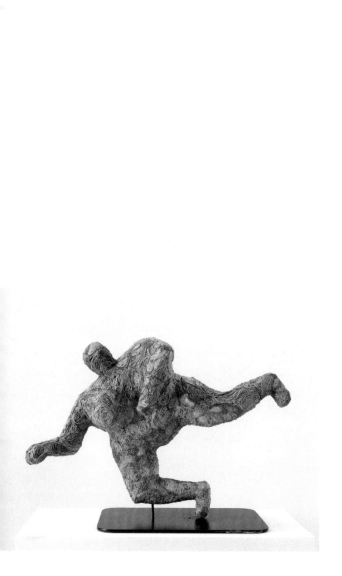

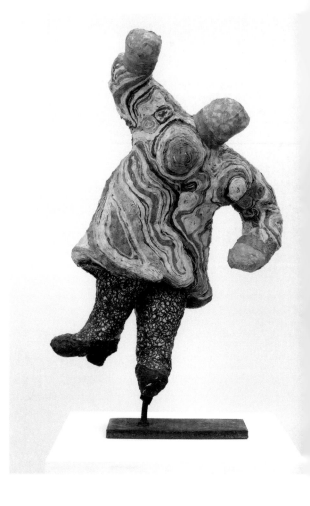

Louise, 1965
Mixed media
26⅞ × 37⅞ × 17½ in. (68.3 × 96.2 × 44.5 cm)
Courtesy of Galerie Georges-Philippe & Nathalie Vallois, Paris

Nana, 1965
Yarn, lace, string, oil, and adhesive on wire mesh,
black-painted metal base
28⁷⁄₁₆ × 21 × 13¾ in. (72.3 × 53.3 × 34.9 cm)
Private collection; courtesy of Galerie Georges-Philippe
& Nathalie Vallois, Paris

Clarice Again, ca. 1966–67
Painted polyester resin
75 × 55 × 49 in. (190.5 × 139.7 × 124.5 cm)
Private collection; courtesy of Niki
Charitable Art Foundation, Santee

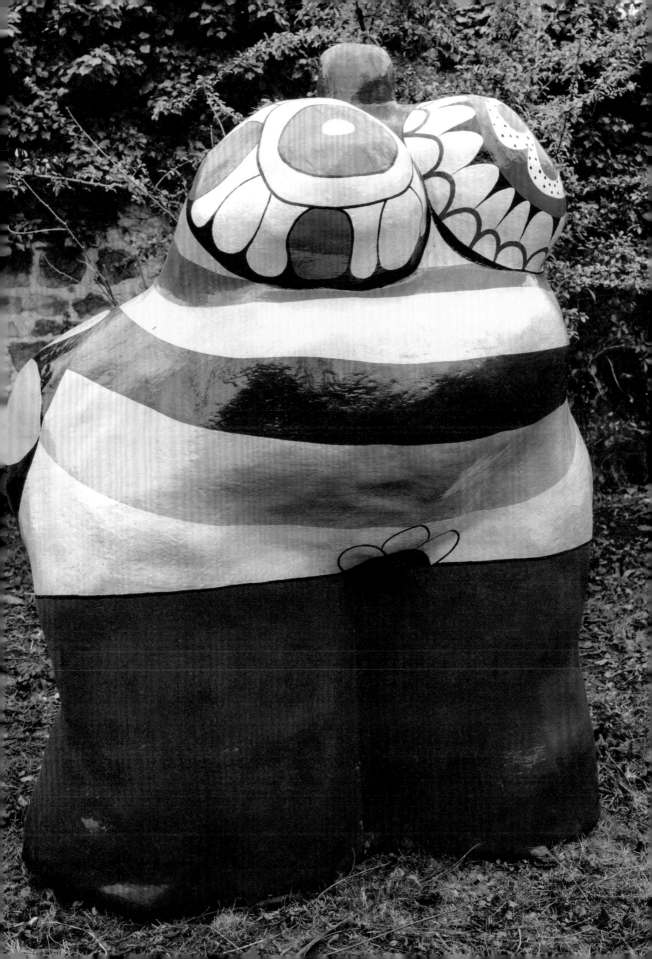

Madame, ou Nana verte au sac noir [*Madame, or Green Nana*
with Black Bag], 1968
Painted polyester resin
101¹⁵/₁₆ × 60⅝ × 25⁹/₁₆ in. (258 × 154 × 65 cm)
Private collection; courtesy of Galerie Georges-Philippe
& Nathalie Vallois, Paris

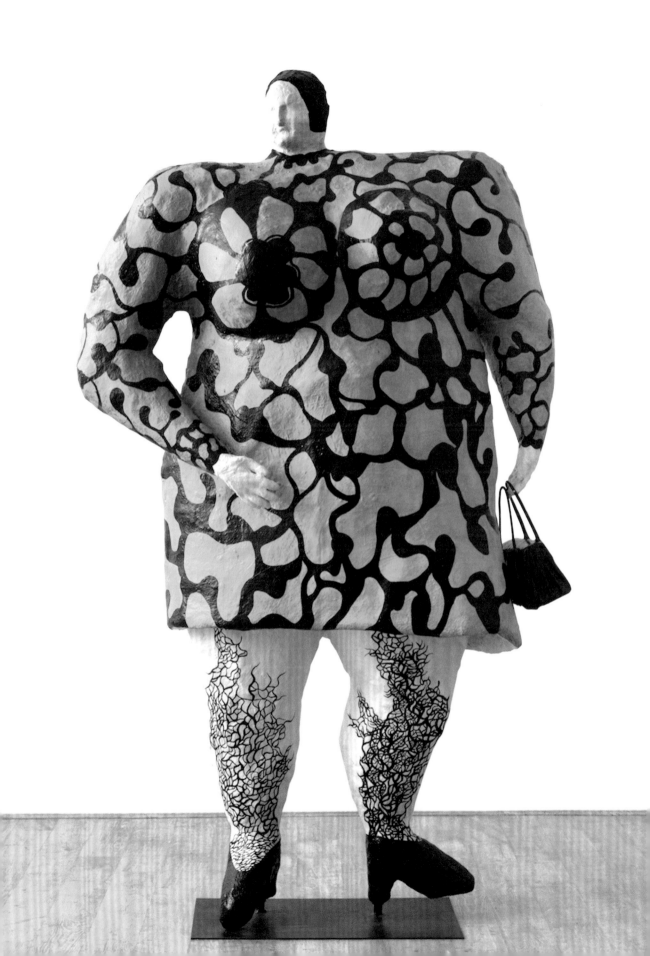

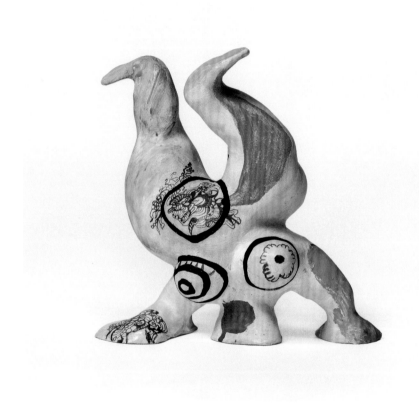

Mini Nana acrobate, ca. 1966
Painted plaster
8 × 7 × 6 in. (20.3 × 17.8 × 15.2 cm)
The Rand Collection

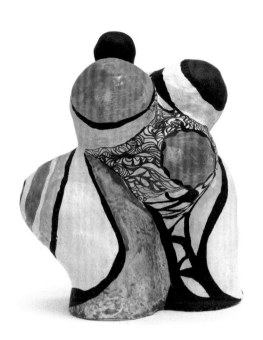

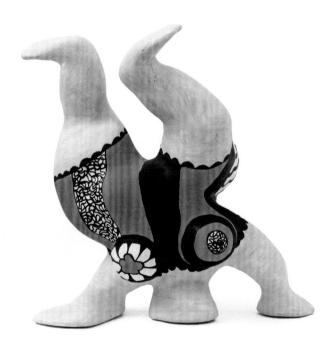

Mini Nana acrobate, 1968
Painted plaster
8⅟₁₆ × 7¹¹⁄₁₆ × 3⅜ in. (20.4 × 19.5 × 8.5 cm)
Courtesy of Galerie Georges-Philippe & Nathalie Vallois, Paris

Mini Nana maison, 1968
Painted synthetic resin
6⁵⁄₁₆ × 5½ × 4¼ in. (16 × 14 × 12 cm)
Private collection; courtesy of Galerie Georges-Philippe
& Nathalie Vallois, Paris

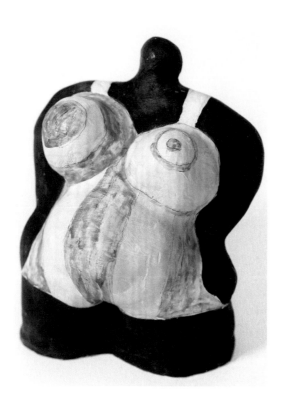

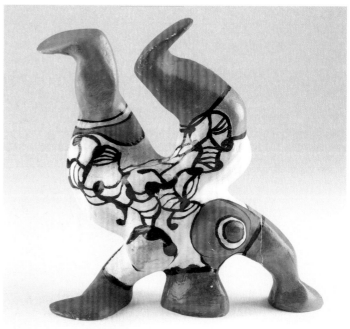

Mini Nana boule noir, ca. 1966
Watercolor on plaster
5⅞ × 4⅜ × 4⅜ in. (14.9 × 11.1 × 11.1 cm)
Private collection, New York

Mini Nana acrobate (tête bleu), 1969
Painted polyester resin
6⁵⁄₁₆ × 5⅞ × 3⁹⁄₁₆ in. (16 × 15 × 9 cm)
Private collection; courtesy of Niki Charitable Art
Foundation, Santee

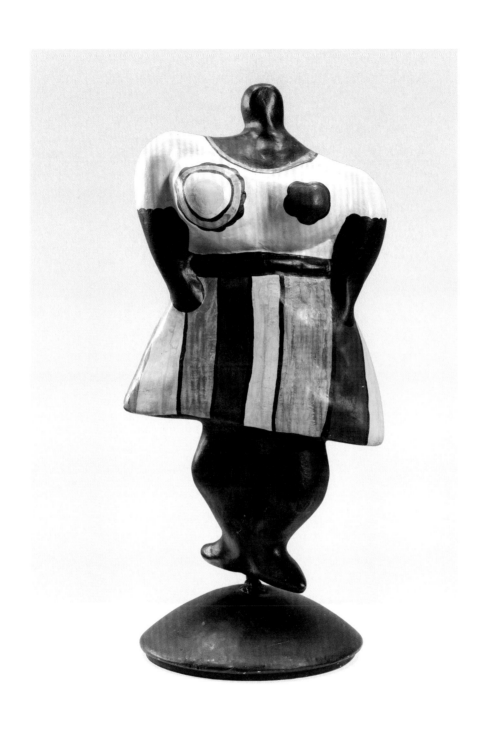

Nana moyenne Waldaff [*Medium-sized Waldaff Nana*], 1969
Acrylic and polyester resin, metal base
27 × 15 × 6¼ in. (68.6 × 38.1 × 15.9 cm)
Collection of Museum of Contemporary Art San Diego,
Gift of Marne and Jim DeSilva

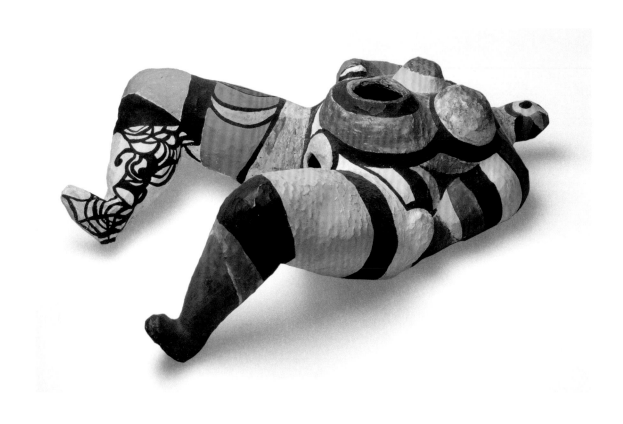

Model for Hon, 1966
Painted papier-mâché on wire mesh
13¾ × 35⅟₁₆ × 52 in. (35 × 89 × 133 cm)
Moderna Museet, Stockholm. Donation 1998
from Pontus Hultén

Photo de Hon repeinte [Overpainted Photo of Hon], 1979
Paint on offset print
118⅛ × 115⅜ in. (300 × 293 cm)
Three panels, each 118⅛ × 36⅝ in. (300 × 93 cm)
Collection of Niki Charitable Art Foundation, Santee

Bathing Beauty, 1967
Painted polyester resin, joined iron base
by Jean Tinguely
$64^{15}/_{16} \times 64^{15}/_{16} \times 35^{1}/_{16}$ in. (165 × 165 × 89 cm)
Private collection, USA, courtesy of Galerie
Mitterrand, Paris

Machine à rêver [*Machine for Dreaming*], 1970
Painted plaster
34¹³⁄₁₆ × 49⅝ × 30⁵⁄₁₆ in. (88.5 × 126 × 77 cm)
Collection of Niki Charitable Art Foundation, Santee

My Love, My Love, 1968
Screenprint
15½ × 20¼ in. (39.4 × 51.4 cm)
The Menil Collection, Houston

My Love We Won't, 1968
Screenprint
19½ × 24¼ in. (49.5 × 61.6 cm)
The Menil Collection, Houston

My Love Why Did You Go Away? 1968
Screenprint
15¾ × 23¾ in. (40 × 60.3 cm)
The Menil Collection, Houston

My Love What Shall I Do If You Die? 1968
Screenprint
15¾ × 23¾ in. (40 × 60.3 cm)
The Menil Collection, Houston

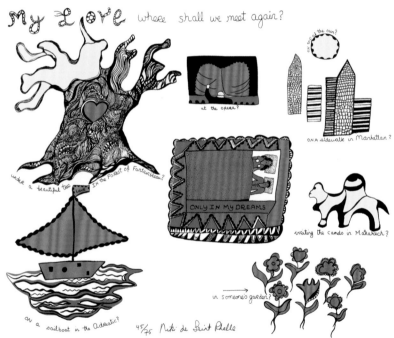

My Love Where Shall We Make Love? 1968
Screenprint
15¾ × 23¾ in. (40 × 60.3 cm)
The Menil Collection, Houston

My Love Where Shall We Meet Again? 1968
Screenprint
19½ × 24¼ in. (49.5 × 61.6 cm)
The Menil Collection, Houston

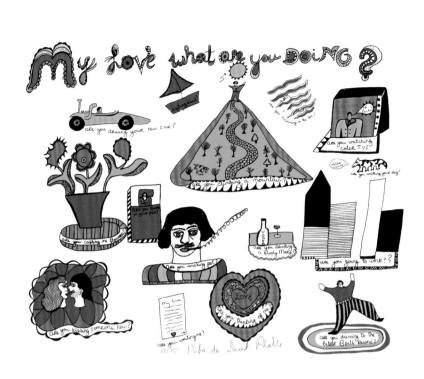

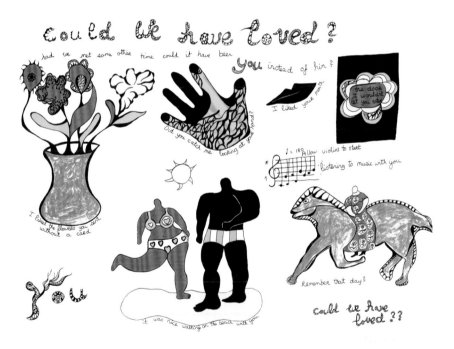

My Love What Are You Doing? 1968
Screenprint
19½ × 24¼ in. (49.5 × 61.6 cm)
The Menil Collection, Houston

Could We Have Loved? 1968
Screenprint
23¼ × 29¼ in. (59.1 × 74.3 cm)
The Menil Collection, Houston

NIKI DE SAINT PHALLE AND THE ETHICS OF AMBIGUITY

Alena J. Williams

Although Niki de Saint Phalle was born in France and raised in the United States, her artistic career took shape after she returned to Paris to live in 1952. Eight years later, her life shifted dramatically when she moved into the studio of the Swiss artist Jean Tinguely in the Impasse Ronsin. This was in the same year, 1960, that the French philosopher Simone de Beauvoir published her first autobiography, *La force de l'âge (The Prime of Life)*, on her intellectual and personal life before and during the Second World War, when Beauvoir and her life partner, the French philosopher Jean-Paul Sartre, were arguing about "the relationship between 'situation' and freedom."[1] In the memoir, Beauvoir sets out her existentialist ideas in relation to the expansion of her own subjectivity into the world, insisting that one person's "active transcendence of some given context" is neither equally applicable to, nor valid for, every situation or person.[2] In her previous work, Beauvoir had characterized the fundamental basis of this human condition as an *ambiguity*—that is, the perpetually unfulfilled desire for self-actualization due to "the paradoxes and necessary failures of action."[3] In this essay, I will explore the ways in which subjectivity negotiates and generates creative spaces of *existence* in Niki de Saint Phalle's work with respect to Simone de Beauvoir's philosophical thought, which was ascendant in the artist's own time.

In her 1947 book *Pour une morale de l'ambiguïté (The Ethics of Ambiguity)*, Beauvoir asserts that every subject is embedded in its own life circumstances, within and against which it makes choices: an *ethics*.[4] She differentiates between two types of ethics in relation to humanity's ambiguous condition: a nihilistic point of view and a creative point of view. Beauvoir points out that nihilism's valorization of negation and death overlooks the fact that one may nevertheless *go on living* despite a will for death.[5] Setting the creative point of view in contradistinction, she contends that intellectual and artistic endeavors—all the inventive works and creative thinking that our pursuit of freedom, in our unique contexts, might yield—reflect the "positive aspect of ambiguity."[6] She proposes that individuals grapple best with ambiguity by conducting productive, engaged lives and devotes many pages to aesthetics and to art's role in concretizing the "passionate assertion of existence in a more durable way."[7] With respect to Beauvoir's ethics, I will discuss how Saint Phalle's critical reconfiguration of the relations among embodiment, mortality, and material trace in her early work sought to desublimate death-making in artistic production, even as it simultaneously opened up critical intersubjective relations with the artist's professional and personal interlocutors in France.

In 1952 Saint Phalle had already begun reading the existentialist works of Sartre and his fellow French authors Jean Genet and Albert Camus; concurrently, she engaged deeply with Beauvoir's 1949 book *Le deuxième sexe (The Second Sex)*, which expands on ethical themes.[8] In this work, Beauvoir effectively asks, What freedom is possible, exactly, for the female subject under male oppression? Rather than differentiating the sexes within human societies along essentialist or biological lines, she draws a parallel between the conventional status of "woman" under patriarchy and in French society under German occupation during the Second World War. Living under oppression, according to Beauvoir's reasoning, necessitates an ethical response, one that is contingent upon a subject's unique situation, "personal psychic history," and "social circumstance."[9] If one chooses to live, she writes, one is nevertheless "a thing crushed by the dark weight of other things."[10] This existential situation was critical for Saint Phalle. In the summer of 1953, when she and her husband, the American musician Harry Mathews, were living in the South of France, a breakdown temporarily consigned her to hospitalized psychiatric care. Later that same year, Saint Phalle's father acknowledged in writing that he had raped her at the age of eleven.[11]

The artist's first published statement about the assault, made forty years later, explicitly equates existence with death: "Destruction is an affirmation that one exists in the face of all opposition."[12] In the wake of this incident, Saint Phalle was confronted with an ongoing ethical choice. Ultimately, during her 1953 convalescence, the pastime she had taken up in 1950—painting with gouache—expanded into full-blown artistic production.[13] She later wrote that she believed this creative activity would demonstrate that she "had a RIGHT TO EXIST.'"[14]

Yet, scholars have typically recounted the Impasse Ronsin as the site of two "primal scenes" with respect to Saint Phalle—first, her initial introduction to Tinguely, and second, the making of her first *Tir*, or "shooting painting," when the French art critic Pierre Restany formally invited her to join his countrymen Arman, François Dufrêne, Raymond Hains, Yves Klein, Jacques Villeglé, and Martial Raysse, as well as the Swiss artists Tinguely and Daniel Spoerri, in the Nouveau Réalisme movement. The Impasse Ronsin was an amalgam of derelict structures, provisional doorways, and metal sidings just off rue de Vaugirard in Paris, not far from the Montparnasse Cemetery, where both Beauvoir and Sartre were ultimately interred.[15] Even now, from the extant photographs, it is difficult to reconstruct all the relations among the actors, objects, and spaces of the site without some guidance from a hand-drawn map. In 1908, decades before the complex became a haven for the artists who varyingly lived or worked there—scribbling their names in white chalk on unceremonious signage—the Impasse was the site of a double murder.[16] What remains absent from any surviving documents, of course, are the psychic and intersubjective connections between the material object and its space of production and, above all, any reflection of the ways in which works of art, makers, and receivers inhabit matter in their environments.

My interest in the Impasse Ronsin is tied to the larger conversation it mobilizes about the ethical nature of Saint Phalle's practice. The site afforded her new personal and professional contexts and served as repository of relics and discursive relations across and among artistic subjectivities, creative activities, and works of art (p. 200). The French word *impasse* not only refers to a "dead-end street" but also denotes a particular "situation"—that of the "deadlock" or "blind alley"—which obliquely correlates Beauvoir's phenomenological ruminations on existentialism and death to the locus of Saint Phalle's creative life in the early 1960s. The Romanian sculptor Constantin Brancusi was a reigning four-decade presence in the Impasse when Saint Phalle and Mathews first crashed in the studio of the American sculptor James Metcalf in August 1956. Across from Brancusi's studio block (p. 201), the lives of two couples first intersected—those of Tinguely and his partner, the Swiss artist Eva Aeppli, with those of Saint Phalle and Mathews.[17] It was here that Saint Phalle began actively inventing novel life-work configurations of the kind that persist in contemporary feminism and political theory—especially the demand, articulated by the scholar Kathi Weeks, "to create spaces in which to constitute new subjectivities, new work and nonwork ethics, and new practices of care and sociality."[18] After Saint Phalle and her family officially moved to Paris in August 1956, she began living alone in order to work more intensively within this new social milieu.[19] The artist later wrote, "I did the worst thing a woman can do: I abandoned my children. I abandoned them as men often do for their work."[20]

While much has been written about Saint Phalle and Tinguely's relationship,[21] I am interested in what Saint Phalle's reinvention of her life-work situation reflects about her engagement with the world in existential terms. When she finally began living with Tinguely in the Impasse, her life and work radically diverged from her familial life with Mathews.[22] At the same time, literary impressions of Saint Phalle at this site by the German author, playwright, and

filmmaker Peter Weiss capture the artist's entirely new association between life and work:

> In the mornings I saw her in her workshops, which she inhabited with Tinguely, sheds, pavilions, next to the foundation walls of Brancusi's demolished studio, between factories, rubble heaps, high firewalls, the complex was full of constructions made from discarded metal, full of signs of adventurous work, a fairground with booths of marvelous happenings with torture machines, with two-headed calves.[23]

Saint Phalle lived at the complex amid the heterogeneous materiality of production. Aesthetic objects, built structures, and mechanical devices converged into new generative constellations, while discarded refuse coexisted synergetically with interpersonal connections.

Although it was likely class privilege that protected Saint Phalle from the oppression of wage labor and granted her the financial freedom to end her first marriage, she avoided reentering into a conventional union with Tinguely for the first eleven years of their relationship.[24] This privilege again sets her in dialogue with Beauvoir, whose father was a wealthy banker and who was similarly accorded a certain level of personal and professional freedom.[25] As the French theorist Jacques Derrida points out in *The Politics of Friendship* (1994), the "matter of living together, cohabiting in the same place (*tópos*), contracting marriages," or forging new kinship structures is political.[26] Like Saint Phalle and Tinguely, Beauvoir and Sartre critically rewrote relations between the sexes by pursuing romantic and sexual relations alongside and in tandem with their own relationship, rendering it as much an intellectual and political project as their philosophical and literary work.[27] Saint Phalle characterized her intimacy with Tinguely as either "violent disagreement"[28] or shared reciprocity.[29] For both

couples, cohabitation often operated metaphorically, corresponding to the ethics of living and working within a community rather than strictly within a single abode.[30] These configurations amplified Beauvoir's rejection of the idea that there is, by default, any separation between the self and others, because the mutual recognition and coexistence of selves and others—intersubjective relations—are a critical precondition of the individual subject's "life-world."[31]

An early assemblage Saint Phalle completed in this critical period exemplifies the interrelation of self, other(s), and work of art in a manner consistent with Beauvoir's thought. In *Tu est moi*, 1960 (p. 129), from the artist's *Paysage de la mort [Death Landscape]* series, Saint Phalle embedded various objects, including weapons and a rope, into a layer of plaster, with the red lid of a paint can hovering in the image's upper register. Significantly, the French title, *Tu est moi*, is grammatically incorrect; it literally translates as "you *is* me" because the verb Saint Phalle chose, *est*, is the form of *être* (to be) typically used for a third-person subject, while her subject, "you," is a second-person pronoun. Using the word *est*—"is"—suggests an equivalency between two different subjects, namely, those represented by the personal pronouns "you" and "me." At the same time, the third-person verb, *est*, implies a third subject—"he," "she," or "it"—one not explicitly enumerated in the sentence. The entire arrangement—and its sheer variety of significations—reflect the multiplicity of subject-object positions open to the viewer while engaging with a work of art. When spoken aloud, the title *Tu est moi* dilates the polysemy further; it sounds, invariably, like any of the following three statements: "you are me" (*tu es moi*), "you and me" (*tu et moi*), and "kill me" (*tuez-moi*).[32] Each of these shadow titles of the work relativizes the subject with respect to an *other*—or *others*. Beauvoir argues that death places subjectivity—and, significantly, one's own "situation"—in stark relief.[33] Saint Phalle's work

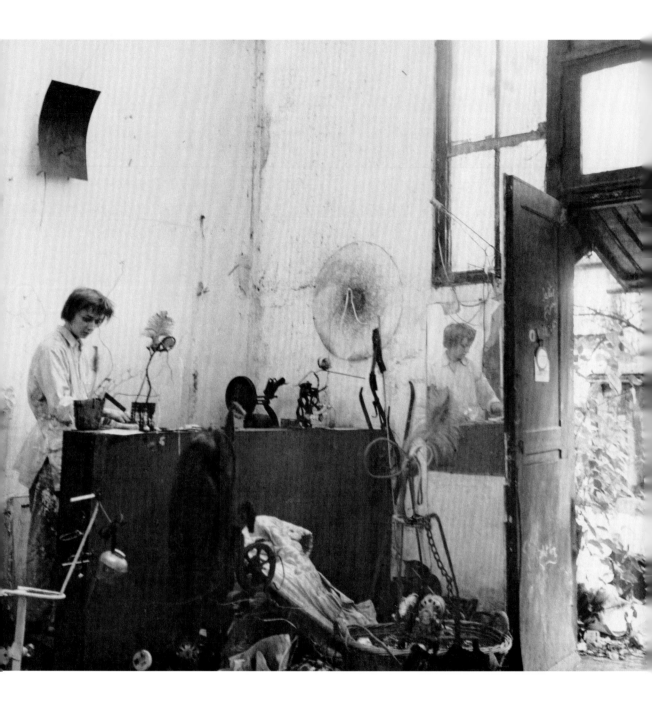

Saint Phalle working in her studio in the Impasse Ronsin, Paris, 1961. Photo by Shunk-Kender

Photograph by Constantin Brancusi of his studio in the Impasse Ronsin, Paris, 1925 , which, after the artist's 1957 death, remained intact though shuttered until the mid-1960s

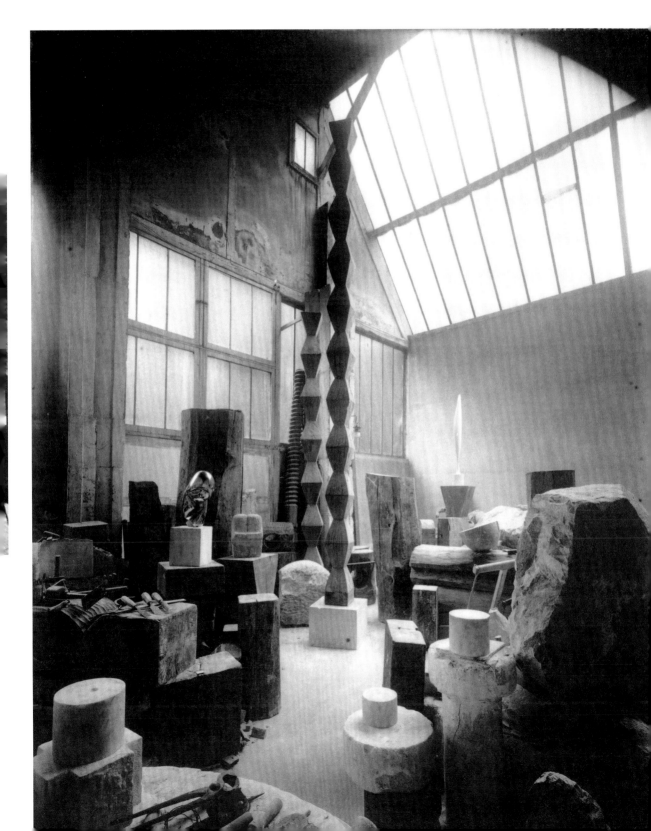

manifests these existential ethics in both linguistic and material form. The imperative statement, "kill me," implicates the speaker within an existentialist schema as both the primary *subject* of identification and an *object* of lethal violence.

Indeed, libidinal tension appears to have broken out in physical violence in Saint Phalle's early days in the Impasse Ronsin. Within the first few months of living there, she collaborated with Tinguely and Spoerri on another early work. It is as if the triad's unconsummated love triangle collapsed into a single object. On a white surface under a globular handful of white plaster, tool parts and broken objects congeal in high relief as if indiscriminately stuck to the painted assemblage. At the bottom edge of the work are the signatures of Tinguely, Saint Phalle, and Spoerri. The union of the three names reinforces the intersubjective relation of the artists' collective creative activity, bespeaking the empathetic mechanism by which one becomes aware of the subjectivity of other minds. The three-day period over which they completed the assemblage is parsed out next to their names, day by day—January 11–12–13, 1961—suggesting that they either created the piece with one another over the entire period or worked on it sequentially in a Neo-Surrealist exquisite-corpse style. In a statement addressed to Tinguely after his death, Saint Phalle wrote, "It was in 1960 that we fell in love with each other.... For you, I think it was when you realized you didn't like your friend Daniel Spoerri flirting with me."[34] This work, synthesizing the artists' respective subjectivities into a material unity, captures the highly contentious relations among the three of them, exemplifying the Beauvoirean idea that "a *common situation* can give rise to a *common project*," or her proposition that "a joint action is what creates ensembles."[35] It also resists the conscription of Saint Phalle and Tinguely's relationship into the rubrics of a modernist "anxiety of influence," by which the historiography of art seeks to differentiate between closely paired artists.[36] The artist later conceded that it had been Spoerri who openly questioned her persistent recourse to representational form.[37] When he suggested that she use a "real rocket" in her work instead of one made of nails, she "got very annoyed" and "slapped him."[38]

Even as incipient second-wave feminism was striving to liberate intimacy and love from heteronormative coupledom and reproductive labor in the 1960s, it was Saint Phalle's fundamental breach of the separation between author and work and her insertion of others into that schema—artists, viewers, readers, participants—that ultimately recommended her for membership in Nouveau Réalisme.[39] Villeglé featured her assemblage *Hors-d'oeuvre ou Portrait of My Lover*, 1960 (p. 128), alongside work by

Niki de Saint Phalle
Assemblage: Collaboration with Tinguely and Spoerri, 1961
Paint, plaster, and objects
17⅝ × 19 in. (45 × 49.5 cm)
Collection Bruno Bischofberger, Zürich

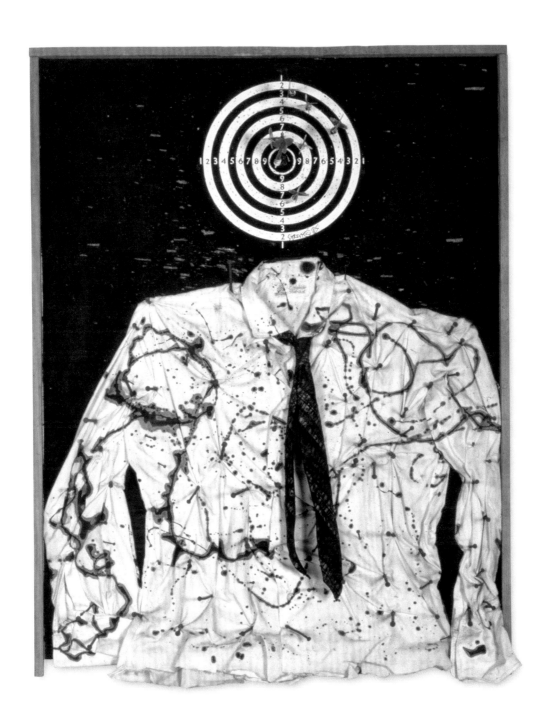

Niki de Saint Phalle
Saint Sébastien (Portrait of My Lover / Portrait
of My Beloved / Martyr nécessaire), 1961
Paint, wood, and objects on wood
39⅜ × 29⅛ × 5⅞ in. (100 × 74 × 15 cm)
Sprengel Museum Hannover, Donation of the artist (2000)

some of the Nouveaux Réalistes in *Comparaisons: Peinture Sculpture*, a group exhibition he curated at the Musée d'Art Moderne de la Ville de Paris in early 1961. When Saint Phalle made the assemblage, she was having an affair with a married artist, and she later claimed: "I didn't like this dependence so I bought a gun to kill him symbolically. There were no bullets in the gun. The revolver was in my handbag and it made me feel better."[40] *Hors-d'oeuvre* represents that unnamed lover in effigy, wearing one of his dress shirts.[41] In lieu of a face, a small, circular dartboard is affixed to a wood panel that the artist covered in paint, plaster, and buttons. Tellingly, in a subsequent iteration of the work, *Saint Sébastien*, 1961, Saint Phalle drove long nails into the figure's chest, as if to wound him. These two versions of the assemblage yield an interpretation analogous to *Tu est moi*, except that, in this case, the effect is achieved through action instead of words: during the *Comparaisons* exhibition, Saint Phalle encouraged visitors to throw darts at the figure's head, initiating them, too, into the ritualistic violence.[42] Once you assume the role of the dart thrower, "you," the viewer/participant, become "me," the artist—that is, Saint Phalle (*tu es moi*). The image's subject—Saint Phalle's lover (or one's own)—is what, by implication, invites a violent blow, or even death (*tuez-moi*).

Until this point, violence in Saint Phalle's work had operated in either symbolic or iconographic terms. Affective relations between the artist and the work of art had crystallized as ready-made weapons and sharp objects in other assemblages in the *Paysage de la mort* series, such as *Paysage de la mort (Collage of Death)* and *Le hachoir* [*Meat Cleaver*], both 1960. However, in 1961, with the *Tirs*, this hypothetical relation decisively shifted toward lethal force. If Brancusi's sculptures served as a critical hinge between abstraction and representation in

twentieth-century France, Saint Phalle shattered this dichotomy when she procured a rifle from a nearby carnival's shooting gallery—a popular mid-twentieth-century entertainment in Europe—for the purpose of firing it point-blank at her paintings. The French word *tir* refers to the *act* of shooting, and, typically, the prize awarded at the fairground was the shooter's portrait taken at the moment of hitting the target; thousands of such "snapshot" photographs issued forth from the galleries, which were rigged with cameras armed to "shoot" the winner. As the curator Clément Chéroux has illustrated, the pro-

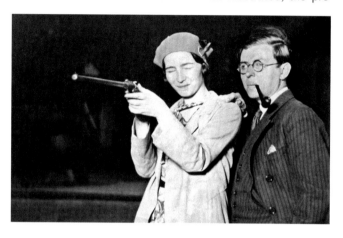

duction and circulation of these carnival portraits resonated with burgeoning existentialist thought; they encapsulated the way in which the awareness of death coincided with the assertion of the shooter's creative, expressive agency in a demonstration of skill.[43] This form of self-representation was double-edged: by transposing the game's target with the shooter's image, it simulated the act of suicide. Beauvoir and Sartre's own shooting-gallery double portrait at the fairground at Porte d'Orléans, Paris, in 1929—made the same year they met, in which she completed her initial studies at the Université de Paris and they both sat for the state exams in philosophy—captures this unexpected confrontation of annihilation and selfhood between the wars.

Simone de Beauvoir and Jean-Paul Sartre at the Porte d'Orleans fair, Paris, June 1929. Photo by JAZZ EDITIONS/Gamma-Rapho

In the wake of the German occupation of France and the Holocaust, weaponized violence became integral to the writing and political activism of the two philosophers. After the Second World War came to an end, and as Europe's imperial grip on the Global South withered, conflicts in Southeast Asia and North Africa began to localize within France itself and became a preoccupation for artists and intellectuals alike.[44] Despite the fact that the French public had voted to confer self-determination on Algeria in January 1961, local police, later that year, stringently enforced civic restrictions and curfews on Algerians and other French citizens of Arabic heritage in retaliation for the activities of the Front de Libération Nationale in Paris.[45] Sartre was an outspoken advocate for Algeria's sovereignty, and in July 1961 the Organisation Armée Secrète (OAS), a French right-wing terrorist group, targeted him with the first of two bombings at his residence in the rue Bonaparte.[46] At this time, both Sartre and Beauvoir singled out the Swiss sculptor Alberto Giacometti as an exemplar of existentialist thought; in their view, Giacometti imputed to the sculptural object "a face *in its context*," which reflected the subject's phenomenological relation to its environment (broadly defined) and its sociality.[47]

However, scholars have also read Saint Phalle's *Tirs* and her altarpiece *Autel O.A.S.*, 1962, in relation to the violence and censorship of the Algerian War of Independence.[48] Indeed, only a few weeks before the first bombing of Sartre's home, and just four blocks away, Saint Phalle opened her first solo exhibition of the *Tirs* at Galerie J, a commercial gallery owned by Jeanine de Goldschmidt-Rothschild,

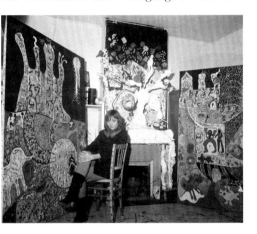

Restany's wife. The exhibition—entitled *Feu à volonté*, or "fire at will"—included a range of large-scale paintings and assemblages, some of which have survived only in pieces, as gallery visitors were invited to shoot a gun at the pictures for two hours every evening.[49] Postwar Nouveau Réalisme, according to the art historian Kaira Cabañas, "cut across a range of genres and mediums, including the visual arts, literature, and film,"[50] in order to advance what Restany conceived as "new ways of perceiving the real."[51] Saint Phalle's works made use of the same language of violence invoked in the lacerated posters of the *décollage* artists of Nouveau Réalisme, Villeglé and Hains; however, her deployment of the medium of painting as a participatory act manifested the acute distinction between the sphere of art and cultural production and the real.[52] On October 17, a few months after *Feu à volonté* closed, the police's suppression of Algerian resistance in Paris culminated in an all-out massacre on the streets. The incommensurability of these overlapping contexts—art institutions vs. social reality; freedom of artistic expression vs. revocation of civil liberties (namely, the right to live)—was not lost on Peter Weiss, who characterized the scene at Saint Phalle's opening at Galerie J as a kind of unwitting political theater.[53] Decades later, the artist herself marveled: "I could go around with my rifle on my back and nobody bothered me."[54]

For Saint Phalle, attention to the "situation" of her existence involved not only her civic context but also the materiality of the *Tirs* themselves, which are notoriously fragile. Plaster has traditionally been used in the reproduction, dissemination, and reception of

celebrated sculptures of the European tradition, from ancient Greek statuary to the work of the French sculptor Auguste Rodin. An amalgam of water and limestone, plaster undergoes an exothermic reaction, releasing energy in the form of heat, as it hardens. In opposition to Brancusi—for whom plaster facilitated the transformation of ideas from marble to bronze and the making of replicas to be installed in his studio—and Giacometti, who focused on plaster's suitability for anemic figuration, Saint Phalle mined the material's chemistry for its explosive potential. By design, the plaster surfaces of her *Tirs*—impregnated with bright colors—burst and shattered into pieces when shot with bullets. Over time, they have also succumbed to the forces of nature. In contrast to the European paintings canonized in the discipline of art history, the *Tirs* in Saint Phalle's *Old Master* series (pp. 130–33) are irreverently ill suited for their elaborate frames; the contents spill over, escape, and adulterate the picture plane while dissembling its separation from the world.

While plaster ranks fairly low in the hierarchy of mediums in comparison to gold, marble, or bronze, it often serves as a substitute for stone in architectural ornamentation and can be a wildly expressive material for provisional or hypothetical ideas; one compelling example is Rodin's *Assemblage of Heads of "The Burghers of Calais,"* 1880s/1926, an illogical tangle of heads and body parts that projects a beautifully grotesque unity.[55] Saint Phalle deployed this same substance crudely in her paintings, eschewing any pretense of masterful virtuosity. She later related:

> The first stage was construction. Plaster, tomatoes, eggs, whatever lay at hand. . . . After impregnating my figure with bags of color, I painted the whole thing white. That was absolutely necessary. It was a rite. It had to be totally white. It was like a sacrifice. It was like an assassination.[56]

The artist's iconographic representations of sacred architecture—in works such as *Autel noir et blanc (Autel)* [*Black-and-White Altar (Altar)*], *Cathédrale* (p. 152), and *Reims* (p. 153), all 1962—and the amalgam of skulls and mutilated human figures in her *Autel des innocents* [*Altar of the Innocents*], 1962, defile the aura around the work of art with a profane materiality. Even in her will to annihilate form, Saint Phalle executed an existentialist act by which the "negation of aesthetic, spiritual, and moral values [becomes] an ethics."[57]

As the scholar Jill Carrick has pointed out, contemporary critics thought Saint Phalle's audiences were "seduced during the *Tirs* into a symbolic act of self-destruction."[58] However, I would argue that the eroticism of the *Tirs* both overlaps and supersedes the act of sex. Unlike Tinguely's kinetic mechanical devices that stand in for specific *acts* of seduction and coitus—such as *Striptease*, 1961, and the explosive phallic ejaculation *La vittoria*, 1970—Saint Phalle's emphatic pronouncements that the shooting sessions were "EXCITING and SEXY"[59] embodied Beauvoir's intersubjective phenomenology. Above all, Beauvoir conceptualized eroticism itself as an ethics—as a "pleasurable existential life force," which the scholar Elaine Stavro asserts "is

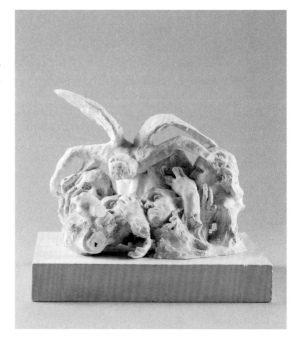

Auguste Rodin
Assemblage of Heads of "The Burghers of Calais,"
modeled late 1880s, cast 1926
Plaster
9½ × 11 × 9¼ in. (24.1 × 27.9 × 23.5 cm)
The Rodin Museum, Philadelphia: Bequest of Jules E. Mastbaum, 1929, F1929-7-92

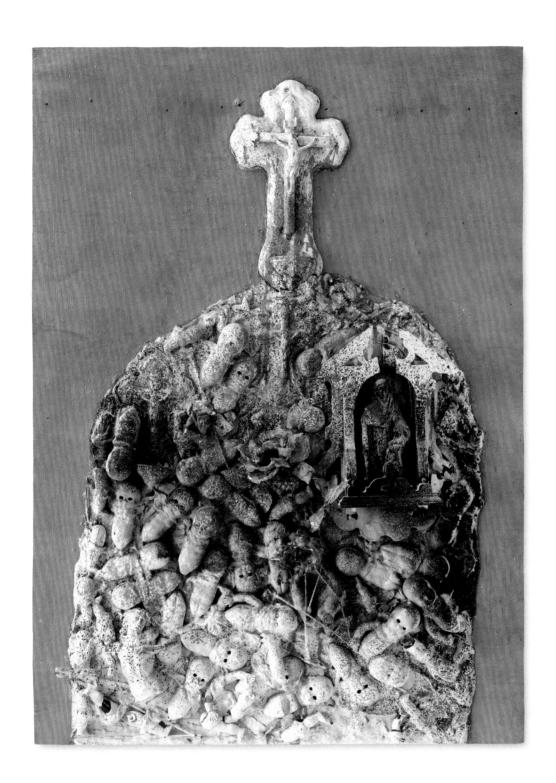

Niki de Saint Phalle
L'autel des innocents [*Altar of the Innocents*], 1962
Paint, plaster, and objects on plywood
39⅜ × 27½ × 5⅞ in. (100 × 70 × 15 cm)
Collection of Niki Charitable Art Foundation, Santee

life affirming" and "infuses both one's sexual and social activities."[60] This frenetic and erotic energy in Saint Phalle's work reflects a clear existential articulation of the desire to be "concretely engaged in the world, being purposive":[61]

> I became hooked on this macabre yet joyous ritual. It got to the point where I lost control, my heart was pounding during the shoot-outs. I started trembling before and during the performance. I was in an ecstatic state.[62]

Photographs documenting Saint Phalle's production in the Impasse Ronsin stunningly capture her art-making as an ethics of existential transcendence. Her corporeal engagement with the materiality of these paintings, and her forceful alteration of their physical state, reflected her own evolving self-actualization as a subject with agency in the world.[63]

Although Saint Phalle epitomized Beauvoir's existential subject with "the capacity to enlarge one's situation through shared understanding and communicative action,"[64] her position in the art world in France was predicated on the support of a predominately male peer group of the Nouveaux Réalistes. Saint Phalle's induction into this panoply of preeminent artists both reinforces the intersubjective nature of her practice and complicates the desire to align her ethics directly with radical feminism's rejection of "modes of ideological mystification, naturalization, privatization, and romanticization" over the decade that followed.[65] Saint Phalle identified as a feminist because she supported "equal wages, equal opportunities,"[66] yet her powerful connections to major art institutions and influential figures ran counter to ensuing strategies of feminist refusal. These include the idea of "deculturation," which sought—as the scholar Giovanna Zapperi has shown in her work on the Italian art historian and critic Carla Lonzi—to "situate women outside of patriarchal production" by rejecting the art world altogether.[67] However, Saint Phalle's loyalty to Tinguely, Restany, and Pontus Hultén, a Swedish curator and museum director, remained steadfast throughout her career.

For this reason, I would argue, Saint Phalle's engagement with the real was not merely a feminist gesture within Nouveau Réalisme but was simultaneously, and overwhelmingly, an existentialist assertion of artistic subjectivity. While Saint Phalle's copious use of vernacular objects—from common household tools to children's toys—situated her work within the formal aesthetics of Nouveau Réalisme, it also exemplified Beauvoir's concurrent existentialist understanding of the real in painting, which argues that "painting *itself* is this movement toward its *own reality*."[68] This autonomy is not of the same nature as that found in modernist theories of painting, which insist upon the separation of abstract painting from social reality. Instead, it is one which affirms Beauvoir's assertion that "every assassination of a painting is still a painting"[69]—that even in the face of ruination or destruction, works of art relate intersubjectively to their makers, other subjects, and the objective world.

Although existentialist philosophy situates the human subject as "a sovereign and unique subject amidst a universe of objects,"[70] the ontological status of the aesthetic object, according to this logic, persists in relation to its ever-shifting contexts. For Saint Phalle's work, the first of those contexts was the Impasse Ronsin, a large-scale assemblage of mortar, persons, and things; the second was the intimate intellectual community of the Nouveaux Réalistes; and the third was the nexus of intersubjective relations visible as residue and traces in the work of art. Yet, as I have endeavored to show, Saint Phalle's approach to making work in the early 1960s forced the autonomy of the objective world to hang in suspension. Her production emphasized the relationship between artistic identity and the objects that surround it and remain in its wake—

as matter existing according to its own principles. These objects circulate, scatter to the wayside, and dissociate from aesthetic form, reflecting the fragility of life and its ambiguity. Nascent in this idea, with respect to Saint Phalle, is the openness of her artistic subjectivity to the objective world and its engagement with others. This is where Beauvoir's conceptual understanding of "ethics as an art of living"[71] is central to any critical reading of Niki de Saint Phalle's practice. The artist's early work shifted away from an apotheosis of form toward the materialist nature of intersubjective relation—it was an ethical shift in the exploration of freedom.

For their generous thoughts and suggestions on this essay I thank Siona Wilson, Joseph Fitzpatrick, Giovanna Zapperi, Evan Neely, and Lauralee Summer.

1 Simone de Beauvoir, *The Prime of Life: The Autobiography of Simone de Beauvoir*, trans. Peter Green (New York: Lancer Books, 1962), 523.

2 Ibid. In the memoir, Beauvoir recounts a conversation she had with Sartre in 1940 about his plans for *Being and Nothingness* in which she questioned his assumption that existential transcendence is universal. See also Jean-Paul Sartre, *Being and Nothingness: An Essay on Phenomenological Ontology*, trans. Hazel E. Barnes (London: Methuen, 1958).

3 Sonia Kruks, *Simone de Beauvoir and the Politics of Ambiguity* (Oxford: Oxford University Press, 2012), 6.

4 Simone de Beauvoir, *The Ethics of Ambiguity*, trans. Bernard Frechtman (New York: Open Road, 1948).

5 Ibid., 61.

6 Simone de Beauvoir, "The Positive Aspect of Ambiguity," in *Ethics of Ambiguity*, 79–168.

7 Ibid., 137.

8 Simone de Beauvoir, *The Second Sex*, trans. Constance Borde and Sheila Malovany-Chevallier (New York: Vintage, 2012). On Saint Phalle's literary and philosophical influences, see Nathalie Ernoult, "Timeline," in Camille Morineau, ed., *Niki de Saint Phalle, 1930–2002* (Madrid: La Fábrica; Bilbao: Museo Guggenheim Bilbao, 2015), 316.

9 Elaine Stavro, *Emancipatory Thinking: Simone de Beauvoir and Contemporary Political Thought* (Montreal: McGill–Queen's University Press, 2018), 139.

10 Beauvoir, *Ethics of Ambiguity*, 5.

11 Ernoult, "Timeline," 316.

12 Niki de Saint Phalle, *Mon secret* (Paris: La Différence, 1994), n.p., quoted in Ernoult, "Timeline," 314. In 1993 Saint Phalle disclosed the rape and her forthcoming publication, *Mon secret*, to a *New York Times* reporter, Roger Cohen,

stating: "I was raped by my father when I was 11, so perhaps it's no wonder I started shooting my paintings." Quoted in Roger Cohen, "At Home with Niki de Saint Phalle; An Artist, Her Monsters, Her Two Worlds," *New York Times*, October 7, 1993.

13 Saint Phalle, *Mon secret*, quoted in Ernoult, "Timeline," 316.

14 Niki de Saint Phalle, "Letter to Jean," n.d., in Pontus Hultén, *Niki de Saint Phalle* (Bonn: Kunst- und Ausstellungshalle der Bundesrepublik Deutschland; Stuttgart: Gerd Hatje, 1992), 147.

15 Renewed attention has been brought to the Impasse Ronsin with two recent exhibitions: *Impasse Ronsin: Meurtre, amour et art au coeur de Paris,* Museum Jean Tinguely, Basel, October 21, 2020–January 24, 2021, and *Impasse Ronsin*, Paul Kasmin Gallery, New York, October 28, 2016–January 14, 2017. See Adrian Dannatt, ed., *Impasse Ronsin* (New York: Paul Kasmin Gallery, 2016). See also James McAuley, "The Artists and Their Alley, in Postwar France," *New York Times*, September 22, 2016.

16 The French socialite Marguerite Steinheil (1869–1954) was suspected of killing her husband, Adolphe Steinheil, a painter, along with her mother, Emilie Japy, on May 31, 1908, in their shared residence in one of the Impasse's front buildings. See Kate Summerscale, "How to Frame a Murder: The Photographic Pioneer Who First Helped Police Decode a Crime Scene," *The Telegraph*, October 8, 2015, https:// www.telegraph.co.uk/photography /what-to-see/steinheil-murder -summerscale-bertillon/. See also Adrian Dannatt, "Murder!" in Dannatt, *Impasse Ronsin*, 45–56.

17 "During this period Harry and I got to know Jean and Eva as friends. We would occasionally drop by each other's quarters for a visit every month or so. They lived in quite an original way as a married couple. Eva had her teenage lover living with her and Jean had many girlfriends who came and went. All of this took place above board, in what seemed to be total harmony." Niki de Saint Phalle, *Harry and Me: 1950–1960, the Family Years* (Zürich: Benteli, 2006), excerpt reprinted in Dannatt, *Impasse Ronsin*, 163.

18 Kathi Weeks, *The Problem with Work: Feminism, Marxism, Antiwork Politics, and Postwork Imaginaries* (Durham, NC: Duke University Press, 2011), 174.

19 Mathews later wrote, "Niki had disappeared from my life, from family life, from about September of 1959 until a couple of months before her show at Galerie J in the summer of 1961." Harry Mathews, untitled text, in Dannatt, *Impasse Ronsin*, 168.

20 Niki de Saint Phalle, *Traces: An Autobiography; Remembering 1930–1949* (Lausanne: Acatos, 1999), 90, quoted in Ernoult, "Timeline," 319.

21 See Patrizia Cattaneo Moresi, Alice Invernizzi, and Francesca Masciadri, eds., *Niki de Saint Phalle Jean Tinguely Duo: Anime ribelli, spiriti gemelli, destini intrecciati nell'arte/ Rebel Souls, Kindred Spirits, Intertwined Destinies in Art* (Melano, Switzerland: Artrust, 2015); Veronica Kavass, *Artists in Love: From Picasso and Gilot to Christo and Jeanne-Claude; A Century of Creative and Romantic Partnerships* (New York: Welcome Books, 2012); and Bloum Cardenas, Ulrich Krempel, and Andres Pardey, eds., *Niki & Jean: L'art et l'amour* [in German] (Munich: Prestel, 2005).

22 Saint Phalle and Mathews divorced in late 1963 after separating in 1960. Ernoult, "Timeline," 319, 326.

23 Peter Weiss, *Notizbücher,* vol. 1, *1960–1971* (Frankfurt am Main: Suhrkamp, 1982), 12. Translation mine. Weiss exercised extensive poetic license in these accounts of his visits to Paris in the 1960s. Reprinted from his notebooks, the narration is a bemused yet sharp critique of artistic goings-on in the Montparnasse and Saint-Germain-des-Prés districts. The last of Brancusi's studio spaces in the Impasse Ronsin was demolished at some point after Saint Phalle and Tinguely moved out in 1963; according to the American painter Reginald Pollack (who also rented a space in the complex), the adjacent Hôpital Necker–Enfants Malades, which owned the land, needed to build a heating facility on the property. Reginald Pollack, "Paris in the Fifties: A Golden Age in the City of Light," excerpt reprinted in Dannatt, *Impasse Ronsin,* 90.

24 With respect to Saint Phalle's financial circumstances, Harry Mathews later said, "I had always had enough money to keep us fed, lodged, and provided for in general. She'd never had to fend for herself, and after we separated she never asked for any alimony, she just asked me at one point to buy some of her work, which I did, eight or nine pictures"; he also stated that it was Tinguely who encouraged Saint Phalle to sustain herself with the commercial sale of her work. Mathews, untitled text, in Dannatt, *Impasse Ronsin,* 168.

25 Although Beauvoir began addressing class privilege in her work in 1955, it is unclear whether Saint Phalle ever explicitly reflected upon it. See Sonia Kruks, "Confronting Privilege," in *Beauvoir and the Politics of Ambiguity,* 93–123; Simone de Beauvoir, *Privilèges* (Paris: Gallimard, 1955); Simone de Beauvoir, *Force of Circumstance,* trans. Richard Howard (New York: Putnam, 1965); and Simone de Beauvoir, *Political Writings,* ed. Margaret A. Simons and Marybeth Timmermann (Urbana: University of Illinois Press, 2012), esp. pp. 37–258.

26 Jacques Derrida, "Recoils," in *The Politics of Friendship,* trans. George Collins (New York: Verso, 2005), 199.

27 According to Nathalie Ernoult, Tinguely and Saint Phalle married in 1971 for the purpose of estate management (Beauvoir and Sartre, by contrast, never formalized their relationship with a marriage). Saint Phalle's granddaughter Bloum Cardenas has noted that Tinguely's anticipation of a child with Micheline Gygax may also have precipitated the marriage. See Ernoult, "Timeline," 326, and Bloum Cardenas, "Niki & Jean," in Cardenas et al., *Niki & Jean,* 18. Beauvoir's 1943 *L'Invitée (She Came to Stay)—* a fictionalized account of her and Sartre's relationship with her student Olga Kosakievicz, to whom she dedicated the novel— captures the contentious nature of these intersubjective ethics. See Simone de Beauvoir, *She Came to Stay: A Novel,* trans. Yvonne Moyse and Roger Senhouse (Cleveland: World Publishing, 1954).

28 Saint Phalle, quoted in Cohen, "At Home with Saint Phalle."

29 "Between you and me was forged a solid friendship, founded on our mutual passion for our work." Niki de Saint Phalle, "A Little of My Story with You, Jean," in *Museum Jean Tinguely Basel: The Collection* (Bern: Benteli, 1996), 16.

30 At the end of 1963—the same year Saint Phalle and Mathews's divorce was finalized—and after Saint Phalle and Tinguely were evicted from the Impasse Ronsin, they purchased the Auberge du Cheval Blanc, a former hostel and brothel south of Paris, near Soisy-sur-École. They transformed parts of the house and garden into studios, and Saint Phalle used the house as a permanent residence, while Tinguely lived elsewhere. See "Soisy-sur-Ecole, 1963," in Cardenas et al., *Niki & Jean,* 93. Saint Phalle's comments on marriage to the French art historian and novelist Maurice Rheims six years before their marriage would seem to support the idea that the union was primarily administrative: "Marriage is the death of the individual, it's the death of love. . . . When you ask me the question about marriage, what's evident is a total lack of individuality due to male incompetence at assuming real responsibilities." Quoted in Maurice Rheims, "Niki de Saint Phalle: L'art et les mecs," *Vogue Paris,* February 1965, quoted in English translation in Morineau, *Saint Phalle 1930– 2002,* 89.

31 See Edmund Husserl, *Cartesian Meditations,* trans. Dorion Cairns (Dordrecht: Kluwer, 1970), 136. Even Saint Phalle's writing seems to capture these ideas of intersubjectivity: "Is perceiving only personal? Does that mean my version is only mine? Where does that put reality? Does it exist? Do I exist?" Saint Phalle, "A Little of My Story," 13.

32 Cécile Whiting, "Apocalypse in Paradise: Niki de Saint Phalle in Los Angeles," *Woman's Art Journal* 35, no. 1 (Spring/Summer 2014): 16. See also "*Tu est moi (You are me)*, 1960," Princeton University Art Museum website, accessed December 19, 2020, https://artmuseum.princeton .edu/collections/objects/32702.

33 "Death challenges our existence, it also gives meaning to our lives. It may be the instrument of absolute separation, but it is also the key to all communication." Beauvoir, *Prime of Life*, 731.

34 Saint Phalle, "A Little of My Story," 18. According to Spoerri, he, Aeppli, and Tinguely had a consummated love triangle in Basel, predating their time in Paris. Daniel Spoerri, untitled text, in Dannatt, *Impasse Ronsin*, 121. Tinguely was initially resistant to sharing Saint Phalle with others, and she and Spoerri were never intimate after Tinguely thwarted their first date. However, Saint Phalle was intimate with Aeppli, among others.

35 Sonia Kruks, *Situation and Human Existence: Freedom, Subjectivity, and Society* (London: Unwin Hyman, 1990), 94.

36 Harold Bloom, *The Anxiety of Influence: A Theory of Poetry* (New York: Oxford University Press, 1973). Art historians have begun addressing the interrelation of intimacy, visual representation, and work. See C. Ondine Chavoya and David Evans Frantz, eds., *Axis Mundo: Queer Networks in Chicano L.A.* (Los Angeles: ONE National Gay and Lesbian Archives at the USC Libraries; Munich: DelMonico Books/Prestel, 2017); Bibiana Obler, *Intimate Collaborations: Kandinsky and Münter, Arp and Taeuber* (New Haven: Yale University Press, 2014); and Whitney Chadwick and Isabelle de Courtivron, eds., *Significant Others: Creativity & Intimate Partnership* (New York: Thames and Hudson, 1993).

37 "I would say the one person who really influenced me with my early collages, by pushing me to go farther, more directly, was Spoerri, not Jean, because Spoerri was involved with collage." Niki de Saint Phalle, quoted in Ernoult, "Timeline," 322. See also Jo Ortel, "Re-Creation, Self-Creation: A Feminist Analysis of the Early Art and Life of Niki de Saint Phalle," PhD diss., Stanford University, 1992, 131.

38 Niki de Saint Phalle, interview by Jo Ortel, June 12, 1989, Soisy-sur-École, France, quoted in Ortel, "Re-Creation, Self-Creation," 131. Spoerri tells a different story: "In Niki's early work she put objects in plaster, fixing them down, and when I said she was copying me she actually gave me a slap, so she was no longer my great friend, to put it mildly. To tell the truth none of us were really 'copying': we were all together, it was more an affinity within this community of artists." Spoerri, untitled text, in Dannatt, *Impasse Ronsin*, 127.

39 On second-wave feminism and marriage, see Silvia Federici, *Revolution at Point Zero: Housework, Reproduction, and Feminist Struggle* (Oakland, CA: PM Press, 2012). See also Mia Ruyter and Chuck Thurow, "Why Marriage? Introduction," *Carceral Notebooks*, no. 10 (2014): 1–4, http://www.thecarceral.org /cn10/WhyMarriage-revised -feb18.pdf.

40 Saint Phalle, "Letter to Jean," 156.

41 Ibid.

42 Ernoult, "Timeline," 319.

43 I had the opportunity to visit Clément Chéroux's compelling exhibition *Shoot! Existential Photography* at the 2010 Rencontres d'Arles photography festival, which subsequently inspired the present essay. The show, which included Peter Whitehead's photograph of Saint Phalle pointing a gun in the film *Daddy*, was co-organized with the Museum für Photographie Braunschweig and traveled to the Photographer's Gallery, London, in 2012–13. See Clément Chéroux, *Shoot! Existential Photography* (Berlin: Revolver, 2010). See also Annebella Pollen, "Moving Targets: Photography and Its Metaphors," *Modernism/Modernity* 20, no. 1 (January 2013): 123–27.

44 For the influence of postwar anticolonial movements on art in France, see Hannah Feldman, *From a Nation Torn: Decolonizing Art and Representation in France, 1945–1962* (Durham, NC: Duke University Press, 2014), and Laurence Bertrand Dorléac, *L'Ordre sauvage: Violence, dépense et sacré dans l'art des années 1950–1960* (Paris: Gallimard, 2004).

45 See Jean-Luc Einaudi, *La bataille de Paris* (Paris: Seuil, 1991). On the French electorate, see David Drake, *Intellectuals and Politics in Post-War France* (New York: Palgrave, 2002), 124–25.

46 See David Drake, "Colonialism and Anti-colonialism: Indochina and Algeria," in Drake, *Intellectuals and Politics*, 119–27; the bombings are discussed on p. 126.

47 Beauvoir, *Prime of Life*, 588; Jean-Paul Sartre, "The Search for the Absolute," in *Albert Giacometti* (New York: Pierre Matisse Gallery, 1948), reprinted in Jean-Paul Sartre, *We Have Only This Life to Live: The Selected Essays of Jean-Paul Sartre, 1939–1975*, ed. Ronald Aronson and Adrian van den Hoven (New York: New York Review of Books Classics, 2013), 187–97.

48 Ernoult, "Timeline," 320. There are two versions of *Autel O.A.S.*, one that was shot when it was created and a bronze edition of the work from 1992. According to the scholar Nicole L. Woods, Saint Phalle recognized the implications of her *Tirs* against the backdrop of the Algerian War. Nicole L. Woods, "Pop Gun Art: Niki de Saint Phalle and the Operatic Multiple," in Eric Crosby with Liz Glass, ed., *Art Expanded, 1958–1978*, Living Collections Catalogue 2 (Minneapolis: Walker Art Center, 2015), http://walkerart.org /collections/publications/art -expanded/pop-gun. See also Laurence Bertrand Dorléac, "Living to Live: The Conditions for Another Politics," in Morineau, *Saint Phalle 1930–2002*, 102–9, and Pontus Hultén, "La fureur et la plaisir du travail," in Hultén, *Saint Phalle*, 15.

49 For the history of this gallery, see Elienne Michelle Wells Lawson, "Pierre Restany, Jeannine de Goldschmidt, and the Galerie J (1961–1966): The Art of Marketing Nouveau Réalisme" (MA thesis, University of London/Courtauld Institute of Art, 2002).

50 Kaira Cabañas, *The Myth of Nouveau Réalisme,: Art and the Performative in Postwar France* (New Haven: Yale University Press, 2013), 16.

51 Pierre Restany, "The Nouveaux Réalistes Declaration of Intention" [1960], trans. Martha Nichols, in Kristine Stiles and Peter Selz, eds., *Theories and Documents of Contemporary Art*, 306–7.

52 On the disparate strategies of realist aesthetics in Nouveau Réalisme with respect to the real, see Cabañas, *Myth of Nouveau Réalisme*, especially pp. 96–125.

53 Weiss, *Notizbücher, 1960–1971*, 11–12.

54 Niki de Saint Phalle, "The *Sun God* and Other Sculptures" (lecture, Price Center Theatre, University of California San Diego, April 5, 1994), DVD, vol. 4 of *Stuart Collection*, produced by UCSD-TV in con- junction with the Stuart Collection, 54 min., UC San Diego Library, La Jolla, CA.

55 Laure de Margerie (delivered by Richard Brettell), "Plaster in the French Sculpture Census" (lecture, 360 Speaker Series Panel Discussion ["Plaster: Medium and Process"], Nasher Sculpture Garden with Edith O'Donnell Institute of Art History, University of Texas, Dallas, August 27, 2016), YouTube video, 1:21:42 (begins at 21:53), https://www.youtube.com/watch ?v=VbxfeRkz0nY&t=1319s.

56 Quoted in Rheims, "Saint Phalle," quoted in English translation in Morineau, *Saint Phalle 1930–2002*, 88.

57 Beauvoir, *Ethics of Ambiguity*, 59.

58 Jill Carrick, "Phallic Victories? Niki de Saint-Phalle's *Tirs*," *Art History* 26, no. 5 (November 2003): 712.

59 Niki de Saint Phalle, "Letter to Pontus," n.d., in Hultén, *Saint Phalle*, 160–65.

60 Stavro, *Emancipatory Thinking*, 147.

61 Ibid., 149.

62 Saint Phalle, "Letter to Pontus," 164. After 1963, Saint Phalle renewed the shootings only for documentary purposes and on commemorative occasions, such as the tenth- anniversary celebration of Nouveau Réalisme held in Milan in 1970.

63 Stavro, *Emancipatory Thinking*, 141. See also Sara Heinämaa, *Toward a Phenomenology of Sexual Difference: Husserl, Merleau-Ponty, Beauvoir* (Lanham, MD: Rowman and Littlefield, 2003).

64 Stavro, *Emancipatory Thinking*, 325.

65 Kathi Weeks, "Down with Love: Feminist Critique and the New Ideologies of Work," *WSQ: Women's Studies Quarterly* 45, nos. 3-4 (Fall/ Winter 2017): 38. As Weeks points out, Beauvoir's work critiques the naturalization of romantic love (p. 49). See also Shulamith Firestone, *The Dialectic of Sex: The Case for Feminist Revolution* (New York: Farrar, Straus and Giroux, 2003).

66 Saint Phalle, quoted in Cohen, "At Home with Saint Phalle."

67 Giovanna Zapperi, in conversation with the author, Paris, April 7, 2013. See Giovanna Zapperi, "Self- Portrait of a Woman: Carla Lonzi's *Autoritratto*," trans. Jason Francis McGimsey, previously published as "L'autoportrait d'une femme: Préface," in Carla Lonzi, *Autoportrait*, ed. Giovanna Zapperi, trans. Marie-Ange Marie-Vigueur (Paris: JRP Ringier, 2012), 7–35.

68 Beauvoir, *Ethics of Ambiguity*, 140. Emphasis mine.

69 Ibid., 59.

70 Ibid., 6.

71 Karen Vintges, *Philosophy as Passion: The Thinking of Simone de Beauvoir* (Bloomington: Indiana University Press, 1996), 94.

INSIDE
THE
EMPRESS

Ariana Reines

My eyelids were flitting like sparrows and leaking liquid all over me. I say they were like sparrows because they fluttered like the little birds that betoken the presence of the Holy Spirit in old paintings and because the sensation in their fretfulness was that my eyes were not eyes and most of all that they did not belong to me. They gave me to imagine the motes of light and birds conjuring sunlight into a prism of such intensity it transfigured the little girl who would become, while still a girl, Joan of Arc. And like the knights that too once tilted within me other histories, which survive down to today as metaphors for things my body does, roared their roaring feeling through my blood. My heart was God's vessel beckoning for my attention. Would I too be called to high deeds? But without the kind of pain that smashes the brain to smithereens, shatters mirrors, and resolves right angles into the curvaceous caverns on whose walls, deep in a France that hides behind the France we know, art began, how could I ever learn the discipline to carry a vision all the way through to its achievement?

But I'm not talking about myself. I'm talking about her.

I saw my father grinning like a worm. I saw him on Instagram. His birthday had just passed. I didn't call him, as he never calls me—and a small squirt of love rose in my guts and fell back down and died in the place where it began.

Unmolested & safe inside my Freedom
Of Expression I maintained my argument
Against him, not because he harmed me the way, at eleven,
Her father hurt her, but because he abandoned me for his
religion, he left me alone with my mother.

Some of us, as we climb out of the hole of our youth, I mean especially when we are first beginning, have a need to make works or to construct situations in which it is possible to kill our parents. I think many artists would agree with this, including those of us who never suffered nervous breakdowns, were not born rich or raised to find husbands, including those of us who never wanted literally to put a bullet into anything, except perhaps our own brains. Some of us as we are climbing out of the hole of our youth especially find it necessary to do violence to the tradition that seemed to be killing us the whole length of our education.

The noble aggression of a cunning youth full of nothing but her-self, identifying her target, and proving herself against an entrenched adversary is a story as old as the Marasa, David, and Odysseus and as enduring as Billy the Kid and Godfather Two. In certain women it runs very deep. I'm talking about how Niki de Saint Phalle staged painting in order to put bullets in her past, used her considerable beauty only just enough, organized a good old-fashioned American cowboy showdown, and had the wisdom to move onto brighter climes once her score had been settled.

To clear space for the worlds living through her, she would have to assassinate important aspects of her education, certain looming figures that would otherwise keep her in the corner for-ever. Doubtless it is a privilege to carry out these killings in aesthetic, in symbolic space. I understand this need and the aggression and insanity of her youth because my body—even without her nobility, her aristocracy, her beauty, or the particular damage her father inflicted on her—I understand why she broke plates and fired guns into a plane in which time and space were one, and the assertion of her existence had to be made explicit, both in the timelessness of Art's histories and in the eyes of the people assembled to watch her take aim, in figure-hugging white, a model doing things with "the gaze" that had not yet been done, and causing her assemblages to bleed and change, kind of cartoony and funny, like ketchup in a grindhouse movie, but also carnivalesque and chevaleresque, on account of her excellent aim.

The *Tirs* refer, it seems to me, to centuries of bloody Christs and tortured saints, to which spaghetti westerns also referred. They also send us back to Rimbaud, not only the bullet Verlaine put into his hand but his time of the assassins, his "Dormeur du val," one of the most understated and enduring war poems of all time, and his gunrunning in Abyssinia. As I write this my culture is so awash in white supremacist murder, in miserable teenagers destitute of legends, and in contorted loathing of the feminine that the erotic dimension of how she staged herself, and more importantly the fattening lusciousness, the joy unblemished by shame and unencumbered by any need to justify itself by pointing to any prior brokenness, the genial immensities to which her oeuvre would become the testament as the era of the *Nanas* began to feel like a miracle.

When looking at what she made from the outside, the broken china and bullet-ridden patriarchs of her earlier work seem almost to justify the exuberant, immense joy the *Nanas* would evince—to go from arranging shattered pieces on a flat plane to shooting textured assemblages that would paint themselves in getting shot to the mosaic convexities and unabashed joy of the style we really know her for—I mean, you almost see Nicki Minaj in them—I have to ask what is it in my bad training, my own ingrained misogyny, that needs a woman broken, enraged, or in an out-and-out duel with her overlords, in order to appreciate the courage it took for Niki de Saint Phalle to refer us to a deeper beauty and an experience of vastness that was no longer about a woman's being looked at, but rather about our being encompassed by the feminine itself, like the long starry body of the Egyptian goddess Nuit, whose very flesh is the entire vault of heaven, the universe itself?

This is what I mean by *inside* the Empress. When you were a child, you ever stare at a seashell and dream yourself tiny enough to live inside the palace of it? Did you ever stare at a scallop shell and understand all Pantheons and Capitols to be its mere enlargement? Did you ever look at a playing card, a double-headed Queen or Jack of Hearts and wonder, really wonder, what it was they were, with their mysteriously signifying and far from blank faces, or stare into the face of a gerbil or a goldfish or a dog and ask yourself just who and what they were, really? Did you ever imagine your way into the heart of yourself? It's a child's simple skill, and it's a cliché to say we're educated out of it, but to understand ourselves as figures in unbreakable relation to a great, an encompassing divinity and beauty—this faculty is essential, I think, to comprehend an exultant experience of sculpture—of space—that teaches the viewer what she really lives within, rather than merely to look at objects in rooms, things for sale, ideas on a page.

I don't know of a good equivalent in English for *nana*. It's a casual term for a woman that can be derogatory or neutral depending on the context. French people don't call their grandmothers Nana but I do hear a little of the Spanish language's and many cultures' *Mami* which is used to address females of all ages, including little girls by their own mothers. Nana is both casual and reverent and can also be dismissive, like Bitch, as in where my bitches at. You'll see Nana translated as "broad," "chick," "babe," and "girl," we could also add "ho," "heaux," and a nod to the Sumerian queen/goddess Inanna, and, inevitably, in this day and age, though Niki of course predates her, Rihanna.

I am engaging in dreary semantics here because there is something about a term that contains its opposite, an endearment that can also be a condemnation, that seems to speak to the enduringly peculiar position of the feminine on planet Earth. It cannot merely be respected. It is either the immensity that devours us or the force that must be continually turned into a thing to look at or institutionalized like a public utility you can access at home—a faucet, a gas main, a drab domestic transmitter of general fuel. When you first begin to glimpse the depths of all you are and more, the immensity of what moves through you, it *is* like a fairy tale and like a horror story, and I mean this unmetaphorically. The way I was taught art of the Renaissance, single-point perspective, the visible was given to me as some kind of diagram or copy of the known. But what I always loved were the curvaceous animals at Lascaux and the gold glair of Duccio—testimonies to an inner world, to treasures that cannot be earned, and to a vastness we have not been trained to love, let alone understand.

We are dealing, here, with an artist who inherited the great weight of chivalric myths, whose name literally means Saint Phallus, whose beauty and stern mother and whose brilliance and marriage within the avant-garde could not make her happy, whose productively competitive partnership with Jean Tinguely and perhaps also the preferable miseries of that entanglement inspired her to push herself to greater heights of devotion to her purpose.

If I had been a knight in the thirteenth century, serving faithfully my suzerain lord, I might have been delighted to come back, in 1930, as Niki de Saint Phalle, whose many exuberant high deeds on behalf of the feminine and the space of art itself could only be dismissed, by academic feminists, as commercial for so long. Is it really so difficult to trust those who come to art for their own survival? I think it is more difficult, at this stage, to trust a woman who affirms joy.

Honestly, it used to bother me that Captain Misery himself,
Ludwig van Beethoven, wrote an Ode to Joy. Why did joy
need to be praised? Doesn't it contain its own joy? Now that I'm
older I understand that in an agonistic culture like this one,
which celebrates strife and ambition, murder and mayhem, over
care, hilarity, and delight, joy must in fact be praised and praised
formally, lest we forget entirely its virtues.

I have survived myself, and daily I drink the nectar of this fact.

This nectar is in fact a brine: my cup is full of sweat. I drink it
and I am covered in it. I keep on having to make my joy from
scratch. This makes me feel insane, but it is also my happiness,
and I think I feel I relate to her in this.

I see a woman who managed to transmute her inheritance into
a joy she cannily put into circulation, first on the stage of her
personal life, then as happenings dead center in the avant-garde,
then moving into, through, and out of major museums, &
ultimately onto the landscape itself, building & inhabiting
sculpture whose particles she breathed in, and they killed her.
To die in the accomplishment of a great errand is a knight's
true privilege and she did so. I read somewhere that every day
she'd laugh intentionally for twenty minutes to clear her
lungs. How many knights have sacrificed themselves not in
conquest of the feminine, which is how the old romances are
organized, but as the feminine's true servant? Niki de Saint
Phalle is a fairy tale to me, and it's because I know my own faults
so well that I can comprehend the grit and unlikelihood of
her achievement. It hurts to have been able to speak so little
from inside the Empress. That's the fallenness of all Aboutness.
The archaic smile and voluptuous body of the universe
itself are a seduction that, I suppose, should embarrass a poet,
no matter how true of heart she swore to be.

WILD MAID, WILD SOUL, A WILD, WILD WEED

Niki de Saint Phalle's Fierce Femininities in the 1960s

Amelia Jones

Niki de Saint Phalle (NSP) produced an art that was simultaneously joyous and angry. (I will call the artist NSP to avoid the overfamiliar "Niki" as well as the awkward problem of her aristocratic surname, which relates to her father's family property.)[1] This is no small accomplishment. Binding signals of happiness and rage in singular objects and performances is a strategy that parallels and, arguably, elaborates the life experiences NSP extensively explored in autobiographical writings and artworks, and it points to the radical feminist energy of her oeuvre. Here, I will focus primarily on the period of the 1960s in which NSP developed this strategy of twinning play and danger, happiness and malevolence, cheer and despair, in works that speak to the particular paradox of being an ambitious, creatively gifted, and intellectually astute woman making art in that period of Euro-American history.

It was NSP herself who used the terms "wild maid," "wild soul," and "a wild, wild weed," embedded in my title; she called them forth to describe herself in her autobiography *Traces*. The "wild maid" points to a femininity characterized by simultaneous savageness and restraint ("the wild maid is hidden in my woman's heart, often tamed and contained"), and the "wild soul" and the "wild, wild weed" to her life-long tendency "to rebel and to experiment."[2] I open with the words of NSP because her insistent elaboration of her life story—in autobiographical books and published letters to her daughter and granddaughter as well as in interviews—has become inextricable from her art, providing its overdetermined discursive context.[3] This elaboration was itself part of her strategy of doubling emotional registers—of enacting on a literal and literary level the complexities conveyed by her visual artworks and performances.

But in accepting this inextricability of NSP's autobiography and artistic practice, it is worth questioning *how* best to address the life stories in relation to the art. I hope to signal immediately the impossibility of avoiding biography with NSP and, at the same time, the dangers of drawing on it (most often through her own statements) to "explain" the appearance, meaning, and significance of her work. In a sense, among many other values, this overt connection between autobiography and artwork makes NSP's career a perfect case for interrogating how these two registers actually connect. It raises key questions, such as: how can we "know" the significance of the link between NSP's life and the objects and remnants that survive today as her work, no matter how directly NSP seems to have associated them with each other? For example, in a moving letter to her granddaughter in which, at one point, she purports to address her father directly, she links her *Tirs*, or "shooting paintings," to her anger over being raped by him at age eleven:

> In 1961, daddy, I would revenge myself by
> shooting at my paintings with a REAL GUN.
> Embedded in the plastic were bags of paint.
> I shot you green and red and blue and yellow.
> YOU BASTARD YOU!
> When you saw me do this did you ever guess
> I was shooting at you?[4]

NSP articulates, in various mediums, this theme of her creative expression as catharsis in relation to her father's abuse; the theme reaches an apotheosis in her film *Daddy* (made in 1972–73 with Peter Whitehead; see pp. 222, 242), which narrates an extensive revenge fantasy, beginning with NSP's performing a *Tir* work and moving on to scenes in which a girl, a teenager, and a grown woman (the last played by NSP herself) humiliate the "Daddy" figure. A key and striking image, near the beginning of the film, shows NSP opening a coffin in which rests a giant, human-sized phallus (p. 223); about halfway through the film, she slices a phallus-cake in half and serves it to her teenaged "daughter," scolding, "It's not going to bite you! Lick it!" These phallic images (intercut with Catholic imagery) sum up the artist's violent rage toward religious hypocrisy and patriarchal authority.[5]

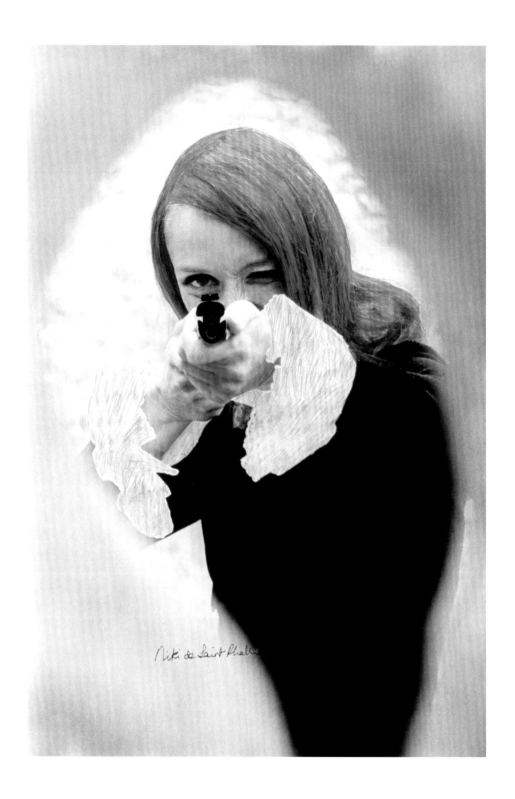

Promotional image, photograph hand-colored
with wax crayon, for the film *Daddy*, 1972/73,
showing the artist aiming a rifle

Saint Phalle, as "Agnes," opening a coffin to reveal
a giant phallus in the film *Daddy*, 1972/73, written by
Saint Phalle and directed by Peter Whitehead

As feminist art historian Anna Chave has argued, this kind of highly charged self-narration linked to intense and expressive artworks (notably more common in the careers of women, those who identify as queer, and people marginalized by white privilege in the French and American contexts of which NSP was a part) invites "personalized critical treatment."[6] In such cases, exemplified for the art historian by that of Eva Hesse, Chave elaborates the importance of self-reflexively acknowledging the role of life stories in writing art histories and the ways in which we, as interpreters, attach ourselves to or distance ourselves from such autobiographical or biographical details out of our *own* personal investments. In a sharp response to Anne Wagner, another feminist art historian, who had taken her to task for unabashedly drawing on Hesse's journal entries in examining the artist's work, Chave thus writes, "All (modern, Western) works of art are inextricably tied to an artist, no less than scholarship is to a scholar. In ways opaque or transparent, we all write our lives into our work."[7]

Chave makes a key point about our access to autobiographical or biographical details in relation to artists and their work. Let it be said, then, that—like Chave with Hesse—I admit openly to having read all of NSP's published autobiographical texts as well as most of the interviews and secondary texts taking off from them. I admit, too, to over-identifying with certain aspects of her publicly presented and enacted persona and to distancing myself from other elements. NSP's self-narrated life stories are thoroughly imbricated in my interpretations of her work because I insist—*as a feminist gesture*—that we *always* read art in relation to what we think we know about the person who made it. Refusing to acknowledge this, as Wagner does, does not make our interpretations more "objective." It just makes them more naïve. Therefore, I must insist—as NSP's case seems to make essential—that the ubiquitous life stories are part of the discursive

meaning of her oeuvre as a whole. *How* we make use of them is the key question. Here, Chave's work, and also Griselda Pollock's recent writing on Polish feminist artist Alina Szapocznikow (born in 1926, she was NSP's almost exact contemporary), provide exemplary models—although Szapocznikow did not engage in the same kind of compulsive self-narration as did NSP.[8]

As Pollock makes her way through Szapocznikow's extremely fraught biography—not least her internment, as a Jew, in concentration camps during the Holocaust; her recurrent illnesses and infertility; and her premature death, in 1973, of cancer—the art historian notes the Polish artist's connection to the Nouveaux Réalistes in Paris in the mid- to late 1960s and the similarities between her work and NSP's as well as that of fellow maverick feminist artists Louise Bourgeois and Eva Hesse.[9] More importantly, for the purposes of this essay, she tackles the issue of Szapocznikow's harrowing life story head-on to argue that "*encrypted trauma* ultimately surfaces in forms and materials . . . embedded . . . with memories of the body."[10]

While we may question the idea of art as a direct or indirect expression of repressed trauma to be deciphered in the future through signs of disruption in the work itself, we would be wrong to reject considerations of the biographical altogether in cases such as Szapocznikow's and NSP's. In fact, arguably, NSP, with her midlife volubility about her life experiences and particularly with her self-narrated triumph over her suffering at the abusive hands of her father, makes it impossible to pretend that we can avoid paying attention to the textures and pressures the artist stated or implied she had faced in her life and had addressed through her work. Usefully, in this regard, historians such as Michel de Certeau have warned against *repressing information* to make a claim of objectivity or produce a more coherent, less messy narrative of the past: "Whatever this new understanding of the past holds to be irrelevant . . .

comes back, despite everything, on the edges of discourse or in its rifts and crannies: 'resistances,' 'survivals,' or delays discreetly perturb the pretty order of a line of 'progress' or a system of interpretation."[11]

Given this model of history writing, which takes into account what we think we know about the artist herself, we must, in the case of NSP, interpret the work with the acknowledged understanding that we bring to it ideas about the artist's experiences, which, in turn, condition what we see, touch, and feel and how we engage with the objects before us. That NSP framed her work in her autobiographical texts as therapeutic and (in the case of the *Tirs*) as a mode of working through her rage and sorrow at having been sexually abused can hardly be ignored.[12] At the same time, it would be to draw on her statements to create a model of simple cause and effect. If we accept art historian Sarah G. Wilson's comment that "as with Bourgeois, Niki [de Saint Phalle]'s vivid personal memoirs add a supplement to the psychoanalytic interpretations we can bring to her work," we can acknowledge that the autobiography is *supplementary* discourse inevitably informing our understanding of the practice.[13]

NSP herself seems to have viewed art-making as a potential dialogue with others, a way of speaking or articulating herself (and, arguably, her *self*) for audiences who would sympathize and also gain from her magical, emotionally charged—often simultaneously enraged and celebratory—view of the world. She anticipated and understood future audiences as substantiating and completing her work. This aspect of her approach aligned her with new strategies in Euro-American art in the 1960s, identified during this period by art critics such as Kenneth Coutts-Smith and Dorothy Gees Seckler as "audience participation art," and often involving the use of the artist's body as well as public situations and spaces that engaged spectators actively.[14] By creating *situations* such as her shooting sessions, which she, by seizing the gun, activated or invited others to activate, NSP positioned herself, in 1961, at the forefront of a radical shift away from what Coutts-Smith identified as the modernist or "Renaissance [to] Cubist tradition" of viewing art as a static object toward the production of art as "a matter of participation, a three-way dialogic situation . . . taking place in space and time between the artist, spectator, and the object. It is something which *happens*, in which one is actively and psychologically involved rather than something you look at and take on subjectively."[15]

NSP radically inserted her autobiography into the field of meaning around her work—and clearly, as Chave and Pollock point out, this has long been an explicitly feminist political gesture (an extension of the "personal is political" clarion call of the second-wave feminist movement). In addition, NSP innovated a genre of art-as-action in the early 1960s with her *Tirs*. As *action*, art, for the first time in the European tradition, became explicitly relational, a "matter of participation," as Coutts-Smith noted. It is through this dual lens that I will examine NSP's projects of the early to late 1960s.

Structuring Ambivalences: Family, Feminism, Man/Woman

As noted, NSP had a dramatic life story, marked by childhood incestuous sexual abuse and a binational family identity; both French and American, both feminine and masculine in her skills, aspirations, actions, and appearance, NSP expressed violent ambivalence about her nationality and her gender. Ranging from aggressive (the *Tirs*, begun in 1961) to celebratory (the *Nanas*, first exhibited in 1965) to inviting yet bitingly critical (*Hon—en katedral*, 1966), NSP's work is powerfully structured by these ambivalences (the joy and the rage, two sides of the same experience—*in* NSP and beyond her, in the circuit between the work and its audience). Exemplary in this regard is *Hon* ("she" in Swedish), the huge public installation whose overall shape and theme the artist clearly masterminded—given its formal similarity to

her earlier *Nanas*—and constructed, with the help of her partner in art and life, Swiss artist Jean Tinguely, as well as Swedish artist Per Olof Ultvedt, at Stockholm's Moderna Museet in 1966.[16] *Hon* joins aggression and a radical political critique of gendered modes of embodiment with tenderness and an exultant concept of the feminine. This joining can be understood through attention to NSP's ambivalent comments about gender relations, feminism, and her national identity.

There is no question that we can—and arguably should, given the impact of NSP's work on feminist art practice and theory—view her life's work as radically feminist. And yet her relationship to feminism, in her own estimation, was not always positive. As NSP wrote in the same letter to her granddaughter cited above, productive tensions in her national and gender-role identifications were central to her motivations as an artist:

As a child I could not identify with my mother or my grandmother, my aunts or my mother's friends. . . . I wanted the world and the world then belonged to MEN. . . . After having rejected my parents and their social class, I would be FACED WITH THE ENORMOUS PROBLEM OF REINVENTING AND RECREATING MYSELF. To add to the problem, I had no defined national feelings. I felt half French, half American. Also half man and half woman.[17]

This double sense of disorientation (in terms of gender and nationality), according to her various autobiographical accounts, opened a space of creative possibility for NSP, perhaps going some way toward explaining the emotional dualities that define the presentation and experience of the work.

In spite of distancing herself from some aspects of feminism, NSP was making art and navigating the art world in what has clearly been interpreted as a *feminist* way. The *Tirs* baffled and frightened some

Installation view of *Hon—en katedral* [*She—A Cathedral*], Moderna Museet, Stockholm, June 3–September 4, 1966. Photo by Hans Hammarskiöld

but were viewed by most journalists, writers on art, and spectators as enactments of a woman artist's singular empowerment in a world filled with men. Furthermore, NSP did sometimes explicitly align herself with feminism (stating in one of her memoirs that, at her all-girls prep school, she "became a feminist").[18] At other times, however, she aggressively distanced herself from feminism in ways that point to her ambivalence about specific *national* or cultural versions of gendered norms—that is, her reluctance to identify directly as a feminist tended to be expressed in relation to the "European" context, as in a 1993 statement to a *New York Times* journalist:

> I have always refused to be in a feminist
> show because I do not see the world
> in that way. I'm a feminist in that I believe
> passionately in equal wages, equal opportu-
> nities and so on. But there's a war going
> on between the sexes in the United States. . . .
> I like the European game of flirting, I like to
> live my femininity and I think it's fun to . . .
> *rouler les hommes*; you know, manipulate
> them a little.[19]

Here, she aligned herself with womanly wiles as elements of female assertiveness, a position that the French may have considered empowering for women but that British and American feminists would likely have found antifeminist. Thus, it is clear that ambivalence about gender and national identifications, interconnected in the description above, structured and motivated NSP's work throughout her career. For example, *Saint Sébastien (Portrait of My Lover / Portrait of My Beloved / Martyr nécessaire)*, 1961, made in 1960 or early 1961 (p. 203), signals her angry explosion onto the international art scene as both a woman energized by rage toward men and as an innovative action artist. In *Saint Sébastien*, an actual man's dress shirt and necktie are nailed to a board and covered with drips of paint; the "head" of the figure is a target, and visitors to the gallery where the work was exhibited were encouraged to throw darts at the apparent representation of a man's head. A related assemblage, *Hors-d'oeuvre ou Portrait of My Lover*, 1960 (p. 128), similarly includes a dartboard in place of the male head. With these works, NSP established her strategy of enlisting members of the audience in her attack on the modernist picture plane—also, in this case, an assault on her "lover," clearly a man she believed had wronged her. In this way, NSP established a participatory aesthetic and, through the use of darts and dartboards, engaged participants in an aesthetics that was simultaneously based on play *and* rage.[20]

There is a direct lineage between these works and the *Tirs*, begun in the same year; the *Tirs* were reliefs or sculptures packed with bags of paint or aerosol paint cans that, when shot with a gun, exploded in bursts of color. Some, such as *Tir (Old Master)—séance Galerie J*, 1961, were set up as conventional pictures, with the paint leaking and dripping down the surface onto the frame (see pp. 130, 131). *Long Shot—Second Shooting Session*,[21] 1961, is, in contrast, not a painting but a remainder, an object produced from a *Tir* session. Consisting of paint, plaster, and plywood, *Long Shot* hovers between image and object, thus interrogating the status of painting as well as of sculpture. Other *Tirs* began as identifiable objects or figures, most notably the example NSP contributed to the 1962 play *The Construction of Boston* (written by Kenneth Koch and directed by Merce Cunningham, with participation by Tinguely, Robert Rauschenberg, Frank Stella, and others).[22] On stage in New York, NSP herself shot at a plaster cast of the Venus de Milo (p. 50), an icon of both art history and female beauty, thereby massacring classical art and ideal femininity in one blow. These are playful yet aggressive works, funny but sophisticated commentaries on complex gender and art relations and values.

The *Tirs* perfectly enact the double ambivalence of NSP's national and gender identifications. They were both stereotypically "French" (ironic, compatible with the tone and performative gestures of NSP's fellow Nouveau Réaliste Yves Klein) and normatively "American" (in their reliance on gun culture and their aesthetic appearance, which linked them to the assemblage works of Neo-Dada artists such as Rauschenberg, a close colleague of NSP's and Tinguely's in the early 1960s). The *Tirs* were, in fact, performed primarily in the United States and France, at venues ranging from a gallery in Paris to the top of a hill overlooking a beautiful stretch of coast in Malibu, California. The works seem to express NSP's desire to break out of traditional feminine roles (she stated in her autobiography, "When I became an adolescent, I felt resentful that the only power allotted to me was the power to attract . . . men"[23]) while, at the same time, affording her a potentially masculine empowerment.

It may have been NSP's flirtation with male aggression that prompted French critic Pierre Restany to invite her to become one of the Nouveaux Réalistes, thus giving her the opportunity to make important connections among the rising art stars (all male) of the international art world: Rauschenberg and Jasper Johns both executed shooting works set up by NSP at Galerie J in Paris in 1961, and Los Angeles–based artist Edward Kienholz assisted her with the Malibu performance in 1962.[24] In this way, the *Tirs* could be said to operate between NSP's Frenchness and her Americanness (as well as literally between French and American sites and collaborators). The *Tirs* project was considered Nouveau Réaliste, but it engaged American art both in its action of violating the picture plane and in the expressionistic, "bleeding" objects that resulted from the shootings. The works attacked the dominant American version of abstract art (Abstract Expressionism), which adhered, more or less, to the representational codes set forth in modernist formalist criticism, insisting that art resided in static "objecthood," not *between* acts of making and later acts of interpretation (as in participatory art). Finally, some of the objects to be shot at were constructed as altarpieces; these also assaulted the iconic imagery of the Catholic Church of NSP's French forebears.

Furthermore, the *Tirs* connected these broad cultural signifiers with explicit personal history, as narrated by NSP. In the artist's words, the shooting works were both cathartic—allowing her to take metaphorical revenge on her abusive father ("I was raped by my father when I was eleven, so perhaps it's no wonder I started shooting my paintings")—and just plain "fun" or even frivolous ("I shot because it was fun and made me feel great. . . . I shot for that moment of magic. Ecstasy").[25] Ultimately, as NSP herself ruminated, the targets—and the shooter—were both masculine and feminine, both her father and herself:

> WHO was the painting? Daddy? All Men? Small Men? Tall Men? . . . Or was the painting ME? . . . I was shooting at MYSELF, society with its injustice. . . . I was shooting at my own violence and the VIOLENCE of the times. By shooting at my own violence, I no longer had to carry it inside me like a burden. . . . Instead of becoming a terrorist, I became a terrorist in art.[26]

The shooting works allowed NSP to activate and explore performatively the burgeoning contestations of gender roles being made by feminists in French and American society in the 1960s, a situation in which violence was starting, on occasion, to be aligned with women perpetrators (for example, in media reports of radical feminists such as Valerie Solanas). NSP proposed empowerment through a reversal of the normative gender roles that had shattered her adolescence: shooting a gun at icons of art and culture, she took revenge on past male

violence against the sanctity of her own adolescent body. In the *Tirs*, NSP performed herself with grace and aplomb across the fields of masculinity and femininity: for later versions, she developed a costume that looks like a cross between a *Star Trek* uniform and the jumpsuit of a working-class laborer. The ensemble was sleek, flattering to her feminine form, and macho at the same time. And it is worth stressing again that in her capacity as orchestrator of the shooting works, NSP also *directed* powerful male artists who had growing international presences—for example, in the Rauschenberg and Johns *Tirs* noted above. She was able to direct men, tell them what to do, while maintaining her glamorous persona and acting as a proper hostess, a role her mother (both Southern American and French) had taught her well. (It is notable how self-possessed NSP looks in all existing photographs of the shooting performances; in 2020 one might see these events as "Instagram ready," indicating the savvy artist's concern not only with the purpose of the action and the final result but with orchestrating the acts themselves as works of performance in their own right.)

As art historian Jill Carrick has pointed out, NSP's gender identity was elaborate and performative—and a key aspect of her work in the 1960s. Carrick notes that she "self-consciously staged herself as 'phallic woman,' that is as a fetishized *femme fatale* sporting phallic props," or, as Jo Applin puts it, "as a coquettish, gun-wielding femme fatale."[27] Confirming this performative trope of empowered masculine femininity is the image of the artist opening a coffin holding a giant phallus in the film *Daddy*, as noted above. Having inherited from her mother a love of feminine accoutrements, NSP was overt about her inclination to maintain a coquettish glamour at all costs. As she stated in a 1965 interview in *Vogue Paris* (sounding, from the middle of the quote onward, more like a member of the 1960s gay counterculture than a mainstream feminist):

In actual fact I have no grudge against men. I just think that, basically, they're pathetic types only just good enough to decorate my bed, polish my boots. But for other things I don't need them. . . . I believe that my boas, my boots, my red dresses, my disguises—in fact!—are nothing but accessories of my creation, expressing more a desire to make myself into an object, like the celluloid dolls I use in my work. I use my body in the same way I use a base of wire netting to make a sculpture.[28]

Here, NSP established a precedent for the explosion of self-imaging strategies among feminist and queer artists in the 1970s and 1980s.[29]

NSP's performances also combined a conventionally feminine exhibitionism with a renegade desire to "make trouble." As she wrote in her autobiography *Traces*, "Attention. I needed attention. I wanted attention. If you're a trouble maker you get attention. If tenderness isn't out there to touch, to take . . . attention will do."[30] Attention: arguably inherent to inhabiting a white female body in Western culture (where the notorious heteronormative male gaze pins this body to the man's field of vision) and certainly a key motivator for feminists navigating the art world in the 1960s and 1970s. Attention would also have been a central concern of those artists who were starting to use their bodies in the same way they used art materials to "make a sculpture," as NSP put it so well, with the ultimate goal of transforming art and shaking up the male-dominated art world—that is, *making trouble*. Why not also gain redemption through a cathartic, self-narrated connection between the violence of the art and the violence experienced—through the worst kind of incestuous sexual acts—in one's past?

Niki de Saint Phalle
L'Accouchement rose [**The Pink Birth** or **Childbirth**], 1964
Paint, toys, objects, and wire mesh on wood panel
86¼ × 59⅞ × 15¼ in. (219 × 152 × 40 cm)
Moderna Museet, Stockholm.
Donation 1964 from the artist

Niki de Saint Phalle
Kennedy-Khrushchev, 1962
Paint, wire mesh, and objects on wood
78¾ × 47¼ × 7⅞ in. (200 × 120 × 20 cm)
Sprengel Museum Hannover, Donation of the artist (2000)

The *Nanas* and *Hon*: The Ambivalence of the Spectator as Participant

Starting in the early 1960s with the female birthing figures and, slightly later, with the *Nanas,* NSP's giant and gaily decorated sculptures of rotund yet commanding women, the artist shifted her ambivalence from negativity and rage into an increasingly positive register—in other words, the balance tipped toward fun and exultation, but anger was arguably still a guiding force in the work. If the shooting performances allowed NSP herself to enact a fierce, even "macho," femininity, the *Nanas* afforded her a means of moving femininity from a state of decrepitude and violation to one of empowerment and celebration. Leaping in the air, the larger-than-life *Lili ou Tony,* 1965 (p. 177), with its apparently bigendered name, enormous breasts, and heart-shaped genitalia, epitomizes the double-edged emotional energy of these sweet yet menacing figures. *Lili ou Tony* is unmistakably female but has a force and scale that would have been more aligned with masculinity at the time.

The appearance and materiality of NSP's female figures transformed from the early to the late 1960s, from ramshackle and still violent/violated bodies, in works such as *Lucrezia (The White Goddess / Weiße Hexe),* 1964 (p. 164), to increasingly decorative surfaces and celebratory poses, in the *Nanas*—witness *Clarice Again,* ca. 1966–67, a massive female figure, rainbow-colored and stolid, but with a tiny head and no arms (p. 179). Is she empowered? Hard to say—but, as a sculpture, she dominates. It is tempting to extrapolate from this formal transformation a calmer yet also more exuberant and empowered state of mind on the artist's part—a shift from the violent catharsis of her earliest years as a professional artist, which she herself linked insistently to her anger at having been sexually abused by her father.

Lucrezia still evidences the radical ambivalence and rage explored above: the massive (almost six-foot-tall), gorilla-like female body constructed of wire, with plastic hands and face, is covered with thick ribbons of white paint and found objects such as dolls, toy guns, and plastic animals. While some of NSP's female figures seem to be squeezing dolls out of their vaginas—as in *L'Accouchement rose* [*The Pink Birth* or *Childbirth*], 1964—this one extrudes what looks to be the head of a toy horse (p. 164). The frightening tone of this cacophony of assembled parts is mitigated by the bemused expression on the mask that forms the face. Another early work, untitled and possibly unfinished, consists of a traumatized, eviscerated female form, stripped down to the very chicken-wire frame in places, with a gaping wound in her side and her torso beribboned by the "snake" that symbolized, for NSP, her father's sexual aggression; the work is illustrated in a 1980 exhibition catalogue across from NSP's savage statement (in her characteristic loopy handwriting) "Mes putes sont des femmes crucifiées—sacrifiées" (my whores are crucified, sacrificed women).[31]

Another terrifying specter from the earlier period is the massive figure *Kennedy-Khrushchev,* 1962, in which the grimacing mask-faces of these two world leaders, then locked in Cold War battles, appear atop an enormous female body, replete with strange, protruding (almost phallic) labia and wearing black boots (p. 231). The figure's right arm hugs its other side, and the surface drips with red, green, and pink paint. Clearly, NSP was capable of directing her anger away from the strictly personal and outward at the male politicians responsible for violence in the world, siphoning her personal rage into political commentary. These works are reminiscent of some of the visceral, and explicitly feminist, pieces made around the same period by Bourgeois (*Destruction of the Father,* 1974) and Szapocznikow (*Caprice* [*Monster*], 1967).

As previously noted, however, by the late 1960s NSP had moved dramatically away from the harrowing to the triumphal: the *Nanas* invite us to dance. And yet, playful as they are, they inspired no small amount of anxiety in the male artistic and critical establishment of the time. As Pierre Descargues

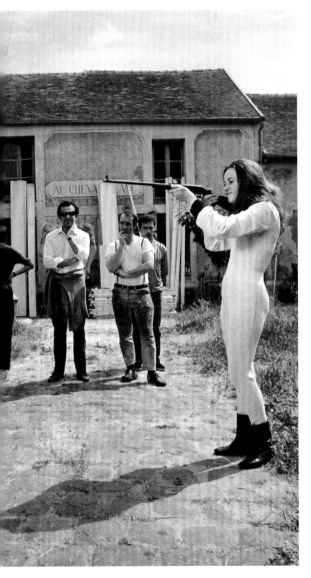

wrote in a 1965 catalogue, the *Nanas* are "enjoying themselves....They're having fun ... at the expense of others. And, gentlemen, this *is* at our expense. They're trampling on our stomachs, our army, our moral code, they're attacking our philosophy, and they're still doing the splits across our father land.... Niki de Saint Phalle knows how to avail herself of feminine weapons."[32]

Hon—en katedral, the largest *Nana* of all, not only encouraged bodily movement (infamously, she opened her gigantic vagina for visitors to enter) but solicited visitors' physical participation *in* her embodiment through the range of activities staged inside her body, with contributions from all three artists involved (NSP, Tinguely, and Ultvedt). Thus, *Hon* epitomized the spectacular oscillation between female rage and an invitation to frolic, experience joy, within the body of the woman. There was a Coca-Cola bar in one breast; also inside were a small movie theater, a planetarium, an aquarium, and an art gallery with copies of modern artworks.[33] As American art critic Barbara Rose put it, the *Nanas* were NSP's "mutant alter egos," and with the mega-*Nana*, *Hon*, NSP "turned [Salvador] Dalí's representation of woman as sex object inside out, forcing men to walk back in the birth canal and confront their secret horror of the female anatomy."[34] Images of men, women, and children walking into *Hon*'s giant opening press this point home.

As with all of NSP's best work, *Hon* courted and rearticulated the aggressive ambivalence I am attributing to NSP's approach as a whole, an ambivalence that was beginning to lean toward the celebratory and would be increasingly weighted in that direction for the rest of her career. The vaginal opening between the figure's legs "welcomed" the visitor into a fun house of art and culture—while also consuming that visitor. There is no question that through this doubled action, *Hon* (as Rose puts it) turned normative gender relations inside out. Working with two male artists under the aegis of the male chief curator of the Moderna Museet,

Director Roland Petit, Jean Tinguely, and others watching Saint Phalle shoot *Le monstre de Soisy* (*The Monster of Soisy*) outside her studio, Essonne, France, during the filming of *Éloge de la folie*, 1966. Photo by Giancarlo Botti

Pontus Hultén (a key figure in promoting NSP's work throughout her career), NSP produced a female form that was nominally a gargantuan "object" but that *consumed the spectator* (vaginally, no less!) rather than being "consumed" by the masculine "gaze" of patriarchal culture.

Not surprisingly, given the ambivalence I am tracing here, critics and other artists responded with drastically opposing views: Swedish American Pop artist Claes Oldenburg, in characteristically blunt fashion, celebrated the vaginal canal of *Hon* as inviting his gaze ("from my studio in the Moderna Museet, I looked straight up *Hon*'s Cunt"); others understood the figure as exemplifying the increasingly liberated woman of 1960s Euro-American culture; and a Swedish feminist critic, Barbro Backberger, interpreted the work as reactionary for women, arguing that the figure reiterated "Primitivism's view on woman. . . . A woman who wholeheartedly identifies herself with her own sexuality."[35]

The female figure of *Hon* is just as much one of the *putes*, or whores, NSP described in the rather violent assertion quoted above, viewed, as it was, by some critics as a potentially savage *vagina dentata* and by others as a reiteration of the primitivist view of woman as object. Completed just before NSP's decisive turn toward the celebratory, *Hon*, then, becomes the apotheosis of her radical ambivalence—embracing and promoting an empowered form of female embodiment and subjectivity yet echoing, at least, the potential for the violation and diminishment of women's bodies and minds by the forces of patriarchy (from rape to ideological assumptions about the impossibility of women's making great art). These were extreme and actual forces at work in the 1950s and 1960s, when NSP was shaping her creative approach—forces that were being increasingly exposed and interrogated during this same period by nascent feminist voices in Paris and New York, from Simone de Beauvoir to Louise Bourgeois, Alina Szapocznikow to Betty Friedan.

In the 1960s nothing was completely clear about how best to interrogate the oppressive forces of patriarchy in Euro-American culture, but the outlines of these forces were being sketched by writers and explored by artists such as NSP, who—I have argued here—brilliantly navigated the oppositional range of emotions and identifications that traditionally positioned women on the far ends (as either passive or too emotional, pretty or horrific, rage-filled or hilarious, virgin or whore). Rather than acceding to the impossible opposites, NSP combined them. Each work, each performance, each utterance sketched a new version of how women could exist in complex registers of experience and energetic being. By persistently narrating her autobiographical emotions and stories, by

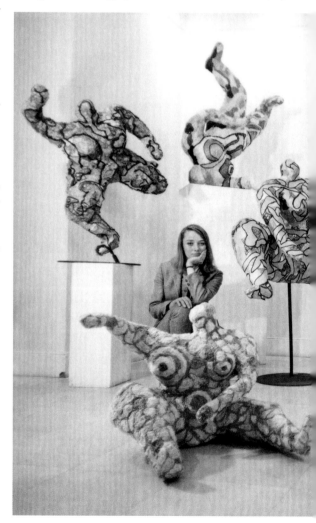

Saint Phalle among her *Nanas* at the time of their first public exhibition, Galerie Alexandre Iolas, Paris, fall 1965. Photo by André Morain

refusing to reduce the feminine or female to characteristics that could be contained so as not to threaten patriarchy or the men in her life, from her father to Tinguely to colleagues such as Rauschenberg, NSP gave a gift to future viewers. We have works such as the energetic *Louise*, 1965, leaping sideways with her decorative pink-and-red body as if revolting and rejoicing in one movement (p. 178). Such an object—even this more diminutive *Nana*—still dynamizes, inviting us into a new future for muscular female bodies that can encompass joy and rage at once. NSP's work made future feminist art and culture possible. To NSP and the other artists who engaged in similar projects, we owe nothing less than second-wave feminism and the feminist art movement.

I would like to thank the Niki Charitable Art Foundation (particularly the Director of Archives Jana Shenefield), Lucia Pesapane, and Bloum Cardenas for their generosity in sharing numerous sources with me, including the DVD of NSP's 1973 film *Daddy*, as well as my research assistant, Claudia Stemberger.

This text is revised and expanded from an essay originally published in Camille Morineau, ed., *Niki de Saint Phalle, 1930–2002* (Paris: Reunion nationaux musées–Grand Palais, 2014).

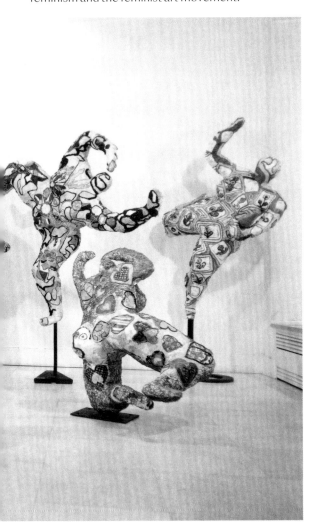

1 Many texts on the artist refer to her as "Niki." From a feminist point of view, this is jarring, particularly in contrast to the more respectful surnames used for the many men ("Tinguely," "Restany") with whom she worked throughout her career.

2 Niki de Saint Phalle, *Traces: An Autobiography; Remembering 1930–1949* (Lausanne: Acatos, 1999), 24, 122, 148. She also calls herself "devouring mother," in "Niki by Niki" [1986], reprinted in Carla Schulz-Hoffmann, ed., *Niki de Saint Phalle: My Art, My Dreams*, trans. Stephen Telfer (Munich: Prestel, 2003), 28.

3 The autobiographies include *Traces* (see n. 2); *Mon secret* (Paris: La Différence, 1994), an extended letter to her daughter about the sexual abuse perpetrated by her father; and *Harry and Me: 1950–1960, the Family Years* (Zürich: Benteli, 2006). A definitive biography was published in 2013, pulling together these sources and other archival information: Catherine Francblin, *Niki de Saint Phalle: La révolte à l'oeuvre* (Paris: Hazan, 2013).

4 Niki de Saint Phalle, "A Letter to Bloum [Cardenas]," in Susan Hapgood, *Neo-Dada: Redefining Art, 1958–1962* (New York: American Federation of Arts; Universe, 1994), 142.

5 The film is queer in its recourse to numerous scenes of sadomasochism and woman-to-woman eroticism. And yet these relations are presented less as empowered alternatives to the heteronormative violence perpetrated by "Daddy" than as examples of how women have to sell each other out (for example, pimping their daughters to older men) to survive patriarchy. *Daddy* offers a bleak view of sexual relations in general.

6 Anna Chave, "Minimalism and Biography," in Norma Broude and Mary D. Garrard, eds., *Reclaiming Female Agency: Feminist Art History after Postmodernism* (Berkeley: University of California Press, 2005), 392.

7 Anna Chave, "To the Editors" [Response to Anne Wagner's "Another Hesse"], *October*, no. 71 (Winter 1995): 147. See also Anne Wagner, "Another Hesse," *October*, no. 69 (Summer 1994): 49–84. On the debate between Chave and Wagner, I am indebted to the arguments of Abigail Shapiro in "Personal Politics in the Archive: Theorizing a Feminist Approach to Artists' Sketchbooks and Diaries," unpublished paper, 2012.

8 Griselda Pollock, *After-affects/ After-images: Trauma and Aesthetic Transformation in the Virtual Feminist Museum* (Manchester, UK: Manchester University Press, 2013), 185.

9 I have not found any direct evidence of a meeting between Szapocznikow and NSP, but it is likely that one occurred, as they were both living in Paris in the 1960s.

10 Pollock, *After-affects*, 185.

11 Michel de Certeau, *The Writing of History*, trans. Tom Conley (New York: Columbia University Press, 1988), 4.

12 See Saint Phalle, "Letter to Bloum," 141–42.

13 Sarah G. Wilson, "Tu es moi: The Sacred, the Profane, and the Secret in the Work of Niki de Saint Phalle," in Simon Groom et al., *Niki de Saint Phalle* (London: Tate Publishing, 2008), 26.

14 See Dorothy Gees Seckler, "The Audience Is His Medium!" *Art in America* 51, no. 2 (April 1963): 62–67; and Kenneth Coutts-Smith, "Violence in Art," *Art and Artists* 1, no. 5 (August 1966): 5–6. Seckler specifically includes NSP and Tinguely in the movement.

15 Coutts-Smith, "Violence in Art," 5.

16 Annika Öhrner has clarified *Hon*'s authorship by noting that "Saint Phalle credited Hultén for the suggestion of letting one of her *Nanas* become a giant in Moderna Museet in 1966, but she was confident about being the author of this sculptural form"; see Öhrner, "Niki de Saint Phalle Playing with the Feminine in the Male Factory: *HON—en katedral*," *Stedelijk Studies*, no. 7 (Fall 2018), https://stedelijkstudies.com /journal/niki-de-saint-phalle -playing-with-the-feminine-in-the -male-factory-hon-en-katedral/.

17 Saint Phalle, "Letter to Bloum," 141. For more on the artist's ambivalence about France versus the United States, see the quotations in Roger Cohen, "At Home with Niki de Saint Phalle: An Artist, Her Monsters, Her Two Worlds," *New York Times*, October 7, 1993.

18 Saint Phalle, *Traces*, 70.

19 Quoted in Cohen, "At Home with Saint Phalle," 8.

20 Phyllis Braff discusses this piece in her article "Nanas, Guns and Gardens," *Art in America* 80, no. 12 (December 1992): 104. Braff attributes NSP's anger to her husband Harry Mathews, whom she had left in the mid-1950s, but gives no evidence for the idea that NSP had Mathews in mind.

21 CR 163.

22 See Jill Carrick, "Phallic Victories? Niki de Saint-Phalle's *Tirs*," *Art History* 26, no. 5 (November 2003): 707.

23 Saint Phalle, *Traces*, 88.

24 A thorough account of these events
 and connections can be found
 in Patrik Andersson, "Euro-Pop:
 The Mechanical Bride Stripped Bare
 in Stockholm," PhD diss., University
 of British Columbia, 2001. For
 a video of the Malibu shoot, see
 "Niki de Saint Phalle—Tir a Malibu
 (1962)," accessed April 28, 2021,
 https://www.youtube.com/watch
 ?v=KBjLuRfinQU.
25 Quoted in Cohen, "At Home with
 Saint Phalle," 8; and in David
 Bourbon, John Cage, and Harry
 Mathews, *Niki at Nassau: Fantastic
 Vision; Works by Niki de Saint
 Phalle* (Roslyn, NY: Nassau County
 Museum of Fine Art, 1987), 12.
 Both sources are cited in Carrick,
 "Phallic Victories?" 717, 724.
26 Niki de Saint Phalle, "Letter to
 Pontus," n.d., in Pontus Hultén,
 Niki de Saint Phalle (Bonn:
 Kunst- und Ausstellungshalle der
 Bundesrepublik Deutschland;
 Stuttgart: Gerd Hatje, 1992), 161–62,
 cited in Carrick, "Phallic Victories?"
 724.
27 Carrick, "Phallic Victories?" 708–9;
 Jo Applin, "Alberto Burri and Niki de
 Saint Phalle: Relief Sculpture
 and Violence in the 1960s," *Source:
 Notes in the History of Art* 27,
 nos. 2–3 (Winter/Spring 2008): 80.
28 Quoted in Maurice Rheims, "Niki de
 Saint Phalle: L'art et les mecs," *Vogue
 Paris*, February 1965, 60, translated
 and cited in Carrick, "Phallic
 Victories?" 716. NSP also cross-
 dressed (as did Tinguely) in the play
 she co-organized with Tinguely,
 Kenneth Koch, Frank Stella, and
 Robert Rauschenberg, *The
 Construction of Boston* (1962). As
 Patrik Andersson puts it, "Saint
 Phalle made her entrance striding
 down the centre aisle through
 the audience, slim and colourful
 in the uniform of a Napoleonic
 artillery officer"; see Andersson,
 "Euro-Pop," 113.

29 On this trend, see my book *Self/
 Image: Technology, Representation,
 and the Contemporary Subject*
 (London: Routledge, 2006).
30 Saint Phalle, *Traces*, 45.
31 Jean-Yves Mock, *Niki de Saint Phalle:
 Exposition rétrospective* (Paris: Musée
 National d'Art Moderne, Centre
 Georges Pompidou, 1980), 46–47;
 nowhere in the catalogue is this
 work titled or attributed.
32 Pierre Descargues, "Nanas," first
 published in French in the catalogue
 for NSP's 1965 show at Galerie
 Alexandre Iolas, Paris, and reprinted
 in English in Schulz-Hoffmann,
 Saint Phalle, 22, 24.
33 Patrik Andersson supplies a nuanced
 reading of *Hon*, in terms of gender
 and technology as well as national-
 ism, in his dissertation (for example,
 the short, silent film showing in
 the theater was Greta Garbo's first
 movie, in which Swedish women
 bathe in a Nordic landscape);
 see Andersson, "Euro-Pop," 186–93.
34 Barbara Rose, "Niki as Nana," in
 Groom et al., *Saint Phalle*, 88.
35 Both critics are cited in Andersson,
 "Euro-Pop," 192. The Oldenburg
 quotation is originally from Barbro
 Sylwan, [Pontus] Hultén, John Melin,
 and Anders Österlin, eds., *Hon—
 en historia* (Stockholm: Moderna
 Museet, 1967), 167; and the Barbro
 Backberger, from Backberger,
 "Hon," *Ord och Bild* 75, no. 4 (Summer
 1966): 324–25.

BIOGRAPHICAL CHRONOLOGY

1930–37 Catherine Marie-Agnès Fal de Saint Phalle is born on October 29, 1930 in Neuilly-sur-Seine, in France. She is the second of five children born to Jeanne Jacqueline Harper—a Paris-born American citizen who grew up in the United States—and André Marie Fal de Saint Phalle, a member of a French aristocratic family.

Following the 1929 stock-market crash, the family business had collapsed. André de Saint Phalle lost his entire fortune. Three months after her birth Marie-Agnès is sent to live with grandparents in Nièvre, France. In 1933, she is reunited with her parents, who have moved to Greenwich, Connecticut. As a family they move to New York City. By this time, Marie-Agnès is now known as Niki.

1948–49 Saint Phalle works as a fashion model, posing for *Vogue*, *Harper's Bazaar*, *Elle*, *Life*, and other magazines.

She marries Harry Mathews, a native New Yorker, on June 6, 1949.

1950–1960
BECOMING AN ARTIST

1950–51 Mathews and Saint Phalle move to Cambridge, Massachusetts, where Mathews studies music at Harvard College. In April 1951 their daughter, Laura, is born in Boston.

1952 Mathews and Saint Phalle move to Paris.

1953 Mathews and Saint Phalle rent a house in Menton, near Nice, for the summer months. Following a nervous breakdown, Saint Phalle is hospitalized in Nice for six weeks,

during which she undergoes electro-convulsive therapy. She begins to paint and create collages, which help her to recover from her breakdown. Upon leaving the hospital, she decides to become an artist.

1954 In September, after initially returning to Paris, Mathews and Saint Phalle move to Deià, on the Spanish island of Mallorca.

1955 Mathews and Saint Phalle's second child, Philip, is born in May.

The family travels to Barcelona, where Saint Phalle is deeply affected by the work of Antoni Gaudí, particularly Park Güell. She dreams of one day creating her own park with monumental sculptures.

1956 From April 28 to May 19, under the name Niki Mathews, Saint Phalle has her first exhibition, displaying a series of oil paintings at Galerie Gotthard in Saint Gallen, Switzerland.

In August, Saint Phalle and Mathews move back to Paris, where they meet Jean Tinguely and his wife, Eva Aeppli, artists who live in the Impasse Ronsin, in the fifteenth arrondissement.

1958 In September, Saint Phalle visits Joseph Ferdinand Cheval's Palais Idéal, south of Lyon, and it becomes a source of inspiration for her.

1959 In January or February, at the Musée National d'Art Moderne, Paris, Saint Phalle sees the joint exhibitions *Jackson Pollock: 1912–1956* and *The New American Painting*; the latter features the work of Willem de Kooning, Grace Hartigan, Barnett Newman, Mark Rothko, and Arshile Gorky, among others. In October, the first Biennale de Paris opens at the same venue. Among the participants

are Tinguely, Yves Klein, Raymond Hains, Jacques Villeglé, Robert Rauschenberg, and Jasper Johns.

1960 Wishing to dedicate herself fully to her artistic career, Saint Phalle leaves Harry Mathews and their two children.

Following a stay in Lans-en-Vercors, Mathews and the children move to an apartment on rue de Varenne, Paris. Saint Phalle continues to live in what had been the family's apartment on rue Alfred Durand-Claye, in the fourteenth arrondissement, and transforms it into an artist's studio. There, she creates her first assemblages in plaster as well as the "dart portraits."

Later in the year, she moves in with Tinguely, into a studio in the Impasse Ronsin, where they are surrounded by other artists.

Tinguely introduces Saint Phalle to the important Swedish curator and museum director Pontus Hultén, who will become a great supporter of her career.

1961–1963
PERFORMANCE AND THE *TIRS*

1961 At the invitation of the artist Jacques Villeglé, Saint Phalle takes part in the collective exhibition *Comparaisons: Peinture Sculpture* at the Musée d'Art Moderne de la Ville de Paris. There, she presents her first "dart portrait," *Hors-d'oeuvre ou Portrait of My Lover*. The figure's head has been replaced by a dartboard, and the public is invited to throw darts at it.

On February 12, Saint Phalle stages her first shooting session, in the Impasse Ronsin. Pierre Restany, founder of the Nouveau Réalisme movement, attends and participates by shooting a rifle at one of the paintings, known as *Tirs* ("shots" or "shootings"). He invites Saint

Phalle to join the group of Nouveaux Réalistes, and she becomes the only female member. (The group's original members were Arman, François Dufrêne, Raymond Hains, Yves Klein, Restany, Daniel Spoerri, Tinguely, and Villeglé; joining in 1961, along with Saint Phalle, were César, Mimmo Rotella, and Gérard Deschamps.) Saint Phalle will continue her series of *Tirs* through 1963, holding shooting sessions in both Europe and the United States.

Saint Phalle participates in the exhibition *Movement in Art*, organized by Pontus Hultén. At the show's three venues (Stedelijk Museum, Amsterdam; Moderna Museet, Stockholm; Louisiana Museum of Modern Art, Humlebaek, Denmark), her work *Saint Sébastien (Portrait of My Lover / Portrait of My Beloved / Martyr nécessaire)*, is on view. Other participating artists include Marcel Duchamp, Jasper Johns, Robert Rauschenberg, Spoerri, and Tinguely.

On June 20, Saint Phalle, Tinguely, Rauschenberg, Johns, and David Tudor participate in the concert-performance *Homage to David Tudor* at the United States Embassy in Paris.

From June 30 to July 12, Galerie J, owned by Jeanine de Goldschmidt-Rothschild, hosts *Feu à volonté*, Saint Phalle's first solo exhibition at the gallery. Pierre Restany, Goldschmidt-Rothschild's husband, curates.

In July, Saint Phalle participates in the Festival du Nouveau Réalisme, held at Galerie Muratore in Nice. For the July 13–14 opening, she performs a shooting session at the Abbaye de Roseland. Almost all the Nouveaux Réalistes are in attendance.

During the summer, while on holiday on the Costa Brava, Saint Phalle and Tinguely are introduced to Salvador Dalí by Marcel Duchamp. On August 12, at a party in Dalí's honor, they create the work *Toro de fuego* [*Bull of Fire*], a lifesized bull of plaster and paper filled with fireworks. It is exploded that night in the bullfighting arena in Figueres.

Saint Phalle participates in the exhibition *The Art of Assemblage* at the Museum of Modern Art, New York.

1962 During a trip to the United States, Saint Phalle and Tinguely visit California, Nevada, and New Mexico. In Los Angeles, they discover Simon Rodia's Watts Towers, which will inspire some of Saint Phalle's later work. While in California, she organizes her first two shooting sessions in the United States, sponsored by Everett Ellin Gallery and the gallerist Virginia Dawn.

In New York, on May 4, Saint Phalle, Tinguely, Rauschenberg, and Frank Stella, among others, participate in a staging of Kenneth Koch's play *The Construction of Boston,* under the direction of the choreographer Merce Cunningham.

From June 15 to July 15, Galerie Rive Droite in Paris hosts the solo exhibition *Niki de Saint Phalle.* There, the artist meets the dealer Alexandre Iolas, who invites her to exhibit in New York in the fall (October 15–November 3). Iolas will be a major source of financial support in her career and will devote many exhibitions to her work. He introduces her to the Surrealists René Magritte and Max Ernst.

Saint Phalle participates in the exhibition *Dylaby* at the Stedelijk Museum, Amsterdam. In her contribution, visitors are invited to shoot at "prehistoric" creatures with rifles.

1963 In February, Saint Phalle participates in the second Festival du Nouveau Réalisme, in Munich.

In May, at the invitation of the gallerist Virginia Dwan, she performs a shooting session of her major work *King Kong* in Los Angeles. Later that summer, most likely, she completes the work *Kennedy-Khrushchev.*

Late in the year, threatened with eviction from the Impasse Ronsin, which is to be demolished, Tinguely and Saint Phalle acquire the Auberge du Cheval Blanc, in the Essonne region, which will become an important meeting place for the Parisian artistic milieu.

Saint Phalle starts creating reliefs and figurative assemblages that deal with the archetypal roles of women in society—bride, mother, goddess, witch, sex worker—and their representation.

1964 Saint Phalle participates in various exhibitions, including, from September 23 to October 17, her first solo exhibition in London, at the Hanover Gallery.

She spends her summer holidays in Lutry, not far from Lausanne, Switzerland. There, she creates heads in paper and glued fabric as well as her *Mariée* [*Bride*] sculptures.

In collaboration with the artist Larry Rivers, she makes a drawing of her pregnant friend Clarice Rivers (Rivers's wife), which inspires her *Nanas*.

Late in the year, Saint Phalle and Tinguely stay in New York City at the Chelsea Hotel.

1965 In April, assisted by her teen-aged daughter, Laura, Saint Phalle creates her first *Nana* sculptures.

From September 30 to October 30 Saint Phalle has an exhibition at Galerie Alexandre Iolas in Paris. There, she presents her first large-scale *Nanas*. One is named after her sister Elisabeth, and the others, after close friends, such as the arts patron and impresario Bénédicte Pesle (who worked for Iolas at the time). She also designs the promotional materials for the exhibition, including the invitation, the poster, and her first artist's book, containing a hand-written text and *Nana* drawings.

1966 Saint Phalle, Tinguely, and Raysse are invited to create the scenery and costumes for Roland Petit's ballet *Éloge de la folie* [*In Praise of Madness*], which is to be staged at the Théâtre des Champs-Elysées in Paris. Saint Phalle designs the fourth, fifth, and sixth acts, entitled "La femme au pouvoir" ["Power to the Woman," or "Woman Power"], "Les pilues" ["The Pills"], and "La guerre" ["The War"]. The fourth act ends with a large, multicolored *Nana* descending from above and crushing the male dancers on stage.

Pontus Hultén, director of the Moderna Museet, Stockholm, invites Saint Phalle, Tinguely, and Per Olof Ultvedt to install a monumental sculpture in the museum's entry hall. Titled *Hon—en katedral* [*She— A Cathedral*], it is a reclining *Nana* measuring over eighty feet long, almost thirty feet wide, and almost twenty feet high. The exhibition is a major success with both the public and the press. Presented from June 3 to September 4, the work brings Saint Phalle greater international recognition. Following the exhibition, the work is dismantled and destroyed. During the realization of the exhibition, Saint Phalle meets Rico Weber, who will later become one of her assistants.

In September, several *Nanas* serve as window mannequins in the Yves Saint-Laurent boutique on rue de Tournon in Paris.

On October 2, the preview of a new adaptation of Aristophanes's *Lysistrata*, directed by Rainer von Hessen (under his stage name Rainer von Diez), takes place at the Staatstheater Kassel in Kassel, Germany. Saint Phalle designs the stage set, costumes, and poster for the production. The Acropolis of Athens is represented by a headless variation on *Hon*.

1967 The French government commissions a monumental work from Saint Phalle and Tinguely for the French pavilion at the World's Fair (Expo '67) in Montreal, to be positioned on the roof. The artists create *Le paradis fantastique* [*The Fantastic Paradise*], a work consisting of nine painted sculptures and six moving machines, on display from April 27 to October 27. The sculptural ensemble will later be shown in Buffalo, New York; New York City; and, finally, Stockholm.

From August 28 to September 15, Saint Phalle has her first solo museum exhibition at the Stedelijk Museum, Amsterdam. The exhibition is titled *Les Nanas au pouvoir* [*Nana Power*]. For the first time, Saint Phalle presents a *Nana maison*

[*Nana House*] and a *Nana fontaine* [*Nana Fountain*], both of which are made of polyester resin, a new material for her.

1968 Saint Phalle exhibits several *Nana maisons* and designs a series of inflatable plastic *Nanas*, which are produced and sold in the United States.

On June 28, the stage production *ICH (I*, or *ME)*, cowritten and directed by Saint Phalle and Rainer von Hessen (as Rainer von Diez), premieres at the Staatstheater Kassel as part of Documenta 4. Saint Phalle also designs the stage set, costumes, and poster for the production. The play follows the life of the narcissistic character ICH, who is determined to assume supreme power and be universally adored.

In the summer, Saint Phalle begins construction on her first architectural project at Rainer von Hessen's residence in the South of France. The project, *Le rêve de l'oiseau* [*The Bird's Dream*] consisting of three habitable *Nana maisons*, is completed in 1971.

In October, Saint Phalle presents her eighteen-part relief *Last Night I Had a Dream* in an exhibition at Galerie Alexandre Iolas in Paris.

Toward the end of the year, she suffers major respiratory problems, which have been exacerbated by toxic fumes emitted during the production of some of her works.

1969 From July 27 to September 14, Saint Phalle's first retrospective exhibition is held at the Kunstmuseum Luzern in Lucerne, Switzerland.

The Whitney Museum of American Art, New York, acquires Saint Phalle's sculpture *Black Venus*. It is presented in the second part of the museum's group exhibition *Contemporary American Sculpture*.

In October, Tinguely, supported by Saint Phalle, begins work on a major public artwork, *Le cyclop* [*The Cyclops*], at Milly-la-Forêt, near Fontainebleau. The work will take more than twenty years to complete and involves the participation of many artists.

ARCHITECTURAL PROJECTS AND CINEMA DEBUT

1970 In November, the exhibition and festival *Nouveau Réalisme 1960–1970* is held in Milan, celebrating the group's ten years of existence. For the opening, Saint Phalle shoots at one of her altarpieces.

1971 To ensure the posthumous protection and management of their respective bodies of work, Saint Phalle and Tinguely marry on July 13 in Essonne, although they are by then in an open relationship. In the process, Saint Phalle obtains Swiss citizenship.

Saint Phalle creates a series of sculptures called *Mères dévorantes* [*Devouring Mothers*] and begins the film *Nana Island*, which remains unfinished.

She creates her first public art commission, *Le golem* [*The Golem*], her first play structure for children, in Rabinovich Park, Jerusalem.

1972 In July, filming begins in the south of France for Saint Phalle's first feature-length film, *Daddy*, a collaboration with filmmaker Peter Whitehead. Saint Phalle acts in the movie alongside Clarice Rivers and Rainer von Hessen (credited as Rainer von Diez).

1974 Saint Phalle creates three large-scale *Nanas* to be sited outdoors in Hanover, Germany; residents of the city title them *Caroline*, *Charlotte*, and *Sophie* after prominent historical Hanoverians (an astronomer, a young love of Goethe's, and a princess, respectively).

At the end of the year, Saint Phalle is hospitalized in Switzerland with a serious lung ailment.

1975 While Saint Phalle is recuperating in the Swiss Alps, she confides her dream of building a sculpture garden based on the major arcana of tarot to Marella Agnelli, a childhood friend. Agnelli's brothers offer a piece of land in Garavicchio, Tuscany, as a site.

The artist makes her second feature film, *Camélia et le dragon*, or *Un rêve plus long que la nuit* [*Camélia and the Dragon* or *A Dream Longer than the Night*], starring Saint Phalle, her daughter, Laura, and Tinguely, among others.

1978–79 The initial construction for the Tarot Garden begins in Garavicchio. Work on the garden will continue for the next nineteen years.

1980 From July 2 to September 1, the Centre Georges Pompidou, Paris, holds Saint Phalle's first major retrospective exhibition in France. The show subsequently travels to Germany, Austria, and Sweden.

1982–83 In collaboration with Jacqueline Cochran, Inc., Saint Phalle launches her eponymous perfume. She designs the bottle and the stopper. The launch party in New York is sponsored by *Interview* magazine, and Saint Phalle attends the event with Andy Warhol. The perfume helps to finance a third of the overall cost of the Tarot Garden.

Saint Phalle collaborates with Tinguely on a commission from the City of Paris to create the Stravinsky Fountain beside the Centre Georges Pompidou, Paris.

In 1983 Saint Phalle moves into *The Empress* in the Tarot Garden, making it her home and studio for the next five years while construction on the garden continues.

1987–88 Saint Phalle is one of the first artists to join the fight against AIDS. Many close friends are victims of the disease, including her assistant Ricardo Menon and her gallerist Alexandre Iolas. In collaboration with the Swiss immunologist Silvio

Barandun, she coauthors and illustrates the book *AIDS: You Can't Catch It Holding Hands.* In 1990 she and her son, Philip, will adapt it into an animated film for the French Sécurité Sociale.

François Mitterrand commissions a new fountain from Saint Phalle and Tinguely for the town of Château-Chinon. It is inaugurated in March 1988.

1991 In August, Tinguely dies of a heart attack in Bern, Switzerland.

1993 To address her ill health (thyroid disorder, rheumatoid polyarthritis, and respiratory problems), Saint Phalle moves to La Jolla, near San Diego, California, where she will remain for the last eight years of her life.

1994 Saint Phalle publishes *Mon secret* [*My Secret*], in which she reveals the sexual abuse committed by her father when she was a girl.

On Tinguely's instructions, she finalizes *Le cyclop* for its inauguration at Milly-la-Forêt on May 24.

The collector Yoko Shizue Masuda opens a museum devoted to Saint Phalle's work, called the Niki Museum, in Nasu, Japan. (The museum will close in 2011, two years after Masuda's death.)

1996 The Museum Jean Tinguely, designed by Mario Botta, opens in Basel, Switzerland, following a major donation of works from Saint Phalle.

1998 The Tarot Garden officially opens to the public in Garavicchio on May 15.

1999 The first volume of Saint Phalle's autobiography, *Traces: An Autobiography; Remembering 1930–1940*, is published.

2000 The artist is commissioned by the city of Hanover to redecorate three rooms in the grotto of the Royal Gardens of Herrenhausen.

Saint Phalle finalizes a donation of 363 artworks to the Sprengel Museum in Hanover, Germany.

2001 Saint Phalle finalizes a major donation of works to the City of Nice, which are to be held in the collection of the Musée d'Art Moderne et d'Art Contemporain (MAMAC), Nice.

Saint Phalle finishes writing the second volume of her autobiography, *Harry and Me: 1950–1960, the Family Years.* It will be published posthumously in 2006.

2002 Niki de Saint Phalle dies on May 21 at the age of seventy-one in La Jolla.

Her granddaughter Bloum Cardenas and assistants Marcelo Zitelli and Lech Juretko help to complete her last projects, in Escondido, California, and Hanover, Germany.

2003 The artist's final project and only major public project in the United States, *Queen Califia's Magical Circle,* opens in October in the Iris Sankey Arboretum, Kit Carson Park, City of Escondido.

The Niki Charitable Art Foundation (NCAF), a nonprofit organization, is established.

This chronology was edited for this publication by Kyla McDonald. It is an abridgment of the biography compiled by Kyla McDonald and Caroline Dumoulin originally published in Kyla McDonald, ed., *Niki de Saint Phalle: Here Everything Is Possible* (Ghent: Snoeck, 2018).

Niki de Saint Phalle in »DADDY« Niki de Saint Phalle in

242

SELECTED BIBLIOGRAPHY

Sources are listed in reverse chronological order and alphabetically within years.

Katrib, Ruba, ed. *Niki de Saint Phalle: Structures for Life*. With contributions by Anna Dressen, Nick Mauss, Alex Kitnick, and Lanka Tattersall. New York: Museum of Modern Art, 2021.

Niki de Saint Phalle: The Joy Revolution Reader. Edited by Alison M. Gingeras. With contributions by Judy Chicago, Catherine Francblin, Jeanne Greenberg-Rohatyn, Hella Jongerius, KAWS, Raúl de Nieves, Clarice Rivers, Tschabalala Self, Laurie Simmons, Fabienne Stephan, and Carrie Mae Weems. Unpublished, Salon 94, New York, 2021.

Hambursin, Nina. *Niki de Saint Phalle: L'Ombre et la lumière / Shadow and Light*. In English and French. Cannes: Ville de Cannes; Paris: In Fine Éditions d'Art, 2019.

McDonald, Kyla, ed. *Niki de Saint Phalle: Here Everything Is Possible*. With contributions by Caroline Dumoulin, Catherine Francblin, Alison Gingeras, Denis Laoureux, Camille Morineau, and Xavier Roland and interviews by Daniel Abadie and Marcelo Zitelli. Mons, Belgium: Musée des Beaux-Arts Mons; Ghent: Snoeck, 2018.

Francblin, Catherine, ed. *Belles! Belles! Belles! Les femmes de Niki de Saint Phalle*. With contributions by Pilar Albaracin, Aya Cissoko, Marc Donnadieu, Valérie Donzelli, Caroline Eliacheff, Ann Hindry, Jean de Loissy, Marianne Le Métayer, Camille Morineau, Catherine Millet, Lucia Pesapane, and Naja Rasmussen. In French and English. Paris: Galerie Georges-Philippe & Nathalie Vallois, 2017.

Ich bin eine Kämpferin: Frauenbilder der Niki de Saint Phalle / I'm a Fighter: Images of Women by Niki de Saint Phalle. With contributions by Ulrich Krempel, Naja Rasmussen, Regina Selter, and Karoline Sieg. In German and English. Dortmund: Museum Ostwall; Berlin: Hatje Cantz, 2017.

de Menil, Francois, and Monique Alexandre. *Jean Tinguely. Niki de Saint Phalle*. Narrated by Pontus Hultén. In English and French with English subtitles. Houston: The Menil Collection, 2014. 57 min., PAL format.

Morineau, Camille, ed. *Niki de Saint Phalle, 1930–2002*. With contributions by Álvaro Rodriguez Fominaya, Patrik Andersson, Laurence Bertrand Dorléac, Émilie Bouvard, Bloum Cardenas, Catherine Dossin, Nathalie Ernoult, Catherine Francblin, Catherine Gonnard, Amelia Jones, Ulrich Krempel, Kalliopi Minioudaki, Lucia Pesapane, and Sarah Wilson. French edition, Paris: Reunion nationaux musées– Grand Palais, 2014. English edition, Madrid: La Fábrica; Bilbao: Museo Guggenheim Bilbao, 2015.

Francblin, Catherine, ed. *Niki de Saint Phalle: En joue! Assemblages et Tirs, 1958–1964*. With contributions by Michelle Grabner, Norbert Nobis, and Jacques Villeglé. In French, German, and English. Paris: Galerie Georges-Philippe & Nathalie Vallois; Herford, Germany: Ahlers Pro Arte Foundation, 2013.

Francblin, Catherine. *Niki de Saint Phalle: La révolte à l'oeuvre*. Paris: Hazan, 2013.

Huijts, Stijn, and Sytze Steenstra, eds. *Niki de Saint Phalle: Outside-In*. In Dutch and English. Heerlen, Netherlands: Schunck, 2011.

Groom, Simon, ed. *Niki de Saint Phalle*. With contributions by Amy Dempsey, Barbara Rose, and Sarah Wilson. London: Tate Publishing, 2008.

Saint Phalle, Niki de. *Harry and Me: 1950–1960, The Family Years*. Zürich: Benteli, 2006.

Niki de Saint Phalle: Catalogue raisonné, peintures, tirs, assemblages, reliefs, 1949–2000. Vol. 1. In English, French, and German. Lausanne: Acatos; Wabern: Benteli, 2001.

Saint Phalle, Niki de. *Traces: An Autobiography; Remembering 1930–1949*. Lausanne: Acatos, 1999.

Longenecker, Martha, ed. *Niki de Saint Phalle: Insider/Outsider— World Inspired Art*. La Jolla, CA: Mingei International Museum, 1998.

Hultén, Pontus. *Niki de Saint Phalle*. With contributions by Uta Grosenick, Wenzel Jacob, Marie-Louise von Plessen, and Niki de Saint Phalle. Bonn: Kunst- und Ausstellungshalle der Bundesrepublik Deutschland; Stuttgart: Gerd Hatje, 1992.

Hultén, Pontus, and Jean-Yves Mock, eds. *Niki de Saint Phalle*. With contributions by Pierre Restany, John Ashbery, and Larry Rivers. Stockholm: Moderna Museet, 1981.

[Mock, Jean-Yves, ed.,] *Niki de Saint Phalle exposition rétrospective*. Paris: Centre Georges Pompidou, Musée national d'art moderne, 1980.

Niki de Saint Phalle: Les Nanas au pouvoir. In French and Dutch. Amsterdam: Stedelijk Museum, 1967.

Niki de Saint Phalle. With text by Pierre Descargues. New York: Alexander Iolas Gallery, 1966.

Niki de Saint-Phalle. Paris: Galerie Alexandre Iolas, 1965.

CREDITS

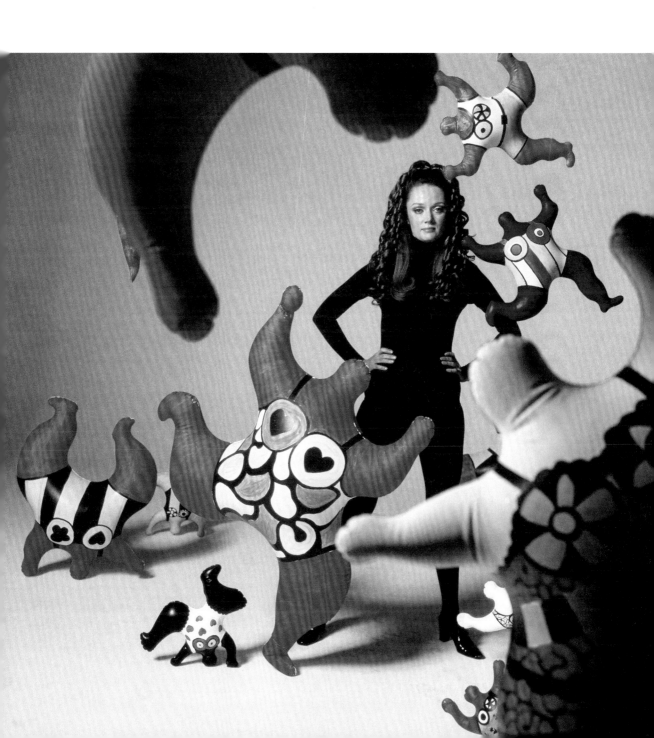

Published in conjunction with the exhibition

NIKI DE SAINT PHALLE IN THE 1960s

Co-organized by
**The Menil Collection, Houston,
and the Museum of Contemporary Art San Diego**
Co-curated by
Jill Dawsey and Michelle White

The Menil Collection, Houston
September 10, 2021–January 23, 2022

Museum of Contemporary Art San Diego, La Jolla
April 3–July 17, 2022

●

Major support for the exhibition catalogue is provided by Cecily E. Horton;
additional support is provided by the Niki Charitable Art Foundation
and the Menil Collection Publishing Fund.

Major funding for this exhibition at the Menil Collection
is provided by Louisa Stude Sarofim; Cecily E. Horton; a gift in memory
of Virginia P. Rorschach; Bettie Cartwright; and the National
Endowment for the Arts. Additional support comes from Dragonfly
Collection, Garance Primat; MaryRoss Taylor;
Carol and David Neuberger; Julie and John Cogan, Jr.; Robin
and Andrew Schirrmeister; MCT Fund; Niki Charitable Art Foundation;
UBS Financial Services; and the City of Houston through
the Houston Arts Alliance.

Institutional support of the Museum of Contemporary Art San Diego
is provided by the City of San Diego Commission
for Arts and Culture.

Support for this exhibition at both the Menil Collection
and the Museum of Contemporary Art San Diego
is provided by Christie's.

Research for this exhibition was supported by
the Terra Foundation for American Art.

Support as of June 1, 2021.

Copublished by

The Menil Collection
1511 Branard Street
Houston, Texas 77006
menil.org

and

Museum of Contemporary Art
San Diego
700 Prospect Street
La Jolla, California 92037
mcasd.org

●

●

Distributed by Yale University Press
P.O. Box 209040
302 Temple Street
New Haven, Connecticut 06520-9040
yalebooks.com/art

ISBN: 978-0-300-26010-6
Library of Congress Control Number: 2021909543

Produced by the Menil Collection
Publishing Department

Joseph N. Newland, Director of Publishing
Nancy L. O'Connor, Associate Editor
Manuscript Editor: **Jennifer Bernstein**
Proofreader: **Richard Slovak**
Graphic Design: **Lorraine Wild and Xiaoqing Wang,
Green Dragon Office**, Los Angeles
Reproductions: **Echelon Color**, Los Angeles
Printing, binding: **Conti Tipocolor**, Florence
Font: **SangBleu Sunrise**
Paper: **Gardapat Kiara**

Printed in Italy

Cover: Detail of *Fragment
de l'Hommage au Facteur Cheval
[Fragment of Homage to
Cheval the Mailman]*, 1962,
see page 149. Photo by Andre Morin

Page 4: Niki de Saint Phalle during
the first shooting session behind her
studio in the Impasse Ronsin, Paris,
February 12, 1961. Photo by
Shunk-Kender

Page 242: Promotional material for
the film *Daddy*, 1972. Black-and-white
photograph painted by Saint Phalle
and distributed by Constantin-Film.
NCAF Archives, Santee

Page 245: Niki de Saint Phalle with
inflatable *Nanas*, photographed for
"Les Nanas sur la plage: Bouncy
New Versions of Niki de Saint-Phalle's
Famous Sculptures," *Vogue*, April 15,
1968. Photo by Bert Stern

Page 248: Niki de Saint Phalle standing
in front of *Model for Hon*, 1966. Photo
Keystone/Hulton Archive

Back Cover: Niki de Saint Phalle during
her first shooting session, February 12,
1961, see p. 17. Photo by Shunk-Kender

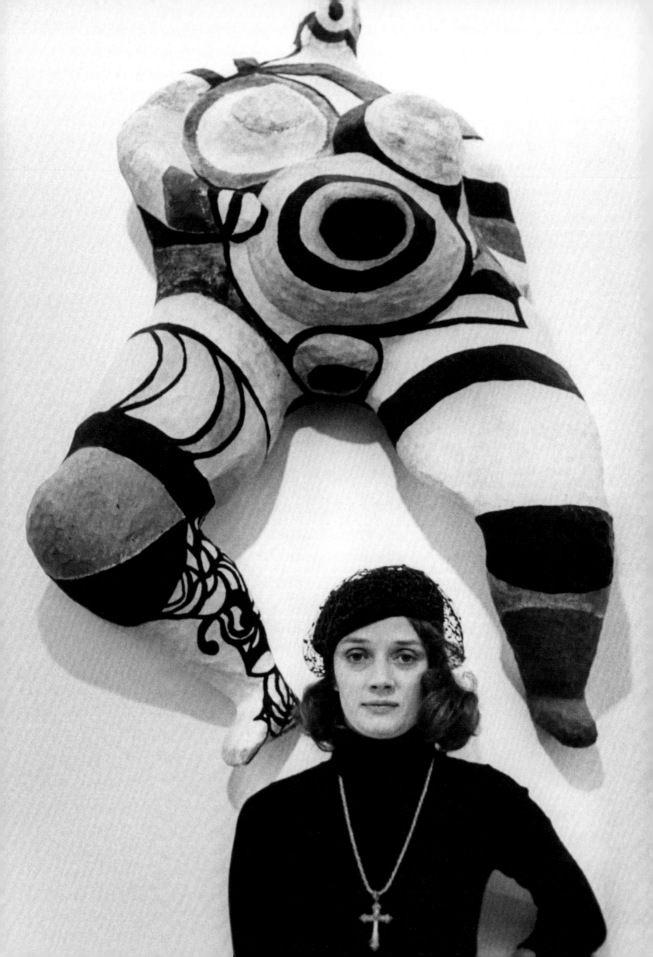